Unauthorized Pleasures

Unauthorized Pleasures

Accounts of Victorian
Erotic Experience

ELLEN BAYUK ROSENMAN

CORNELL UNIVERSITY PRESS

ITHACA AND LONDON

First published 2003 by Cornell University Press
First printing, Cornell Paperbacks, 2003

Printed in the United States of America

Library of Congress Cataloging-in-Publication Data
Rosenman, Ellen Bayuk.
 Unauthorized pleasures: accounts of Victorian erotic experience/
Ellen Bayuk Rosenman.
 p. cm.
Includes bibliographical references and index.
 ISBN 0-8014-4113-7 (cloth: alk. paper)—ISBN 0-8014-8856-7 (pbk.)
 1. Erotic literature, English—History and criticism. 2. English
literature—19th century—History and criticism. 3. Sex in literature.
I. Title.
 PR468.S48 R67 2003
 820.9'3538'09034—dc21

 2002151357

Cornell University Press strives to use environmentally responsible suppliers and materials to the fullest extent possible in the publishing of its books. Such materials include vegetable-based, low-VOC inks and acid-free papers that are recycled, totally chlorine-free, or partly composed of nonwood fibers. For further information, visit our website at www.cornellpress.cornell.edu.

Cloth printing 10 9 8 7 6 5 4 3 2 1
Paperback printing 10 9 8 7 6 5 4 3 2 1

Contents

Illustrations

Acknowledgments

It is my pleasure—finally!—to be able to thank the people whose help and support made this book possible.

Sharon O'Brien and Harold Weber have been in it for the long haul. Both read early drafts of several chapters, encouraged me to pursue my barely formulated ideas, bolstered my confidence, fed me, made me laugh, commiserated, stayed in touch—in short, continued to be exemplary friends. To Sharon goes credit for the title; to Harold, credit for other titles too outrageous for publication.

I cannot imagine having finished this project without the help of friends and colleagues at the University of Kentucky. Virginia Blum and Susan Bordo have read more of this book than they probably care to remember; their responses were a miraculous combination of incisiveness and support, and our many phone conversations, lunches, dinners, movie dates, and shopping trips were essential in keeping me and this book afloat. Gordon Hutner and Dale Bauer offered sustaining friendship and indispensable advice, reading substantial portions of the manuscript at crucial moments with characteristic insight (though with uncharacteristic agreement). Joe Gardner, Paul Taylor, Jo Ellen Green Kaiser, and especially Suzanne Pucci were also perceptive and helpful readers. English Department chairs David Durant and Greg Waller helped me manage my work load and take advantage of sabbatical opportunities; they have made the department a collegial place to work over the years. Greg Waller and Brenda Weber greatly assisted my research by finding the complete Grove edition of *My Secret Life,* against all odds, at a used book store in Winchester, Kentucky. Kakie Urch and Cyndy Henderson were crack research assistants; I thank the College of Arts and Sciences at the University of Kentucky for funding them.

Many people outside of the University of Kentucky also deserve thanks. I am especially grateful to Martha Vicinus for her early en-

couragement and sustained assistance, as well as her inspiring scholarship. Jay Clayton gave support at a critical moment, and Ivan Crozier shared his then-unpublished work on William Acton and lent his expertise. Andrew Miller took my essay on *Mysteries of London* under his wing at *Victorian Studies* and, along with the anonymous readers, made it a better piece. I am delighted that my manuscript has found a home at Cornell University Press, for its Victorian list has shaped much of my understanding of the period. Bernhard Kendler has been a wonderfully kind and effective editor, and the first, anonymous reader provided cogent advice. I am deeply grateful to James Eli Adams, who articulated many of the book's concerns better than I did, and whose reading was as generous and astute as any author could hope for.

Thanks, too, to organizations that helped along the way. Without the extraordinary collections and the helpful staffs of the Bodleian Library, the British Library, the Royal College of Surgeons Library, the British House of Lords, and the Scottish House of Lords, this book could not have been written, or even imagined. Grants from the American Council of Learned Societies, the University of Kentucky, and the Kentucky Foundation for Women freed time for travel and writing. A special thank you to the Interlibrary Loan Department at the University of Kentucky, which handled my avalanche of requests with efficiency and aplomb.

My deepest gratitude goes to my family. My mother, Jill Rosenman, and my late father, Bernard Rosenman, have supported me in tangible and intangible ways too numerous to mention. Daughter-on-loan Danielle Deneys joined our household in the midst of this project and adapted effortlessly to the demands of living with a mildly crazed college professor. My daughter, Lizzie Youngblood, has seen me through this project with the love, humor, and sympathy that only one writer can share with another; the number of times she has brightened my day is beyond measure. Most of all, I want to thank my husband, David Youngblood. Of course, he ran plenty of errands during the final push. But beyond that, he was always willing to be amused, appalled, and fascinated by my discoveries of obscure Victoriana; always available as a stylistic editor par excellence; and always there to remind me of the book I really wanted to write. I couldn't ask for more.

Unauthorized Pleasures

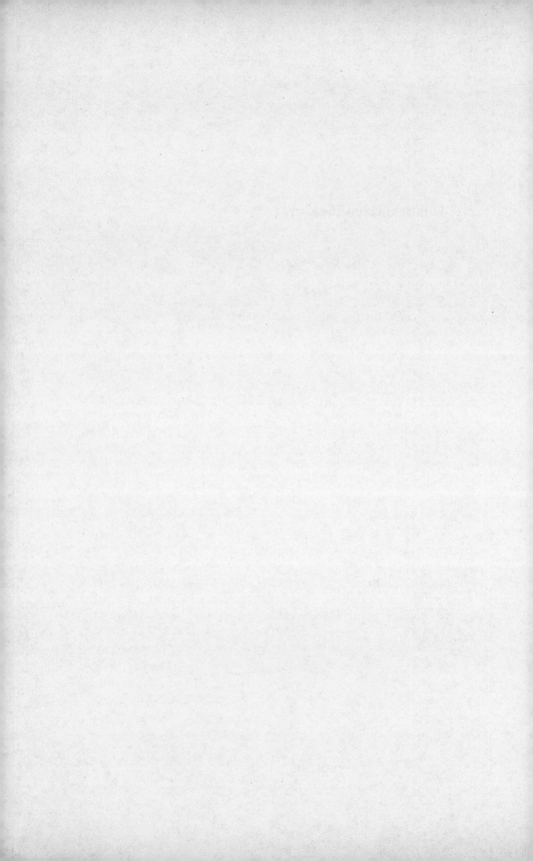

Introduction

Seeking Pleasure in Victorian Britain

"The absurdity of calling anything indecent or improper, which men and women may like to say or do together when in private, had not occurred to me. I now believe that it matters not whether what they do be called unnatural, or beastly, or not. So long as both like it and enjoy it, it is natural to them, concerns no one else, is in the instincts of their nature, and is to them proper." So says Walter, hero of the erotic epic *My Secret Life* (1:656–57). Repeated throughout his expansive memoir, this libertarian creed seeks a realm of sexuality requiring only the body's raptures for its justification. Walter imagines sexual pleasure as escaping the deformation of conventional morality: it is, as he says, private, instinctive, and—in a word whose variants occur three times in this short passage—natural. While Walter's astounding promiscuity is hardly representative, his utopian dream is not; it comes with the territory of Victorian culture, whose closely guarded categories of normality and deviance, like twin prisons, seem bound to prompt fantasies of escape. This is true for modern critics no less than for the Victorians themselves. Even Foucault, unsparing in his insistence that there is no "outside" to the discursive regime, imagines a realm of "bodies and pleasures" defined by their freedom from categorical identities that might serve as a "rallying point" against ideology (157).[1]

Of course, Walter never realizes his fantasy of natural sexuality—how could he?—but he does perform enough unnatural acts to defy

[1] Discussions of Foucault's "bodies and pleasures" can be found in Grosz, McWhorter, and Butler, "Revisiting." These critics disagree on whether Foucault hypothesizes forms of sexuality that lie outside the discursive system, as Butler argues, or within it (McWhorter, Grosz).

any classificatory system. The bodies he embraces (and spies on, and licks, and buggers) are carefully marked for proper consumption—lower-class heterosexual women available to men, male bodies of all sorts off-limits to other men, all bodies designated male or female, heterosexual or homosexual—but Walter's freewheeling appetites show no respect for these labels. Instead of regulating his desires, they incite him to experiment with alternative arrangements that, although they grow out of official taxonomies, rewrite them by refusing their mutually exclusive categories.

This second, strategic response is the subject of my book: how tales of erotic self-fashioning and sexual gratification emerged through the very structures that were meant to curtail them. My aim is less to challenge the view of the mid-Victorian age as sexually conservative than to emphasize the failure of ideology to script erotic lives and imaginations in definitive, predictable ways. Extending from the mid-1830s with the initial publication of Alexander Walker's *Beauty in Woman* to the 1880s, when the spermatorrhea panic runs its course and Walter concludes his memoir, the historical setting of my study is generally considered a time of relative constraint before the late Victorian sea change in sexual attitudes. In the standard history of the nineteenth century, the "sexual anarchy" of the fin-de-siècle challenged rigid mid-century norms: the consolidation of "the homosexual" provided a site of resistance to compulsory heterosexuality; the New Woman repudiated marriage; the increasing circulation of women on city streets as philanthropists, members of social clubs, and (of course) shoppers revised the pejorative connotations of the "public woman."[2] Although I also see mid-Victorian ideology as sexually inhibiting, I believe that the period sheltered more inventive forms of eroticism than it has been given credit for. In his pursuit of sensual gratification, Walter is less the Other of Victorian prudery than an outlying case on a continuum of desires. What Foucault calls the productive constraints of ideology inspired creative responses as individuals "metabolized" official pronouncements, finding unexpected resources with which to author and authorize unconventional pleasures.[3]

[2] The best-known accounts of fin-de-siècle sexuality are by Dellamora (*Desire*) and Showalter. For discussions of women in the city, see Walkowitz (*City*) and Nord, and see Rappaport for women as consumers.

[3] I have borrowed the word "metabolize," a wonderful description of individuals' reworking of ideology, from Victoria McTeer's paper "Moral Travel," delivered at the Narrative Conference, Atlanta, April 2000.

Although the sexual landscape was publicly mapped in terms of licit and illicit sexualities, these judgments did not exhaust erotic repertoires in either experience or imagination. Decades of rich scholarship have familiarized us with categories of subjectivity that organized the period: the prostitute, the fallen woman, the modest woman, the continent man, the homosexual.[4] But by bifurcating sexuality into normative and deviant identities, these categories rest on the binary between containment and subversion that, in forcing either/or evaluations of concrete phenomena, can mask their dynamic, nuanced, multifaceted quality. This recognition has led me to avoid pronouncements about "the nature of Victorian sexuality" and to resist the urge to propound alternative paradigms and categories. Instead, I follow a more open-ended, exploratory approach, tracing erotic pleasures as they emerge, not according to some universal principle but in idiosyncratic ways, through the rich particularities of individual texts, social actors, and occasions. Although my analysis engages familiar subjective categories, I am especially interested in experiences that do not reach the threshold of official perversity. Official identities marked the starting point of these adventures, and they furnished the means by which to normalize them, providing the cover stories, aliases, and justifications to appease censors or sidestep retribution. But pleasures emerged that were not colonized by a specific name or diagnosis; they had no recognized history within medicine or public health, nor were they explicitly prescribed or forbidden by conduct books or popular literature. The "fallen woman" might be condemned for her heterosexual crime, but the woman excited by images of female bodies eroticized for male consumption had no official existence. The pleasures of the medical examination, of passing attractive strangers on the street, of viewing art, of readerly identification, of melodramatic suffering are as much a part of erotic experience as conjugal bliss and homosexual anxiety. Even activities that are more recognizable within a Foucauldian taxonomy can elude simple classification, as in the spermatorrhea panic, whose encoded homoeroticism did not always mark an enduring orientation but was often layered with heterosexual practices.

[4] Anita Levy and Judith Walkowitz (*Prostitution, City*) have provided insightful accounts of the construction of the prostitute; Amanda Anderson of the fallen woman; Ruth Yeazell of the modest woman; Ed Cohen of the continent man and the masturbator; and Richard Dellamora (*Desire*), Ed Cohen, and Linda Dowling, among others, of the construction of the homosexual. This distinguished list should suggest how powerfully these categories have structured scholarship on Victorian sexuality.

In this respect, my book extends recent work on Victorian sexual dissidence, including that by Jonathan Dollimore, Christopher Lane, and Richard Dellamora, whose wide-ranging essay collection *Victorian Sexual Dissidence* exemplifies the impressive diversity made possible by this umbrella term.[5] Like these critics, I emphasize the fluidity and multiplicity of sexual experiences as they complicate familiar binaries.[6] I also emphasize a second assumption of this approach: that the meanings and ideological valences of Victorian sexual behaviors are seldom simple and cannot be understood in terms of our own modern politics of sexual transgression. As Lane writes, such a tactic risks "the eclipse of historical difference by substituting terms such as 'deviance' and 'perversion' for the dissimilarities, aporias, and discontinuities they only partially represent" (227).

The Victorian adventurers I discuss did not always enter into their pleasures with an ideological agenda in mind—though sometimes, like Walter, they did. Erotic experiences took many forms, some crabbed by anxiety, some flying under the radar of explicit taboos, some robust and brazen in their defiance. Moreover, modern theory is itself divided about the role of sexuality in politics, and of pleasure in particular. On the one hand, pleasure has been seen as a reward or a bribe that weds subjects to the status quo, as in Laura Mulvey's foundational essay "Visual Pleasure and Narrative Cinema," which ties the "satisfaction, pleasure, and privilege" of conventional film viewing to patriarchal codes of gender and vision (18). This alignment of pleasure with ideological complicity continues to preoccupy critics, especially in discussions of mass entertainment, as I discuss in chapters 3 and 4 in relation to popular literature. On the other hand, libidinal energy has also been understood as a potentially anarchic force inimical to social discipline, while sexual experiences that depart

[5] Peter Gay might be included in this list as exploring sexual dissidence before the term was coined.

[6] See, for instance, Christopher Lane's insistence on "a fluid politics that tries to displace binary logic (heterosexuality vs. homosexuality)—and especially 'heteronormativity'—by promoting polymorphous perversity" (13), and Dellamora's observation that "there is . . . good reason to question whether sexual dissidence is always structured within binary terms" (*Dissidence* 5). Dellamora quotes Gayle Rubin's insistence that "as soon as you get away from the presumption of heterosexuality, or a simple hetero-homo opposition, differences in sexual conduct are not very intelligible in terms of binary models. . . . There needs to be some kind of model that is not binary, because sexual variation is a system of many differences, not just a couple of salient ones" (qtd. in *Dissidence* 13).

from prescribed norms are often understood as subversive in and of themselves, functioning automatically as Foucault's "rallying points."[7] It is perhaps not surprising that the pleasures I survey depart from norms in some ways and conform to them in others; none of them is subversive in the sense that it had a visible effect on prevailing values—an outcome that I think is much more rare than our critical language suggests.[8] Still, if these pleasures cannot claim to have a direct impact on the dominant ideology, they compel recognition exactly because they are, in some sense, part of the system and therefore available within it, marking areas of "give" in strict sexual norms. I seek the political meanings of pleasure in concrete contexts, attempting to make a detailed local accounting of their multiple and sometimes inconsistent implications and effects.

In one important respect this book departs from the concerns of scholarship on Victorian sexual dissidence, which, for the most part, has identified itself with queer theory and charted same-sex desire. While I explore male homoerotic experience in chapters 1 and 5, I do not want to narrow "sexual dissidence" to this single axis. Although "heteronormativity" may be the antagonist against which queer theory struggles, heterosexual pleasures were no less vulnerable to charges of deviance and perversity, and no less capable of bending sex and gender norms (Lane 13).[9] Nor do I concentrate exclusively on either men or women. My aim is to set in motion the terms "heterosexual," "homosexual," "autoerotic," "masculine," and "feminine" as equally problematic and interesting, and as relating to one another in dynamic, unpredictable ways. Especially because the consolidation of sexual categories has had serious political repercussions, it is instructive to see how they have been evaded, even if only partially and on a local level. The narratives I discuss trace out logics for erotic ad-

[7] Dews lists Lyotard, Deleuze, and Reich in this camp, calling them "the désirants" (92–93).

[8] See Lane's discussion of "the damaging effects of declarative criticism," which labels erotic experiences and representations as either complicitous or subversive, and his warning that "sexual meaning buckles under the demand for interpretive certainty" (238, 227).

[9] I might still claim to be writing a work of queer theory in the sense of queering all sexual categories, including heterosexuality. But I have taken seriously Eve Sedgwick's caution: "Given the historical and contemporary force of prohibitions against *every* same-sex expression, for anyone to disavow those meanings, or to displace them from the term's definitional center, would be to dematerialize any possibility of queerness itself" (8).

ventures that remain relevant today. In a brief afterword I consider
the relationship of some of these logics to our own sexual landscape,
not to trace a coherent history of transgression but to explore,
through comparison and contrast, the implications of some of our
own assumptions.

Because of my emphasis on local authoring rather than overarching
generalizations, I have sought breadth by focusing on specific cases
within key social settings and discursive arenas. "The Spermatorrhea
Panic" engages the context of the new scientific medicine; "The Man
on the Street" pays special attention to aesthetic and physiological
protocols for interpreting female bodies in a dramatically urbanized
world; the chapters on *The Mysteries of London* and the Yelverton
marriage trials analyze the representational codes of popular litera-
ture and the cultural construction of the woman reader, while the lat-
ter chapter also explores the courtroom as a setting that construes
the meanings of female bodies; and the chapter on *My Secret Life*
considers the satisfactions of pornography. I have also attempted to
recover texts and events that were available to a popular audience,
though many have fallen into obscurity today (the exceptions are the
diaries of Arthur Munby and *My Secret Life*, both of which have a
central place in modern criticism). Canonical works, like official cat-
egories of normality and deviance, can tell us a great deal, but an ex-
clusive dependence on them can lead to an underreporting of erotic
experience and an incomplete mapping of sexuality. My aim here is
to enrich our map, to sketch the topography in more detail, to fill in
blank spaces, to treat the borders between normality and deviance,
heterosexuality and homosexuality, masculinity and femininity as
territories in themselves. In their lively, resourceful engagements
with their culture, these documents reveal the complex, varied, and
subtle texture of erotic lives in the Victorian age.

To place these experiments in context, I need to cover some famil-
iar ground, sketching the salient details of the sex-gender system
within which they took shape.[10] Although decades of revisionist his-
tory have unearthed examples of frank enjoyment and a range of sex-

[10] Stressing the link between subjectivity and sexual orientation, while paying less
attention to gender distinctions, Foucault understands sexual ideology as a system of
"sex-desire"; either term can serve to describe the interlocking categories of gender
identity and sexual orientation.

ual behaviors, the Victorian era still appears as an erotic age of anxiety.[11] Certainly individuals set out to challenge prevailing beliefs: Peter Gay's spectacular American example of Mabel Loomis, who dedicated herself to voluptuous sex within and outside of marriage; Charles Kingsley, who developed the concept of *thumos*, an explosive male sexual energy; the surgeon Sir James Paget, who emphatically rejected the pathologizing of masturbation.[12] It is equally clear that "Victorian sexual ideology" was, to some degree, class-specific, with greater freedom among the working classes. Neo-Malthusians promoted free love as part of a radical politics, while others, especially laborers in rural areas, were guided by relatively permissive customs regarding premarital intercourse.[13] Nevertheless, an "anti-sensual mentality," deeply fearful of bodily impulses and sexuality, ruled mid-century beliefs (Mason 7).[14] Even Robert Dale Owen, one of the main neo-Malthusian promoters of pleasure, valorized control, commending a "gentle flow" of desire that meanders its "quiet" way through the marital bed, and cautioning readers against the derangement of "passion" (14).[15] With few exceptions, most middle-class commentators were even more disapproving of sensual intensity.

Although the anti-pleasure mentality caught both men and women in its grasp, Victorian sexuality was patriarchal—not in the sense that it granted men extraordinary privilege and freedom but in the sense that it was organized around male anxieties. Masculinity, the first term in the gender dyad, required rigorous protection and policing:

[11] See, for instance, Porter and Hall: "Widespread sexual anxieties and inhibitions should not be minimized" (142). Gay also asserts that "the cultural signals by which nineteenth-century bourgeois oriented themselves [sexually] were often uncertain and anxiety-provoking" (8).

[12] For Gay's account of Loomis, see *Education* 71–108; for a discussion of Kingsley's theory, see Rosen.

[13] See, for instance, Mason's class-sensitive discussion of sexual mores, including his assertion that, in rural communities, baptism not uncommonly preceded the parents' marriage (105–74); see also Barret-Ducrocq's account of the standard narrative of sexual misconduct proffered to the Foundling Hospital, which suggested that the fallen woman retained the support of her family and the sympathy of her community (though it should be noted that Barret-Ducrocq's work has been critiqued for taking the hospital documents at face value, since, if these women wanted help, they would have had to tell the story the authorities wished to hear whether it was true or not).

[14] See also Porter and Hall: "Sensuality came to be practically the antonym of respectability" (32). Likewise, Gay calls attention to the "cult of privacy and timidity" that determined sexual behavior (*Education* 280).

[15] Dale Owen also remarks that "a cultivated race are never sensual" (71).

"constant self-watchfulness, self-discipline, and self-control," Samuel Smiles insists in his popular text *Character* (23). Passion assaulted the rational self, which to Smiles was responsible for enforcing discipline and control, while the body's sensual responsiveness marked it as both delinquent and vulnerable. These fears expressed themselves in issues of body boundaries and physical hardness, as if the self were a citadel under siege that could protect itself only by steeling its borders. The image of the fortified castle, a recurring trope in masculinity theory, captures the defensive quality of embodiment.[16] "Hard" masculinity was cultivated by the rigors of boys' schools, which placed pupils in intimate proximity in classrooms, on playing fields, and in dormitories in order to transmit codes of behavior from one body to another.[17] At the same time, the newly respectable field of surgery put body disgust on a firm scientific basis with its ideal of "continence" (Acton 68). Referring to both sexual self-control and bodily self-containment, this ideal reinforced the link between masculinity as "character," a form of subjectivity, and corporeal discipline. As Ed Cohen argues, even as it was challenged by more permissive theories of male sexuality, continence asserted its priority, insisting on "a nonmasturbating, married, industrious, and (re)productive body as the 'healthy' standard for middle-class masculinity" (69). Masculinity required "virtuoso asceticism," a gender and class performance that visibly repudiated sensual appetites and affirmed corporeal defenses (Adams, *Dandies* 2).[18]

[16] Theoretical elaborations of this ideal can be found in Theweleit, Grosz, and Kristeva. Theweleit associates masculinity with "self-distancing," defined as "a psychic splitting of individuals from their affects . . . a constant advancing of the thresholds of shame and embarrassment . . . [and] the bodily splitting of an individual into *inner* and *outer* physical realms, with the skin forming an increasingly sharp borderline" (312). Kristeva calls the self a "fortified castle" (46). Gay remarks about middle-class men "No other class has ever built the fortifications for the self quite so high" (*Education* 403). It is important to note that this version of masculinity is often associated with phallicism in modern theory and criticism, but this identification is too simple for Victorian culture, which was deeply ambivalent about aggression and self-assertion (unlike, for instance, the Nazi culture described by Theweleit). *Tom Brown's Schooldays* drew criticism as a mindless valorization of physical strength over intellectual qualities, while Wilkie Collins's *Man and Wife* attacks the brutality of muscular masculinity.

[17] Boys' schools both promulgated a cultural ideal in representations such as *Tom Brown's Schooldays* and inculcated this training in a generation of middle-class boys; according to John Tosh, the socialization these schools provided became the "defining experience" of masculine development by the second half of the century (105).

[18] See also Sussman for a nuanced account of masculine self-regulation, esp. 1–15.

As masculinity studies have increasingly focused on the creation of "the homosexual" by the end of the century, they have emphasized homosexuality as *the* form of male deviance (and, by and large, implicitly regarded earlier homoerotic activities as part of the history of homosexuality, despite caveats about the dangers of projecting historically specific categories backwards in time). But the heterosexual norm was also highly fraught. Although a double standard for sexual behavior undoubtedly did exist, and the extent of Victorian prostitution may suggest some latitude in behavior, men could not pursue pleasure freely. Prostitution was never justified on the basis of men's right to erotic enjoyment; instead, resorting to prostitutes was understood as an unfortunate moral lapse or a physiological necessity, and this by only a portion of the medical community (though some men were undoubtedly delighted to find a medical justification for their trysts).[19] Many doctors considered both prostitution and excessive conjugal sex injurious to male health and character. In other words, even as heterosexuality was increasingly invoked as a norm to pathologize homoerotic activities, it carried its own pathology.

It is not surprising that these anxieties had severe consequences for femininity. Made strange by strictures on male arousal, women's bodies were a source of fascination and paranoia. Just as male continence demanded the display of virtuoso asceticism, a woman's virtue was signified by her performance of ladyhood, in which gentility and morality were, in theory, seamlessly joined.[20] Accessible and unthreatening, the female body was expected to be a "constantly available text . . . [with] nothing to hide," framed for male consumption in a variety of ways that contained its sexuality, whether by denying its erotic appeal, as in the case of the nude, or by representing it as a de-

[19] There is some evidence that most customers were working-class men, so prostitution statistics may not reflect the behavior of bourgeois men; see Walkowitz (*Prostitution*). It is also worth noting that the Contagious Diseases Acts, which called forth the most energetic defense of prostitution, applied only to select garrison and naval towns with large populations of soldiers and sailors, indicating a limited and class-specific tolerance. From the outset, the CD Acts excited controversy because they condoned male self-indulgence and were repealed at least in part through Josephine Butler's impassioned pleas for male chastity. Ed Cohen argues that protests against the CD Acts actually solidified the ideal of continence: "Probably the most forceful argument marshaled against the acts, reiterated in a multitude of forms, was that they tacitly—if not actually—legitimated a rampant form of male sexuality which overflowed the boundaries of the monogamous bourgeois family" (82). See his detailed account of the evolution of the ideal of continence (69–93).

[20] The most detailed discussion of the performativity of middle-class femininity is Langland's *Nobody's Angels*.

lectable but passive object (Langland, "Enclosure" 10–11). But constructing femininity in terms of performance and display also led to fears that women might manage their own bodies, that the "constantly available text" might be authored by women themselves. Thus, contradictory attitudes about display became a central, defining ambivalence in Victorian representations of women. Although women were expected to arrange themselves for male admiration, professions such as acting, dancing, modeling, and writing were often charged with indecency, while appearing in public spaces might lead to "the trauma of public exposure" and contaminate women with sexual meanings (Nord 137).[21] And this fear of self-authoring and self-display led to an obsession with the real meaning of women's bodies, especially in an age when gentility was increasingly a function of money, status symbols, and behavior as well as genealogy, so that middle-class status and its attendant virtue could convincingly be fabricated.[22] Emerging as a literary type, the seductress enacts and is punished for this possibility, as her depravity is eventually written on her body: Becky Sharp's metaphorical serpent's tale, the shocking red hair of Lydia Gwilt (not shocking enough for one reviewer, who demanded that she be even more visibly deformed to signal her iniquity), and the lurid portrait of Lady Audley all offer reassurance that the body will somehow give itself away, breaking the erotic spell and affirming its legibility.

But new social spaces, new forms of bodily proximity, newly circulating representations of bodies and sexuality, and new forms of spectatorship and display set off erotic vibrations that could not be easily contained; indeed, one recurring concern of this book is the distinctive sexual charges vision takes on in these new contexts. Bodily and subjective boundaries were inevitably compromised as lines of defense also opened channels of contact. Both medicine and aesthetics,

[21] Again, Nord and Walkowitz (City) provide the richest studies of women in the city, from the earlier, more familiar model of the privileged flâneur to the increasing freedom of women later in the century; Levy also stresses the power of male diagnostic vision over women. See Davis for an account of the role of actresses in Victorian culture, and Mermin for a discussion of the sexual connotations of display applied to women writers. In *Victorian Babylon*, Lynda Nead challenges the view that the city was organized around male visual privilege; I take up the relationship between the flâneur model and Nead's revisionist argument in chapter 2.

[22] In some cases, women are granted preternatural powers of disguise to underscore their dangers, as in the stunning case of Jean Muir, protagonist of Louisa May Alcott's *Behind a Mask*, who pulls off several successful seductions while wearing a wig, theatrical makeup, and false teeth.

prime agents in de-eroticizing bodies, also invited sexual responses. It has been argued that the male body and especially the penis have been veiled to conceal their departure from the phallic ideal; but with the rise of scientific medicine and the professionalization of surgeons, who treated venereal diseases, the nineteenth century served up corporeal representations as never before.[23] Articles and illustrations appeared in respectable scientific journals read by lay readers (especially the *Lancet*, which was founded to serve the interests of surgeons but actively sought a nonspecialist readership); popular medical advice books, quack pamphlets, and medical texts became available in used book stores; and anatomical waxworks and museum displays modeled the body with fetishistic detail and precision. Under the banner of science, they offered men opportunities for corporeal self-reflection and even arousal, as did the self-explorations and medical examinations inspired by the hysteria over venereal disease, which allowed men to touch their own bodies and to be touched by other men.

Aesthetics offered similar pleasures, though for men they were primarily heterosexual ones because of the relative scarcity of male nudes.[24] While nudes were idealized by experts as formalist masterpieces, they could also provide unnamed delights, "haunt[ing]" the spectator with their beauty and tantalizing him "with a dreamy sense that some day I should understand them," as one reader of the *Penny Magazine* reported ("Penny Magazine" 547). With its rhetoric of mystery, the passage foregrounds the threshold of conscious awareness that the writer cannot cross, employing a kind of productive ingenuousness that allows his open-mouthed rapture to stand uncategorized and uncensored. Like the homoeroticism of the spermatorrhea panic, the delights of aesthetic spectatorship thrive beyond the reach of ideological definitions. Women, too, could turn to images and narratives for erotic self-knowledge.[25] Burnished by male fascination in novels, on stage, and in paintings, their bodies took on an appeal that they

[23] For a representative claim about the scarcity of such images in Victorian culture, see Joseph Kestner, who argues that Victorian painting seldom represented fleshly male bodies and, when it did, generally armored them in some way such as placing staves or swords in front of the genitals (239).

[24] The assertion that the female nude was much more common than the male is standard; see Kestner (237), Smith (*Victorian Nude* 25), and Pearsall (*Maiden* 102–3). For a fascinating account of paintings of nude boys bathing, produced from the 1880s onward (that is, after the period of my study), see Saville.

[25] Unfortunately, I have not found any reports of women viewing naked male bodies in medical literature or art.

themselves could respond to in multiple ways, exploiting the sexual connotations of self-display. Women might identify with an implied or actual male spectator, fulfilling John Berger's famous pronouncement, "Men look at women. Women watch themselves being looked at" (47). But male identification might also lead to an active pursuit of sexual gratification or to a sensuous relationship with one's own body. As recent feminist criticism has argued, fetishism, performance, and display can furnish autoerotic delights independent of heterosexuality.[26] In Victorian representations women also find pleasure in their own forms, whose seductive charms are so vividly depicted through male eyes.

As these comments suggest, vision, reading, and interpretation are key issues in my argument, as much a part of the map of pleasure as bodily contact. Socially embedded, context-specific, and dynamic, they exceed the familiar dyad of male viewing subject and female viewed object in a variety of ways.[27] Science and medicine claimed to stand aloof from sexuality, leaving the loyal reader of the *Penny Magazine* to find his own suggestive vocabulary, while the theater and popular literature frankly promised titillation. These realms cannot be collapsed into a single version of male sexual possession, for each had its own distinctive way of managing anxiety and liberating erotic energy. And while art and literature routinely objectified women, other arenas objectified men. Scientific medicine scrutinized middle-class male bodies just as it did the bodies of prostitutes during the reign of the Contagious Diseases Acts, while the bustle of city streets subjected men as well as women to the gazes of passers-by. The flâneur might sweep his detached glance over the urban scene, but the shop girl, the milliner, or the artist's model—freed from the constraints of gentility by her liminal class status and the anonymity of the city—could boldly meet his eye, creating a field of intersecting looks that complicated his privilege. Finally, as I have suggested, rep-

[26] See Garber ("Fetish"), Apter, Gamman, and Fuss ("Fashion"). I take up this issue in chapter 3.

[27] For a recent assertion of this standard dyad as the defining visual dynamic of Victorian culture, see Stratton, who introduces his study *The Desirable Body* with these words: "This book is about the transformation in the experience of the body which occurs around the middle of the nineteenth century. What I am seeking an account for is the male eroticisation and spectacularisation of the female body that takes place in this period, at the same time that the male body is conscientiously hidden from view" (1).

resentations offered spectators and readers of both sexes same-sex mirrors for self-construction. Thus, one recurring project of this book is to reimagine the erotic life of the woman reader. Not quite a sexual deviant but a suspicious character nonetheless, she is an exemplary seeker of unauthorized pleasures.

Indulging my own utopian need to affirm truly pleasurable and not wholly complicit pleasures, I have arranged my chapters into a kind of story with a happy ending—or, rather, several happy endings. Following Victorian ideology, my story begins with male anxiety. Chapter 1, "The Spermatorrhea Panic," represents the extremes to which Victorian culture was willing to go in order to punish the body. Subjecting middle-class men to the gaze of scientific medicine, the spermatorrhea panic helped to construct the male bourgeois subject, including and especially the modern medical professional. Indeed, the price surgeons paid for their emerging middle-class status was the invasion of their own bodies at the hands of their fellow surgeons. Chapter 2, "The Man on the Street," moves from the examining room to the streets to continue this exploration of male anxiety. Though often understood as the happy province of the flâneur, the city encouraged a sexual paranoia with its promiscuous intermingling of ambiguous bodies. I trace an array of gazes designed to fend off these bodies in three texts: Wilkie Collins's novel *Basil;* Alexander Walker's *Beauty in Woman,* a treatise on aesthetic and scientific spectatorship; and the diaries of Arthur Munby, self-described flâneur and amateur sociologist. These texts clarify the identifications and disidentifications with social others, both male and female, that mark the boundaries of proper middle-class bodies. Structured by anxiety, disavowal, and projection, urban sexuality is cramped and conflicted in the extreme. Nevertheless, the very judgments that censor pleasure act as a cover for its emergence in the recovery of a lost homoeroticism in the spermatorrhea panic, and in the sentimental, pastoral heterosexuality of Munby's diaries—another version of the dream of a natural erotics.

Chapters 3 and 4 examine the consequences of male sexual anxiety for women. Despite the familiar objectification of women through male gazes, I examine the ways in which, by projecting sexuality onto female bodies, male looking makes them available for women themselves. In his best-selling novel *The Mysteries of London,* subject of chapter 3, G. W. M. Reynolds fashions a logic of female sexual subjec-

tivity from the voyeuristic codes of popular fiction, mapping out a zone of autoerotic pleasure for its female protagonist. I trace a similar logic in chapter 4, on the Yelverton marriage case. Exploiting these codes in a similar way, Theresa Longworth, a dangerously well-read middle-class lady, develops a rhetoric of active sexual desire from melodrama and romance. Addressed to her lover, Captain Yelverton, her letters constitute a rare Victorian reception study, demonstrating the unpredictable ways in which one reader interpreted and revised literary conventions, while the ensuing trials, focused on their contested marital status, stage the collision of these revisions with beliefs about female virtue. These chapters reveal surprising resources for female eroticism.

The eleven-volume sexual memoir-fantasy *My Secret Life* forms (in an irresistible, overdetermined pun) the climax of my study in chapter 5: at last, a man finds direct sexual satisfaction. A product of the spermatorrhea culture, Walter adopts a strategy of conscious resistance and deliberately transgresses Victorian ideology—not only its moral prescriptions but also its axiomatic assumptions about subjective coherence. Seeking out the "shock" of sex, as Lane terms the power of sexuality not only to constitute but to destabilize the self, he takes on a large-scale rescripting of roles and relationships, approaching Foucault's ideal of "bodies and pleasures" detached from a single inalienable identity (29). My reading of Victorian pornography suggests that, while Walter's explicitness and insight are unusual, his cross-gender and cross-sexual experiments are not: part of the genre's appeal was the fantasy of subjective freedom it granted its readers. Rather than simply amplifying patriarchal roles, pornography also protested against them. Walter's pleasures represent a frontal assault on sexual norms, going beyond the tacit challenges of chapters 3 and 4. But in another sense they are utterly conventional, resting on the privileged position of gentleman that gives Walter the social and economic power to stage his erotic theatrics.

One final word: although I have sought Victorian pleasure in a (relatively) systematic and wide-ranging way, a further commitment—a very subjective one—has informed my choice of works. I have been drawn to all of these texts by their exuberance and excess. They were all great finds and great reads, diverting my attention from more mainstream sources in the course of my research. Many of them began as background material, then elbowed their way into the fore-

ground through sheer force of personality. They have buoyed my spirits through the writing of this book. By modern standards of irony and understatement they are overblown, bombastic, unintentionally hilarious, melodramatic, and sometimes downright weird, reaching out for the reader with both hands. I quote extensively, not only for the sake of concreteness and detail but to share their stylistic flavor as well. If *The Mysteries of London* and the Yelverton marriage case gave vicarious erotic pleasure to Victorian readers, they can also delight a modern audience more jaded about sexual revelations with their narrative vitality. Enjoy.

1 Body Doubles

The Spermatorrhea Panic

A promising young medical student becomes reclusive, tear-
ful, and despondent, neglecting his studies and spending his days in
bed (Lallemand xi). A banker becomes paranoid and aggressive, at-
tacking a fellow businessman on the street for no reason, and eventu-
ally goes completely insane (Lallemand x). Desperate to stop mastur-
bating and arrest his physical and mental deterioration, another man
ties himself up (Acton 159). If they had consulted their doctors, these
men would have received treatments scarcely less frightful than the
disease itself: they might find their penises encased in miniature iron
maidens or have their testicles surgically removed (Milton 95; Wil-
son, 23 August 1856: 215). These symptoms and responses are part of
the panic over spermatorrhea, which we now know to be a nonexist-
ent disease but which preoccupied nineteenth-century surgeons and
laymen alike for decades.[1] Defined as the excessive discharge of
sperm caused by illicit or excessive sexual activity, especially mas-
turbation, the disease was understood to cause anxiety, nervousness,
lassitude, impotence, and, in its advanced stages, insanity and death.
These tragic tales of ruined lives give a flavor of the hysteria sur-
rounding spermatorrhea. What led doctors to imagine this disease
and patients to produce such symptoms? Why did both doctors and
patients respond with such extraordinary and brutal interventions?
Why, since it did not exist, did spermatorrhea have to be invented?

As my last question is meant to suggest, its fictiveness is exactly

[1] Although some scholars have suggested that spermatorrhea was the invention of
quacks, there is ample evidence that legitimate surgeons regarded it as a real disease,
even though its prevalence was debated. For a useful overview of the subject, see
Mason (295–98); also Porter and Hall, esp. 144–45.

what makes spermatorrhea important, not as a quaint instance of primitive medicine but as a revealing cultural phenomenon. It is, as Stephen Heath writes, "one of the diseases which . . . [although they have] nothing to do with the actual diseases of the period (the typhus fever of the slums of the new industrial cities, for example) are strictly *Victorian*," imagined into existence to embody historically specific anxieties (20). In its medical pathologizing of sexual experience, spermatorrhea is a prime example of Foucault's *scientia sexualis*, with its authoritative scientific discourse, its monitory case studies and shameful confessions, and its categories of deviance. But spermatorrhea also complicates the power structure that often emerges in Foucauldian treatments of Victorian medicine, in which middle-class professionals objectify and dominate inferior others, defined in terms of class and gender. Certainly Victorian culture provides classic examples of this structure: the Contagious Diseases Acts authorized surgeons to forcibly treat prostitutes for venereal disease by painting their genitals with mercury, and the Anatomy Act of 1832 offered up the corpses of the poor to anatomists for dissection. These laws clearly depended on what one scholar has called a "medico-moral discourse that extensively deployed a set of class and gender-related polarities" as a foundation for doctors' professional authority (Moscucci 60). But for several reasons, spermatorrhea was considered an ailment of middle-class men: they tended to postpone the legitimate sexual outlet of marriage until they were financially secure; they were prey to sexual panic because of class-specific constraints on erotic pleasure; and they could afford medical care.[2] Nearly every victim of the disease is identified as a member of the bourgeoisie: a lawyer, a military officer, a well-placed clerk, a banker, a student, and, frequently, a doctor. Of the many case studies of spermatorrhea I have read, only one involves a working-class man—a bricklayer—and his situation is presented as a startling anomaly (Dawson, *Spermatorrhea* 78).

Prohibitions on pleasure for both genders and all classes may have projected the stigma of sex onto "othered" social groups *as* groups—

[2] Robert Ritchie, writing of the causes of insanity in the *Lancet*, claimed that there were twice as many middle-class men as men of other classes in insane asylums because of masturbation. He concludes, "This result is just that which might have been expected from the consideration of the inducements to the habit, having regard to morality . . . to occupation, recreation, social intercourse, and facilities for marriage" (216).

the rationales that drove the CD Acts and the Anatomy Act rested on such stereotyping—but it did not exempt middle-class men from sexual policing. On the contrary: middle-class men were caught in a contradiction: the double standard and the semi-tolerant regulation of prostitution offered the privilege of sexual experience, but such experience was tightly constrained, if not forbidden, by the ideal of self-discipline that increasingly defined bourgeois manhood, distinguishing it from aristocratic licentiousness on the one hand and working-class bestiality on the other. Spermatorrhea enjoyed what can only be considered a kind of vogue because it compulsively restaged this impasse of opportunity and punishment. Moreover, the doctors who specialized in spermatorrhea, as we shall see, had a complex investment in the disease: they were surgeons, a class of medical practitioners whose status was ambiguous and in flux. Instead of standing serenely above the contamination of embodiment, they themselves were in the process of renegotiating their identities in order to achieve their own specific version of middle-class manhood: that of the modern professional. Surgeons and patients shared a social position, as well as anxieties about class status and the body, which made it impossible for doctors simply to abject sexuality onto a different, depraved other. Instead, the spermatorrhea epidemic served a different function: it provided the occasion for a sustained, conflicted investigation of a sexuality that doctors and patients both repudiated and laid claim to. It was an epidemic of ambivalence.

Men against Men: Punishing the Body

Spermatorrhea came to public and professional notice in the 1840s, and though ideas about its prevalence varied widely throughout the century, it obsessed doctors and laymen alike until the late 1870s.[3] It gained attention in Britain through the influence of Claude François Lallemand's foundational (I can hardly resist the urge to say "seminal") work, *A Practical Treatise on the Causes, Symptoms, and Treatment of Spermatorrhea*, first translated into English in 1847, and was popularized through an extensive series of articles in the

[3] F. B. Courtenay's *Practical Essay on the Debilities of the Generative System* was already in its second edition in 1839, but widespread interest in spermatorrhea came a few years later.

Lancet and other medical journals, the many editions of William Acton's treatise *The Functions and Disorders of the Reproductive Organs in Childhood, Youth, Adult Age, and Advanced Life,* and a slew of books and pamphlets written for popular consumption.[4] Medical authorities linked the disease to the excessive discharge of sperm, though they differed on whether the problem was the emission itself—a throwback to the idea that semen was a vital fluid whose loss was intrinsically debilitating—or the depletion of energy caused by overstimulating the generative organs.[5] Surgeons might diagnose the disease by listening to the patient's litany of symptoms, including nocturnal emissions, premature ejaculation, and impotence; by examining the testicles, prostate, seminal vesicles, and urethra; or by analyzing the patient's urine under a miscrocope to search for sperm, held by many to be the most up-to-date and reliable test. Although accounts differed in their nomenclature and precise explanations, the disease was generally believed to have two stages, the first involving exessive discharge and the second exhaustion, in which the entire body languishes and the horrifying symptoms described earlier manifest themselves. For several decades, surgeons considered the disease widespread and focused on causes, symptoms, and treatments. Then increasingly, as quacks entered the territory, legitimate doctors began to insist that actual cases were infrequent and transferred their attention to the evils of their illicit competitors, who had quickly discovered that treating the sexual maladies of a guilt-ridden bourgeoisie was an extremely lucrative enterprise. Claims about the rarity of the affliction hardly quelled the anxiety of

[4] As this catalogue suggests, a range of practitioners participated in the spermatorrhea panic. In this section, where I lay out medical beliefs, I quote only members of the Royal College of Surgeons, although I do not distinguish among different degrees of respectability. The expertise of some of these doctors is at issue both in Victorian medicine and in modern studies, but I have not found much difference between the arguments of these "borderline" surgeons and their better-esteemed colleagues. The passages I quote from popular pamphlets do not depart from the material in medical journals. True quacks, with no medical training, do not appear in this section but are discussed in detail in the next section.

[5] Mason allies the vital fluid idea with the older "haematic theory," which held that sperm was an extremely precious form of blood. Although most surgeons did not believe in a literal identity between the two substances, some, like Acton, still considered semen to be essential for overall health (208–9). More common was the belief in overstimulation of the sex organs; Wilson, for instance, writing in the *Lancet,* calls attention to "the abnormal and over-excited condition of these organs in a state of disease" (23 August 1856: 216).

these men, especially those who had engaged in some dubious sexual activity and then watched with dread for the signs of its consequences. One surgeon estimated that over two-thirds of his patients had or thought they had the disease (Mason 297).

Although its symptoms and treatments were similar to those of other venereal diseases, spermatorrhea departed from these ailments in a crucial way: it was not contagious. In other words, while unclean women could be blamed for transmitting syphilis and gonorrhea, spermatorrhea came from within, the result of male corporeality rather than female pollution. For this reason, the spermatorrhea literature foregrounds the symbolism of the male body, enacting in a particularly literal way the familiar tension between the penis and the phallus. On the one hand, medical literature represented the ideal of a forceful, dominant masculinity grounded in the body—what we now call phallic masculinity—using the language of hardness, force, and size to describe male anatomy. Physical growth to maturity instills phallic properties in the body, as it is "hardened into the firm . . . frame of the man" and develops "a very powerful . . . sex-passion" (Acton 120, 121), signaled by "a copious discharge of well-formed semen" (Gascoyen, 20 January 1872: 68). Notable for its "intensity" and "bulk" (Wilson, 13 September 1856: 301), this manly fluid "jets" out during ejaculation (Acton 105). Within the framework of Victorian medicine, which understood the reproductive system as the basis for all physiology and psychology, these phallic properties permeated every part of male identity.[6] The firm, erect penis is "the external sign of virility," displaying man's "consciousness of his dignity, of his character as head and ruler, and of his importance" (Acton 191, 123). Since a healthy sexual function "has a direct effect upon the whole physical and mental conformation of the man . . . helping, in no small degree, to form character itself," the penis not only signifies but actually produces masculinity (Acton 49).

This line of thinking, with its language of hardness, firmness, and jetting, would seem to lead directly to sexual self-assertion and sexual pleasure, as virile men exercise their God-given equipment to the

[6] See Heath (20), Foucault (65–66). For Victorian sources in addition to Acton, see Dawson (*Marriage* 1) and Wilson. Although Wilson took a somewhat more skeptical view of the prevalence of spermatorrhea than Acton, he asserted that as a sexual ailment, it was "accompanied with complete disarrangement of all other functions of the body" (23 August 1856: 217).

end for which it seems so obviously intended. From the standpoint of much feminist theory, the link between this phallic body and sexual domination is well-nigh inevitable.

But this signification was to be no more than symbolic, since, as many critics have argued, masculinity required self-discipline.[7] James Eli Adams's "virtuoso asceticism" represented the essence of the bourgeois male ideal. Relinquishing erotic pleasure was a primary demonstration of this quality, as "manliness is divorced from sexuality [and] potentially dangerous psychic energy channeled into productive work" (Sussman 17). Most spermatorrhea surgeons endorsed and contributed to this ideal, replacing the virile body with a disembodied and disembodying phallicism.[8] While endorsing conjugal sex in controlled doses, surgeons pathologized other forms of erotic pleasure in hierarchies of deviance ranging from extramarital sex with a single partner through promiscuity and prostitution to the ultimate sin of masturbation, with minor variations in the ranking of these dangerous practices. Acton is most explicit in tailoring medical theories to this concept of bourgeois masculinity. Grafting virtuoso asceticism onto virility, he produces a particularly self-denying version of male sexuality. Although he appears to support the link between sexuality and masculinity when he calls the erect penis "the external sign of virility," he sublimates this virility into self-control, an aspect of character rather than of physiology. Man and body are not perfectly aligned in an attitude of domination; in fact, what needs to be dominated is the body itself. A new set of metaphors represents sexual self-denial in heroic terms. Evoking sport and war, doctors compare this mastery to training for a race or a boxing match (Milton 134), and speak of taking up "arms" in the "conflict" with the body (Acton

[7] Sussman's assertion that Victorian masculinity was "consistently theorized as being grounded in the regulation of male sexual energy," and his extended discussion of this regulation in the realms of literature and art, are highly germane to my discussion (11). See also Ed Cohen on the ideal of sexual self-restraint in bourgeois heterosexual men (69–93).

[8] This was the dominant understanding of male sexuality, but it was not the only one. Oppenheim notes that nervous debility was understood to result from sexual frustration as well as sexual indulgence and that doctors might propose marriage as a cure (164). She also asserts that masturbation began to lose its demonic associations later in the century, partly owing to the arguments of the surgeon Sir James Paget (162); Hall, however, argues that anti-masturbation sentiments were strongest from the late nineteenth century until the beginning of World War I ("Forbidden" 371).

61).[9] Acton's term for victory is "continence": "The very word we have used—continence—admirably expresses the firm and watchful hold with which [a man's] trained and disciplined will grasps and guides all the circumstances and influences of his life" (68). His exhortations sublimate the masturbating hand into the abstract will, which "grasps" the body's desires with a "firm . . . hold," keeping them securely in check. Like the more obvious visual depictions of muscular bodies—those of Nazi propaganda, for example, analyzed by Klaus Theweleit—this body has been rigorously trained to harden and preserve its boundaries, resisting the incursions of desire.

Without the vigilance of the virile will, the male body is anything but phallic. The spermatorrhea literature records a deep mistrust of bodies in their "natural" state, freely generating sensations and responses. Such an unsupervised body is a kind of hypersensitive protoplasm, trembling on the brink of dissolution because of its sexual susceptibility.[10] It is weak, almost permeable in its responsiveness to stimulation. The catalogue of items and actions that might incite its unwanted arousal is astonishing. Nothing, it seems, is too quotidian to seduce it: soft beds, flannel trousers, sitting in front of a fire, a full bladder, sleeping on one's back, thunderstorms, even sitting in railway carriages.[11] One unfortunate soul ejaculated twice on the Brighton-London train because he sat instead of standing (Milton 21). When surgeons attempt a cure, they confront the hyperresponsive body. On the one hand, the disease's most horrific consequence is impotence: one anecdote circulating in a number of pamphlets quotes a suicide note that reads simply "*I am impotent,*" as if that fact alone would inevitably lead to self-destruction.[12] But at the same time, im-

[9] Discussing Acton, Mason describes these mental violations as "semi-continence" (208–9).

[10] For a fascinating discussion of Carlyle's phobias about liquidity, see Sussman: "His fantasies of the male body turn upon a liquid interior whose touch is polluting" (20). Sussman links Carlyle's phobias to spermatorrhea and fear of masturbation.

[11] This catalogue is drawn from Acton (239–40), Lallemand (316), Gascoyen (96), and Milton (25), with many repetitions in other sources.

[12] The anecdote originates with Courtenay (*Practical Essay* 12), and is taken up in several quack pamphlets by Perry & Co. (55), De Roos (13), and La' Mert (57). These last two pamphlets follow each other almost verbatim; since La' Mert was actually a legitimate apothecary for a portion of his professional career, I suspect that his work is the original. The fact that the pamphlet I read was published almost ten years before De Roos's strongly suggests that it came first, although these popular treatises were often reprinted many times.

potence is also an oddly desirable state, since it at least protects the patient against further indulgence. Or, to put the matter a slightly different way, if impotence is potentially lethal, potency is not much better, leading as it does to all the dire consequences of the disease. Several case studies detail this Catch-22 situation: masturbation, nocturnal emissions, and intercourse render the body impotent and unable to pursue its illicit pleasures; but then treatment reinvigorates its appetites, along with its capacity for indulging in them, and the patient falls ill once more.[13] The body is a natural recidivist, lurching back and forth between dangerous hardness and sickly flaccidity. Its hardness is not a natural, healthy state but the cause and precursor of weakness, a collapse waiting to happen; hard or soft, the body is in a state of incipient self-destruction. The penis's natural transformation from soft to hard and back again becomes pathologized in this vicious cycle of sexuality.

In the same way, semen is pathologized as the symbol of everything that is alarming about the body; it is not difficult to see why, symbolically, it became the centerpiece of the disease. Although it borrows the force of hardness in its healthy state as it "jets" from the penis, semen returns to its liquid state when the disease strikes, giving rise to images of weakness and impotence: it becomes a "thin, imperfect fluid" (Gascoyen, 20 January 1872: 68; see also Wilson, 23 August 1856: 216) which no longer spurts majestically but "dribbles from the end of the penis" (Acton 105).[14] In a clear if unwitting image of castration anxiety, one doctor describes the feeble spermatozoa of this diseased fluid as having broken tails (Dawson, *Spermatorrhea* 9). Thus, although semen is identified with the "powerful sex-passion" of virility, it is also a kind of fifth column attacking the masculine ideal from within. Moreover, semen further compromises hardness by breaching body boundaries, symbolizing the body's inability to protect itself from sexual desire. The body that is made to penetrate is itself penetrated, as it were, from within by its own involuntary secretions. Nocturnal emissions were particularly disturbing. Because they occur during sleep, they spoke directly to the difficult relationship between the will and sexual arousal, representing a stubborn

[13] See, for instance, Dawson's description of such a case, which he claims is not at all atypical (*Spermatorrhea* 22–23).

[14] As theorists of the body argue, bodily fluids in themselves threaten masculinity, which contrasts itself to the flows and secretions of the female body and projects the vulnerability of flesh and blood onto women (Grosz 194–99; Theweleit 409).

residue of bodily agency that has managed to dodge the firm hold of
conscious control.[15] As one surgeon notes in despair, "The will at
that period is powerless" (Culverwell, *Solitarian* 4). These "wet and
silvery dreams," as this doctor poetically calls them, dramatize the
gap between the phallus and the penis, as the phallic will struggles all
day to subdue the penis's pleasures, only to be defeated at night (Cul-
verwell, *Solitarian* 4). To Acton, nocturnal emissions that are stimu-
lated by sexual fantasies during waking hours are especially perni-
cious because they implicate consciousness in desire (88).[16] Other
surgeons followed Acton in placing them under the jurisdiction of the
will, seeing them as a kind of ultimate test of character: "the patient
can always master them if he will," John Laws Milton claims; "if he
do not, they will master him" (86). In the alarm over nocturnal emis-
sions, a second meaning of Acton's celebrated "continence" becomes
clear: it implies not only psychological self-control but bodily self-
containment as well.

In spermatorrhea, the body becomes a sieve, losing vitality from
every orifice. Semen leaks away not just in ejaculations and nocturnal
emissions but in urination; sweat oozes from every pore, creating the
clammy palms of the self-abuser (figure 1). Acton even records a case
of death by diarrhea, which he regards as a secondary complication of
the disease. Over and over again, doctors imagine the body as a leak-
ing vessel: "The violated body becomes unable to contain its treas-
ure, and as fast as it is elaborated the seed is poured away on the
slightest provocation" (Acton 35).[17] Small wonder that Acton uses
the metaphor of flooding to describe sexual incontinence: the man
who falters in his purity "will open the floodgates of an ocean, and
then attempt to prescribe a limit to the inundation" (92). Of course,
no body can really "contain its treasure"; it is always passing ele-
ments from inside to outside. Incontinence is a biological given, and
no effort of will can completely plug up the body's orifices. The sper-
matorrhea panic responds to this reality by redefining a basic biologi-

[15] See, for instance, Carpenter (566).

[16] Perhaps the most consistent vestige of corporeally sanctioned phallic manhood
is the omnipotent power of discrimination granted to the penis, which can distin-
guish among these various outlets and activities and then relays the information to
the rest of the body so it can respond with precisely calibrated pathology.

[17] See also Culverwell's description of one of his patients, who experienced "con-
stant drainage of seminal fluid—it oozed from him on all occasions—asleep, awake,
passively or actively engaged" (*Lecture* 93).

FIGURE 1: The masturbator's progress. Note the dripping saliva on the right-hand figure. This is another symptom of the body's loss of control over its boundaries and fluids. R. and L. Perry, *The Silent Friend* (London, 1847).

cal property as a disease, splitting off liquidity into "bad" seminal fluid—separating the dribbles from the jets—in order to maintain the ideal of the inviolate male body as an achievable norm rather than an impossible fantasy. The ideal of continence is really the dream of a de-corporealized body, freed from the vicissitudes of organic and involuntary processes, entirely under conscious control.

In its obsession with the breakdown of continence, spermatorrhea literature provides an encyclopedic rendering of nonnormative masculinity.[18] These men suffer from paralysis, tremors, lassitude, and insomnia; they cannot concentrate, work, or even get out of bed; they are nervous, weepy, distracted, afraid. Most case studies go well beyond listing physical symptoms to describe a complete characterological breakdown. One surgeon presents this portrait of the spermatorrhea sufferer: "A general fright pervades the system, and a feeling of incompetence adds to the despair of the misled sensualist" (Culverwell, *Solitarian* 4). Spermatorrhea offered a dumping ground for all the traits that bourgeois masculinity had to abjure—traits associated with lack of control over the body and the emotions, and with a loss of confidence and power. The tone of sympathy that pervades these case stud-

[18] For a discussion of Victorian attitudes toward male sexuality and nervous debility, see Oppenheim (158–65).

ies suggests a certain covert understanding of these traits; under the
aegis of illness, a man could relax his "firm hold" and wallow tem-
porarily in weakness. As hysteria and the rest cure did for women, sper-
matorrhea offered a refuge from the demands of a rigid gender role, sup-
plying a pretext for an otherwise unacceptable self-indulgence. But the
label of illness also ensured that these states would continue to be de-
fined as deviant and undesirable. The dichotomy of sick and well un-
derscored other dichotomies that preserved this version of phallic mas-
culinity—soft and hard, open and closed, liquid and solid—as absolute.
As it artificially isolated "bad" bodily states and symptoms such as
weak semen, spermatorrhea also split off emotions and behaviors to
preserve its impossible ideal of characterological continence.

Because of the threat the disease posed to masculinity, surgeons
dealt severely with the body in the name of treatment. Spermatorrhea
cures seem shockingly invasive, even punitive. It is as if, in violating
the fantasy of continence, the body has forfeited any claim to intact-
ness; its fate is to give up its boundaries altogether to the doctor. The
various purgatives prescribed to patients seem designed to empty the
body of all fluids: anal leeches, diuretics, laxatives, enemas, and sup-
positories made of camphor, belladonna, and opium.[19] The penis was
pierced with metal rings and coated with chemical irritants until it
was "so sore that [the patient] could scarcely endure the slightest
touch" (Dawson, *Spermatorrhea* 10). Although he claimed that this
latter treatment was unfailingly effective in preventing masturbation,
one proponent remarked that it did have an inconvenient drawback:
"It is difficult to induce them [patients] to repeat it" (10). One of the
most common treatments was cauterization: first, a catheter was
passed through the urethra to empty the bladder; then a *bougie,* a
thin metal instrument with a ball on the end, was coated with a caus-
tic substance, usually nitrate of silver, and passed through the same
canal. Cauterization "deadens and destroys" nerve endings, making
them less susceptible to excitement, presumably overcoming the
body's promiscuous response to feather beds and trousers (Gascoyen
96). Though widely recommended, cauterization did provoke debate.
Some surgeons swore by it, finding it safe and relatively painless,
while others feared its dire effects: cold sweats, "hemorrhage and ex-

[19] Milton (78), Teevan (276) and Wilson (1 November 1856: 483) recommend sup-
positories, Lallemand (63) and Wilson (1 November 1856: 483) recommend leeches,
and Lallemand (67, 197) and Acton (237) prescribe diuretics, enemas, and purgatives.

cessive pain" (Milton 106), "violent spasmodic contractions," "visible agony" (Lallemand 67, 77). One doctor warned that "occasionally, even cautious, gentle, and successful cauterization is followed by alarming symptoms, and even by death" (Gouley 31). Small wonder, then, that proper technique was imperative: the patient must lie absolutely flat on the examining table, the *bougie* must be introduced slowly, and the doctor must ensure that the urethral canal is straight and unblocked by holding the penis firmly upright. What could be a more striking example of Theweleit's insistence that the policing of bodies depends not simply on ideology and discourse but on the actual co-optation of corporeal experience, "the installation of displeasure and anxiety in the experience of pleasure itself," as the doctor's painful treatment replaces the masturbating hand (414)?

The penis, symbol and site of virility, has been reduced to a vulnerable, flaccid body part manipulated by someone else. Who has the phallus during cauterization? Not the patient with the penis but the doctor with the unbending instrument whose rigidity the shrinking organ must be made to accommodate. This tableau seems to insist that the professional has a special relationship to the body: unlike his patient, he sidesteps its weakness when he takes up the mantle of his authority and his metal instrument, harder than flesh could ever be. The ideal of continence ultimately rests with the surgeon: he enacts the mastery of the body as if he did not also participate in its corporeality, as if his role as a professional exempted him from its weakness.[20] Phallic mastery is most firmly claimed when it is positional, and this positionality is achieved not only through the perquisites of status but also through relational categories—patient and doctor, body and science, sexuality and character, penis and *bougie*—in which each term is defined as the absence of the other.

Surgeons against Quacks: Inventing a Scientific Discourse

As I noted earlier, there was a dimension to this violence against male bodies that was directly tied to the professional status of surgeons, the class of doctors who treated spermatorrhea. The appar-

[20] The spermatorrhea panic may have played a part in the fantasy of the superhuman doctor, which persists today in the endless hours of work without sleeping or eating that interns and residents must endure as part of their basic training.

ently bodiless scientist, substituting the *bougie* for the penis and re-
lying on his knowledge and expertise rather than his body for au-
thority, was not a preexisting role into which individual surgeons
stepped but a new identity in the process of being created. Surgeons
did not come to the treatment of spermatorrhea with ready-made
prestige; instead, their history entangled them in many of the same
qualities attributed to these sick bodies. Among all the emerging
professionals of the nineteenth century, medical men had the most
problematic status.[21] They were originally classed with barbers (as
Sweeney Todd reminds us); and the kind of medicine they practiced,
as well as their overall reputation, made them poor relations of the
middle-class masculine ideal precisely because of their too close as-
sociation with the incontinent bodies they treated.[22] But with the
Victorian creation of "the professional" as an elite category came op-
portunities for redefinition. For surgeons, becoming professionals de-
pended on forging a new relationship to the body, one of distance and
repudiation. The spermatorrhea panic was one of a series of medical
events, including the cholera epidemics of the 1830s, the develop-
ment of obstetrics, and the administration of the Contagious Dis-
eases Acts, that helped to transform the authority of the medical
profession in the nineteenth century.[23] Surgeons certainly did not in-
vent spermatorrhea for the purposes of professional advancement (al-
though they did invent it), but in redefining their relationship to the
body, it provided them with an ideal opportunity to increase their
cultural capital.[24]

To understand the symbolic importance of the male body in the
construction of surgeons as professionals, we need to understand
the history and structure of Victorian medicine as a whole. Because
of the rules governing the treatment of various illnesses, the doc-
tors who treated spermatorrhea were surgeons. From the eighteenth
century to the passage of the Medical Act of 1858, which loosened

[21] My discussion of medical history and the status of surgeons is based on Reader
(16–68), Porter (48–54), Cooter (70), Waddington, Peterson (*Medical*), and Digby.

[22] Readers who remember Steve Martin's "Medieval Barber" routine on *Saturday
Night Live* will also be aware of this association.

[23] Surgeons fit neatly into Reader's witty description of the "characteristic activi-
ties" of middle-class professionals, "earning a living, raising the moral tone of soci-
ety, and social climbing" (1).

[24] See Crozier on the need for nineteenth-century surgeons "to locate the kinds of
symbolic capital available to . . . practitioners who were writing [medical books and
articles] in order to position themselves in the struggle for acceptance" (11).

the boundaries between the different echelons of medical practitioners, surgeons occupied the middle tier of a three-part hierarchy between the more prestigious physicians and the lowly apothecaries.[25] The aristocrats of medicine, physicians were schooled in the classics at Cambridge or Oxford, often receiving a somewhat limited medical training. Surgeons generally lacked a classical education, traveling to Scotland or the Continent to pursue a more purely medical training, which was considered inferior because it was more technical, as if it were preparation for a trade. In fact, whereas physicians received honoraria, surgeons could set their fees, a dubious prerogative that also associated them with tradesmen. Physicians and surgeons had their own governing bodies, accreditation standards, and procedures for membership. More important, they had their own specialties and forms of practice. Approaching their patients through observation and examination, physicians engaged in activities that were primarily mental and visual. They were empowered by law to treat internal diseases—that is, diseases that remained safely inside the body, contained by the skin. In a sense, even in sickness physicians treated a continent body, one that decorously maintains its own boundaries and protects physicians from its interior.

Surgical practice, by contrast, was a messier affair. Surgeons immersed themselves much more literally and directly in the bodies of their patients, and they did so with their own hands. As W. J. Reader observes, nineteenth-century surgery could be "a rough and bloody business" (33). In complaining of plans to train physicians in surgery, Sir Henry Halford, the president of the Royal College of Physicians, declared that such "manual labour" would "discredit" his caste (qtd. in Waddington 40, 39).[26] Unlike the more mediated consultations of physicians, surgeons' work called attention to the corporeality of patients. Furthermore, surgeons treated external diseases that compromised the body's boundaries: venereal diseases, contagious ailments, illnesses requiring bloodletting, burns, sores, and open wounds (Willcock 30). For surgeons, bodies were visibly organic, composed of blood, muscle, bone, and tissue. Symptoms broke through the skin, and the surgeon had to treat them by cutting bodies open, dressing

[25] Because apothecaries are not germane to my discussion, I will ignore them.
[26] Convention had it that physicians, in contrast, "used their heads not their hands" (Charles Newman, qtd. in Waddington 10).

their wounds, drawing off blood, and collecting urine.[27] These sick
bodies were unclean, improper, and, in a sense, incontinent. The sta-
tus of surgeons ranged widely from that of high respectability to
criminality. The most eminent, such as Astley Cooper and James
Paget, treated members of the royal family and were awarded baronet-
cies, and fictional surgeons such as Lydgate in *Middlemarch* and Dr.
Speedwell in Wilkie Collins's *Man and Wife* obviously enjoy a good
deal of social prestige and professional authority. But mid-century
surgeons struggled against the disreputable legacy of earlier years,
when, as the social reformer Anna Jameson claimed, "drunkenness,
profligacy, violence of temper, horribly coarse and brutal language"
were "common" among them (77).[28] Physicians sought to maintain
an antiseptic distance from such contaminating contact; although
physicians and surgeons might perform each other's tasks in their ac-
tual practice, ideologically the medical hierarchy preserved both the
individual bodies of physicians and the professional body of the Royal
College of Physicians from such degradation.

The simple fact that they treated venereal disorders stigmatized
surgeons and tainted their work with specifically sexual connota-
tions as well. Surgeons felt obliged to declare their obliviousness to
these connotations; one prominent surgeon proclaimed, "Who is not
able, in the course of practice, to put the idea of sex out of his mind,
is not fit for the medical profession at all" (Jex-Blake 8). With easy ac-
cess to women's bodies, surgeons became an obvious target as charac-
ters in scenarios of illicit sexuality. Walter in *My Secret Life* some-
times impersonates a surgeon to facilitate "some of his more difficult
seductions," as Michael Mason drily remarks (191); a brothel owner
and white-slaver also found such a role useful in decoying young girls

[27] The requisite training in anatomy, which involved the dissection of corpses, did
not help surgeons' status, especially as resurrectionism—grave robbing—became an
increasingly common way of supplying medical schools with corpses. Southey's
"Surgeon's Warning" and De Quincey's *On Murder considered as one of the Fine
Arts* exemplify diatribes against these practices. For a complete history of grave rob-
bing, including a discussion of the works by Southey and De Quincey, see Tim Mar-
shall.

[28] Jameson is arguing for training women as hospital aides, so she may have an ul-
terior motive in speaking so strongly, but her characterization is not out of line with
the generally negative view of surgeons. A less self-interested source, the biographer
of the surgeon Thomas Wakley, notes that medical students in the early part of the
century were known for their "licentiousness, . . . wildness and irregularity" (Sprigge
21).

to his "office" (*Lancet*, 16 August 1862: 194).[29] These associations
were exploited with gusto in *The Amatory Experience of a Surgeon*, a
pornographic text in which a lusty young surgeon puts his sexual
knowledge to practical use in an endless series of seductions. "We
medical men are not ignorant of the secret pangs and unruly desires
which consume the bashful virgin," he remarks, noting that their un-
derstanding of erotic urges and their promise of confidentially make
doctors highly desirable partners (they are also able to provide abor-
tions when needed as an additional convenience) (33). This link be-
tween surgeons and sexuality was there for the taking, implied by the
low associations of surgical practice.

When surgeons sought to increase their status, spermatorrhea of-
fered an ideal context in which to attenuate their association with in-
continent bodies and sexuality.[30] The new scientific medicine rested
on a more distant relationship to patients. Technologies such as the
microscope and the catheter stood between surgeons and their pa-
tients, mediating their physical contact. The spermatorrhea panic
spawned an avalanche of specialized and often bizarre instruments:
wires, *bougies*, belts, urethral rings, an electrical alarm designed to be
set off by an erection, something called an achromatic magnifier for
measuring sperm, and—an apparent fugitive from Woody Allen's
Everything You Always Wanted to Know about Sex—an "illuminated
urethral explorer," a kind of speculum for men (Dawson, *Spermator-
rhea* 91). Along with these technologies came an up-to-date scientific
vocabulary that disinfected the body disgust associated with surgeons'
work. Founding their new identity on a sexual disease was a risky
strategy. Spermatorrhea doctors recognized that they were "touching
pitch" (Courtenay, *Quacks* 7; see also *Lancet*, 17 May 1862: 518). But
by exploiting the framework of science, they redefined their interest
in sexuality as a worthy medical endeavor rather than an inspiration
for pornography, as in *The Amatory Experiences of Surgeon*.

[29] See Porter and Hall for further information about the association between sex
doctors and brothels (135–36).

[30] This redefinition of surgery clearly follows the widespread shift from "status
professionalism" to "occupational professionalism" (Philip Elliot qtd. in Waddington
22). Chronologically, the spermatorrhea panic and changes in the profession were
closely linked: the first edition of Acton's *Functions and Disorders* appeared in 1857,
one year before the Medical Act of 1858. The *Lancet*, founded by the surgeon Thomas
Wakley and established as the premier British medical journal by mid-century, de-
voted itself to the interrelated legitimization of surgeons and scientific medicine, and
published most of the literature on spermatorrhea.

In this enterprise, quacks were supremely useful. The level of anxiety aroused by spermatorrhea attracted pseudo-surgeons eager to fleece middle-class male patients. These frightened men formed a captive audience, too desperate for help to question the doctors' fees or prescriptions, and too fearful of being "outed" as masturbators or sex fiends to resist extortion. The quack invasion threatened to further depress the stock of surgeons by associating them with money-grubbing opportunists eager to profit from concerns about sex. Unwittingly, surgeons created this pot of gold for quacks with their early alarmist descriptions of the disease. When they found their area of specialization invaded by illicit competitors, they changed their approach and began to define themselves against quacks, using the contrast between legitimate and illegitimate practitioners to enhance their prestige. Early commentaries on spermatorrhea stressed its prevalence and its grim consequences; but as quacks entered the field, surgeons insisted that it was not common at all, and that, unlike their self-serving competitors, they would be perfectly happy to give a negative diagnosis even though it meant losing a patient, along with his fees. In contrast to early claims that the disease was rampant, later discussions argued that "false spermatorrhea" was the true epidemic, its hypochondriacal victims far outnumbering true sufferers thanks to the scare tactics of quacks. A letter to the *Lancet* titled "The Future of Quackery" (and signed "Orthodox Medicine") stated, "Every medical man knows that nine-tenths of the cases of so-called spermatorrhea are really nothing of the kind" (21 February 1859: 174). In fact, the target of surgeons' strongest rhetoric shifted from spermatorrhea to quack doctors, who came to stand in for the disease itself as the source of sexual depravity and human misery. While the disease was on the wane as a subject of attention, quacks increasingly preoccupied the pages of medical journals and books, drawing off all the pitch that might have adhered to surgeons. They were likened to "the seducer, the adulterer," as if they were the real sexual deviants (*Lancet*, 22 August 1857: 202).[31]

[31] The heinous consequences originally laid at the door of the disease were increasingly attributed to quacks. Books and journals abounded with a familiar yet new kind of case study in which young men of promise were driven to panic, despair, and suicide—but by the manipulations of unscrupulous fakes rather than by spermatorrhea. The *Lancet* reported a case in which the pamphlets of one Dr. De Roos were found by the body of a young suicide, along with threatening letters (28 January 1865: 98). A similar case of "imaginary spermatorrhea," which came to the same unfortunate end, occurred in 1861 (*Lancet*, 15 June 1861: 582). Courtenay also reported two

Quacks *became* the disease, absorbing all its connotations of sexuality and deviance.[32]

This struggle between quacks and surgeons is a complicated one to analyze with hindsight, since we now realize that, to put it bluntly, surgeons did not know what they were doing either. In examining their attacks on their competitors, I do not mean to suggest that surgeons consciously sought a scapegoat on whom to pin their own bad reputations. Surgeons were ignorant in good faith; quacks deliberately pretended to knowledge they did not have and shamelessly exploited their patients for profit.[33] But in other ways, the boundary between quackery and legitimate medicine was much more hazy.[34] The *Medical Directory* did not check up on the credentials of its listed doctors, nor was it comprehensive. It included some quacks under their real names and did not include surgeons who could not or would not pay the required fee (*Lancet,* 27 August 1853: 195-96).[35] Moreover, it was sometimes difficult to decipher European systems of accreditation; the notorious Dr. Kahn, whom I discuss shortly, had no medical training, but his brother, who was a partner in some of his enterprises, did hold some kind of European degree.[36] Sometimes, as Mason points out, legitimate surgeons who had trouble making ends

cases in which an inquest attributed a young man's suicide to reading quack pamphlets, though one of these may have been the De Roos scandal, since both sources were published in the same year (*Revelations* 3).

[32] Quacks were identified with the disease to the point where they were described in phallic imagery suitable for an out-of-control penis: the *Lancet* expressed the hope that quackery "has reached its climax" and will not "grow still more enormous" or "attain a still more colossal height" (19 November 1853: 490).

[33] Quacks also impersonated real surgeons shamelessly, using variant spellings of the names of legitimate practitioners for their aliases or working under the name of a legitimate doctor who had recently died so they would appear in the *Medical Directory* (Culverwell, *Solitarian* 20–21). Like bona fide surgeons, they quoted authorities such as Lallemand and Sir Astley Cooper, advertised their use of the very technologies with which surgeons hoped to distinguish themselves—practicing what one surgeon called "the microscopic dodge"—and, of course, denounced quacks in the strongest possible terms (Gascoyen 68). They even published their own list of practitioners, which was such a convincing facsimile that the real *Medical Directory* issued a public warning advising subscribers to "fully specify the EXACT TITLE" or risk receiving the "QUACK'S GUIDE" instead (*Lancet,* 31 December 1853: 632).

[34] See Porter and Hall, who perceive this period as a time when surgeons were "hypersensitive" about distinguishing themselves from quacks, perhaps because, in terms of the content of their writing, there was not much difference (145); see also Digby (62).

[35] See also Courtenay, *Revelations* (51).

[36] See Mason (190).

meet took up treating spermatorrhea because it paid (188–89). Their pamphlets, like those of quacks, were deliberately designed for a popular and perhaps credulous audience, though their knowledge was (from a historical point of view) sound. Robert James Culverwell, a member of the Royal College of Surgeons, complained that he had been forced to go directly to the public because favoritism had prevented him from finding a hospital appointment; he protested that the term "quack" too often signified a doctor who had failed to curry favor (Lecture 18–19).[37] It is true that, unlike legitimate surgeons, a few quacks recommended prostitutes as a cure for nocturnal emissions and then offered preventive medicines for venereal disease in an obvious attempt to boost their income, and on the whole, quacks used a slightly more overheated rhetoric to describe spermatorrhea's consequences and offered slightly more miraculous cures. But aside from these variations, it is hard to see many obvious, glaring differences between legitimate and illegitimate pamphlets, although scientific articles in medical journals use a distinct tone and vocabulary.

The career of Dr. Kahn is instructive here (figure 2). To surgeons, he was perhaps the most offensive of all quacks because he "passed" as legitimate in the medical community, suggesting how indistinct the difference could be, even to doctors themselves. Sometime around 1850 he opened a medical museum in London. To judge from its catalogue, it departed very little from the Anatomical Museum of St. Bartholomew's Hospital, which included descriptions, drawings, and models of the sexual organs among its other exhibits. Enthusiastically endorsing it in 1851, the Lancet pronounced itself "much gratified" with the collection, including its exhibits for doctors only on venereal diseases, and singled out Kahn's "Anatomical Venus," a life-size model of the female body, for special commendation (26 April 1851: 474). Two years later, the Lancet again praised the museum, noting that its traveling exhibits had impressed the "leading medical men of Scotland and Ireland," who "thus stamped our opinion with their approval." Its only complaint was that Dr. Kahn opened his exhibit on the male body to ladies on certain days, but added, "Upon mature reflection, we feel confident that Dr. Kahn will in future only permit male adults to view his museum," implying a strong sense of

[37] Mason accepts Culverwell's explanation of his status (188–89). See also Digby on the difficulty of establishing a successful practice, even for doctors with excellent training (161).

FIGURE 2: The notorious Dr. Kahn, looking every inch the respectable surgeon. Dr. Kahn, *Catalogue of Dr. Kahn's Anatomical and Pathological Museum* (n.d.).

solidarity with the good doctor (13 April 1853: 156). But a few years later the *Lancet* began receiving indignant letters scolding the journal for recommending the museum's "filthy" models and pamphlets (5 January 1856: 28). Once he received the stamp of respectability, Kahn may well have altered his exhibits to appeal to more prurient tastes, though I could find no record of such a change. The change in his reception, however, is dramatically evident. Striving to make up for its earlier endorsement, the *Lancet* now declared its outrage about the sexual explicitness of Kahn's materials—especially the Anatomical Venus it had specifically praised in its initial article (5 April 1856: 377). The museum became a collection of "revolting, filthy, and dis-

gusting" models, a "chamber of horrors"; and the *Lancet* disingenu-
ously insisted that it had never granted it more than "qualified appro-
bation" (376). But although there was evidence that Kahn's activities
were those of a quack, it is not clear to what extent or in what ways
his display materials and pamphlets differed from legitimate medical
representations of sexuality and the human body.[38]

Faced with the difficulty of distinguishing their credentials and
practices from those of quacks, surgeons developed another strategy:
distinguishing their *discourse* from quack pamphlets by identifying
the latter as pornography. Surgeons sought to establish a zone of
strictly scientific writing, impervious to sexual interests and implica-
tions. The sexual markings of their work, exploited by pornographers,
white slavers, and libertines like Walter, were disavowed and abjected
onto the visible obscenity of quack pamphlets, which were attacked
even more obsessively than bogus cures and extortionist tactics. The
sexual impact of these materials became the definitive outrage for
surgeons, who chose to differentiate themselves most emphatically
on this basis.

The *Lancet* hurled invectives at such materials, blasting them as
"abominable" (3 February 1849: 133), "loathsome" (4 July 1849: 55),
"revolting . . . and disgusting" (5 April 1856: 376), "obscene" (22 Au-

[38] Certainly Kahn deserved to be attacked for his practices. In 1857 he was suc-
cessfully sued for extortion by one of his patients, with Acton appearing as an expert
witness—a trial that the *Lancet* reported with relish. Interestingly, Acton and the
prosecutor continually tried to make Kahn's credentials, not his extortion, the sub-
ject of the trial, but the judge would have none of it, rejecting another surgeon's state-
ment that Kahn could not be a doctor since his name did not appear in the *London
and Provincial Medical Directory* by responding, "It would be hard to say that a man
was not a barrister because his name was not in the 'Law List.' I don't see that the
matter is worth much" (*Lancet*, 8 August 1857: 152). Even at the moment of Kahn's
undoing, the court refused to pass judgment on the issue of professional legitimacy,
reminding the surgeons of the difficulty of establishing an incontrovertible distinc-
tion. But if the courts would not draw the line, the surgical establishment did. Using
Kahn to assert the distance between contemporary surgeons and their degraded ori-
gins, one commentator called Kahn "nothing more . . . than a German barber"
(Courtenay, *Revelations* 57). Surgeons reached for other discrediting labels for quacks
in general, sometimes racializing them as Jews. This characterization was often ex-
plicit (see Culverwell, *Solitarian* 5; *Punch*, 22 August 1857: 73) and sometimes more
snide, playing on the stereotype of the money-grubbing Jew with attacks on *nouveau
riche* tastes and "notorious luxury" financed by exorbitant fees and extortion
(Courtenay, *Revelations* 11). De Roos, himself a quack, also identifies quacks as Jews,
showing how easily quacks appropriated the "othering" strategies of surgeons to le-
gitimate themselves (48).

gust 1857: 202), "dirty and obscene" (30 February 1858: 207), "demor-
alising" (4 November 1865: 519), and above all "filthy" (3 February
1849: 133; 4 July 1849: 55; 5 April 1856: 376; 22 August 1857: 202; 4
November 1865: 519). The surgical community coupled the wide cir-
culation of these materials with the racy postcards and suggestive
prints displayed in the shops of Holywell Street, itself synonymous
with urban vice in the popular imagination.[39] The scandal of these
sexually explicit materials, both pamphlets and pictures, was that
they were visible for all to see on the city streets; they were not safely
cordoned off for a self-selecting, already depraved set of viewers but
instead forced themselves on anyone who might wander by. Quack
materials outstripped even the Holywell Street displays in this cor-
rupting potential, for they might easily find their way into the home
through the anxiety of a male family member, the irresponsible prac-
tices of a respectable newspaper displaying bogus ads, or the pre-
sumptuous solicitation of a quack. In an article reprinted in its en-
tirety in the Lancet, Punch asserted:

> The nuisance of quack doctors' advertisements equals if it does not ex-
> ceed, the Holywell-Street nuisance in turpitude, and far surpasses it in
> magnitude. Instead of being confined to an obscure lane, it is spread
> over a vast proportion of the newspaper-press, and thus extended upon
> parlour and drawing-room tables. Immediately under the eyes of the fe-
> male portion of innumerable respectable families throughout the king-
> dom, are lying about advertisements unfit for the vilest blackguard. (22
> August 1857: 73)

As always, women's delicate sensibilities provided a useful ground
from which to launch an attack on sexually explicit materials, as in
the uproar over W. T. Stead's exposé of the white slave trade in "The
Maiden Tribute of Modern Babylon." I mention this largely unrelated
scandal to clarify the category into which surgeons successfully ma-
neuvered quack pamphlets. Like Stead's incendiary articles, these
pamphlets were caught in the rhetoric of urban contagion, in which
the uncontrolled circulation of noxious things—miasmic air, raw
sewage, unclean water, prostitutes, sexual texts and images—was un-
derstood as the unwelcome consequence of city living, with its net-

[39] See Punch, 22 August 1857: 73; Lancet, 15 August 1857: 175; Lancet, 5 Septem-
ber 1857: 251.

works of avenues and sewers linking respectable homes to sources of contamination.[40] Surgeons exploited the idea of urban depravity explicitly, as they repeatedly exhorted the Society for the Suppression of Vice to take up their cause and called for the prosecution of quacks under the Police Causes Act and Obscene Publications Act, designed to curb the displays in Holywell Street.[41] In fact, one purveyor of such pamphlets was successfully prosecuted under the Police Causes Act for distributing "indecent or obscene" books; only by agreeing to leave London permanently did he manage to avoid imprisonment (*Lancet*, 4 November 1865: 518).

But, as with the issue of professional credentials, surgeons asserted a categorical distinction between medical and pornographic discourses that was not really so absolute. In a culture that relentlessly declared naked bodies off-limits for moral reasons, bodily representations could hardly escape sexual inflection. In spite of the double standard, representations of the bodies and sexual experiences of men remained nearly as taboo as representing those of women. Even a confirmed libertine like Walter in *My Secret Life* declares, after a lifetime of nearly unbroken sexual activity, that what he seeks most is "knowledge of . . . the penis" (1548).[42] Implicitly, surgeons declared that they could control the sexual connotations of representations by placing them within the context of science. But Dr. Kahn's Anatomical Venus fell so quickly from a respectable medical exhibit to a pornographic outrage not only because Kahn changed other exhibits and eroticized his address to the public—if indeed he did so—but also because the sexual meanings of such representations were already there. Many generations of adolescents have discovered that medical texts are excellent sources of sexual knowledge and excitement (as Mason asks, who has not found pages excised from such textbooks in the course of research?). Insisting on discursive and legal distinctions between themselves and quacks, surgeons labored to create a context in which their own representations could claim immunity from titil-

[40] For a brilliant discussion of the rhetoric of urban contagion, see Stallybrass and White (125–48).

[41] See the *Lancet*, 21 November 1857: 537; 5 September 1857: 251; 20 February 1858: 207; *Punch*, 22 August 1857: 73.

[42] For a wide-ranging discussion of Victorian veiling of the penis in the context of art, see Kestner. Accounts of this veiling, and of the gap between the penis and the phallus, in contemporary representations are legion, but see especially Bordo.

lating implications or uses. But images of naked bodies, diagrams of the penis, and descriptions of sexual activities were always potentially erotic in Victorian Britain.

Even the participants in the Police Causes Act trial agreed that "everything recorded in the publications might be met with in medical books" (*Lancet*, 4 November 1865: 518). Lesley Hall reports a similar case, in which the apothecary Samuel La' Mert was eliminated from the *Medical Register* for publishing an "indecent and unprofessional treatise" ("English" 351). As Hall argues, "It was not the matter of La' Mert's work that caused scandal—his arguments about the dangerous neglect of this delicate subject by the profession parallel those in the pages of *The Lancet*, and like Acton he warned of the dangers of over-indulgence in sexual pleasures"("English" 352). In terms of content, it was not very different from the work of the doctors who condemned it. La' Mert did not use unusually graphic or explicit sexual representations or present them in a particularly salacious way. Instead, he was guilty of speaking about sex to a popular audience in ordinary language, without the prophylactic of a scientific vocabulary. His pamphlet, and others like it, represented a kind of discursive promiscuity, circulating sex talk rather than disinfecting it and confining it within an expert community. Surgeons needed to disavow the sexual potential of their work because the line between quackery and respectability was so fine. Even the references to Holywell Street reinscribe rather than erase the difficulty of making this distinction. Lynda Nead has argued that "Holywell Street" became a shorthand for urban vice precisely to control its ambiguity (*Victorian Babylon* 161–89). Despite its reputation as a repository of unrelieved depravity, it housed not only pornographers' shops but respectable businesses as well, including medical book stores. Concretely, the physical proximity of these different shops suggests the varying uses to which scientific materials could be put. Any customer in the medical book store might slip into a pornographer's shop for further reading, and any bona fide medical student might purchase a textbook with multiple motives and responses. Invoked to affix the label of "pornography," Holywell Street spatializes the indistinct boundary between scientific and sexual representations in its jumble of businesses. It was not that surgeons recovered a categorical distinction that quacks had deceptively blurred; rather, they forced a categorical distinction that was in fact much more ambiguous. Surgeons fought so strenuously to disavow

the sexual import of quack pamphlets not because it was so alien but
because it was uncomfortably similar.

Back to the Body

Yet at the same time, in the midst of this hysteria about male sex-
uality, doctors and patients too engaged in and discussed erotic pleas-
ure through the very framework that constrained them. Spermator-
rhea provided the occasion for doctors and their patients to explore
the forbidden territory of the middle-class male body. Medicine re-
sembled pornography because it was another arena—perhaps the only
other arena—in which it was possible to discuss and represent sexu-
ality, bodies, and penises. Sometimes when patients announced that
they had the disease, doctors understood that they had found a "eu-
phemistic way" to open a discussion of masturbation (qtd. in Mason
298). Moreover, such confidences went beyond the guilty acknowl-
edgment of deviance. Peter Gay remarks, "Doctors and patients were
nervous together"; they were also excited together, collaborating on
narratives of erotic experience and even—in spite of the apocalyptic
warnings that permeate much medical literature—erotic pleasure,
under the cloak of science (*Education* 317).

While, on opposite ends of the spectrum, both quacks and respect-
able surgeons demonized sex, an ambiguous group in the middle pro-
duced a small but significant collection of sexual success stories. Al-
though they sometimes contributed to the panic over male sexuality,
these men—Robert James Culverwell, John Laws Milton, Richard
Dawson, and especially Francis Courtenay—also wrote in a very
different key, with different assumptions and values. They were all
members of the Royal College of Surgeons with genuine credentials,
but they published mainly books and pamphlets rather than articles
in medical journals, and they advertised their addresses, hours of con-
sultation, and fees in these publications like mere tradesmen. Some
of them ran afoul of the medical establishment at one point in their
careers, perhaps because their accepting attitude toward sexual pleas-
ure made them likely targets.[43] But if their brand of medicine com-

[43] Considered one of the "shadier" members of the surgical profession by Mason
(189), Dawson published an article in the *Lancet* early in his career but was later ac-
cused in the same journal of killing a patient by overzealous cauterization, although
nothing ever ensued from the accusation as far as I could tell (15 June 1861: 582–83).

promised their status, their borderline position may also have led them to construct a different, more tolerant sexual discourse. Without lucrative appointments at established hospitals, these men had a built-in economic motivation to develop one implicit thread in the spermatorrhea literature. They followed the lead of Acton's *Functions and Disorders*, described by Ivan Crozier as "an early sexual advice manual" addressing the public as much as the medical establishment (12). Unlike the authors of textbooks and journal articles, who presented sexual disorders as "strictly physiological functions" and addressed themselves to a community of scientists, they took a more holistic approach to sexuality and fashioned their own distinctive narratives (Marcus 22).[44] They tell of sexual experiences unfolding over time in the context of relationships, with special attention to the emotional and psychological dimensions of erotic life. The aim of these borderline surgeons was less to correct the body as if it were a malfunctioning machine than to calm and counsel the anxious human beings who arrived at their offices with detailed, idiosyncratic, and highly emotional stories. With one foot in the realm of scientific medicine, their consultations also anticipate the talking cure.

The happy endings of these stories involve not sexual renunciation but a return to sexual potency; rather than make fearful predictions about backsliding masturbators, these case studies express an unusual confidence in the body's capacity for pleasure. Dawson, for instance, quotes the testimonial of a longtime spermatorrhea sufferer after the miracle cure of cauterization: "The erections are more vigorous, and the ejaculation not so precipitate; it is accompanied by

Courtenay and Culverwell were both singled out by the *Lancet* in an essay titled "Mesmeric Humbug and Quackery" (28 June 1851: 705–6); Courtenay fired off an irate letter demanding an apology, but I could find no such response (6 September 1851: 242). He continued his career without any apparent ill effects, writing a number of books on both spermatorrhea and stricture of the urethra, as well as a famous attack on quackery, all of which were published both in England and internationally by H. Bailliere, identified in one publication as "Foreign Bookseller to the Royal College of Surgeons." Mason cites him without any qualification, as if his respectability were not in question, which, along with his extensive publications, leads me to believe that he should be considered a legitimate surgeon, albeit not one at the top of the status hierarchy. I do not consider him a quack. Mason sees both Culverwell and Milton as surgeons who were sometimes attacked for their sexual specialties but "managed to stay within the pale" of legitimacy (189).

[44] Marcus says that Acton himself helped to make sexuality a purely physiological matter, but Crozier's assertion that he was an early sexual adviser seems more accurate to me.

sensations, the vivacity of which were unknown to me" (50). Though generally opposed to sex as a cure, Milton does claim that "connexion [intercourse] is, *under a surgeon's care,* often a most valuable aid to treatment" (136). Culverwell speaks of sexual pleasure as "one of the greatest ecstasies allowed to [the male] sex," insisting that *"sexual association is indispensable"* (*Solitarian* 7, 14).[45] Most interesting and extensive are the case studies advanced by Courtenay in his *Practical Essay on the Debilities of the Generative System* (1838). Perhaps the early publication date of the *Practical Essay* helps to account for its unusual freedom and sympathy in discussing sexual experience, as the imputed distinction between respectable medical texts and pornography had not yet been asserted. In contrast to the usual thunderous denunciations of sexual self-indulgence, these case histories read like tamer, more credible versions of the *"Playboy* Advisor," airing men's frustrations and offering commonsense solutions so that they can get on with their sex lives.

These histories are surprising enough for me to reproduce their details here. One man reports that he becomes impotent when he sees his lover during the day instead of making his usual nighttime visit. Remarking in an aside about the powerful hold of consciousness on the body, Courtenay convinces him that his imagination, not his penis, is at fault, and the man takes up where he left off, perfectly potent at any time of day. When he marries, he begins to fear failure again, but Courtney reminds him that his debility is "only imaginary," cautions him against "the folly of indulging in such idle fancies" (a nice counterpart to the usual warnings against indulging in happy sexual fantasies), and cures him once again. Another man, suffering from "real" spermatorrhea as a result of schoolboy masturbation, cannot sustain an erection. Again advising his patient of "the necessity of discarding from his mind the painful impressions naturally caused by his distressing situation," Courtenay prescribes tonics, cold baths, regular exercise, and "moderate sexual intercourse" (65). Finding himself for the first time with "opportunities for sexual intercourse" after moving out of his parents' home, another victim of masturbation suffers from premature ejaculations and gives up sex altogether. Courtenay prescribes "regular sexual intercourse," with the added stipulation that the man "remain the whole night with his

[45] Culverwell also declared that "sensual gratification" is a natural propensity of both men and women, and should not be repudiated (*Lecture* 34).

lady" (70). Courtenay's final case study involves a middle-aged man who spends many years in India with his wife until she returns to England to supervise their children's education. He has no trouble leading an active sexual life during her absence; on returning to England, however, he finds himself unable to make love to her. Ever understanding, Courtenay, "address[ing] myself to removing the painful feelings caused in his breast by his failures" (and perhaps by his guilt over his affairs), prescribes tonics and sees him "perfectly restored to the manly powers" four months later (73).

Significantly, all of these case studies involve premarital or extramarital sex (whether with prostitutes or other women is not clear, though the first suggests regular assignations of some sort). Although they do not begin to provide enough evidence to suggest conclusions about the behavior of middle-class men in general, they do have a matter-of-factness that suggests more tolerance of such sexual adventuring than Victorian ideology would seem to allow. They appear, in fact, perfectly routine. While there is certainly evidence that Victorian husbands and wives enjoyed their sexual lives and that doctors advised them privately on the pleasurable possibilities of sex, these case studies go further in their shared and unremarked assumption that an active, pleasurable sex life outside of marriage is a reasonable goal for middle-class men; in their willingness to engage in conversation about such a life; and, perhaps most noteworthy of all, in their publication. Courtenay does not present his case studies as tales of deviance or of the wages of sin; on the contrary, they appear as normal if not normative erotic biographies, narrated by doctor and patient together.

In fact, these case studies imply a counter-theory of sexuality that makes possible a different kind of conversation between doctor and patient. If the symptoms of spermatorrhea were produced by organic causes, and if sexuality drove all other physiological systems so that any sexual derangement had wide-ranging physiological consequences throughout the body, then doctors would of course strictly police sexual behavior. But if sexual symptoms were produced not by deviant behavior but by fear, fantasy, and anxiety, then the doctor's job was not to condemn but to comfort—indeed, in most of Courtenay's case studies, to minimize the anxiety his patients feel about their illicit sexual experiences. In contrast to the anxiety-inducing diatribes of most spermatorrhea literature, Courtenay urges men to concentrate on sexual success and pleasure: "There must be a perfect acquiescence of the mind, which should be totally absorbed in the

immediate object. There must be no doubts, no cares, no apprehensions, no want of confidence as to the physical power to complete the act; nor should there even exist an anxiety to its perfect performance, as that very anxiety has itself not infrequently been the cause of failure" (*Practical Essay* 41–42).

The category of "imaginary spermatorrhea" provided the model for this new understanding of sexuality by identifying the emotions and the imagination rather than organic dysfunction as the source of sexual symptoms. Frequently diagnosing imaginary spermatorrhea in his anxious patients, Courtenay also extends this model of emotion-driven sex to real spermatorrhea, counseling all of his patients to take heart and return to a pleasurable sex life. As I have said, in many ways spermatorrhea falls neatly into the Foucauldian framework of *scientia sexualis*, in which the doctor performs the "hermeneutic function" of the confessor and is necessarily "scandalized" and "repelled" by these confessions (Foucault 67, 64). But these intimate and apparently nonjudgmental conversations depart from this model, implying moments of self-disclosure and reassurance rather than playing out ideologically scripted postures of abjection and authority.[46] This small batch of narratives undermines the power imbalance Foucault describes, drawing the doctor and patient into partnership with a shared interest in sexual pleasure.

This recognition leads me back to the tableau of the surgeon inserting a catheter into his patient's penis, which I presented earlier. Paradoxically, this moment of graphic violence also suggests a shared collaborative investment in sexuality. While spermatorrhea treatments punished and "othered" male bodies, the recurring double image of the masturbator and the surgeon suggests a covert, displaced participation in those deviant practices that medical advice was supposed to end. The doctor who takes hold of his patient's penis to insert a catheter, the doctor who pulls down his patient's trousers and "put[s] his hand down there" (Acton 335), the doctor who supervises his patient's sex life, as Milton recommends—even Acton's continent man, who "grasps" his desires with a "firm . . . hold" (68)—simultaneously expel the masturbator and take his place (figure 3).

[46] Perhaps, too, because these nervous patients violated norms of masculinity, they cried out for a cure, even if it involved some illicit pleasure; a philandering colonel was probably a more acceptable figure than a panic-stricken, impotent hypochondriac.

FIGURE 3: The surgeon replaces the masturbator. J. L. Curtis, *Manhood: The Causes of its Premature Decline, with Directions for its Perfect Restoration* (London, 1859).

For, despite the paradigm of phallic professional/incontinent other that structures the violence of spermatorrhea treatments, patients and doctors were also more or less interchangeable. Both occupied the same social position—that of the bourgeois man who ought to be defined by Adams's "virtuoso asceticism"—so both were equally in need of special circumstances to justify their bodily curiosity. Surgeons invented spermatorrhea not only to repudiate the incontinence represented by their patients but also to instate themselves by proxy in bodies much like their own. Patients were body doubles, performing dangerous sexual stunts that doctors experienced vicariously through their consultations and treatments. And—a striking and recurring feature of many of these case studies—patients were often medical students or doctors themselves.[47] In the manner of an ex–drug addict who leads a D.A.R.E. program, one military officer suffering from spermatorrhea became a surgeon in order to help combat the disease (Dawson, *Spermatorrhea* 46). The figures of patient and doctor collapse completely in Dawson's warning to his "numerous anonymous medical correspondents" that they should not attempt to cauterize themselves—a scenario that again conjures up the tableau of the doctor holding a penis,

[47] Dawson (*Spermatorrhea* 72, 56); Courtenay (*Practical Essay* 11, 21); Milton (17); Lallemand (xi); *Lancet,* 15 June 1861: 583.

except in this instance the penis is literally his own (73). Surgeons and patients were mirror images of each other—and sometimes, according to Dawson, even the same person. It was in part this doubling that engaged surgeons in the disease, since they themselves were deeply enmeshed in the painful process of eschewing their own bodies both as ordinary middle-class men and as aspiring professionals. Their demonizing of quack pornographers reflected the fact that, for all its scientific trappings, the spermatorrhea literature inevitably gave rise to erotic narratives and physical self-exploration. Perhaps this doubling helps to account for the accepting tone of Courtenay's case studies. As positions in medical discourse, the dyads of doctor/ patient, confessor/confessee, expert/deviant, scientist/sex fiend map out a hierarchy of power that encourages authority figures to meet sexual confessions with disapproval, as Foucault suggests. But these positions were occupied by multidimensional and mobile social subjects who shared experiences and values, and who could and often did change places. Their movement altered the dynamics of the confession, muting the pathologizing function of the expert's hermeneutic role.

I suspect, too, that the dyad of surgeon and patient re-created what was perhaps *the* formative sexual experience for middle-class men: schoolboy sex. Articles, pamphlets, and case studies consistently locate the practice of masturbation in boys' schools, where pupils learn self-abuse in ways that are never spelled out.[48] These sources do not mention the obvious factors of privacy or lack of adult supervision; instead, they blame boys' physical proximity. Suggestively describing schools as places "where the bodies of boys or young men are collected," Acton expresses his concern about "the *platonic attachments* that sometimes become fashionable in a school" and that deviate from the "ordinary boyish friendship . . . cemented by scrapes, fights, sports, [and] sorrows" into a "manly, happy connection" (40). Acton emphatically condemns these "sentimental" friendships as a kind of "moral infection" that boys can catch at school, and that later emerges as the physical infection of spermatorrhea (40, 39). These comments lead me to think that "the solitary vice" may not have

[48] For sources that locate the practice of masturbation in boys' schools, see Courtenay (*On Spermatorrhea* 33), Dawson (23), Curtis (66), Wilson (23 August 1856: 215). For a useful overview of the medical history of masturbation, see Porter and Hall (135–53); see also MacDonald.

been solitary enough, that schoolboy "self-abuse" may itself be a eu-
phemism for mutual masturbation and perhaps for homosexual inter-
course—activities that, if we are to believe Walter in *My Secret Life*
and John Addington Symonds, among others, were hardly unknown
in boarding schools.[49] Looking, touching, and exchanging erotic
pleasures was one of the fullest sexual initiations middle-class boys
had—perhaps the only one.[50] Although these adventures were to be
abruptly replaced by heterosexuality in adulthood, it is hard to be-
lieve that some remnant of same-sex desire did not haunt the self-de-
fined heterosexuals who both complained of and treated spermator-
rhea. Because of the importance of this phase of life in the nineteenth
century, Victorian men may well have experienced the tension be-
tween homosociality and homosexuality with special intensity, and
may have found it irresistible to straddle the divide once again, even
momentarily and despite the stigma of deviance.[51] The spermator-
rhea literature evoked moments of lost erotic pleasures in its consul-
tations, case studies, and illustrations.

Spermatorrhea reconfigured these sexual initiations both to dis-
credit and to preserve them. Acton, Courtenay, Dawson, Milton,
Kahn—respected surgeons, borderline practitioners, and outright
quacks alike—all decry masturbation, and if they allow for any erotic
pleasure, it is exclusively heterosexual. Paradoxically, these middle-
class men must thoroughly repudiate masturbation and its associated
erotic rituals to continue experiencing their bygone pleasures in a
different context and with vastly different connotations. Spermator-
rhea provided a kind of alias for homoerotic activity, apparently dis-
avowing it while allowing it to travel under an assumed name. I am

[49] Scholarship on Victorian homosexuality has now become so extensive that it is
almost impossible to enumerate sources, but it is worth noting that even *Tom
Brown's Schooldays* acknowledges the presence of homoerotic friendships at Rugby,
in much the same terms as Acton (see chapter 5).

[50] Spermatorrhea may even have replicated schoolboys' pissing contests when sur-
geons watched their patients urinate to gauge the strength of the flow; see Dawson
(36).

[51] Hall has argued that Victorians did not see schoolboy erotics as leading to the
development of "a permanent homosexual or 'inverted' tendency" ("Forbidden" 374).
I agree; I see no reason to link schoolboy sex play or the homoerotics of spermator-
rhea to an abiding homosexual identity in any absolute or inevitable way. I see this
continuity as reflecting men's unacknowledged, probably unconscious longing for
lost practices and pleasures rather than as evidence of a lasting, coherent form of sub-
jectivity.

not claiming that medical consultations were a version of the school-boy "frigging parties" that Walter describes in *My Secret Life*, or that these spermatorrhea patients and doctors were "really" homosexuals; rather, these consultations allowed men to keep alive, in a deeply encoded and displaced form, the experiences they were obliged to give up when they entered the world of heterosexual middle-class manhood. A man could reexperience these practices only by patho-logizing their origin so completely that they seemed unwanted, dis-graceful, and degrading. Through this shame and disgust over mastur-bation, averred in every document of the spermatorrhea panic, middle-class men maintained a subterranean contact with their erotic pasts.

In the spermatorrhea panic surgeons acted out their own mastery over—and perhaps revenge on—the oozing bodies that had tainted their professional identities. This is one important message of the panic and its onerous treatments: middle-class men also lived under the oppressive abstractions of "patriarchy" and "masculinity," and their bodies were equally subject to appropriation in the name of the phallic ideal. Spermatorrhea surgeons objectified, dismembered, and invaded middle-class male bodies as quickly as they did those of pros-titutes and paupers. The spermatorrhea panic is a concrete reminder of the virulent anti-pleasure ideology that literally made itself felt on the bodies of real people. Negotiating taboos on erotic experience, bodily self-knowledge, and embodiment itself may require an other to bear the stigma of sexuality, but anyone can be impressed into this role. Feminist, race, and postcolonial theorists have ably analyzed the physical differences that have rationalized many forms of othering. But, counterintuitively, it is the *sameness* of the spermatorrhea pa-tient that makes him so useful.

This sameness, however, also ensured that the spermatorrhea panic was more than a simple othering of sexualized bodies. It reminds us of the multiple positions of the middle-class men who appear in this medical literature as doctors and patients, scientists and sexual de-viants, phallic professionals and guilty masturbators. This sameness allows for the complex interplay of disgust and desire, abjection and identification that gave men access to their own bodies in the very act of repudiating them. When I discovered Courtenay's case studies, I found myself applauding the resourcefulness of doctors and patients, and wondering how many similar conversations went unrecorded in

the literature. I cannot completely account for these case studies—how they were received by the medical community or by lay readers of Courtenay's pamphlets, how typical they were of sexual behavior. But they suggest that if one outcome of the spermatorrhea panic was to demonize sex, another was to authorize it, not only as a form of deviance but also as a source of pleasure.

2 The Man on the Street

Gender, Vision, and the City

Though in more metaphorical ways, the mid-Victorian urban milieu raised the same issues of masculine character and body boundaries that fueled the spermatorrhea panic. Often perceived as a paradise for confident, privileged men, the city was also a place of danger, a chaotic mob of unreadable strangers—especially women, tempting men with their enticing bodies. Densely packed city streets formed a highly charged force field, with currents of sexuality, vision, and power buzzing from body to body, unsettling autonomy and penetrating defenses. In this environment, male anxieties about erotic susceptibility flourished. If one key narrative of city life is the story of the flâneur strolling the streets with impunity, another less familiar one is the seduction story, in which alluring strangers of dubious pedigree imperil respectable men. The urban seductress dominates these narratives, her extraordinary powers of dissimulation reflecting the intensity of male paranoia. Whether cast as a literary fantasy, an imagined social problem, or a real-life experience, the seduction story organizes central fears about urban experience. In this chapter I trace its features in three disparate texts: Wilkie Collins's novel *Basil;* Alexander Walker's *Beauty in Woman*, a popularization of aesthetic and physiological theory designed to instruct men on how to interpret beautiful female bodies; and the diary of Arthur Munby, the self-styled flâneur who dedicated himself to studying urban women. Each is structured around encounters with threatening women and each advances a different defense against women's bodies: *Basil* demonizes them, *Beauty in Woman* aestheticizes them, and Munby idealizes them. Virtuoso asceticism is hard-won: only by transforming women's bodies into something else can men survive the city.

These texts also complicate the idea of urban vision, a key aspect of male dominance. We are familiar with the view of the privileged man as a "sovereign spectator," wielding an array of powerful gazes that fix and subordinate women (Tester 7). His sightline frames and evaluates women in its many incarnations: the censorious descriptions and photographs of prostitutes by Henry Mayhew, John Thomson, and William Acton; the "penetrating gaze" of the flâneur, who takes the prostitute as his favorite urban spectacle; the juridical gaze of the Contagious Diseases Acts, which empowered policemen and magistrates to decide on the basis of appearance who might be a prostitute (Nord 1).[1] But despite the unilateral power implied by these well-known examples, the city's vitality could not automatically be organized and subdued by a single point of view, nor did the dyad of male viewing subject/female viewed object come ready-made to public spaces.[2] Instead, currents of power and vision flowed in many directions, in what one Victorian journalist called "the ocular freedom of the London streets" ("Rape" 125).[3] Rather than enforcing a clear specular hierarchy, the city exposes men to competing glances. Instead of wielding vision as a secure form of privilege, the men in *Basil*, *Beauty in Woman*, and Munby's diary struggle to fabricate some version of a penetrating gaze in order to distance themselves from temptation. But, with varying degrees of self-awareness, all three retain the uneasy sense that urban looking is fundamentally enmeshed in dangerous desires.

[1] Unlike men, "the too-noticeable female stroller" lacked the anonymity and power to look back, for in an age in which prostitutes were called "public women," appearing in public was tantamount to a sexual transgression (Nord 4). Walkowitz discusses the "powerful streak of voyeurism" in *flâneurie* (*City* 16). Others have also insisted that urban space is a "mechanism of social discipline" that "puts women in their [place]," subordinated to privileged men (Kearns and Philo 12, 13). Critics have certainly complicated this paradigm, most often emphasizing the presence of women in the city and searching out the female spectator in the contexts of philanthropy, social clubs, and shopping, though many of these examples belong to the end of the century; see Nord, Walkowitz (*City*), Rappaport, Nead (*Victorian Babylon*).

[2] As Steve Pile says of contemporary cities, "The psychodynamics of violations work across the spaces of power and exclusion" (89).

[3] I am indebted to Nead's *Victorian Babylon* for calling this article to my attention (see 62–73). Nead eloquently describes the city as "a world of scopic promiscuity, where the exchange of looks is constant and potent" (66).

Sex and the City: Wilkie Collins's *Basil*

Wilkie Collins could have had many things in mind when he subtitled the 1852 edition of *Basil* "A Story of Modern Life," but surely one of them was the idea of falling in love on an omnibus. That this commonplace beginning leads to tragedy and despair signals the high stakes of mid-Victorian urban living. When Collins affirms the realism of the encounter, noting its source in an actual event and contrasting it to the "artifices of sentimental writing," he also implicitly insists on the dangers that lurk in the everyday settings of the city (xl). Like prostitutes and sewers, though without their melodramatic flair, the ominibus both symbolizes and literally effects the free circulation of dangerous influences in the city, spreading contagion across geographical and class boundaries as it traverses London's streets.[4] Venturing into town to collect his allowance from his father's bank, the aristocratic Basil enters a strange new world when he steps onto the omnibus and sees the beautiful Margaret Sherwin. His discovery of vice hidden behind her seductive exterior is a parable of urban male paranoia involving sight, space, and bodies.

The novel's plot is a typically sensational Collins concoction. The scion of a rich and ancient family, including his socially fastidious father and saintly sister Clara, Basil falls in love with Margaret, the daughter of a tradesman. Fearing his father's objections, he agrees to a secret courtship and marriage. But Margaret has her own secret: she is actually the lover of Manion, her shadowy tutor, whose father was ruined long ago by Basil's father. When Basil decides to surprise Margaret at a party on the night before the announcement of their marriage, he discovers her in a hotel with Manion, whom he brutally assaults. Disengaging himself from Margaret, he attempts to bury himself in the city. But Manion recovers and, after Margaret dies of typhus contracted while visiting him in the hospital, pursues Basil throughout England. Attempting to push Basil off a cliff, Manion falls to his death, leaving a shattered Basil to retire with Clara to a remote family estate.

As even this brief summary should suggest, Collins sees nothing but heartache in "modern life," suggesting that the misalliance be-

[4] Stallybrass and White provide the most thorough account of the circulation of urban contagions (125–48).

tween Basil and Margaret—equally intolerable in terms of class and character—could only emerge within the horrors of urban experience. Within this improbable plot, Collins puts into play all of the central features of men's urban fantasies: the unpredictable cross-currents of city life, the threat of the seductive stranger, the unveiling of depraved female sexuality, and the ultimate power of masculine vision.[5]

The urban world in which Basil's story unfolds is an anarchic one whose sheer empirical reality undermines social hierarchies. Unlike homes, clubs, or colleges, public spaces were available to all classes and characters; anyone might walk the streets—or ride in an omnibus, as its name suggests. A "miscellaneous throng" of people poured through the city, sowing "confusion" on the "densely crowded streets" (Munby, 3 April 1860; "City Highways" 135).[6] One writer estimated that 706,000 people entered London in a single day—three times the total population of Liverpool—while 56,000 crossed at a single intersection ("Mending" 614).[7] The city did little to sort out these crowds. While an unofficial "moral geography" offered a means to segregate different groups into different parts of the city—the East End was the land of the working poor, Smithfield of the criminal element, Holywell Street was the pornography district, while prostitutes haunted the Covent Garden area and respectable shoppers thronged Regent Street—these distinctions were rough, imperfect, and frequently violated. Prostitutes mingled discreetly with the bourgeoisie and were informally ceded one side of Regent Street on which to ply their trade ("Rape" 125), while on Holywell Street shop windows juxtaposed medical textbooks with obscene photographs (Nead, *Victorian Babylon* 183–84). People might easily find themselves—or others—out of place; observers might have trouble judging the identities of passers-by. Heterogeneous waves of people crowded the city, spilling over its spaces indiscriminately, without respect for social distinctions.

As he boards the fateful vehicle, Basil recognizes this chaotic inter-

[5] Basil's status as an aristocrat emphasizes his native refinement and raises the stakes of his seduction, but the novel's paranoia about female sexuality rests on bourgeois standards of male self-containment.

[6] Modern scholarship reinforces this sense of chaos: Marcus calls London "illegible," while Maxwell characterizes the city as a text of indecipherable mysteries (257, ii).

[7] Indeed, pedestrians are described as dodging one another and traffic so frantically that they would hardly have a moment for detached gazing ("Dangers").

mingling of strangers, remarking, "I know not any other sphere in which persons of all classes and all temperaments are so oddly collected together" (27). Thus, while an omnibus might seem to be a singularly inappropriate setting for passionate love, it provides a necessary precondition: Basil's infatuation can take hold because he knows nothing about Margaret or her origins. Stripped of reliable markers of family, class, and character by the anonymous, democratic space of the city, Margaret appears as a beautiful body removed from any defining context. The novel insists on the difficulty of reading her with the metaphor of the veil. Margaret is veiled at first, but when she lifts her veil, Basil thinks he knows all he needs to know: she is dark, voluptuous, full-lipped, slender, supple, beautiful. "The veil! How little of the woman does it hide, when the man really loves her!" Basil observes with heavy-handed irony, mistaking her for a modest woman and an appropriate wife (31). Lifting her veil, Margaret only disguises herself further by exposing Basil full-force to her deceptive beauty.

It is not only Margaret's beauty that deceives Basil but her simulation of gentility as well. On her misleading body the novel inscribes its fears about class and sexuality, insistently linking Margaret's social status with her sexual taint. Basil quickly learns that she is the daughter of a linen draper whose shop stands in "one of the great London thoroughfares!"—the exclamation point registering Basil's horror at this appalling location—and lives in a suburban villa, another excrescence of urbanization (34). Still, he naively imagines that she has transcended this debased world through her store-bought training in gentility. Possessing all the accomplishments money can buy, Margaret walks "with dignity and ease," steps gracefully in and out of carriages, and has perfected a "lady-like manner." She has learned all the signifiers of ladyhood, including the "modesty and reserve" with which to meet Basil's declaration of love (56). As her vulgar papa proudly announces, "No duchess has had a better education" (71).

But education does not make the duchess. Margaret is no lady but a true urban type, a woman of liminal class status poised between the authentic elegance of hereditary ladyhood and the unambiguous vulgarity of the lower-middle class, whose faux gentility both conceals and points to her sexual secret.[8] As with similar characters such as

[8] Of course, in another sense, Margaret has a perfectly authentic class identity as a card-carrying member of the nouveau riche, but the novel chooses to consider this status inherently deceptive.

Becky Sharp, Lady Audley, Lizzie Eustace, and Lydia Gwilt, this sta-
tus attends and figures sexual temptation. Assuming that morality,
manners, and social station are inextricably linked, the novel all but
guarantees Margaret's vice when it identifies her father as a trades-
man. Or, to put the matter in a different way, class furnishes the cat-
egory through which to register the dangerous otherness of the se-
ductive urban woman. At a time when conduct books and literature
offered detailed recipes for ladylike behavior, and when consumer
culture marketed status signifiers to whoever could afford them, class
identities seemed dangerously unstable: well-trained bodies might be
"imitations, copies, counterfeits" with no original, and might require
an expert "corporeal connoisseurship" to penetrate their false exte-
rior to the imputed true self beneath (Crary 11; Stafford 86).[9] In the
seductive, social-climbing woman, fears of class imposture and illicit
sexuality are condensed as mutually constitutive crimes: her class
performance ensnares respectable men, while her seductiveness
raises the stakes of her imposture, threatening not simply to fool men
but to marry them. Issues of interpretation and legibility mark Mar-
garet as a doubly palimpsestic text of status and sexuality. The novel
condenses these issues in the figure of the parvenue, as if class were
not always a matter of performance, and as if seduction did not re-
quire a willing male participant. Thus, Margaret represents the
disidentifications necessary to preserve Basil's identity as a true gen-
tleman, underscoring the idea that sexuality itself is an alien force,
something that infects Basil from the outside, and asserting the firm
foundation of his class status in contrast to Margaret's.[10]

The novel underscores these disidentifications in the contrast be-
tween Margaret and Clara, made not only through the familiar tropes
of dark and fair, polluted and chaste, duplicitous and true, veiled and
transparent (Clara's name suggests her Una-like legibility), but also
through the more surprising terms of stranger and sister. Basil is torn
not between two lovers but between an exogamous attachment and

[9] The work of Marin Cureau, whom Stafford identifies as the father of this ap-
proach, recommends specific techniques for penetrating the defenses of an impostor,
including getting him drunk and, pathetically, pleading with him to reveal himself
(86). For a detailed explication of these assumptions, see Langland, who stresses the
contradictions of conduct book assumptions about class, character, and behavior:
while these books claim that "dress simply expresses the true nature of a lady," they
simultaneously maintain that "dress constitutes the lady" (Angels 36).

[10] Once again, Basil's aristocratic status comes in handy, granting his class identity
an absolute foundation in lineage that a middle-class man could not claim.

his family, as his obsession with Margaret overwhelms his "home sympathies" (89). Pitting the ambiguous impostor against the true-blue and blue-blooded sister, the novel celebrates endogamy as everything that is dependable, familiar, and secure. When he returns to his sister's arms and the family property at the novel's end, Basil reenters a radically hermetic zone of legibility and sexual safety apart from the fluid world of mid-Victorian London.

In a climactic moment, Basil discovers Margaret with her secret lover Manion in a cheap London hotel. Here Collins presents the urban primal scene: the discovery of the woman's sexualized body. Listening through the building's thin walls, Basil overhears a conversation that reveals Margaret's liaison with Manion; like the primal scene of psychoanalysis, this moment grants Basil an unsought, profoundly disturbing sexual knowledge: *"I knew and I heard"* (160).[11] He stands outside the room, screened by the wall, belatedly realizing his lack of knowledge, power, and vision. At this moment—and in contrast to her earlier, literal unveiling on the omnibus—Margaret is truly exposed, revealed as a sexual predator. The novel takes its revenge by disfiguring her beauty, transforming her into a monster: "Her cheeks were ghastly, her features were rigid, her eyes glared like an idiot's; guilt and terror had made her hideous to look upon already" (165). On her deathbed she is grotesque, a soul sister to *Jane Eyre*'s Bertha, with "the smouldering fever in her cheeks; the glare of the bloodshot eyes; the distortion of the parched lips; the hideous clutching of the outstretched fingers at the empty air" (291). The scene of unveiling is the reassuring counterpart to male anxieties about female passing: sooner or later, the truth of a woman's character will be written on her body. Traumatic as it is, the scene restores Basil's equilibrium. Margaret loses her seductive power, her beauty becomes deformity, his attraction becomes disgust and then moral condemnation. In a sense, his initial desire is erased: her appeal is re-

[11] It is possible to give this scene a more detailed psychoanalytic reading as the primal scene: seeing Margaret and Manion together, Basil sees what he and Margaret will presumably do the next night, when they plan to announce their marriage; that is, Basil is implicated in the sexuality that he finds so disturbing when it is acted out by others. As in the psychoanalytic primal scene, Basil is both too early—his time will not come for another day—and too late, since Manion has already possessed his wife. Moreover, Margaret can easily be read as a Medusa figure, disgusting precisely because she appears to Basil's eyes as a dangerous, sexual woman who calls his own intactness into question. This psychoanalytic reading underscores the dynamics of projection, disavowal, and repudiation in the narrative.

vealed as a carefully constructed illusion, the product of her "patience and secrecy" rather than an authentic attraction (160). Basil's infatuation is laid at her door as its cause shifts from his besotted viewing to her calculated seduction.

Once she is unveiled, Margaret is redrawn as profoundly, transparently other, her depravity specified through a class rhetoric marking her as an urban contagion. Correcting the ambiguity of modern life, the novel helpfully redraws Margaret as a prostitute. Her portrait becomes sharper and more focused, like a photographic image in the process of being developed, as metaphors from the underworld of poverty and prostitution drift upward to seize her deceptive body, making her meaning clear at last. She is "foul" (160), a "pestilence" and "pollution" (287) that "ooze[s] out through strange channels" (251).[12] Visiting her lover Manion in the hospital (he is described as the "Great Mystery of London" because he will not reveal his identity, in a clear reference to *The Mysteries of London*, the bestseller that promised to disclose the shocking turpitude of city life, which is the subject of chapter 3), she contracts typhus, frequently (though erroneously) understood as a disease of urban filth, like cholera.[13] Assumed to be spread by breathing tainted air, typhus was classified as a miasmic disease, carried invisibly by the apparently innocuous atmosphere, just as Margaret cloaks her depravity in her lovely appearance.[14] A distinctly urban threat, it crystallized the fear that the evil effects of poverty, disease, and vice could surreptitiously violate body boundaries, infecting respectable citizens with the diseases of the poor: as one of the hospital doctors says, "One breath inhaled from the infected atmosphere hanging immediately around the diseased person, and generally extending about a foot from him, . . . [is] enough to communicate his malady to the breather" (282). Explicitly linking her death to the conditions of modern life, another doctor explains her infection as the result of her accidentally having stood

[12] Stallybrass and White have shown how the rhetoric of dirt and disease demonizes the working poor: as metonyms become metaphors, the poor become identified with their afflictions. They do not simply endure disease, they embody it; they *are* disease (131).

[13] Anthony Wohl writes that "typhus and typhoid were confused in the first half of the nineteenth century" (142). Typhus is also the disease of Carlyle's Irish widow in *Past and Present*.

[14] See Stallybrass and White for a discussion of the miasmatic theory of disease (133–35).

beside the wrong hospital bed, "just as some women run into the wrong omnibus"(279). The novel catches Margaret in the same urban contagion that she herself has spread: after using the anonymity of city spaces, including the omnibus, to ensnare Basil, she is infected by catching the wrong bus herself, standing too close to an anonymous body in a city hospital.[15] It is as if the novel wants to declare that, for all her seductive power, she has not mastered urban space; rather, it has mastered her.

In fact, the novel's retrospective narration suggests that Margaret has always been an open secret. While this strategy intensifies our sense of Basil's naïveté, it also relieves the suspense of Margaret's charade: we cannot doubt that she will eventually be discovered. Even while she retains her beauty, Margaret occasionally gives herself away, most often with her language, which the novel represents as more truthful than her body. Sadistically, she threatens to kill the cat that has killed her canary; later, in the hospital, in her mean-spirited deathbed speech, she taunts Basil with his sexual belatedness: "Ha! ha! he calls himself a man, doesn't he? A husband who waits a year!" (294). Moreover, Margaret has always been under Manion's influence. Although she did attract Basil and agree to be his wife, her duplicity was engineered by Manion: "The power, in her case . . . was all on my side," Manion boasts (244). Basil learns that she has been Manion's pawn all along and that the real battle is between two upper-class men who have inherited their feud from their fathers. Margaret's influence and agency recede as families and fathers trump seductive female strangers. In the superimposition of this gothic plot on this "Story of Modern Life," the contest between the unreadable woman and the love-struck man is overtaken and derailed by other conflicts that, if bizarre and incredible, are nevertheless more manageable because they hark back to the values of an earlier age of paternal inheritance and blood feuds. That is, even as Manion threatens, terrifies, and hounds Basil like Frankenstein's creature, he returns him to the world from which Margaret and her urban contagion estranged him, a world in which people are defined by familial—and specifically patriarchal—affiliations.

Nowhere does *Basil* depart more dramatically from the familiar story of male privilege than in its representation of vision, registering

[15] For a discussion of the idea of prostitutes as a sexual miasma, see Nead (*Myths* 120–21).

its recognition of the "ocular freedom of the London streets" in which men's discernment is not always a match for the wiles of urban women. As one Victorian commentator cautions, it is difficult "to make out the true character of a vessel from the colours under which she sails" and ascertain whether passing women represent "vice or virtue" ("Rape" 125). Moreover, women may have their own arsenal of visual weapons, potent because of their stealth, including "the enviable street-talent" of "pass[ing] men without looking at them, yet all the while seeing them" (Eliza Linton Lynn qtd. in Nead, *Victorian Babylon* 66). These instances of female agency—disguising one's character, glancing imperceptibly at men—complicate the notion of an all-powerful gaze. *Basil* clearly responds to this alternative view of urban spectatorship in its representation of Basil's highly unreliable vision. He prides himself on his discernment—"The veil! how little of [the woman] does it hide, when the man really loves her!"—but he is clearly besotted; his own arousal, in addition to Margaret's skilful performance, clouds his sight. Even when he playfully brings a magnifying glass to her face, he cannot see her true self (98). Consumed by his attraction for her, Basil participates in his own seduction: male desire is the ultimate veil. Moreover, when he muses on his instantaneous infatuation with Margaret, he figures it not in terms of what he sees, but in the vague feeling that someone is looking at him. Conveying his sense that fate has plucked him from the omnibus to become Margaret's true love, he declares, "How often we feel we know, either pleasurably or painfully, that another is looking on us, before we have ascertained the fact with our own eyes!"—apparently unaware of the somewhat sinister suggestion that Margaret may have mastered the "enviable street-talent" of looking without seeming to look, veiled as she is (29). Falling for Margaret, Basil reveals his blind spot, the gap between his limited look and the perspectives of others. With a single, myopic angle of vision that fixates on Margaret, he does not see that he is ripe for seduction, though Margaret, Mr. Sherwin, and Manion know that he will be an easy mark.[16] To use the language of psychoanalysis, Basil thinks he wields "the gaze," an all-powerful vision, when in fact he can only claim "the look": partial, limited, subjective, a "carrier of the libido" driven by the viewer's unruly desires, subject to interference by competing

[16] Pile writes that the psychoanalytic subject "vacillates between the look and the look back, where this subject position is profoundly disturbing" (126).

looks, body-bound (Silverman 130). Just as the spermatorrhea panic
opened the gap between the phallus and the penis, so the urban se-
duction narrative exposes the difference between the gaze and the
look, between men's supposedly impervious authority and the sus-
ceptibility of their bodies.[17]

But while the novel seems to acknowledge Basil's infatuated view-
ing, its retrospective narrative ultimately restores an omnipotent
gaze in its brutal treatment of Margaret. Reducing her to the stereo-
type of the vicious prostitute, catching her in the tropes of disease,
the novel asserts that it has finally read her body with absolute clar-
ity of judgment. In Kaja Silverman's terms, the narrative gaze has
taken a "photograph" of her, an ideological construct that fixes a mo-
bile, complex object in a simplified, static, one-dimensional form
(150). The metaphor of the photograph is a particularly apt and literal
one in the case of the urban prostitute, whose stereotype was estab-
lished in part by actual photographs such as those used by Mayhew
and Thomson, which, despite their appearance as objective truth,
were carefully staged on the street and in studios to emphasize the
women's degradation.[18] While Basil's blind love undercuts the im-
puted power of the sovereign spectator, the work of the narrative as a
whole is to assert the penetrating gaze, as Margaret's ultimate unveil-
ing marks the triumphant "taking" of the urban other.

Building a Better Man: Walker's *Beauty in Woman*

Only a deep-seated sexual paranoia like the one that inspires *Basil*
could have produced Alexander Walker's *Beauty in Woman Analysed
and Classified with a Critical View of the Hypotheses of the Most
Eminent Writers, Painters, and Sculptors*, one of the supremely weird
texts of Victorian social history. A prime example of the "corporeal
connoisseurship" that promised to decipher misleading bodies,
Walker's treatise promises practical help for men who are attempting
to "read" women on the city streets. First published in 1836, it re-

[17] Silverman develops this contrast, arguing that the look is to the gaze as the penis
is to the phallus: an imperfect substitute whose weakness must be covered by an om-
nipotent symbol (130).

[18] These photographs were arranged to mimic well-established pictorial conven-
tions, carefully staged to simulate the impression of a candid, on-the-spot snapshot,
and often completed with a sketched-in background over the studio backdrop. For a
fascinating account of urban photography, see Prasch.

mained in print for much of the century until its fifth and final edition appeared in 1892. The historian Valerie Steele considers it "one of the most influential studies of female beauty" in the period (103). Although its publication history suggests that Steele is right about its popularity, her characterization of its purpose is not quite accurate. Adapting the expert discourses of aesthetic philosophy and physiology to a nonspecialist readership, Walker focuses on the principles of female beauty for a specific purpose: to school erotically vulnerable men in a spectatorship that will protect them from seduction. As Walker says twice in two pages, "Critical judgment and pure taste for beauty are the sole protection against low and degrading connections," the final phrase conflating class and morality just as *Basil* does in the character of Margaret Sherwin (40, 41). Collins's tragedy of modern life is to be averted by a particular kind of viewing that substitutes cool, rule-governed judgment for sexual desire. *Beauty in Woman* is an instruction manual in the gaze.

Walker himself was a popular writer and lecturer with a background in medicine; he attended but did not graduate from the University of Edinburgh medical school and received training from St. Bartholomew's Hospital in London, where he undoubtedly became familiar with the hospital's anatomical museum, a model of its kind, which he adapted in *Beauty in Woman*. He devoted much of his life to popularizing science and art in lectures and essays, a project that culminated in the publication of *Beauty in Woman, Intermarriage* (1838), and *Woman Physiologically Considered* (1839). These ventures were so successful that he republished them in a three-volume set titled *Anthropological Works* (1843), which achieved notable popularity in England and the United States.[19] Committed to educating a wide audience, Walker dedicated *Beauty in Woman* to George Birkbeck, president of the London Mechanics' Institution, whom he praised as "the inventor of the best mode of diffusing scientific knowledge among the most meritorious and most oppressed classes of society" (25). Given Walker's copious quotations from eighteenth-century philosophers of taste and his cranky, arcane arguments with them, it is hard to believe that he intended workingmen as his audience, although perhaps this judgment sells that audience short.[20] But

[19] According to Rosenberg, Walker was "read and quoted extremely widely" (215).

[20] Walker may, however, have followed in Birkbeck's footsteps by overestimating workingmen's appetite for esoteric knowledge; the Mechanics' Institute never fulfilled its promise, at least in part because its students were so bored by the education it provided.

there is no doubt that Walker deliberately adopted the idea of "diffusing . . . knowledge" by making it accessible to a popular audience. *Beauty in Woman* adapts the objectifying, authoritative gaze posited by aesthetics and physiology to everyday social relations, addressing, literally, the man on the street, whoever he may be. While it is difficult to pinpoint Walker's intended audience, his notion that seduction is a problem to be cured by education in these specialized fields symbolically codes desire as a lower-class phenomenon. His plan is to bring real men into line with the bourgeois ideal of virtuoso asceticism, whether they be working-class or lower-middle-class men without access to elite education, or higher-status men who have not been sufficiently socialized into their proper subjectivity.

Despite his high-flown title, Walker's aim is eminently practical: to teach men how to look at women. He imagines the predicament of a man who passes a woman on the street, notes her attractive figure—which "naturally and reasonably excite[s] his interest"—and wants to learn more about her (333). As Basil discovers, to look full-out at a beautiful woman is a dangerous business, an understanding Walker seconds with a quotation from Burke: "Observe that part of a beautiful woman where she is perhaps the most beautiful, about the neck and breasts: the smoothness, the softness, the easy and insensible swell, the variety of the surface, which is never for the smallest space the same, the deceitful maze, through which the unsteady eye slides giddily, without knowing where to fix, or whither it is carried" (101). The female body itself is intrinsically misleading—a "deceitful maze"—and male vision is tremulous and passive, "carried" along by the undulations of the breast and neck. Once again, looking is charged with desire.[21]

In the face of this understanding, Walker promises immunity: if men follow his instructions and learn to master a phallic gaze, they need never be susceptible to seduction again. He constructs a two-step program for reading beauty in women: first, men learn to regard women as if they were purely aesthetic objects and not sensual presences; and second, they learn to interpret physical characteristics as signifiers of character. If men fail to do so, Walker offers them an apocalyptic vision of the result: "That the coquette well calculates

[21] In another work of the trilogy, *Woman Physiologically Considered*, Walker also represents the female look implied in *Basil:* "We learn to guess what is passing in the centre of your hearts by your looks, your gestures, and the tone of your voice. Your sentiments are exposed to us in a thousand ways; your slightest movements are a language that betrays to us your secrets" (85–86).

her procedures, does not admit of a doubt. She appeals to the imagination, which she knows will spread charms over even ugly forms; she seeks the concealment under which sensuality and lust are engendered; and, in marriage, she at last lifts the veil which gratifies only to disgust, and repays a sensual hallucination with years of misery" (30). Once again we have the urban primal scene, which strips the veil from the beautiful woman to reveal a vile seductress. If the source of this "disgust" is unspecified—seeing the true, immoral self? seeing an ugly naked body that has been disguised with artful clothing? seeing a naked female body, period?—the passage insists on the high price of inadequate seeing. But, unlike *Basil*, Walker offers hope: readers can effect this unveiling themselves, before the coquette has caught them in her calculated snares.

While Walker draws most directly on aesthetics and physiology, he also consults the exhibition culture of urban London, which realized the possibility of authoritative looking in controlled, concrete settings. Offering an array of objects organized around the focal point of the spectator, the panoramas, dioramas, and museums of all sorts that sprang up in the nineteenth century temporarily afforded one the position of sovereign spectator. Unlike people on the street, these objects could be clearly identified; they exhaled neither sexuality nor germs into the viewer's body space; they stayed put; they did not look back. If the city stripped bourgeois men of the visual privilege they might expect, it also returned this privilege in the specialized spaces of exhibitions. Stimulated by an "ambition towards a specular dominance," waxworks, art galleries, and anatomical museums served as models for Walker's treatise, presenting human bodies—and especially the female body—in a fully objectified form, obligingly fixed in the viewer's sightline (Bennett 88). Copies of the Venus de Milo and the Venus de Medici, first exhibited as "the Venuses" in 1825, gave viewers a direct view of the naked female form (a sketch of the Venus de Medici adorns the frontispiece of *Beauty in Woman*).[22] Some of

[22] Gail Marshall argues that the Venus statues invited a pleasurable spectatorship: carved in pure white marble without the coloring of their classical originals and decontextualized from any knowledge of the sculptor and Venus' mythological identity, the statues "telescoped [Venus' story] in a moment of gazing made relevant to, and determined by the viewer" (10). Marshall reads the fascination for the Venus statues, as well as the Pygmalion myth, as a defense against fears of female sexual power: "There is no danger of an emasculating *femme fatale* or an otherwise disruptive female sexual presence" (21).

these Venuses also served the purposes of anatomical museums: their stomachs could be opened like the lid on a teapot to reveal their internal organs. Such displays, which ranged from the respectable, like the one at St. Bartholomew's Hospital, to the notorious (such as the Anatomical Venus of the infamous Dr. Kahn, described in chapter 1), offered a gaze so masterful that it could penetrate the flesh to see the physiological inner self. Moreover, in exhibitions displaying the human body, the conditions of viewing were usually controlled by selective admissions policies. Entrance fees changed from day to day to segregate viewers by class, and men and women were admitted on different days; Richard Altick considers the latter custom the "one constant" in these varied exhibits (341). This meant that middle-class men could view the female body without the intrusion of social others. Oases of class and gender privilege in the "ocular freedom" of London, such exhibitions offered a taste of the gaze. It is this confident, risk-free viewing that Walker hopes to import into everyday life.[23]

The first step in Walker's program is to create a new couple from the raw materials of woman and man: the nude and the aesthetic spectator. Urging men to approach the female body dispassionately, he begins by training them as interpreters of classical nude statues. His strategy reflects the increasing public presence of the nude in art: as the Royal Academy extended its influence, art schools proliferated, and statues in the classical style increasingly appeared in sites such as the Crystal Palace, the female nude became a familiar part of the London landscape. With its presence came the protocols for spectatorship that Walker adapts. Developed through Joshua Reynolds's

[23] Whereas art and anatomical museums are obvious sources for Walker's ideas, even exhibitions that did not display bodies created the sense of authority he sought in his treatise. In Thackeray's *Pendennis*, Arthur climbs to the top of the panorama exhibit in Leicester Square when he is troubled by his liaison with the lower-class Fanny, a move that not only restores his class superiority in spatial terms but also marks the contrast between his ground-level look, besotted with the beautiful Fanny whom he has literally met on the street, and the gaze that takes a dispassionate view of its object. For Altick's observations about Arthur's ascent, see 122–23. It should be noted that this sense of privilege was limited, for the more popular panoramas and commercial fairs could be crowded with people, all of whom could look at other observers as well as the objects of display. See, for instance, Tony Bennett's description of how exhibitions encouraged mutual surveillance among spectators, constructing "a consistently orderly public—a society watching over itself" (91).

theory of ideal beauty and the practices of the Royal Academy, and circulated to a nonspecialized audience through exhibition manuals and public debates about the propriety of such exhibits, elite aesthetic theory defined the nude as an ideal type, a formal study to be regarded dispassionately rather than a representation of an actual naked body (Smith, *Nude* 8). To be sexually aroused by a statue as if it were an unclothed body was as naive, critics argued, as interrupting a play to shout advice to a character. The nude not only perfected real bodies; in some sense it also opposed them in its very denial of sexuality: "The ideal classical nude . . . was seen to lift the figure beyond the moral anxieties that the body implicated at the social level" (Smith, *Nude* 47).[24] Drawing on such assertions, Walker understands "the nude" as de-eroticizing the female body by clothing it in the dignity of art and analyzes it in terms of its formal characteristics: symmetry, balance, and so forth. Thus, the nude purposefully rewrites the female body to eliminate corporeality and eroticism: "One of the principal goals of the female nude has been the containment and regulation of the female sexual body. The forms, conventions and poses of art have worked metaphorically to shore up the female body—to seal orifices" and thus to produce a smooth and self-contained form (Nead, *Female Nude* 6). Walker has so much faith in the power of aesthetic spectatorship that he recommends displaying Greek statues in the home to promote "sexual virtue" (39).[25] Following his own advice, he illustrates *Beauty in Woman* with plates of naked women, their hair dressed in Grecian fashion—drawn, the text proudly announces, by a professor of painting from the Royal Academy of Art. Visually turning bodies into art, these illustrations offer readers who are not so fortunate as to have Greek statues at home a chance to develop this sublimating vision.

Having placed the nude before his readers, Walker then trains them

[24] See also Pointon's discussion of this idea of "the real body to which the nude is other" (13). This view of the nude circulated widely, though not without controversy: at the Great Exhibition, statues had to be draped for official visits by the clergy, and Susan Flood, an Evangelical visitor, smashed offending body parts to protest their indecency (Pearsall, *Tell* 46; Smith, *Nude* 16). In addition to attacks by freelance moralists, the aesthetic category of the nude was complicated by an array of related representations, from the popular *poses plastique,* in which actors in nude-colored body stockings adopted classical poses, to pornographic photography.

[25] Apparently he was not alone: according to Pearsall, "advanced educationalists" made a similar recommendation for schoolchildren (*Tell* 11).

to regard it with an appropriately aesthetic gaze, quoting from eigh-teenth-century aesthetic philosophy to construct a notion of specta-torship that is ideally free from bodily contamination. Walker places himself in the tradition of Hume and Burke, who developed aesthet-ics, in Terry Eagleton's words, as "a prosthesis to reason, extending a reified Enlightenment rationality into vital regions which are other-wise beyond its reach" (16). Like these philosophers, Walker distrusts the imagination and sensual pleasure as threats to reason and self-control, and sees proper aesthetic principles as defenses against their power, placing the sensory and potentially sensual act of looking en-tirely under the rule of reason. Walker follows Burke in defining taste as a "rectitude of judgment" and in contrasting this quality to its in-ferior opposite, "a quick sensibility of pleasure" (75); he quotes Hume's recommendation that "good sense" be brought to bear on ob-jects of beauty "in order to perceive the consistence and uniformity of the whole," emphasizing formal qualities rather than sensual im-pressions (74). He further subjects beauty to reason by approaching it with scientific rigor and objectivity, seeking "laws regulating beauty in women, and taste respecting it in man" (141) by "fix[ing] doctrines on an immovable basis . . . by analysis, generalization, and systemati-zation" (123).

The abstracting, rule-governed qualities of this spectatorship join Walker's desire-free aesthetic to create what he calls "the enlightened judge," the ideal male spectator (172). While "vulgar observers" might become excited by the representation of an unclothed woman, the enlightened judge dispassionately assesses its formal properties to determine how closely it conforms to ideal standards of beauty (27). No sexual desire seeps into this evaluative gaze: aesthetics seal up the male body in the figure of the enlightened judge just as they seal up the female body in the nude.[26] As students of art "hang up their passions with their hats" when they enter the life study class, so can Walker's readers hang up their passions when they enter the drawing room or the boulevard (39). Walker's enlightened judge is not simply an expert reader of the female body; he represents the fantasy of an utterly inviolate male body.

In a sense, then, Walker both maintains and collapses the distinc-tion between the naked and the nude by asserting that the female

[26] According to Nead, this is another key function of the nude: "the production of a rational, coherent subject" (*Female Nude* 8).

body in the flesh should take on the qualities of the nude. The enlightened judge discerns the nude beneath the skin: the body need not be clothed in paint or marble but need only be put in the sightline of the aesthetic gaze to appear in its true, objectified form. While trading on the aesthetic philosophies that categorically distinguished nude statues from naked women, Walker also takes the meaning of the nude in the opposite direction, insisting that real bodies, like statues, are not really seductive at all but appear so only to a "vulgar observer" who lacks proper training. Whereas for theorists such as Burke, aesthetic spectatorship requires sublimation—the transformation of the viewer's erotic responses into something less sensual and immediate, something "more conceptually dignified," in Eagleton's dry phrase—for Walker's enlightened judge, there is nothing to be sublimated (Eagleton 33). Walker never considers a situation in which a man might enjoy an erotic encounter; there is no suggestion that, once he has ascertained a woman's good character, he might look at her as something other than a statue. Within his treatise, all desire is the result of mistaken viewing—a "sensual hallucination," as Walker says of the coquette. The body's appeal is only an illusion.

In the second stage of his training program, Walker turns to physiology, interpreting the body in order to assess character. Here he depends on the familiar fantasy that "goodness and beauty in woman will . . . be found to bear a strict relation to each other; and the latter will be seen always to be the external sign of the former"—precisely Basil's delusion, bolstered with a technical vocabulary (27).[27] The body is a perfectly legible allegory: since it always means and mirrors its interior, a woman's character can be unfailingly deciphered. He identifies three types of female beauty, each produced by the dominance of one physiological system—either the nutritive, the intellectual, or the locomotive—and each repre-

[27] The disciplines on which Walker based his work professed increasing faith in their ability to read the signs of nature written on the body: surgeons, who were penetrating the body's sheath to study the workings within; phrenologists, who saw moral and psychological attributes written in the shape of the head; nascent sociologists, who racialized the others of middle-class manhood—prostitutes, Jews, the Irish—in order to read signs of their depravity on their faces and bodies, thus naturalizing their inferiority. Scientists and philosophers asserted a direct "connection between organic beauty and comparative perfection of mind," in the words of Herbert Spencer (151).

senting a different female self. In Walker's ideally beautiful woman, the "most essentially feminine" of these types, the nutritive system is most active (201). It produces a round face, "eyes of the softest azure," a swelling bosom, plump limbs, and "peculiarly small" hands and feet, all of which reflect a loving, submissive nature (203). In contrast, the beauty of the second physiological type, dominated by the intellectual system, is also lovely but dark-haired and a little flat-chested; she is not quite so agreeable a wife (142). The locomotive type of beauty is rather bony and tall, "firm, vigorous, and even actively impassioned" (190). While this type of body can also be beautiful and womanly in its own way (though of course not as appealing as the plump, subordinate, nutritive type), in its degraded form it can signal an alarming inner self: the size of the pelvis causes a sway in the walk that is exaggerated, Walker notes ominously, "by certain classes of the women in London" (198). Personal habits also advertise themselves through the body: insufficient development of the hip and calf, for instance, will cause a woman to lift her foot "in a slovenly manner" and betray her lack of propriety (331). In defining the body as a transparent system of meaning, Walker again abstracts it: it is, he says, a "sign," a representation of physiological systems that in turn point to character (45).

Finally, Walker offers the student of female beauty a lesson in reading clothing, in a chapter memorably titled "External Indications; or, the Art of Determining the Precise Figure, the Degree of Beauty, the Mind, the Habits, and the Age of Women, notwithstanding the Aids and Disguises of Dress." Walker suggests that clothing is one of the main devices by which the coquette engenders the "sensual hallucination" that entraps men in dreadful marriages. Not only does clothing conceal the body, lending it the appeal of forbidden fruit, but also it can create the illusion of beauty by perfecting an imperfect figure. Female fashion takes its place alongside aesthetics and physiology as a necessary kind of technical knowledge. Walker describes colors that flatter particular complexions and bonnet styles that look best on heads of a certain shape so that readers will learn to see through their falsifying enhancements to the real, imperfect body. He even warns readers that women may decorate their homes in colors that lend their complexions unfair advantage. Armed with this knowledge, the enlightened judge should be able mentally to undress "the skillful

woman," the accomplished coquette who makes several appearances in *Beauty in Woman* (116, 331, 334).

The results of these techniques of aesthetic and physiological spectatorship can be seen in the scenario of urban viewing to which I alluded at the beginning of this section. Tackling the problem of the man on the street who has graduated to the position of enlightened judge, Walker develops a method for looking with impunity:

> Additional indications as to beauty are required chiefly where the woman observed precedes the observer and may, by her figure, naturally and reasonably excite his interest, while at the same time it would be rude to turn and look in her face on passing. . . . There can, therefore, be no impropriety in observing . . . the conduct of those who may happen to meet the woman thus preceding. . . . If the person meeting her be a man, and the lady observed be beautiful, he will not only look with an expression of pleasure at her countenance, but will afterward turn more or less completely to survey her from behind. . . . Thus he who happens to follow a female may be aided in determining whether it is worth his while to glance at her face in passing, or to devise other means of seeing it. (333–34)

Here is the classic patriarchal couple, pairing an active male subject and a passive female object. The man is a calm observer, entitled to appraise a stranger on the street and able to evade the constraints of decorum that prevent him from looking her full in the face. Helpfully, a second man collaborates by providing a relay point in a kind of sexual sonar. There is no doubt about which sex is allowed to look and which sex will be looked at. The neutral tone and meticulous spatial logic deny any "sensual hallucination." And the woman, far from being a manipulative charmer, is as oblivious as if she were a statue. This, Walker suggests, is the ideal that his training program will achieve.

And yet the passage bears traces of the sexuality it seeks to banish. Walker's insistence that a woman's body will "naturally and reasonably excite" male interest reminds us that he has been at pains to define this interest as a "sensual hallucination," while his elaborate recommendations for circumventing propriety make us wonder why a man should be so determined to perform a purely abstract aesthetic analysis of a complete stranger passing on the street. For a mo-

FIGURE 4: The odalisque pose. Alexander Walker, *Beauty in Woman* (London: Simpkin, Marshall & Co., 1892).

ment, Walker's enlightened judge resembles nothing so much as an adolescent boy trying to cop a look. We can imagine a similar moment when Walker's readers encounter his pseudo-classical illustrations, ostensibly provided to train men in desexualized viewing. Walker's illustrations trade on an iconography of seduction: some of these nudes recline in an odalisque pose that emphasizes the curve of the back and buttocks (figure 4); others fondle or cup their breast for no apparent reason except to direct the viewer's attention there (figure 5); still another throws the spectator a classic come-hither glance (figure 6). Reading this text is a bit like viewing Manet's *Déjeuner sur l'herbe,* in which a naked woman sits unremarked and apparently unnoticed in the middle of an otherwise conventional scene.

Wishing women into statues, aesthetic spectatorship is less an agent of sexual possession than of fetishism, designed to "ward off" direct sexual contact with an actual woman by replacing her with an object, the nude (Freud, "Fetishism" 151). Replacing the look with the gaze, Walker attempts to create a blind spot around sexuality, desire, and actual bodies. To claim that nudes function to enhance men's "feelings of potency" or to fulfill men's "sexual appetite," as some critics claim, is to miss the disavowal that attends male viewing in Victorian culture (O'Neill 73; Pointon 98). While, as we saw earlier, the reader of the *Penny Magazine,* perhaps lacking rigorous

FIGURE 5: Cupping the breast, for no good reason. Alexander Walker, *Beauty in Woman* (London: Simpkin, Marshall & Co., 1892).

training in Enlightenment aesthetics, found a "dreamy" if undefined pleasure in nude illustrations, the enlightened judge is even less conscious of sensual responses ("Penny Magazine" 547). He encounters and even seeks out erotic stimulation—gazing at nude statues, eyeing women on the street—but he can experience it only by *not* experiencing it, except in the radically displaced and mislabeled form of aesthetic appreciation. Like the spermatorrhea patient, the enlightened judge must disavow his pleasure in order to pursue it. Far from being a prelude to physical contact, this spectatorship is remote, self-

FIGURE 6: The come-hither glance.
Alexander Walker, *Beauty in Woman*
(London: Simpkin, Marshall & Co.,
1892).

contained, encoded, maintaining a
deliberate distance from its object
to secure the equilibrium of the
male subject. Walker's gaze is safe
sex for men.

The Model and the Milkmaid: Arthur Munby's Diaries

We know Arthur Munby because
he left an extensive diary of his en-
counters with urban working women
in the London streets, including Han-
nah Cullwick, the maid-of-all-work
he eventually married in defiance of
social convention. A combination of
urban sociologist and flâneur (a term
he applied to himself, though he
wondered if his interest in milkmaids could be reconciled with so so-
phisticated a title), Munby sought out, described, sketched, and pho-
tographed these women for most of his life. From the outset it must be
said that Munby's experience is complex and heterogeneous; at different
periods in his long life, he encountered hundreds of women who did var-
ious kinds of work and lived in far-flung parts of the city (and throughout
Europe, since he sometimes combined continental vacations with data
collection), to whom he responded in diverse ways. Any attempt to con-
struct a coherent portrait must be highly selective, as mine is. Most crit-
ics have stressed his ambivalent relationship to the dirtiest women per-

forming the roughest manual labor, such as the Wigan pit lasses, who, though admired for their brawny strength, were also the objects of his most racist, disturbing sketches.[28] But other kinds of women played a greater role in his erotic life, engaging his sense of bodily integrity and status more directly than the pit lasses, who were so obviously other to Munby the gentleman. Munby's experience both underscores *Basil's* and Walker's anxiety about women on the streets and adds a new dimension to it, a further elaboration on the theme of male sexual anxiety, as actual women, less easy to dispose of than fictional ones, complicate his attempts at self-protection. Whereas *Basil* and *Beauty in Woman* lay the sexual blame on the urban seductress, Munby finds it harder to maintain his position as innocent observer and confronts his own complicity in his conflicted erotic life. Unsealing the forms of both the nude and the enlightened judge, Munby's diaries turn the spotlight onto men, excavating most fully the psychology of urban paranoia.

Munby assiduously maintains his blind spot, denying any erotic engagement despite his incessant interaction with women on the street, whom he accosts, converses with, photographs, and kisses whenever he can. It is one of the more endearing aspects of his diary that he is so perpetually naive, so endlessly surprised by the codes of urban viewing and the sexual dimensions of his own interest. Inquiring at a photographer's shop about portraits of working-class women, Munby finds himself approached by the doorman, who offers him " 'another young woman' close at hand—'a beautiful specimen' " (22 March 1862, Hudson 118). In the dark about the man's meaning, Munby is further confounded when he produces this young woman from the public house next door: "What I was expected to do with her I could not conceive." The doorman helpfully suggests that he can "have a picture of her taken *with her clothes up*." "Here was a revelation, indeed!" Munby announces, walking off "in disgust." A frequenter of photographers' studios, Munby is no stranger to the "various portraits of nude & semi-nude women" routinely offered to him as he develops his collection of working-class portraits (7 December 1860, Hudson 84). Yet he remains not just disgusted but amazed whenever these enticements are presented to him, as if he has not no-

[28] Munby's precise attitude toward these women has been the subject of critical debate. For Davidoff and Pollack, he "others" them in grotesque and brutal ways; for McClintock, he racializes them to manage their apparent challenge to class and gender categories; to Allen he is a sympathetic observer.

ticed that he is participating in a project of consuming women in ways that are at least partially erotic. Munby does not exactly avoid sexuality; he stages and restages its repudiation, pursuing the bodies of women in the flesh and in representations in order to reassert his innocence.

Despite his protests, Munby remains vulnerable to his own desire, as we can see in a key incident that replays many of the dynamics of *Basil* and *Beauty in Woman*. Once again, a respectable man encounters the urban seductress, the harlot-disguised-as-a-lady who seems to be produced like a weed by the fertility of the streets. Like Margaret—and unlike the unambiguous pit girls—she has a liminal class identity, having learned to reproduce some key signifiers of gentility. While the whole encounter is scaled down from the operatic heights of *Basil*—the woman's initial veil of modesty is less an entrapping lie than an opening gambit in a straightforward flirtation—it engages many of the same fears. What is different, however, is the presence of a woman who turns her own look back on Munby, to his profound discomfort.

Outside the British Museum, Munby notices a young woman, apparently a well-bred shopgirl or a milliner (seemingly adept at the "street-talent" of the subtle gaze), looking at him in "a "grave and diffident way" (7 January 1862, *Working Women* [Reel 2] 10).[29] Munby returns her glance, hoping to "satisf[y] my curiosity." But at that moment she casts aside her feigned modesty to reveal herself as a sexually aware woman: "She accepted at once, and instantly her whole behavior changed. She put her arm through mine, unasked, and throwing off her reserved and lady like demeanor, she grew all at once amorous: a turn for which I was scarcely prepared." In their ensuing conversation, Munby's quite unnecessary delicacy is comically evident (perhaps even to him) as she matter-of-factly describes her work as an artist's model. Munby asks her:

[29] I have used two different citations for Munby's diary. Whenever possible, I refer to the passage in Derek Hudson's condensed version, *Munby: A Man of Two Worlds*, since it is the most accessible source. When I quote a passage that Hudson does not include, I refer to *Working Women*, the microfilm version of the complete diaries. Whenever possible, I include the date to give the reader a sense of chronology. Sometimes this is not possible: Some entries in *Working Women* do not indicate when the described incidents took place but give only the year in which Munby wrote the entries. Although this system is cumbersome, it gives the reader the best chance of locating the original quotations.

"And are you taken draped generally? or—ahem—nude?" "*Naked?*"
she said right out "*oh, I have often been taken naked.*" And she went
on to tell me how she is now a model at the Academy here, and can get
10/s there for a morning's sitting. "And the artists," she added, "don't
take liberties with one at all, it's only a trade with them, just as it is
with me." "Do you mean to say" I asked, in answer to some remark of
hers, "that you like being—ah—naked before men?" "*Yes, I like it very
much,*" she replied, turning her handsome face full upon me. She was
grave now, and looked as frank and innocent as if she had said the most
modest thing in the world. (12–13)

Munby has clearly misinterpreted the woman's appearance, and he is
just as clearly unhinged by the bold flirt who lurks behind her modest
demeanor. Walking beside her as she rattles on about her nakedness,
he finds himself in a state of "frequent discomfiture" (14).

Munby has stumbled on a bona fide sexual subject, one who has
found a life of forthright eroticism in the new spaces of urban cul-
ture—not only the streets, which allow her to pick up strange men
and talk sex with them, but also the life-study class, which Walker
used as a training ground for the male subject/female object dyad.
With the careful semantic choice of "nude," Munby attempts to
place her work in a professional, desexualized context. As an ad-
mirer of art and a friend of Rossetti and other artists, he would have
been familiar with the aesthetic theories of the nude exploited by
Walker, and clearly hopes that the connotations of the word "nude"
will make it a safe one to introduce into this strangely developing
conversation. But in the face of his cautious terminology and dis-
creet "ahem," which signal what he takes to be the extreme sensi-
tivity of the subject matter, the woman supplies her own deliber-
ately carnal vocabulary: she is a nude who insists on being naked.
Refusing to be reduced to a formal study, she remains committed to
her own pleasure. Although the students for whom this is "only a
trade" may "hang up their passions with their hats," as Walker says,
the model does not take off her body with her clothes; she remains
a sexual presence to herself, transforming display into the self-con-
tained pleasure of being, as Munby puts it, naked before men. The
students' gazes do not desexualize her body for herself; rather, they
seem to charge her with a recognition of eroticism—a view of her
modeling that collides with and, from her point of view, overrides
their purely professional interest. Her pleasure also depends on

looking back at the serious art students, seeing them not as disem-
bodied professionals but as men whose sex lends her modeling its
delightful frisson.

She further breaches the boundary between the aestheticized, de-
eroticized female body and lived sensual experience as she segues
into a description of a party she recently attended, linking the gather-
ing to her modeling with the highly charged word "naked": "We were
all naked," she announces gaily, "everyone,—the ball was given for
that very thing." "Do you mean that you had *no* clothing on *what-
ever?*" asks the ever-curious Munby. " 'Not one *iotum!*' she cried—
'and it was such a bit of fun!' " (13). No matter how Munby attempts
to interpret, frame, or defuse her, this woman counters with sexual
explicitness and unabashed delight. Unlike Basil, Munby is clearly
not in danger of being entrapped into a tragic liaison with a loath-
some hag: not only does this woman obligingly perform her own un-
veiling almost immediately, but also she has established a life of
pleasure to which marriage is quite irrelevant. But in another sense,
the stakes are equally high. Munby expects the word "nude" to deny
his sexual interest while allowing it to express itself covertly; he
hopes to maintain his blind spot so he can look at a woman's body
but not acknowledge what he sees. But by repeatedly translating
Munby's carefully hedged comments into a more graphic vocabulary,
the woman explodes his cover as a detached spectator. If the risk of
seduction dwindles in this encounter, a more unsettling threat takes
its place: the unveiling of the male observer's desire. Having begun
the conversation with a desire to know something about this attrac-
tive specimen, Munby meets a response that glaringly exposes the
sexual subtext of his curiosity. When the woman refuses to collude
with him in maintaining his distance, he finds himself directly, em-
barrassingly, and visibly implicated in an overtly erotic scenario.
Munby says, "She uttered her shame in the hearing of all passersby,
to my frequent discomfiture" (13–14). It is easy to imagine that her
"shame," which in fact she does not seem to feel at all, is really
Munby's, as he walks arm in arm with a woman who announces pub-
licly the "fun" of being naked at a ball.

This is the turning point of the conversation, when he feels the
condemning gazes of "all passersby" upon him, when the visual
cross-currents of the city streets subject him to the looks of others.
As in *Basil*, the desired authority of male viewing collapses into a
limited, visibly erotic look. The result is a new item in the litany of

urban anxieties: shame. Munby's shame is simultaneously psychic and social, the product of a split self that, having internalized prohibitions against bodily self-display and graphic language, sees itself, as it were, from the outside. Both the woman's explicit responses and the imagined gaze of others expose him as a voyeur, a position that does not conform to acceptable standards of gentlemanly behavior, even on the street with a perfect stranger who has initiated the conversation; he is not ideologically entitled to employ a frankly erotic look, as Walker's elaborate strategy for urban viewing suggests. While he is not psychically vulnerable in the way that Basil is, he loses control of his self-presentation and of the semantic field; it is not her seduction but his inadequately contained sexual curiosity that provokes the crisis. Just as important, Munby's discomfort reveals the profound vulnerability of being seen in a context where vision is power: shame is above all a recognition that one has been seen by others, found out and exposed, cast out from one's position as subject to become the object of another's disapproving stare. Although the scene resembles Margaret's unveiling, it differs in this crucial respect, as it doubles the sexualized look back on the male viewer to reveal his forbidden desire. We might say that the woman's bold discussion of her nakedness has also left Munby naked, exposed as a collaborator in a pornographic story.[30]

Having moved from the encoded curiosity of the detached observer

[30] Several discussions of shame have been helpful in understanding this moment. Drawing on Lacan, Kaja Silverman associates shame with the experience of self-exposure when one has been caught in an erotic look and feels judged by an all-knowing gaze: "It is precisely at that moment when the eye is placed at the keyhole that it is most likely to find itself subordinated to the gaze. At this moment, observes Lacan, a gaze surprises [the subject] in the function of the voyeur, disturbs him, overwhelms him, and reduces him to shame" (130). Sartre makes a similar analysis, seeing shame as a moment of self-recognition through the eyes of another: "I am ashamed of myself *as I appear* to the Other. . . . I am put in the position of passing judgment on myself as an object, for it is as an object that I appear to the Other" (189). Tomkins provides another relevant account of shame, stressing not only the experience of seeing oneself through another's eyes but also the origin of shame in an "incomplete reduction of interest or joy," a failure of distancing or objectivity that, for propriety's sake, ought to mask an intense investment (5). In this sense, he sees shame as a symptom of the fact that the person has not completely given up his erotic attachment to a taboo object: "To the extent to which intimacy, sexuality, and affect necessarily suffer inhibition, there will inevitably appear taboos on interocular intimacy"; hence the inevitable experience of shame when one looks at another with sexual interest (146). Needless to say, this is an accurate summary of Munby's predicament.

to the discomfiture of a Peeping Tom caught in the act, Munby at-
tempts to recoup his immunity through a process of distancing and
disidentification: reasserting his authority over language, attempting
to abject all of his sexual interest onto her and making his shame her
shame. He quiets his discomfiture by passing judgment on her con-
versation, for, as with Margaret, this is the key to her hidden degrada-
tion. While "to a stranger" she appears "decorous, comely, a quiet,
graceful young woman," Munby insists that "her speech betrayed
her" (14, 13). She can disguise her body, but her speech opens itself to
the interpretation of the male observer, whose reason makes out
what the fallible eye does not see. This reorientation grants him the
authority to diagnose her, asserting his power both to sum her up and
to resist her allure by categorizing her as a "vicious" creature who
brazenly parades her "lustfulness," her "callousness and shameless-
ness" (14). His condemnation removes him from his position as a tit-
illated participant and allies his point of view with the vision of those
passersby who seem to stand outside desire. And though as in *Basil*,
the actual encounter eludes Munby's control, his power as narrator
allows him to exert interpretive authority over his own body as well
as hers, as he arranges the story so that it ends on this note of defini-
tive judgment.

The repeated collapse of Munby's disinterested curiosity into pruri-
ence—thanks to the cynical responses of artists' models, photogra-
phers' doormen, and other citizens of the modern urban milieu—
shadows his perambulations with the threat of self-exposure. In
response, Munby develops a surprising defense: he wishes away the
predatory urban woman and replaces her with an unlikely substitute,
the country girl. Recoiling from the complexities of city life, Munby
reconstructs the grimy workingwomen of London as representatives
of a pastoral English ideal, invoking an older time and a simpler, rural
way of life. In spite of the gritty setting and the burden of their labor,
these women are "glowing with rosy health" (10 April 1863, Hudson
157), their faces "honest [and] ruddy" (1 July 1863, Hudson 167); they
are "hearty" and "robust" (7 September 1868, Hudson 254), with a
"homely, easy attitude" (11 June 1864, Hudson 196). The Wigan min-
ers fascinate him with their gender-bending, brutalized faces, but he
is equally taken with milkmaids, among the most frequently de-
scribed women in his diary, because of their rural associations. Look-
ing at a photograph of a London milkmaid, he writes, "Note the com-
fortable grace, the picturesque neatness, the utter freedom from

fashion, of her rustic dress: she is one who lives in the heart of London, and yet can be like this!" (11 June 1864, Hudson 196). Here, the city forms the contrasting frame that highlights this country specimen, making her rural charm all the more remarkable. Even a female acrobat attired in tights is described as having "a comely rustic face like a milkmaid's," Munby's highest praise (7 September 1868, Hudson 254). We can see the logic of this odd rewriting in a particular aspect of the rural ideal: the nostalgic fantasy of innocent sexuality. Having reimagined urban working women as rural maidens, Munby is able to entertain controlled interactions in which he can maintain his delicately balanced eroticism. The words "natural," "innocent," "frank," and "modest" saturate his descriptions of these women.[31] Whereas, in his encounter with the artist's model, Munby attempted to hide his erotic urges in a pose of detachment, here he finds another solution to the problem of sexual shame by creating a utopian past superimposed on the present.

Thus, Munby invents a highly improbable "photograph" for these women, to return to the language of gaze theory. In place of brutalizing stereotypes highlighting the freakish, degraded nature of the urban other (in which he also participated), Munby seeks to escape from the stresses of modern life by rewriting it as continuous with an idyllic rural past—a maneuver that, if more positive, is equally stereotypical. His choice of workingwomen as exemplars of such values is eccentric, to say the least, but his hankering after sexual innocence is not. This nostalgia went hand in hand with city life, emerging in social commentary such as Eliza Lynn Linton's famous "Girl of the Period" diatribe, which yearns for the days of the "fair young English girl" who dreams of "love in a cottage" (3, 6), and in literature such as George Eliot's *Adam Bede,* in which Dinah blushes and trembles freely in the presence of the virile Adam with a sensual responsiveness attuned to her rustic environment (unlike Hetty, who trembles at the sight of store-bought earrings, a sign of encroaching

[31] See, for instance, 30 July 1859, Hudson 41; 10 April 1863, Hudson 157; 15 April 1868, Hudson 158; 5 May 1866, Hudson 224; 19 July 1867, Hudson 253, for a sample of these comments.

Munby understands his frank and easy interchange with these women as leveling social distinctions; unlike modern ladies, whom he repeatedly attacks as artificial and unnaturally reserved, these women do not attempt to preserve any distance, seeming to place themselves on an equal and unimpeded footing with him. But of course they have little choice; the rural ideal of innocent flirtation naturalizes the class privilege that grants Munby the power to approach them in the first place.

commodity culture).[32] Munby returns us to the dream of a natural erotics, shadow self to the stressful complexities of modern sexuality. We can remember Foucault's call for "bodies and pleasures," and the briefly glimpsed backdrop of an innocent rural past that attends his analysis of Victorian sexuality, in which "inconsequential bucolic pleasures" were an "everyday occurrence in the life of village sexuality" and not subject to judgment (31). In these fantasies, the body is no longer a system of signs that take on meaning within an elaborate social hierarchy or moral system, nor does it require reading and interpretation. Instead, it emerges from an organic world, its erotic impulses authorized by nature. In place of power, status, threat, and shame, these rural settings inspire dreams of untroubled sensual pleasure.

With his notion of innocent sexuality in mind, Munby repeatedly celebrates games of "Kiss in the Ring," in which men and women chase one another into a ring of participants, where they can be kissed. With a history stretching back to the stone structures of pre-Roman England, this pastime originated as a fertility ritual associated with the vernal equinox, and, in more modern times, was the reputed cause of many pregnancies. But for Munby it represents the apex of safe pleasure, displaying the "simplicity" of working-class youth, who participate "frankly and innocently" in erotic play (5 August 1860, Hudson 266). Its scripted movements, self-contained relationships, clear rules and boundaries, preordained end, and lack of consequences make it the perfect model for Munby's pleasure.[33] One can imagine his delight when a "comely" wench "rests on your arm . . . looks full in your face, and expects to be kissed on the mouth"—but expects nothing more (10 July 1861, Hudson 103). Even as he watches the game being performed in London, on the lawn of the Crystal Palace, he identifies it with a rural English past:

> [The game] both proves and maintains the purity of English working women; it promotes a rustic politeness on the one hand, and on the other a healthy familiarity, between the sexes; it is almost the only

[32] See Nead for a discussion of this pastoral nostalgia, especially in relation to painting (*Myths* 39–44).

[33] According to Hudson, Munby is wrong about the absence of consequences; he describes the game as a "rough and ready matrimonial agency" in which participants are looking for partners (105). It is certainly in character for Munby to misinterpret it in this way.

relic of the uncouth and hearty outdoor merriment of old England: and last and chiefly, it is a standing protest against the conventions of a false civilization. . . . Young men and women can do all this & be pure—can do it (the women at least) because they are pure. And so, the servant girl who rather enjoys being kissed in the hayfield or claspt round the waist behind the pantry door, is not therefore indelicate: the want of that "personal dignity" which makes young ladies revolt at such horseplay, is no shame for her; for, even with them, it is a feeling induced by training . . . in order to bring about the reserve and isolation which belong to cultivated life. (104)

All of the crucial elements of the fantasy are displayed here: the happy escape from an overcivilized present to a healthy rural past, the innocent eroticism of country life, and above all "no shame." This phrase recurs in another extended description of Kiss in the Ring, also set on the lawn of the Crystal Palace (the perfect site for the game, since it brought together crowds of working-class people on an expanse of grass). Again, a woman is "brought back to the ring to receive an honest, open kiss—and no shame to her for liking it, as she evidently did" (5 August 1860, Working Women [Reel 1] 266). Stripping the connotations of shame from erotic play, Munby locates pockets of "inconsequential bucolic pleasures" in the front yard of industrial capitalism.

With its ever-present threat of sexual shame, the city leaves a poignant mark on Munby's relationship with Hannah Cullwick. Although critics' accounts have stressed his voyeuristic obsession with Cullwick's dirty labor, Munby focused more and more on her purifying power as their relationship progressed; not surprisingly, the closer their relationship became, the less he wanted to define her as ignorant and degraded.[34] Beginning their relationship as a kind of science project to test the ennobling properties of self-abasement, and never losing his desire to see Cullwick "in her dirt," Munby increasingly manipulates Cullwick's class status to resolve the conflicts con-

[34] Critics have also emphasized Cullwick's uncanny incarnation of the doubling of female sexuality, split between the servant/nursemaid, who stood in close physical and sometimes erotic proximity to her young charges, and the mother/lady, whose distance and purity made her a complicated if more appropriate love object. McClintock takes up both these threads brilliantly; see also Pollack, Davidoff, and Stallybrass and White.

fronting urban male sexuality, constructing her as a safe haven from
the promiscuity of the streets.

In one extraordinary incident occurring early in their relationship,
he visits Cullwick in her place of employment. This moment revises
Munby's encounter with the artist's model, suffusing him with pleas-
ure while discharging his shame onto her. Coaxing Cullwick much
against her will to try on her mistress's ball gown, Munby mounts a
kind of private exhibition in which, in contrast to the pert advances
of liminal urban women, he controls the sexualization of Cullwick's
body:

> On the bed lay a ball dress, of black gauze and lace, with crimson gar-
> niture; and this made me wish to see for once how Hannah would look
> in a lady's condition. I told her to put on the ball dress. She hesitated to
> profane the Missis's things by touching them, much more, by wearing
> them; but to please me, she consented. She took off her own servant's
> dress and put on that of her mistress. It was too short and narrow for
> her, and it would not meet her healthy rustic waist; still, she was able
> to wear it; and seeing a rose in the room, I brushed out her bright hair in
> a lady's fashion, and placed the rose within it. Thus she stood before me
> to be looked at; smiling and slightly blushing; feeling awkward and
> strange, in that unknown garb, but not looking awkward at all, but
> most graceful. I gazed on her in a kind of rapture: so lovely a figure was
> she, so ladylike, so sweet, that I longed "to take her away from her slav-
> ery," and make her a lady indeed. "And now, dear," at last I said, "turn
> round, and look at yourself." She wondered what I meant; for she had
> forgotten, that behind her stood a large cheval glass, capable of showing
> her from top to toe. But she turned round, and saw herself reflected at
> full length in the mirror. The effect of this revelation was startling. It
> was not her beauty, that struck; nor yet the sight of herself in a garb she
> had never worn before; but now for the first time she noticed that her
> neck and bosom, and even her shoulders, were bare. Dazzling white,
> they seemed, by contrast with her hard-working arms, which of course
> were also bare; but *in an instant, they were suffused, like her face, with
> one universal blush—celestial rosyred. Love's proper hue.* She shut her
> eyes, turned sharply from the glass, and suddenly flung herself into my
> arms—"that I might rather feel than see the beating of her heart." "Oh
> Massa," she whispered, "I am naked!"

Never before had I felt so strongly the need for self control in her
presence: never, before or since, have I been filled with a more passion-

ate ardour of love and reverence for that pure and innocent soul, who had trusted herself so utterly to me. I soothed and comforted her and at length released her.

(2 February 1863, *Working Women* [Reel 3] 82)

This passage contains so many rich meanings that it is worth a long look. What strikes one first of all is Munby's control over the many elements of the scene. In a middle-class bedroom rather than on the street, Munby is in control; it is his turf, so to speak. He also controls the codes of ladyhood, brushing Cullwick's hair, decorating it with a rose, enclosing her in the frame of the mirror, itself a signifier of class status with which Cullwick was unfamiliar. There is no possibility of disguise since Munby manipulates the entire mise-en-scène.

The introduction of the term "lady" creates new resonances for both Cullwick and Munby. Cullwick's mock social elevation creates the sense of a split self and, paradoxically, puts Munby in a position of even greater power. While her own experience of the masquerade is uncomfortable, he delights in it: his visual pleasure takes precedence over the awkwardness of her embodied experience. Munby has made a lady, but Cullwick has not become one. Her estrangement from ladyhood, and the productive nature of this estrangement for Munby, is most dramatically obvious when she cries, "Oh Massa . . . I am naked!" Once again, the word "naked" signals a state of erotic undress, as opposed to "nude," but this time class difference works in Munby's favor. As this passage makes clear, no decent servant would expose her neck, breasts, or shoulders, but Munby, a frequenter of drawing rooms, would be familiar with this standard décolleté. Cullwick's abashed declaration is very different from the brazen delight of the artist's model, for this time—luckily for Munby—the woman is more than willing to experience an appropriate shame so Munby need not feel it himself. In the circuit between eye and mirror image, Cullwick absorbs both the sexual body and the sexualized look; it is her blushing self-definition, not his own erotic interest, that first marks her as sexual. But if the sight of her beautiful, blushing, exposed body excites him, at the moment when they embrace and touch replaces sight—"that I might rather feel than see the beating of her heart"—Munby takes on the role of protector. Abstracting her rosy female flesh into "that pure and innocent soul, who had trusted herself so utterly to me," Munby subdues, or at least covers, sexual

desire with paternalistic comfort.[35] By dressing Cullwick as a lady, Munby stages another scene of unveiling to disclose a sexualized female body—but, taking on the authority and detachment of a theatrical director, he arranges its meanings so that he arrives at a moment of disinterested concern.

As their relationship develops, Munby relies more and more on his pastoral ideal to account for Cullwick's purity, as the mention of her "rustic waist" foretells. Although Cullwick feels "at home" in the city and declares "anywhere isn't to me like being in London," she becomes his own private symbol of rural purity (Stanley 237). He insists on retrieving her personal past—she had been born in Shropshire—and recasting her as a country wench. Munby repeatedly dwells on her "rustic charms," "pleasant Shropshire tongue," "sweet healthful country face," and "wonderful mobcap, with a border of antique lace and a violet ribbon; just such a cap was worn by country girls about 1820" (Working Women 1 [Reel 12] 3, 38; 16 October 1874, Hudson 374; 14 April 1873, Hudson 328). With her "innocent rustic ways," she offers a renewing contrast to urban life, much like the milkmaid in the photograph, about which Munby says, "To come out of those hideous roaring streets into her peaceful presence . . . is like coming into a harbour after a storm" (10 April 1874, Hudson 363). Deciding to confess his attachment to a friend, Munby "told him all: except the details of [Cullwick's] past drudgery and humiliation as a charwoman, which to him might have seemed to mar the pure ideal of a rustic sweetheart" (29 May 1872, Hudson 331). As this last comment hints, Munby imagines Cullwick as a sort of literary type, a character from a charming love story. More than once he compares her to Pleasance Hatton, heroine of the popular novel What She Came Through, an "ineradically refined" agricultural laborer (Tyler 153). This novel suggests the distance his fantasies have traveled from his initial obsession with her degrading filth; unlike Cullwick, Pleasance remains "delicately clean" as she performs her wholesome outdoor chores (Tyler 124).[36] Turning to these rural descriptions, Munby

[35] Cullwick may indeed have found pleasure in her masquerade and her nakedness, or she may have experienced an erotic bond with her mistress by sharing her dress, as Carol Mavor claims, though the passage provides no evidence for this possibility; since Cullwick does not recount the incident in her own diary, it is impossible to say (106–9).

[36] Even her hands are dainty, in contrast to Cullwick's large, red, coarse hands, which Munby fetishizes in the earlier period of their relationship (126).

seeks in Cullwick a companion who can recover the fantasied simplicity and purity of the country, a milkmaid of his very own.

If the threat of urban women subtly shapes his love for Cullwick, it also exerts its influence on their separation, occurring in 1877, the unhappy result of a cataclysmic quarrel. Although there is no record of the subject of the fight in either diary, the scene capped Munby's frustration over a part of Cullwick that he could not civilize to his satisfaction.[37] In the beginning of their relationship, he is distressed by a "coarse" outburst; at the end, he describes Cullwick's verbal failings in an unpublished poem written at the time of the final breach:

> What, was *that* the glad beginning,
> And the ending such as *this?*
> Loathsome words, & shameful spewings,
> From the lips I used to kiss?—
> (Hudson 395)

The milkmaid has turned back into a harlot, wielding the sociolect of the streets. Her loathsome words could have been spoken by Margaret Sherwin or the artist's model whose "speech betrays . . . [her] callousness and shamelessness," while her shameful spewings hint at an even more degrading bodily incontinence.[38] Tragically but fittingly, Munby takes a home in the country, where he can awaken to genuine rustic purity every day, and, instead of contending with a real, strong-willed woman, composes a poem, titled "Dorothy," in which the eponymous heroine is based on, and perfects, Cullwick herself. Unlike Cullwick, Dorothy suffers from no contaminating urban influences; a strong, dedicated worker like Cullwick with no desire to rise above her station, Dorothy enjoys "the freedom of outdoor labour," incarnating Munby's ideal of rustic womanhood as

[37] Hudson conjectures that "it almost certainly involved an hysterical outburst and a painful scene," though his use of the word "hysterical" and his assumption that Cullwick's moods were menopausal discounts the considerable tension of living in secrecy with Munby who, as Cullwick notes frequently in her diary, had moods of his own (390).

[38] It is worth noting that Munby's rewriting of Cullwick rests heavily on improving her cultural literacy. Although at first he wishes for more "*intelligent* companionship," he tutors her and reads to her until she shares some of his tastes (2 September 1860, Hudson 72–73). Increasingly he records the signs of her growing literacy: she develops a taste for *Clarissa, Midsummer Night's Dream, The End of History*; discusses the merits of Dr. Johnson; and learns to enjoy the opera. Like Henry Higgins, Munby has transformed his guttersnipe into a well-read, thoughtful person.

"young, and healthy and hearty" (Hudson 446).[39] Real women, whether strangers on the street or his beloved wife, repeatedly stepped out of the frames he created to control them; only as the master of a fictional world could Munby realize his fantasies.

As these three seduction stories suggest, the figure of the urban man, harassed and endangered by his erotic susceptibility, does not so much oppose or contradict the model of the sovereign spectator as unearth the anxieties that produce him as a compensatory figure. They are paired terms in a single fantasy of danger: one victimized by alluring women whom he cannot read properly, the other impervious and in control. Perhaps it is most accurate to see the sophisticated flâneur as a reassuring ideal rather than a widespread social phenomenon, his figure representing the "utopian presentation of a carefree (male) individual in the midst of the urban maelstrom" (Shields 65). Although urban life undoubtedly put women, and especially disadvantaged women, at risk, it also threatened men with its mysterious temptations. Another figure of fantasy whose dystopic presentation shadows the ideal of the sovereign spectator, the urban seductress takes the fall for male anxiety. But her temporary power testifies to the anxieties of respectable men: neither the acceptably pure and passive woman of their own class nor the unmistakably inferior prostitute, she is a kind of fun house mirror, throwing back at men their alienated desire.

[39] Munby's manuscript poems reveal a similar preoccupation with country wenches. One celebrates a "peasant girl," another a "country servant maid," while still others praise a "ruddy brown cheek" and "modest, meek" manners. Other poems describe a country woman who is "as modest as the blushes on her face" and speaks in a delightful "country tongue"; another such character "talk'd of the neatest way to hem / A patchwork counterpane"—fairly genteel labor compared to Cullwick's housework (Working Women [Reels 25–26]). Other late poems by Munby record his nostalgia for country ways and his despair over the corruption of the city; see "Out of Heart" and "London Town" (Hudson 447–48, 449–50).

3 Spectacular Women

The Mysteries of London and Female Pleasure

Describing his encounter with the artist's model, Munby provides a tantalizing glimpse of an urban woman earning her keep and finding her pleasure through bodily self-display. G. W. M. Reynolds gives that figure a full fictional life in his popular novel *The Mysteries of London*. Reynolds's Ellen Monroe also makes her living as a professional body, working as a model for various artists, as a dancer, and as an actress. In some ways this experience engages her in the same dynamics of vision and sexuality that we saw in chapter 2. As a model, she is packaged according to male needs, although Reynolds gleefully unearths the erotic subtext of aesthetic spectatorship to represent a gendered vision that more closely resembles the eroticizing male gaze. As a denizen of London, Ellen also takes on the markings of the urban woman, exhibiting a suspect sexual self-awareness, a seductiveness akin to Margaret Sherwin's, which assumes the familiar form of vanity and calls forth some dramatic, if short-lived, censure from Reynolds. But these visual and moral frameworks, meant to capture and condemn her, instead prove productive of pleasure for her, as they did with Munby's anonymous model. In a significant way, Ellen's story stretches normative categories even further because it detaches itself from heterosexuality; her greatest pleasure is not exciting men in the life-study class or picking up strangers on the street but experiencing her own body in self-contained autoerotic performances. *Mysteries of London* compels our attention because it finds resources for unconventional female pleasure within prevailing codes of urban vision and gender norms.

Moreover, its revisionist erotics reached an impressively wide audience. It was not an obscure piece of popular ephemera but was in fact the best-selling novel at mid-century. Widely distributed in Manches-

ter, Leeds, Leicester, and many Scottish towns as well as in London, *Mysteries of London* sold forty thousand copies a week in penny installments and over a million copies cumulatively before it was issued in bound volumes.[1] It enjoyed an international circulation in French, German, Italian, and Spanish translations; although (or because) it was outlawed by the authorities, the German version achieved the status of a cult favorite on the Russian black market. For decades the novel remained in print on both sides of the Atlantic (an 1875 edition of Reynolds's *Ciprina*, published in Philadelphia, lists forty novels including *Mysteries of London* under the heading "George W. M. Reynolds's Great Works," priced between fifty cents and one dollar). Reynolds himself was well known as a popular author with over forty novels and a number of short stories to his name, and as the editor of the *London Journal* and *Reynolds's Miscellany*, two important working-class journals (Bleiler 154–57). In its obituary, the *Bookseller* called Reynolds "the most popular writer of our times" (3 July 1879: 600).

Now the novel is almost completely forgotten. On the rare occasions when modern critics take note of it, they tend to dismiss it precisely because of its damning popularity. It has been regarded as a banal piece of popular culture, a category whose appeal is assumed to reside in its conventionality. The novel has been characterized as a "formulaic story in which totally conventional rewards and punishments are handed out" (Humphries 79), as an uncritical repository of "the conventions of romance" (James, *Fiction* 167), and as a classic example of "formula fiction with stock characters and incidents" (Burt 142). Reynolds appears as a "lesser" Dickens who sets the master's genius in sharp relief (Maxwell 166).[2] One of the novel's most pervasive and degraded formulas, according to these readings, is its representation of sexuality. Rife with "titillating descriptions of sex," dependent on the conventions of "soft-core pornography," the text debases itself, critics argue, because it intends to arouse (one might say seduce) its readers (Burt 150; Humphries 70). Leaving aside the inaccuracy of the first claim as a purely descriptive statement (the novel deliberately avoids descriptions of sexual intercourse, titillating

[1] For information about the novel's circulation and readership, see Berridge (esp. 107–10), James (*Fiction* 41), Humphries (71), and Bleiler (vii).

[2] The only dissenting opinion is Margaret Dalziel's insistence that *Mysteries of London* forms "a rather staggering exception" to conventions of characterization and narrative (97).

or otherwise, and focuses instead on other erotic scenarios), these comments assume that sexual content can have no aesthetic or ideological significance, and that the aim of arousal is beneath analysis.

But Reynolds's sexual representations are among the novel's most surprising and exciting features. He understood this aspect of his writing as a departure from literary tradition rather than a recycling of conventions and consciously adopted the position of a sexual libertarian eager to undo the repressiveness of his culture. An extended stay in France left him with a taste for explicitness in literature and a desire to convert prudish British readers to the same standards of frankness.[3] In an anthology of French literature published as part of this mission, Reynolds recommends the French style as more accurately representing human experience: "The French author paints the truth in all its nudity; and this development of the secrets of Nature shocks the English reader, because he is not as yet accustomed to so novel a style. . . . It is much better, says the French writer, to prepare a youth for that life in which he is about to be embarked, by a bold and naked display of the truth, than to expose him to all the bitterness of disappointment" (*Modern Literature* xvii–xviii). Reynolds's argument is certainly disingenuous—not even his most ardent defender would consider his wildly plotted novels useful guides to life— but his language implies the underlying force of his sexual representations. In the redundancy of "truth in all its nudity" and "a bold and naked display of truth" we can discern his relish for nakedness, not as a metaphor for honesty but as the desired state for the bodies on his pages. His aim is not exactly to demystify sex, as his praise of the French might suggest, but to celebrate openly the hidden erotic potential of female bodies without the usual moralizing condemnation of female self-display. In doing so, *Mysteries of London* also marks off a subversive reading position for women, one that encourages their own erotic self-construction.

[3] A bona fide Victorian eccentric, Reynolds was no stranger to conversion experiences. The son of middle-class parents, he dropped out of Sandhurst to make his way as a publisher, eventually becoming known for his Chartist sympathies and his working-class journals (though Marx reportedly called him a charlatan). His visit to France, undertaken as part of his publishing ambitions, left him bankrupt but did not sour him on French sexual mores, which he championed throughout his writing. He also had a brief bout of temperance work when he challenged a speaker to a debate, became convinced by his opponent's arguments, and joined the cause himself. Quarrels with his co-workers (also a recurring pattern) ended this phase of his life. A biography can be found in Bleiler's introduction to *Wagner, the Wehr-Wolf.*

I offer this reading of *Mysteries of London* to recover a forgotten but widely read novel that, to be honest, I found arousing. For me, as a female reader, the novel's apparently degraded sexual content and its seductive address were not beneath analysis; instead, they formed a powerful part of my reading experience and my analysis. Writing about pornography, Angela Carter says, "It can never be art for art's sake. Honourably enough, it is always art with work to do" (12). The deliberate courting of pleasure—especially female pleasure—is, I would argue, important cultural "work to do." Although I do not consider Reynolds a pornographer (for reasons I explain in detail later in this chapter), Carter's assertion that sexually explicit writing has a project, and an honorable one, underwrites my reading of *Mysteries of London*.

The Voyeur and the Dancer: Making Female Pleasure

If, as George Eliot says, "the happiest women, like the happiest nations, have no history," the principal female characters in *Mysteries of London* should be very unhappy indeed (*Middlemarch* 494). But, while retaining some allegiance to this gender stereotype, Reynolds also creates prominent female characters with extended and irregular histories who nevertheless prosper. Diana Arlington, who begins the novel as a courtesan with a past full of aristocratic protectors, becomes the wife and trusted adviser of an important politician. After spending two years in prison for cross-dressing as her dead twin, Walter, in order to receive his inheritance, Eliza Sydney marries a wealthy Italian duke; returning to England after his death, she continues her life as a cheerful, powerful, respected, and still-voluptuous widow. The richest example of these history-laden women is Ellen Monroe, and it is on her story that I focus here, with passing attention to Eliza a bit later.

A brief summary of Ellen's plot should make clear how unorthodox her fortunes are. When her father goes bankrupt in a disastrous speculation, she is forced into needlework to earn money. Near starvation, she turns to a series of dubious jobs as a professional body which underscore the Victorian association between work and sexual transgression (Michie 31–33). Spotted by a procuress who thinks that her beauty will suit her for prostitution once she loses her ladylike modesty, Ellen is dispatched to a statuary to serve as a model. At the end

of her work with him, she models for a painter, a sculptor, and a photographer, who exhibits her nude portrait in the Gallery of Practical Science. Later, she appears on stage with a phony mesmerist. When the last of these jobs ends and she can find no other source of support, she engages in a single, desperate act of prostitution with Eugene Markham (who, in a typically labyrinthine plot device, turns out to be the shady speculator who swindled her father), and bears a child out of wedlock. At this point, miraculously, her fortunes begin to rise. Meeting the enterprising procuress once again, she is sent to a theatrical producer who places her in his corps de ballet. A quick study, and an even more voluptuous presence than before as the result of her pregnancy, Ellen becomes a soloist and, on the strength of her fame as a ballerina, embarks on a spectacularly successful career as a tragic actress. When Markham sees one of her performances, he is moved to kidnap her and attempts to seduce her again, but Ellen eventually reforms him and marries him just as his luck runs out. Crippled and on the verge of financial ruin, he is killed by his perfidious valet, leaving Ellen and her adored infant to retire comfortably and happily, with the full approval of the other characters, the author, and, presumably, the reader.

In terms of plot alone, Ellen and her cohorts depart dramatically from the nearly hegemonic literary treatment of female sexual experience—not only in canonical novels but also in the penny literature with which Reynolds's work is classed, despite its reputation for immorality and sensationalism—in which the fetish of female virtue and the cataclysm of a sexual fall are unquestioned. Ruth Yeazell provides a succinct commentary on the role of women's bodies in canonical British novels of the eighteenth and nineteenth centuries: if a heroine is to provide us with "the story of her consciousness," she must offer a "resistance to the body and its desires"; in respectable novels, sexual experience and even the body itself are at odds with ongoing plots of self-fashioning or development (x). A brief catalogue of well-known female characters who depart from these conventions of virtue and passivity suggests the consequences of departing from standards of purity: Ruth Hilton, Lady Dedlock, Mrs. Transome, Lady Audley, and Isabel Vane all suffer death, dishonor, or both. For the most part, even penny literature retained this convention, exalting heroines whose unshakable virtue repels all rakish advances and who maintain their honor in the most compromising circumstances. As one such heroine accurately warns a would-be seducer, "I am so

strong in virtue that all your artifices will prove unavailing; they will recoil upon yourself" (*Almira's Curse* 124). In another penny dreadful, the heroine retains not only her chastity but her demure English clothing as well even when kidnapped and deposited in a harem.[4] The potential eroticism of this setting is quickly denied; the novel describes concubines' dancing as "sensual, even gross at times," and "not by any means equal to . . . our ballet"—offering a nice contrast to Reynolds's celebration of precisely the sensuality of "our ballet," which I discuss shortly (*Alice* 178). At best, a fallen woman may retire to a convent so that, in the words of one such character from a penny novel, she is "hidden from the world, and no longer permitted to contaminate the pure and virtuous" (*Almira's Curse* 154). As this self-flagellating remark suggests, whatever sexual desires provoke transgression must be disclaimed, and sensuality appears almost exclusively as a dreadful illusion when it appears at all.

In her extensive survey of mid-Victorian fiction ranging from penny novels to middle-class literature, Sally Mitchell finds almost no female characters who survive sexual irregularity. She concludes, "Looking back over the novels about the unchaste woman written between 1835 and 1860 we see, with few exceptions, a field littered with broken bodies; the survivors (including, in typically ironic manner, Becky Sharp) are on their knees to God" (69). Reynolds's immediate model, Eugène Sue's *Les Mystères de Paris*, provided the paradigmatic ending to the story of female sin: the unfortunate prostitute Fleur-de-Marie has no choice but to die despite her repentance because "the mark of the Cité [that is, of dishonor] is ineffaceable, the past irremediable" (Brooks 154). Whatever consciousness these characters have of their bodies is coded as a dangerous and unacceptable vanity that paves the way for their downfall. When Hetty Sorrel, in *Adam Bede*, gazes admiringly at her image in the mirror (while her spiritual cousin Dinah in the bedroom next door looks up at the heavens), we can anticipate her unhappy end. For these female char-

[4] These novels are part of the Barry Ono Collection of popular literature, microfilmed by the British Library; many of them are listed without an author, place of publication, or copyright date. Extensive (though not comprehensive) reading in this collection has convinced me that Reynolds's treatment of female sexuality is highly unusual in the context of popular literature; see also Margaret Dalziel's argument that Reynolds's descriptions of women are much more sensual than those of his counterparts. Useful treatments of the convention of the virtuous heroine can be found in Vicinus, "Helpless"; and Mitchell, "Sentiment" and *Fallen Angel*.

acters, sexuality and selfhood appear as mutually exclusive terms: "fallenness," defined by Amanda Anderson as "attenuated autonomy or fractured identity," is the vanishing point of subjectivity, overdetermining the exile or death of the sexual woman (23).

The urban context heightened the stakes of women's sexuality, as we have seen in the defensive maneuvers of Basil, Walker, and Munby. In a society that called prostitutes "public women," to appear on the street—let alone on the stage—was to cast off the sheltering modesty of domestic space, to experience "the trauma of public exposure," and to take on contaminating sexual meanings, as Judith Walkowitz, Deborah Nord, and Anita Levy persuasively argue (Nord 6). Singling out for special censure the prostitute, the ballet dancer, and the actress—all women who made their living by displaying themselves—Victorian sociology both responded to and helped to construct the equation between sexuality and visibility; likewise, Peter Brooks's description of Fleur-de-Marie's dishonor as "the mark of the Cité" implies that urban space and sexual taint are one and the same.[5] Indeed, this may be one of the central organizing principles of urban space, as women become "the masculine observer's spectacle" (Nord 137).[6]

Reynolds was well aware of these conventions and honored them

[5] For excellent discussions of public space and female sexuality in literature, see Nord on *North and South* and Barbara Harman on *Mary Barton;* in both novels, Elizabeth Gaskell presents this equation with particular explicitness. The equation was institutionalized most notoriously in the Contagious Diseases Acts, which declared that a woman walking the streets could be taken—interpretively and literally, by the police—as a prostitute, and forced to undergo gynecological examination for venereal disease. The CD Acts subjected women to two authoritative gazes—first of the police and second of doctors—which were empowered to "see" and hence to certify their deviant sexuality. It is not entirely surprising that when the genteel Josephine Butler campaigned publicly against the CD Acts under the banner of sexual purity, she was accused of being a kind of prostitute herself and was subjected to the same affronts that her "unmanly assailants" usually reserved for streetwalkers (Butler, *Personal Reminiscences* 71). One of Butler's eroticizing male observers was John Addington Symonds, who reported that when he heard her speak at Oxford, "his reproductive equipment swelled" (Walkowitz, *Prostitution* 110). Throughout *Prostitution* and in *City of Dreadful Delight* (87–93), Walkowitz offers extended discussions of Butler and the CD Acts.

I specify mid-century here because Nord, Walkowitz, and Vicinus (*Independent Women*) all argue that by the 1870s and 1880s, women were appearing much more often, and with more agency, in urban spaces.

[6] See also Judith Walkowitz's repeated designation of the flâneur as voyeur (*City* 21).

conspicuously, if inconsistently, in his sprawling, multiplot novel. Asserting the novel's claim to good morals and setting off Ellen's adventures in sharp relief, he acknowledged the narrative currency of female virtue in his characterization of the noble Isabella, for instance, who eventually weds the novel's hero, Richard Markham. Isabella is a properly sexless woman, one whose beauty "seemed rather to belong to the ethereal inhabitant of heaven than to a mortal denizen of earth" and whose expressive virtue "alone repressed the impertinence of the libertine's gaze" like the penny dreadful heroine quoted earlier (1: 252, 108). She exemplifies Eliot's comment about virtuous women having no history, doing little except waiting for Richard to prove himself to her father. When Richard has not merely demonstrated his personal worth but acquired a title in recognition of his heroism in an Italian civil war, Isabella is pleased to be passed from father to husband like a valuable piece of property: "Receive my daughter as the reward of your achievements," her father declaims (2:222).

Moreover, *Mysteries of London* exploits the visual/sexual economy of the city for erotic impact. Like Mayhew and Dickens, to whom he was sometimes compared, Reynolds promises to lay bare the secrets of the city, including its women. In its stated goal of "exposing . . . the witching beauty of virtue" amid urban vice, the novel implies that it will expose more corporeal witching virtues along the way, metaphorically linking its project of urban commentary with its erotic impulses (2:424). Reynolds repeatedly situates Ellen in new urban spaces of male spectatorship: the art gallery, the street, the theater, and the Gallery of Practical Science, which exhibits photographs of her naked form. In one engraving Ellen sits naked to the waist, while the sculptor measures her breasts against those of his statue (figure 7). While in one sense her body is the original on which the statue is based, it takes on its value and meaning only in relation to an erotic/artistic sense of beauty that precedes her. Representational codes for women have priority, and the body is obliged to fulfill them: the ease with which various artists dismember and fetishize Ellen's body implies that it exists only to serve their conceptions of female beauty. In Valie Export's words, "the *idées and images fixes* of women have become a reality, a materiality, whose double and accomplice is the body" (24). Packaged and reproduced according to aesthetic conventions, Ellen's body is not her own to enjoy but belongs to male viewers, whether they wish to train themselves in the disembodying spectatorship recommended by Walker, as the dispassionate

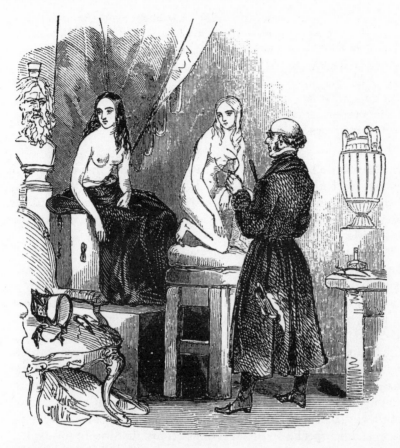

FIGURE 7: The sculptor measures Ellen Monroe's breasts against those of his statue. G. W. M. Reynolds, *The Mysteries of London,* 1st ser., 2 vols. (London: George Vickers, 1846), 1:169.

artist and his measuring equipment suggest, or to enjoy the safe stimulation of a virtual naked body.

When Ellen does register the erotic potential of her body, it is, at least at first, in the familiar form of female vanity. Reynolds suggests that she is in danger of becoming a coquette, a seductress, a skillful woman, a fallen woman—in short, a stereotypical example of urban depravity. As a result of her work as a model,

> the step of the maiden was less timid than formerly, and her look was more confident. She was also dressed in a style which savoured of co-

quetry, for her occupation at the artist's had taught her the value of her
charms, and prompted her how to enhance them. . . . She therefore oc-
cupied all her leisure time in studying how to set it [her beauty] off to
the greatest advantage. Thus dire necessity had compelled that charm-
ing young creature to embrace occupations which awoke all the latent
female vanity that had slumbered in her bosom throughout the period
of her pinching poverty, and that now shone forth in her manner—her
gait—her glance—her speech—her attire. (1:174)

Occurring in a chapter titled "The Road to Ruin," this description
seems to seal Ellen's fate. Indeed, Reynolds intones, "the Philan-
thropist must mourn for thee," as if her sin has already outpaced
those professional regenerators spawned by the urban vice of the
novel's title (1:367).

The theater, site of Ellen's performances as a dancer and an actress,
foregrounds issues of display and sexuality as female bodies present
themselves for the delectation of a male audience. A voyeuristic sce-
nario par excellence, it is the setting in which Reynolds's multivalent
treatment of female spectacle begins to assert its complexities, where
Ellen's "road to ruin" veers off in uncharted directions, and where she
learns not to cast off vanity but to perfect it in a potent form of self-
hood. Though in some ways continuing the standard treatment of the
female body described earlier, Ellen's career as a ballet dancer also in-
sists on performance as a means to sexual subjectivity and agency.
Historically, dance is one area in which women's bodies have been
able to claim a special status; it is one activity that Iris Young explic-
itly exempts from her discussion of women's physical dis-ease in her
wonderful essay "Throwing Like a Girl," perhaps because it is con-
ventionally understood as a rare social zone of physical self-assertion
for women. When it comes to dancing, it is men who throw like girls
(143).

Moreover, the specific meanings of the ballerina in Victorian cul-
ture rework the dynamics of male spectatorship. On the one hand,
ballet dancers were often perceived as variations on prostitutes; ac-
cording to Henry Mayhew, "ballet-girls have a bad reputation, which
is in most cases well deserved," since their "natural levity" fre-
quently guides them into actual prostitution (4:257). But the obvious
sexual meaning of scantily clad dancers—sometimes "apparently
nude," as Munby reports with a mixture of shock and delight—was
complicated by the aesthetic mystique of the new romantic ballet

that captivated English audiences at mid-century and the legendary discipline of Marie Taglioni and Fanny Elssler, its foremost practitioners (Hudson 147). Reynolds cites Taglioni and Elssler explicitly as Ellen's models, along with the revisionist discourse on ballerinas initiated by their extraordinary performances. In contrast to Mayhew, ballet revisionists focus on a different kind of levity—the effortless leaps produced by arduous technical training. In both attitudes, "levity" indicates a kind of disdain for normal constraints that implies a subversive power, which Mayhew attempts to contain with moral condemnation. But revisionist treatments trace the ballerina's defiance of gravity to a process of self-creation. In constructing "a natural history of the ballet girl," the title of one such work, these commentators foreground the often repressed production of the spectacle of female grace (Smith, *Ballet*). Ellen endures the excruciating pain of *"se tourner,"* a "perfect martyrdom" which places the feet heel to heel in a narrow box to turn them outward, and *"se casser,"* which increases the pliancy of the foot by flexing it on a metal bar (1:264). She learns to dance on pointe, and to manage trapdoors and guy wires, until she appears to float across the stage and fly through air as if by magic.

In the face of such application, critics identified ballerinas as skilled workers, members of "the Industrious Classes" rather than "Those That Will Not Work," the rubric under which Mayhew classifies both dancers and prostitutes (Smith, *Ballet* 84). This hardworking ballet girl is not a social parasite, implicated in the urban contagion that marks so much Victorian discourse. Moreover, ballet's "terrible drudgery" and "stern training regimen" constitute a kind of discipline that produces a particular subject through a distinctively articulated body (Fitzgerald 142). We might regard the grooved box that trains Ellen's feet as a literal technology of subjectivity. Schooled to consider the aesthetic effect of various postures on her audience, she also learns to inhabit and experience her body through accomplishment and mastery. Ellen's ballet training installs her as the owner of her own body. While they serve male pleasure, technique and the levity it accomplishes constitute a corporeal reinvestiture, producing the agency, intentionality, and authority of the ballerina.

The impact of this particular art form at this historical moment provides the leverage with which to dislodge the meaning of the female body as an object for male pleasure, especially in performance. In her triumphant debut, Ellen wears Taglioni's celebrated costume

FIGURE 8: Taglioni in *La Sylphide*. *Illustrated London News*, 5 July 1845: 7.

from *La Sylphide*, wings and all (figures 8 and 9), but her dance in-
vokes nothing so much as Elssler's trademark sensuality and emo-
tional volatility. Reynolds might even have had a specific well-known
review in mind when he depicted Ellen as a sensuous, expressive
dancer. Compare these two descriptions:

FIGURE 9: Ellen Monroe triumphs as a ballerina (note the wings, modeled on Taglioni's *Sylphide* costume). G. W. M. Reynolds, *The Mysteries of London*, 1st ser. 2 vols. (London: George Vickers, 1846), 1:265.

> She literally wantoned in the gay and voluptuous dance; at one moment all rapidity and grace, and airiness; at another suddenly falling into a pause expressive of a soft and languishing fatigue;—and then again becoming all energy, activity, and animation,—representing, in all its phases, the soul!—the spirit—the very poetry of the dance! (Reynolds, *Mysteries* 1:266)

> . . . now peering over him with a languishing gaze, and now floating about the atelier like a bird . . . mingling the most sparkling playfulness

with the most deep-souled passion as she alone can do. (*Morning Herald*, 4 August 1843: 4)

In both of these passages, the dancer's body is simultaneously the object of pleasure to the audience and to herself. The vocabulary describing Ellen's experience in particular is one of intense sensuality: "wantoning," "voluptuous," "languishing." Her dance is an autoerotic carnival, recovering aspects of power and pleasure in spectacle.

Ellen's acting extends this representation of pleasure. Trading on prevailing assumptions about actresses in order to sexualize Ellen, Reynolds then takes her offstage and develops for her an erotic private life as an outgrowth of performance. Like ballet dancers, actresses were the objects of stern social commentary. Sociologically, they were associated with prostitution because theaters were popular haunts for prostitutes and because of the allegedly loose morals of female performers.[7] Symbolically, they were construed as prostitutes because they displayed themselves in public using their bodies as commodities. Reynolds literalizes the link between theatrical and sexual spectacle when the procuress offers Ellen her first acting job, hoping that repeated self-display for hire will prepare her for a life of prostitution: "How dazzling would your polished arms appear when clasped by costly bracelets!" she exclaims (1:263). Here, both Ellen and the procuress participate in the transvestite identification that has often been suggested as an outcome of feminist theory's male gaze.[8] They take up the male point of view because it is both ideolog-

[7] Tracy Davis provides an extensive study of theaters, actresses, and sexual meanings. As in ballet, a revisionist discourse emerged about actresses, this time stressing their high morals more than their technical accomplishments; Mrs. Matthews's "Ennobled Actresses" and Mrs. C. Baron Wilson's *Our Actresses* are representative examples from the mid-1840s, contemporary with *Mysteries of London.* The strenuous efforts of well-known actresses to present themselves as paragons of middle-class virtue, persuasively documented by Mary Jean Corbett, form an important part of this counter-discourse. Reynolds does not seem to have had much interest in this point of view in *Mysteries of London,* but he makes liberal use of it in *Ellen Percy; or, the Memoirs of an Actress.*

[8] Mulvey, "*Duel*" 13; Doane, *Desire* 19; Berger 47. We might say that the male gaze has undergone a "vicissitude," to use Freud's characterization of the processes of a scopophiliac economy, but one that consolidates its power. Freud's discussion of scopophila ("Instincts") is useful in relation to gaze theory because it is less deterministic than accounts of "the male gaze," regarding looking and being looked at as complementary processes rather than fixed and opposed positions. But Freud's essay does not note the fact that patriarchal ideology entrenches the male gaze as the dom-

ically privileged and instrumental to their survival in a patriarchal society, a kind of essential job skill. On the stage, Ellen becomes the object of male admiration just as the procuress predicted: "The eyes of ancient libertines, aided by opera-glasses and lorgnettes, devoured the charms of that beautiful girl" (1:266). In this description, Reynolds's treatment of the theater depends on what Tracy Davis calls "the Victorian lexicography of sex," drawn from erotica and encoded in theatrical performances in order to create a salacious subtext (107). When Ellen's seductive performance inspires Eugene Markham to kidnap her in order to make love to her again, the novel plays on the common assumption that public appearance advertises sexual availability.

But once again, the very processes of representation that make her available for male consumption simultaneously render Ellen a sexual subject. This possibility reveals itself when Markham kidnaps her, locks her in his bedroom, and waits outside, assuming that she will eventually consent to intercourse. In the terms that Brooks lays out for *Les Mystères de Paris,* Markham wants her to turn her "sold body"—that is, the body she gave him unwillingly out of dire economic necessity—into an even more degraded "erotically deviant body," one that willingly chooses its own ruin (154). But *Mysteries of London* imagines an erotic body that evades degradation. Rebuffing Markham's advances, Ellen locks herself in a bedroom, calmly disrobes, and, like her male audience, feasts her eyes on her half-naked form in the mirror:

> She approached a long Psyche, or full-length mirror, that stood near the dressing-table (for the room was elegantly furnished) and for a moment contemplated herself with feelings of pride and pleasure. . . . [A]ssuredly, hers were charms of which she had full right to be proud. The mirror reflected to her eyes a countenance that had been deemed worthy to embellish a Venus on the canvass of a great painter. . . . Those swelling globes of snow, each adorned with a delicate rose bud, needed no support to maintain their full and natural rotundity. . . . Ellen smiled—in spite of herself—smiled complacently, smiled almost proudly, as she surveyed her perfect form in that mirror. (1:280)

inant structure of looking and as a form of social and sexual power rather than one mere "vicissitude" among many.

What are we to make of this scene? We might consider it another transvestite identification or a standard pornographic episode designed for male readers with scruples about rape, who can enjoy the pleasure of seeing Ellen undressed without having to participate vicariously in a forced sexual encounter. But the scene works differently as well. Ellen repudiates Markham's sexual power, reinterprets her imprisonment as protection, and enjoys her own body as he stands unsatisfied somewhere outside the door, not quite the master in his own house. Ellen derails his seduction and turns instead to her own body with an active pleasure.

What makes this eroticism possible is precisely her career as a female body, her participation in "the *idées images and fixes*" of femininity. When Ellen sees, in the mirror, a countenance "worthy to embellish a Venus on the canvass of a great painter" (1:280), she receives her body through the filter of her experience as a model, when a painter did use her features in his portrait of Venus; when she admires her breasts, she has learned to interpret her body from the sculptor who singled them out as a preeminent signifier of femininity. Her self-admiration, initially condemned as a dangerous vanity, has been stripped of its negative connotations; through her work as a model, Ellen has developed a kind of body consciousness and now reappropriates her image for her own desire. While the statues, paintings, and theatrical performances exploit what is already there—the sexual semiotics of the female body—for Ellen the process is reversed. It is the presentation of her body in art objects that makes it erotically available to her. As feminist critics have argued about fetishizing the female body, cultural framing can function not only as a way of securing women's compliant place in patriarchy but also as a "support structure of a critical femininity" in which women pursue a sensuous relationship to their own bodies outside the mandates of heterosexuality (Apter 81).[9] By installing herself in the position of the

[9] Both Apter and Fuss reconsider the relationship between femininity and fetishism in their analyses of fashion photography and fashion writing, arguing that, while these practices seem bent on "producing and securing a female subject who desires to be desired by men," they also provide women with images of female bodies as "objects of desire," thus cultivating autoeroticism and lesbianism (Fuss, "Fashion" 713, 714). Fashion has been a fruitful arena in which to reimagine female pleasure; see, for instance, Gamman's review of changing feminist understandings of the politics of fashion ("Self-Fashioning" 94–97) and Young's essay "Throwing Like a Girl." Gamman considers the pleasures of fashion as an escape from heterosexuality, quoting Suzanne Moore, who says, "Most of the pleasure [of buying shoes] involves a private fantasy that starts with me and ends at my feet. Men don't get a look in" (101).

viewer, so helpfully marked out by her culture, she finds her own pleasure. Standing before her mirror, Ellen is both subject and object, body and image, spectator and spectacle. In place of the visual dynamic that opposes subject and object as entities or positions, objectification and subjectification appear as mutually dependent and interleaved processes. While her body remains the "double and accomplice" of conventional femininity—male readers can still enjoy the sight of her half-naked form—it also appears as a different kind of double, participating in a project of self-constitution that depends on objectification.

The logic of male spectatorship makes this self-regard possible. I want to return to a moment to chapter 2, and especially to Walker's *Beauty in Woman,* which projected male desire onto female bodies, imagining them as diabolically seductive. Although for the most part Walker conquers this fear with wishful-thinking protocols for desexualizing bodies into statues and biological specimens, his guard momentarily drops when he analyzes the ideal female form, and he dwells lovingly on the "beautiful elevation" and "admirable expansion" of various contours of the body. For a moment, sensuality bleeds through the disinterested language of aesthetic theory, as Walker wistfully acknowledges "all of these admirable characteristics of female form, the mere existence of which in a woman must, one is tempted to imagine, be, even to herself, a source of ineffable pleasure" (316). By investing women's bodies with such intense desirability, Walker imagines them as equally arousing for women. Indeed, one senses in Walker's comment a kind of envy of women, whose delicious bodies are always accessible and whose enjoyment seems more immediate and automatic than that of their male pursuers.

Conversant in the visual economy detailed by *Beauty in Woman,* Reynolds follows up Walker's passing suggestion and creates a new dynamic in which the pleasure of looking belongs to women. Of course, the celebration of woman's "ineffable pleasure" can be seen as a male fantasy, a projection arising from masculine responses to women's bodies. But read in the context of the surrounding narrative, Ellen's self-admiration cannot be understood as completely contained by male desire. Significantly, the mirror scene explicitly excludes Markham; Ellen refuses him access to her body, claiming it as her own. She is not rehearsing a heterosexual encounter, for she has no interest in purveying her body to a male admirer. What the scene accomplishes is to make use of the objectification that gives the body its sexual frisson without embedding it in a drama of heterosexual ex-

ploitation. This episode unlinks the usual chain of gaze-objectifica-
tion-domination, retaining the suspect pleasure of objectification
while putting it to a new, ideologically deviant use in the service of
female autoeroticism. Unlike those stories of female development
that depend on suppressing "the body and its desires," and unlike
doomed female characters such as Hetty Sorrel, whose mirror-gazing
is their downfall, Ellen's consciousness evolves through the story of
her body and its pleasures (Yeazell x). Ellen's career as a spectacle ul-
timately produces a female sexuality that resists heterosexual imper-
atives—indeed, that rejects heterosexuality as a sexual practice alto-
gether, though it originates in codes that frame female bodies for
heterosexual consumption.[10]
 A second mirror scene, this one involving the cross-dressing Eliza
Sydney, reinforces the connection between display and female pleas-
ure when male disguise provides the occasion for autoerotic self-con-
templation. In the story of this unconventional heroine, Reynolds's
fascination with women as performers implies a modern understand-
ing of the performativity of gender.[11] As with Ellen's display, the
novel presents a double-sided treatment of Eliza's male disguise. On
the one hand, it insists on Eliza's "real" identity as a woman, refer-
ring to her male impersonation as "a walking lie" (1:18), and fetishiz-
ing her "luxuriant" hair and "polished ivory flesh" as she disrobes
(1:17); in case the reader has missed the point, the illustration depicts
her lounging in bed with her breast exposed (figure 10). At this mo-
ment, Eliza's body seems to offer an absolute grounding for her gen-
der identity—a "bold and naked display of the truth" if there ever was
one. But a few paragraphs later, Reynolds uses the "to-be-looked-at-
ness" of women in a different way (Mulvey, "Visual" 17). In her secret
boudoir, Eliza reports, she sometimes dresses for herself in women's
clothing "just to see myself reflected in the mirror" (1:18). The expe-
rience of being a woman or dressing in women's clothes is not
enough: she needs to construct and see herself as a woman in order
fully to be one. Once again, the construction of the body as an object
for visual consumption establishes the gendered subject, here per-

[10] As Jennijoy La Belle says of a handful of modern female characters who con-
struct themselves through their mirror image, Ellen finds "a mirror of her own"
(173).
[11] Reynolds limits this understanding to women, more in keeping with earlier the-
orists such as Irigaray and Mulvey than with Butler, who sees both masculinity and
femininity as performative.

FIGURE 10: Eliza Sydney relaxing in her boudoir. G. W. M. Reynolds, *The Mysteries of London*, 1st ser., 2 vols. (London: George Vickers, 1846), 1:17.

formed in costume and before an audience—herself—just as she performs the role of Walter Sydney. And, as in Ellen's mirror scene, Eliza's mirroring helps to constitute her sexuality. When she stands before the mirror dressed as a woman, a heightened consciousness of gender developed through her male disguise invests her femininity with a sensual pleasure. She "loves" and even "adores" the accouterments of womanhood, which fill her with a "soft voluptuousness" (1:19). When they are thus objectified and denaturalized, the pleasures of femininity can be more consciously enjoyed. After Eliza permanently discards her male clothing, her body remains marked by both gender and sexuality, becoming plumper and more luscious each time she appears. Inflated to the bursting point with womanliness, Eliza is the Dolly Parton of *Mysteries of London*, a kind of female–

female impersonator. I see this voluptuousness, named and insisted upon in her every appearance, as the continuation of her enhanced femininity before the mirror—that is, as the paradoxical trace of her masculine disguise. It is as if Eliza has transferred what Marjorie Garber calls "the complex and often unconscious eroticism of such [transvestite] self-transformations and masquerades" to her feminine self (*Vested* 70). The pleasures of self-representation supplement and italicize her "real" gender, hyperbolically gendering and eroticizing her plentiful female flesh.

In the stories of Ellen and Eliza, *Mysteries of London* provides the element of excess that constitutes the subversive potential of gender performance.[12] We can maintain no illusion that these are "natural" bodies going about their business, whether on stage, in a painting, or in a boudoir. The artistic work of "representing" that Ellen does as a ballerina is not the special business of the stage but the condition of womanhood itself, in which the function of the female body is to represent femininity— "the *idées and images*" of femininity again, but no longer "*fixes*" in a single ideological meaning. The repeated iconography in the novel's illustrations emphasizes this fact with an almost parodic exaggeration and uniformity (figures 9, 11, 12). The body announces itself with a flourish—"Here I am, take a look!"—in a stock theatrical pose from a well-known acting manual (figure 13). Although the original illustration obviously portrays a male actor, Reynolds adapts it in his construction of femininity as spectacle, that is, he re-genders it to attribute the quality of self-presentation to femininity. Even this last pose, which appears to present an aristocratic

[12] The idea of excess or self-conscious representation as subversion has a long history in feminist theory; see, for instance, Irigaray's claim that "mimicry" is perhaps the only avenue for female subversion: "One must assume the feminine role deliberately. Which means already to convert a form of subordination into an affirmation, and thus to begin to thwart it" (76). More recently, one might note Judith Butler's question, "What would it mean to 'cite' the law to produce it differently?" (*Bodies* 15) and her reading of *Paris Is Burning* (*Bodies*). Most useful to me has been Mary Ann Doane's understanding of how Joan Riviere's theory of femininity as masquerade reconfigures the masculine subject/female object dyad in which gaze theory has been stalled, although her Lacanian vocabulary has not been easy to incorporate into my analysis. For Doane, the masquerade yields a productive "alienation," creating a subject—by definition split or self-divided—out of the undifferentiated "presence" of femininity as it is traditionally understood in (much of) Freud and Lacan (*Femmes Fatales* 37). Doane's thinking has helped me bridge the gap between gaze theory and phenomenologies of the body as articulated by Elizabeth Grosz and, in less theoretical terms, Jennijoy La Belle.

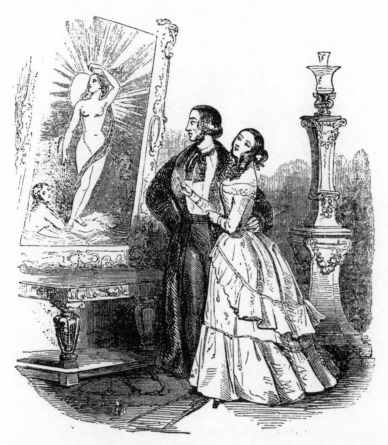

FIGURE 11: Ellen Monroe looks at the painting for which she modeled. G. W. M. Reynolds, *The Mysteries of London*, 1st ser., 2 vols. (London: George Vickers, 1846), 1:217.

young man, is really Eliza Sydney. Her disguise would have been de-coded almost immediately, for the text drops a number of transparent hints that "he" is really a "she," describing "Walter's" curiously del-icate hands and feet, luxuriant hair, soft voice, and so forth. It is also possible that the figure itself would have been recognized as female because of the well-known conventions of theatrical cross-dressing in which male attire, emphasizing body parts that were concealed by women's clothes, actually evoked femininity, and, more specifically, female sexuality (Davis 112–15; Rosenman 304). In this way, Eliza's disguise is a close counterpart to Ellen's performance, a point under-

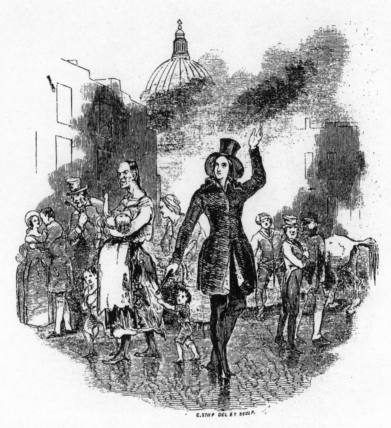

C.SIIF DEL ET SCULP.

FIGURE 12: Eliza Sydney disguised as her twin brother. G. W. M. Reynolds, *The Mysteries of London*, 1st ser., 2 vols. (London: George Vickers, 1846), 1:1.

scored when Eugene Markham, that lightning rod of sexual meanings, attempts to seduce her, too, assuming that Eliza's "principles of rectitude . . . had been undermined or destroyed by the cheat which she was practising with regard to her sex" (1:54). In each illustration, the novel frames the female body to emphasize its "to-be-looked-at-ness"—with the theatricality of the pose in all three illustrations, with the stage in figure 9, with the picture frame in figure 11, and with the spatial organization of the illustration itself in figure 12, which centers, foregrounds, and articulates Eliza against the shadowy figures behind her. This iconographic repetition cheekily recycles the "always already" formula until it becomes a kind of joke, serving

FIGURE 13: Classic acting pose. Jonathan
Barber; *A Practical Treatise on Gesture,
Chiefly Abstracted from Austin's Chrono-
mia* (Cambridge, Mass.: Hilliard and
Brown, 1831).

each woman up on a platter like a prize goose—as the novel all the
while reinterprets her objectification in its extraordinary stories.

What is perhaps most surprising about these stories is their implied
mythology of female sexuality, a mythology that is particularly com-
pelling because it does not rest on the fantasy of a "natural" or un-
marked body. Consistently linking sexual pleasure to performance
and femininity, Reynolds presents women as specially made for
pleasure—that is, for their own pleasure. Even apart from scenes of
actual performance, their heaving bosoms and flashing eyes seem to
mark women as more fully embodied creatures than men, and their
embodiment is more erotic precisely because of the ways in which
their bodies are at issue within patriarchal formulas. The geography
of Ellen's mirror scene clarifies this implication by dividing sexuality
into two distinct and gendered forms, separated by the closed door:
on the male side, desire is structured by the polarity of subject and
object, and requires pursuit and possession to fulfill itself; on the fe-
male side, we see the interplay of complementary processes in which
the loop between body and image promises perpetual fulfillment.
While Markham's frustration in this scene might be regarded as

purely circumstantial, the novel also suggests that it is part and parcel of the male gaze. *Mysteries of London* is filled with failed voyeurs. The rapacious Reverend Tracy spies on Ellen through the keyhole of a locked door, "gnash[ing] his teeth" because he cannot force his way in (2:26), while she enjoys a sensual bath with her infant; and a petty thief named Henry Holford crouches under a sofa to gaze obsessively on Queen Victoria (he is drawn, of course, by her "magnificent" bust [1:181]), having broken into Buckingham Palace under the mistaken impression that it was an elegant private residence.[13] I have said that the woman-as-spectacle signifies subjectivity as well as dehumanization; by the same token, voyeurism signifies impotence as well as power. Often in this novel men gaze because they have no other access to the bodies they desire and take no pleasure from their own, exempt as they are from eroticizing codes.

In fact, a well-known description of Fanny Elssler's effect on her audience suggests that female performance might actually privilege the sensual pleasure of the dancer over, and even at the expense of, that of the male spectator, who is portrayed as helpless, even grotesque, rather than powerful:

> We perfectly recollect . . . the emotion of several ancient aristocrats in the stalls, on the recent appearance of the legs of Fanny Elssler. We thought that we observed one aged and respectable virtuoso shedding tears; another fainted in his satin breeks and diamond buckles; one appeared to go mad, and bit his neighbor's pig-tail in half in sheer ecstasy. Oh! the legs of Fanny displaced a great deal of propriety, and frightened sober men from their prescribed complacency. (*Illustrated London Life* 16 April 1843: 7)

As in the works discussed in chapter 2, these men are terrified rather than delighted by the sight of an alluring female body. Focused on "the legs of Fanny," they betray an overinvestment in her sexual appeal that is both ridiculous and graceless, in contrast to Fanny's inspired levity. This scene returns us to the psychoanalytic origins of the gaze: the clumsy "ecstasy" that drives the aristocrat to bite his neighbor's pigtail in half perhaps deserves to be read as an uninten-

[13] Improbably enough, this incident is modeled on the exploits of a real person, Boy Jones (Maxwell 162).

tional rendering of castration anxiety, provoked by the spectacle of sexual difference.[14]

The scene also suggests the protective distance that the aesthetic context grants the performer, confining the physical responses of the spectator to the awkward expressions of his own anxiety. Fanny's allure is more unnerving than seductive, and certainly does not promise or even stand in for actual sexual pleasure. Although the history of the ballet girl's graceful form is not represented in this account, the story of the production of another body does emerge—that of the male spectator, no longer shielded, as it were, by the disembodiment of vision but displayed with all its physical vulnerabilities. Rather than gaining possession of the female body, the gaze doubles back on the male body, arousing a solipsistic agitation that marks the distance between desire and its object. The voyeur has the power to desire but not to possess, and falls apart "frightened," overheated, and psychically disorganized when faced with this powerful, self-contained sexuality. Similarly, Henry Holford's obsession with his unattainable object drives him to Bedlam, in the novel's most extreme version of voyeuristic frustration. In the review of Elssler's performance just quoted, the theater divides and genders positions into (male) audience and (female) performer, much as in the mirror and bath scenes. In these recurring voyeuristic moments, the male gaze is a kind of pleasure *faute de mieux*, one whose rewards are much more limited and less gratifying than those of aestheticized embodiment. Of course, these moments also provide pleasure for an implied male reader (perhaps the novel's chief voyeur), as Henry Holford's escapades grant him the utterly forbidden pleasure of gazing at Queen Victoria's breasts. Nevertheless, the model of voyeurism proposed by the novel does not replicate an imputed male omnipotence.

The limits of the male gaze are never more obvious than when Ellen visits Markham, her seducer, demanding that he marry her in order to

[14] The fetishism that contributes to female objectification also signals male anxiety; both Freud's theory of the fetish and gaze theory suggest that, in focusing on Fanny's legs or on the ubiquitous breasts of nearly every female character, *Mysteries of London* both acknowledges and evades the fear of castration by replacing female genitalia with less threatening body parts. As in Walker's *Beauty in Woman*, the voyeurism in *Mysteries of London* provides a kind of "safe sex" for men, arousing them without subjecting them to the psychic danger that, according to psychoanalysis, complete female nakedness and sexual intercourse would incite.

legitimate the child she is soon to bear. Discovering that his art col-
lection is full of objects for which she served as a model, she says, as if
confirming his complete possession of her, "I sold my face to the stat-
uary—my likeness to the artist—my bust to the sculptor—my whole
form to the photographer— . . . And my virtue to you!" (1:218). But
Markham's possession is hardly complete. Although the novel's illus-
tration shows him with his arm encircling her waist, Ellen eludes him
more and more as the conversation progresses (figure 11). Her preg-
nancy lends her an almost magical power that leaves him cowed: "He
knew not why—he was afraid!" (1:217). Literally standing outside the
frame of the painting for which she once modeled, her figure swelling
into new contours, she implicitly mocks his attempts to possess her.
Her body has taken on a life of its own. Reynolds adapts the Victorian
deification of motherhood, not only to grant Ellen moral authority but
also to redefine her body as something other than an image that exists
for Markham's pleasure. The interview between Markham and the
pregnant Ellen parallels the scene in Charlotte Bronte's *Villette* in
which the heroine Lucy Snowe visits an art gallery displaying ap-
proved images of women: a voluptuous Cleopatra and a tableau of the
virtuous woman as girl, wife, and widow. Repudiating Cleopatra's pas-
sive sexuality and the "brainless" contingency of the idealized
woman, Lucy refuses to be captured by these images; like Ellen, she
stands literally outside the frame (270). In his conversation with Ellen,
Markham notes the gap between image and body, the one fixed in the
sightline of the gaze, the other carrying out corporeal processes be-
yond his control and indifferent to his desires. Once again, Ellen's
body is visually available but not fully controlled or possessed by the
voyeur; in fact, visual availability only highlights the failure to pos-
sess. In the frustrations of Ellen's voyeurs, we hear the echo of Iri-
garay's famous warning: "They [women] are already elsewhere in that
discursive machinery where you expected to surprise them" (29).
Ellen is indeed "elsewhere," a walking critique of the imputed power
of male vision. Thus the novel creates a complicated viewing position
for its male readers, inviting voyeurism but consistently registering its
anxieties and disappointments. In *Mysteries of London*, looking is se-
riously circumscribed and qualified as a form of pleasure: it is sexual-
ized, to be sure, but it is not synonymous with sexual fulfillment.

And the woman reader? In considering what erotic representations
of the female body might mean, we must ask, "To whom?" As Ellen's
mirror scene suggests, *Mysteries of London* addresses male and fe-

male readers in different ways, sometimes simultaneously. A further subversive function of the mirror scenes is to model a reading position for a female reader from which the female body signifies pleasure and agency. When she follows the narrative and views the illustrations, the woman reader of *Mysteries of London* can also enjoy representations of the female body, just as Ellen and Eliza enjoy their reflections, in a process compounded of objectification and identification. She can vicariously experience sexual desirability without the dangers of heterosexual intercourse. The novel can form a kind of mirror for the woman reader, providing pleasurable and safe images of female embodiment in which she can participate.[15] It could be—and, I would argue, it probably was—a significant piece of erotica for women. There is no doubt that, despite the male readership that the novel's voyeuristic scenarios seem to imply, many of its readers would have been women. Indeed, the *Bookseller* turned up its nose at "the half-educated girls by whom his [Reynolds's] novels are principally patronized" (1 July 1868, qtd. in Berridge 53), while more recently Louis James has identified it as the quintessential reading of female servants ("Betsy"). Among those who read its million serialized copies, thousands must have been women.

Purveying "the truth in all its nudity," Reynolds makes possible a sensual transaction between the bodies of female characters and those of female readers (*Modern Literature* xvii).[16] Such a transaction,

[15] My discussion also raises the possibility that *Mysteries of London* functioned as lesbian erotica. It seems to me entirely plausible that the novel's form of female pleasure, though it originates in heterosexual codes, could be easily appropriated for lesbian pleasure. Why not? But in a sense, classifying women readers as heterosexual or lesbian misses the point, since the novel does not construct sexuality in terms of the sex of the object choice.

[16] Once again, Fuss's analysis of fashion photography provides an illuminating analogue as an arena in which "eroticized images of the female body [exist] for the explicit appreciation and consumption by a female audience." Fuss argues, "To look straight *at* women, it appears, straight women must look as lesbians" ("Fashion" 713–14). As I have said, I do not think it is necessary to insist that the autoeroticism modeled by *Mysteries of London* be classified as lesbian, though that is one possibility; still, Fuss's analysis of women's erotic spectatorship of female bodies is germane and provocative, though less optimistic than mine. She sees this "homospectatorial look" as ultimately serving the interests of compulsory heterosexuality by containing the viewer's homoerotic identification (see especially her discussion of "vampiric identification," which analyzes a stock pose in fashion photography that elongates and exposes the woman's neck as if to offer her up for consumption ["Fashion" 728–36]).

of course, is exactly what Victorian critics feared. Their attacks repeatedly raise the specter of the overheated woman reader, thrilled, chilled, and overstimulated by the bodily sensations induced by popular novels.[17] Women readers of *Mysteries of London* were specifically condemned for being "feverishly engrossed" in its sensational plots (Dixon, 26 October 1847: 2). We tend to dismiss such attacks as merely paranoid, but my reading of *Mysteries of London* suggests that women could be seduced by the text, though not necessarily into a yearning for heterosexual romance, as critics glibly assumed.[18] Reynolds's erotic address to women raises the question of the ideological function of pleasure in popular culture, a question that modern critics continue to debate. While pleasure has been attacked as a narcotic that addicts women to damaging values—a sugar coating to mask the bitterness of patriarchy—it has also been seen as potentially subversive in its unpredictability.[19] Examining Victorian popular literature, Patrick Brantlinger suggests that critics who see fiction as "*merely* an ideological or discursive tool for the forging and policing of bourgeois subjectivity" must reckon with the disruptive effects of pleasure (21). While Brantlinger may not be right about all popular literature or all pleasures, his comments certainly apply to *Mysteries of London*, which sketches a new female subject quite at odds with Victorian norms. Reading *Mysteries of London*, women might be seduced by fictional women, and even by themselves, as they see themselves in new frames, new plots, and new ways. In a wonderfully suggestive phrase, Henry Mayhew called Reynolds's fiction "the literature of an uneducated body." One of its effects, I would argue, was to educate the bodies of female readers to the possibilities of autonomous sensual pleasure (qtd. in Bleiler x).

Normalizing the Erotic

Both its unorthodox sexual content and its extraordinary popularity argue for the historical importance of *Mysteries of London* in

[17] Useful accounts of these attacks can be found in Brantlinger, Flint, and Mays.

[18] See also *Eclectic Review* (76). Kate Flint provides an extensive survey of attitudes toward women reading in *The Woman Reader*.

[19] Examples of such anti-pleasure arguments can be found in early feminist critiques of popular romances; see Coward and Modleski. I take up this position in slightly more detail in chapter 4.

mapping Victorian sexual discourse, and particularly in extending our notions of acceptable representations of female pleasure. Its unconventionality was clearly not so deviant as to compromise its widespread appeal; though by no means perceived as high art, it was sold and regarded as a novel rather than pornography. It is true that Reynolds was the target of attacks from other writers: according to Dickens, he "pander[ed] to the basest passions of the lowest natures" (1–2), while Hepworth Dixon condemned *Mysteries of London* as even "more miserable, more murderous, more immoral, more reprehensible" than its French original (2 November 1847: 3). But because both Dickens and Dixon were Reynolds's direct competitors, the first as a novelist and the second as an editor, it seems likely that their diatribes reflect the novel's highly visible if dubious place in popular culture rather than its general unacceptability.[20] Widely considered "borderline," *Mysteries of London* was neither wholly scandalous nor wholly respectable (Humphries 70). Standing on this border, it helps to mark the often indistinct threshold of discursive deviance and to demonstrate some of the strategies by which erotic representations normalize themselves.

One of these strategies involves content: Reynolds creates safe zones for sensual pleasure by aestheticizing it and by articulating a large and complex field of sexual experience into several dimensions, only some of which receive the novel's endorsement. Though radical in offering pleasure and agency to its female characters, the novel maintains a modicum of moral capital by adhering to a central tenet of Victorian sexual ideology: the pathologizing of genital desire.[21] For if *Mysteries of London* is brazenly engrossed in sensuality, it is fairly

[20] Reynolds was one of the many plagiarizers of *Pickwick Papers*, writing knock-offs titled *Pickwick Abroad* and *Pickwick Married* (Bleiler 154, 155). Dixon's attack on Reynolds in the multipart essay "The Literature of the Lower Orders" was in part a defense of his own *Daily News*, which competed directly with *Reynolds's Miscellany* for a popular audience.

[21] I have in mind here public discourse about prostitution, marriage, and gynecology, including William Acton's famous assertion that "as a general rule, a modest woman seldom desires any sexual gratification herself" (394). Other sources suggest a greater acceptance of sexual desire; see, for instance, F. Barry Smith; M. Jeanne Peterson (*Family* 73–78); and especially Michael Mason, who documents a significant amount of premarital sex and illegitimacy, especially among betrothed working-class couples (70–72). Nevertheless, as I argue in the introduction, official public discourse about sexuality (as opposed to letters and diaries, or advertisements for sexual aids in working-class newspapers) did not advocate or accept intense sexual passion, especially outside of marriage, and especially for upper-middle-class women.

alarmed by sex itself, literally stopping at the bedroom door when the marquis of Holmesford takes a member of his harem to bed: "Here we pause; we dare not penetrate farther into the mysteries of Holmesford House," the narrator intones, refusing to duplicate the sexual penetration of the salacious marquis in a narrative penetration of his fictional bedroom (2:100). In this episode, the novel defines its (tenuous) Victorian respectability against the excesses of the Regency era, signified by its sanitized treatment of Holmesford House, whose historical original was Hertford House, site of the notorious sexual escapades of the duke of Hertford, friend of the Prince Regent and alleged model for Lord Steyne in *Vanity Fair*.[22] The novel scrupulously avoids the graphic representations of genitalia and sexual intercourse that characterize Victorian pornography.[23] Moreover, Reynolds is quite explicit in casting almost all of his women who experience sexual intercourse as victims of force or economic exigency, exempting them from overt sexual desire; they are not portrayed as choosing or enjoying these encounters. Along with his celebration of female eroticism, Reynolds upholds the prevailing sexual values that demonize intense sexual longing in either sex. Eugene Markham's "lustful cravings" rout the calculation and cunning by which he prospers in business (1:141).

We can see Reynolds setting the boundaries of erotic experimentation in the story of Lady Cecilia and her illicit affair with the Reverend Tracy, which results in their double suicide. Described as possessing a tragically passionate nature, Lady Cecilia seduces Tracy, "passing into his soul a small portion of that same voluptuousness," like a sexual Typhoid Mary (1:390). (Note that Eliza's delightful and noncontagious "voluptuousness" is not linked to sexual passion.) She accomplishes this infection by appearing naked before him, posing as a statue in order to highlight her desirability (figure 14). In this she reverses the gender roles of the conventional seduction story but retains the narrative of pursuit and capture which Ellen rejects when she finds herself locked in Markham's bedroom. In imagining her effect on Tracy, Lady Cecilia appropriates the male point of view in order to manipulate her status as a sexual spectacle, as her story also

[22] In a satisfying historical irony, Hertford House is now the ultra-respectable Dorchester Hotel, home of one of the most elegant of afternoon teas in London.

[23] See Pearsall for an examination of the explicitness of Victorian pornography, especially French editions that circulated widely in England (*Worm* 96–98).

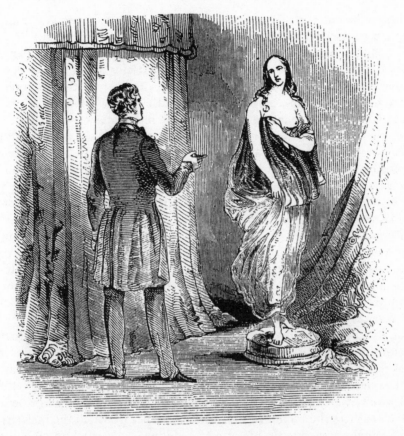

FIGURE 14: Lady Cecilia as a statue. G. W. M. Reynolds, *The Mysteries of London,* 1st ser., 2 vols. (London: George Vickers, 1846), 1:393.

exploits the representation codes that link artistic self-display with sexual availability. But unlike Ellen, Lady Cecilia leaves the realm of art; she simultaneously steps off the pedestal of the statue and, the novel declares, "falls from the pedestal of purity" to a life of irredeemable corruption (1:392). The complex interplay of body, sensuality, and representation collapses in the literalization of her sexual fall when she leaps to her death from a London monument. As her mangled corpse attracts a crowd, the female body becomes, once again, a spectacle, but one that, unlike Ellen's, comes into being through the death—literally—of the female subject. (Tracy's fate is no less symbolic: in a nice touch of black humor, his likeness appears in Madame

Tussaud's museum. This final "vicissitude" of the scopophiliac instinct turns Tracy the voyeur into a posthumous exhibitionist.)

Lady Cecilia's contrasting plot suggests the cultural logic of Ellen's sensuality. Sharing widespread cultural anxieties about sexual passion, the novel produces a sexuality that is arguably both more radical and "softer." In a novel that so relentlessly pathologizes genital sexuality, Ellen's pleasure falls within the realm of acceptable desire. While autoeroticism is not exactly more respectable, Ellen's pleasure is protected in several ways. First, it occurs in the context of artistic projects, which both implies her control of the experience, in contrast to the obsessional desires of Cecilia and Tracy, and grants it a "higher" purpose. Framed by the aesthetic, her pleasure also takes on a kind of self-containment, the erotic version of "art for art's sake." Reynolds imagines an erotic impulse that sustains itself without striving for an object or a climax. The dangers of wanting are built in to sexual intercourse, lending it a hectic frenzy. For all its excitement, Ellen's voluptuousness is composed, in both senses of the word: it is an artistic composition, and it retains a saving poise. Because this aestheticization orders and contains its energy, Ellen's sexuality could be understood as falling within the "gentle flow" that even the neo-Malthusians, in their defense of conjugal sexuality, saw as the furthest outpost of acceptable pleasure (Owen 14). In this way, the novel participates in the conventional association of women with less intense sexuality, which persists in some forms to the present day (witness the infamous Ann Landers survey in which the majority of female respondents preferred "cuddling" to sexual intercourse [84–88]). Ellen's pleasure is both an unexpected by-product of Victorian ideology and a challenge to it, a residue of desire precipitated from heterosexuality rather than a polarized resistance to it. Her erotic satisfaction is an unpredicted but nevertheless legible outcome of prevailing values. But of course the reverse is also true: conformity to one set of sexual norms produces the novel's unconventionality in relation to another set. In repudiating sexual intercourse, the novel makes way for other forms of pleasure.

In addition, several formal features of the novel allow it to wrest respectability from its prurient content. Its heterogeneous construction and serial publication would seem to permit, even encourage, multiple meanings and effects, providing several sites on which to ground its propriety. Among its fifty-plus plots are stories that follow the simplistic moral conventions by which melodrama is said to operate

and that modern critics have inaccurately generalized to the whole of the novel. *Mysteries of London* has its share of virtuous heroines such as Isabella, and it is framed by the moralistic plot of two brothers, the evil Eugene Markham and his noble brother Richard. This formulaic opposition resolves itself in sententiously moralistic fashion at the end of the novel: " 'Tis done: VIRTUE is rewarded—VICE has received its punishment," announces the epilogue (2:424). I assume that modern critics have this resounding conclusion in mind when they speak of the novel's "conventional disbursement of rewards and punishments," but the sheer number of plots and pages ensures that no single story will overtake the others.

Moreover, the novel's generic multiplicity further diversifies its effects: interspersed with the erotic scenes are lessons in Italian geography, treatises on political economy, and fervent exegetic declamations against the oppression of the poor, complete with statistical tables on the unequal distribution of wealth for every year of the novel's chronology. Though often classified as a penny dreadful (Burt 142; Neuberg 160–61), it more closely resembles Reynolds's journalism—the *London Journal, Reynolds's Miscellany, Reynolds's Political Instructor,* and *Reynolds's Weekly Newspaper.* Reynolds was intimately familiar with—and, indeed, helped to develop—the genre of mid-century popular journalism. He adapted Charles Lloyd's experiments with publishing serial fiction and sensational news stories in *Lloyd's Penny Sunday Times and Police Gazette, Lloyd's Illustrated London Newspaper,* and *Lloyd's Weekly Newspaper* to his own brand of popular journalism, mixing sensational fiction, political diatribe, and "useful knowledge" articles on geography, politics, economics, and science. Reynolds began writing *Mysteries of London* shortly before he assumed the editorship of the *London Journal* and worked on these ventures simultaneously. (In fact, it is hard not to suppose that the *London Journal*'s glowing review of *Mysteries of London,* praising "the vivid interest of the tale . . . the skill of the artist . . . and the immense popularity it enjoys" was written by Reynolds himself [1 (1845): 253].) The model of popular journalism provided Reynolds with a way of diluting his fiction's sexual content: *Mysteries of London* can be classified as erotica, but it is so many other things as well that this label does not define its identity.

Most likely, too, the episodic reception of its serialized version would have worked against ideological and generic coherence. As lengthy serialization attenuates its relationship to other parts of the

novel, the plot involving the Markham brothers does not exert the control that it would in a more compact or unified text; the normally strong positions of beginning and end in which that plot might establish its priority lose some of their privilege. It also seems plausible that, as a repeatedly interrupted text, a serial provided readers with time and opportunity to reflect on, reassess, and mentally remake their initial reading, as Linda Hughes and Michael Lund propose (13).[24] It is my guess that the popular audience, absorbing the novel in small bits and without the expectation of organic unity, used the text in whatever way provided the most interest and excitement. They could enjoy both the thrill of transgression and the reassurance that moral standards still held—and that they need not be wholly ashamed of their reading.

A brief example of Reynolds's own intertextual practice suggests that he understood such usage well. In one of the famous "Letters to the Industrious Classes" in *Reynolds's Miscellany* titled "To the Needlewomen of the United Kingdom," he refers, with disarming inaccuracy and self-promotion, to "the true, the touching incident of Ellen Monroe" (251). Of course, not only is Ellen's story fictional, but also her career as a starving needlewoman is short-lived, and her subsequent history hardly illustrates the tragic consequences of poverty that Reynolds develops in the rest of the article. Reynolds clearly expects that readers of *Mysteries of London* will be able to detach this segment of her story from the novel and use it to intensify and individualize his social commentary in *Reynolds's Miscellany* without being overly distracted by the more unconventional, less pathetic parts of her story. By the same token, he also expects readers of *Mysteries of London* to understand "the distressed needlewoman" as a social type that he invokes to win sympathy for Ellen, especially when she turns to prostitution. Her voluptuous pleasure on stage does not disqualify her from serving as an example of virtue besieged in another section of the novel. The story of "the distressed needlewoman" remains intact, in a sense, despite the ensuing plot developments. Ellen's story does not function as an organic whole; instead, it

[24] Hughes and Lund offer persuasive and interesting hypotheses about the experience of reading serials, arguing that it is quite a different process from reading a single, self-contained volume, although their uncritical privileging of high art limits their sample texts and may also limit the reach of their argument. They voice concern about "the dangers of sensationalism" in serial form, for example, as if the sensational must always work against complexity or seriousness (274).

is made up of related but quasi-independent parts, each of which carries its own interpretive frame and meaning.[25]

The novel's heterogeneous effects are precisely what Christine Gledhill terms "pleasurable negotiations," bargains made with the dominant ideology that, in disarming some of its injunctions, allow readers agency and enjoyment without casting off cultural authority altogether (72).[26] The stories of Ellen's and Eliza's unconventional sexuality do not exactly subvert the dominant ideology since they exist alongside it without affecting the valorization of female virtue. But neither are their stories contained by this convention, for, in addition to significantly reworking representations of female sexuality, the novel refuses this kind of ultimate conclusion. Its various plots and their inconsistent implications are not brought into relationship with one another, nor is the reader encouraged to force a relationship among them and adjudicate their competing claims. In this respect, Reynolds's apparent lack of artistry, his refusal to shape his divergent materials into a unified whole, his casual regard for the principles of thematic, formal, and moral coherence make possible his unorthodox treatment of female sexuality. Even though for modern critics of *Mysteries of London* "popular fiction" is synonymous with "formula fiction," the characteristics of popular fiction provide some of the enabling conditions of Reynolds's ideological experiments. I do not mean to suggest that popular fiction will always or even generally be more unconventional than high art—only that in this particular instance a more heterogeneous aesthetic opened the way for different sexual meanings.

The popularity of *Mysteries of London* can also be constructed in another way, that is, in its insistence on addressing a broad and sometimes unschooled audience through conventional erotic scenarios,

[25] Reynolds regularly remakes his heroines as his lengthy novels develop, presumably hoping that serialization would make such transformations easier to swallow. In *Mysteries of the Court of London*, for instance, Lady Bess begins the novel as a highwayman (or highwaywoman) in male disguise, with features that are repeatedly described as "coarse" (1: 58, 68, 80). But as her plot develops, Reynolds apparently decides to improve her fortunes; once she falls deeply in love with an aristocrat, her coarse features miraculously give way to "the virginal freshness of youth" (2:5).

[26] See also Theodore Leinwand's useful rethinking of the containment/subversion binary in "Negotiation and the New Historicism": "It is a thorough falsification of historical processes to argue that subversion offers the only alternative to the status quo. And it is a comparable falsification to argue that anything short of authentic subversion is but another instance of discipline" (479).

however much it reorganizes them to admit divergent readings. The novel spoke to its public in images, tropes, and scenes that would trigger pleasure in part because they were so familiar, and because they proclaimed their desire to arouse so directly. That it also charmed a feminist college professor is, in a sense, no surprise, since, like the half-educated girls who read the novel in the 1840s, I too have become a subject within patriarchy's productive constraints. The novel's scenarios may remain erotic for other women, as they have for me, because our sexuality has already been produced through them. *Mysteries of London* demonstrates that, for all their familiarity, such conventions do not encode only retrograde forms of desire. One of the aspects of *Mysteries of London* that I found the most interesting was its recovery of the "incorrect" pleasure of self-display and objectification—the latter almost exclusively identified with dehumanization in feminist theory. The grudging admission that "objectification . . . may be an inherent component of both male and female eroticism as constructed by western culture" is about as far as anyone has been willing to go, though I suspect that objectification of both partner and self has been a central and gratifying aspect of many people's erotic lives as it has in mine (Kaplan 39). Ironically, this sensationalistic popular text shows a certain subtlety in decoupling objectification from dehumanization, creating distinctions within an apparently monolithic phenomenon and freeing erotic responses from their automatic containment in patriarchal designs. The meaning of objectification is contextual: while it *may* and often does undergird exploitative representations of female bodies, it does not *necessarily* do so.

Writing twenty years after the publication of *Mysteries of London*, the journalist E. S. Dallas proclaimed,

> But it so happens that no critical doctrine is in our day more unfashionable than this—that the object of art is pleasure. Any of us who cleave to the old creed, which has the prescription of about thirty centuries in its favour, are supposed to be shallow and commonplace. Nearly all thinkers now, who pretend to any height or depth of thought, abjure the notion of pleasure as the object of pursuit in the noble moods of art. But what if these high-fliers are wrong and the thirty centuries are right? (1:143)

What indeed? It seems unlikely that Dallas had *Mysteries of London* in mind when he spoke of "the noble moods of art," but his defense of pleasure is an appropriate gloss on Reynolds's specular and spectacular novel. The ability to arouse a reader—and, indeed, the construction of female pleasure as a central reading effect—is what marks the originality of *Mysteries of London,* not its triviality or conventionality. It is also what made the novel, for me, such a welcome discovery. *Mysteries of London* makes the hopeful suggestion that discredited but compelling pleasures—both the "good read" of popular novels and the *mise en scène* of the male gaze—might not simply repeat old oppressions but might yield new erotic models as well.

4 Theresa Longworth and the Yelverton Marriage Story

How to Write Your Own Romance

In 1852, on a steamer from Boulogne to London, Maria Theresa Longworth met Charles Yelverton.[1] Nineteen years old, she was lovely, convent-educated, and, for all practical purposes, an orphan; he was a dashing officer in the Royal Artillery and heir to the viscountcy of Avonmore. The attraction was mutual and immediate: the casual pleasantries of their introduction bloomed into extended conversation and then into a night spent on deck together wrapped in a warm plaid shawl, watching the stars until the sun came up.

From this romantic, almost novelistic beginning grew one of the most tangled, contested, and well-known love stories of the nineteenth century. If anything, its novelistic flavor intensified as it unfolded. Longworth and Yelverton corresponded for six years, met in secret while he was stationed in the Crimea and she was a Sister of Charity in a Constantinople convent nursing wounded soldiers à la Florence Nightingale, and developed a compelling attachment whose nature was never fully resolved. According to Yelverton, Longworth consented to be his mistress during their assignation in Constantinople and lived with him on and off out of wedlock. According to Longworth, he proposed a clandestine marriage because of his financial obligations to a difficult uncle, an offer that she at first refused but finally agreed to as a temporary measure. They corresponded, met occasionally, and went through two irregular marriage ceremonies in two different countries. Then, in 1858, Yelverton married a woman

[1] I refer to her throughout as "Longworth" in the interests of clarity, not because I am convinced that she was not married.

named Emily Forbes. In response, Longworth initiated a series of legal actions that extended over ten years, attempting to establish her status as his wife. Longworth lost in the end, but in the meantime "Yelverton" had become a household name: the trials were widely publicized, and the first jury trial, held in Dublin, was attended by hordes of spectators. Including it among a sample of "great Irish trials," the legal historian M. McDonnell Bodkin describes it as an event of "universal and unparalleled interest" (44). The correspondence between the two lovers, which formed much of the evidence, was published twice; a ballad and several novels, two by Longworth herself, retold the basic story. An Irish musician composed "The Yelverton Waltzes" and presented Longworth with a signed copy, while a renowned hosier sent her six pairs of gorgeously embroidered stockings similar to those it had given the empress of France. For a time, Longworth became a popular heroine, pitied and petted as that poignant Victorian figure, "an injured woman" (*Times*, 22 July 1864: 9).[2]

But behind this icon of femininity lay a messier reality. In the complicated texts spawned by this story, Longworth and her culture made and remade the relationship between femininity and sexuality. Throughout her correspondence with Yelverton, Longworth engaged in a complex erotic self-fashioning by drawing on literary and cultural conventions, including both the generic characteristics of melodrama and historical romance and the representational codes arranging women's bodies for the pleasure of male spectators, as in *The Mysteries of London*. A real-life Ellen Monroe, Longworth raided the stock of gender norms to fashion new and unconventional personas, finding subtle resources for sexual subjectivity and, in the end, a libidinal life beyond the heterosexual dyad. In its fluid intermingling of experience, narrative, and fantasy, Longworth's correspondence offers a rare Victorian reception study, showing how one reader absorbed literary conventions and actively rewrote them in her own life. But Longworth's revision of romance, femininity, and sexuality collided with gender conventions in the trials that followed, which held up her private correspondence and person to public scrutiny. In trying to establish whether Longworth was a wife or a mistress, the trials were also forced to pronounce on the sexuality of middle-class women, ul-

2 The *Freeman's Journal* called her "the injured woman" as well (23 February 1861: 2).

timately reabsorbing her complicated, sometimes contradictory auto-
biography in letters into ideological norms. The erotic bond between
Longworth and Yelverton stretched the interpretive capacities of a
popular audience, but it ultimately rebounded into a culturally ap-
proved message about female purity, as the public nature of court
cases and particular local details weighted the outcome of the trials—
particularly the Dublin trial—toward normative ideology. In its
twists and turns, its multiple retellings and reinterpretations, Long-
worth's life story displays the complex interplay of individual experi-
ence and cultural norms.

Theresa Longworth's Story

Because Longworth's biography is not well known, I recount it now,
with special attention to her relationship with Yelverton, describing
it in detail and quoting from the letters to stress its convoluted na-
ture and to provide a context for the more detailed account of Long-
worth's epistolary self-presentation later in this chapter.

Maria Theresa Longworth was born in 1833, one of six children.
She was raised as a Roman Catholic and educated in a convent. Her
mother died when she was only four, and, to escape from her increas-
ingly eccentric and misanthropic father, she left home at seventeen to
live in London with a cousin, John Augustus, and in Boulogne with
her sister Ellen. John was a romantic figure, having served as a guer-
rilla fighter in Circassia (a region on the northeast coast of the Black
Sea), where he acquired the *nom de guerre* "Alcide." Longworth was
so taken by his exploits that she always referred to him as Alcide in
her correspondence.

Her public story began in August 1852, when she met Charles
William Yelverton. She was nineteen; he was twenty-eight. They en-
joyed each other's company on the steamer trip, then parted when
they arrived in London. Two months later Longworth asked Yelver-
ton, who was stationed in Malta, to forward a letter to Alcide, a re-
quest that began their six-year correspondence. What started as a ca-
sual, bantering exchange of letters soon became an epistolary
romance, as "My dear Miss Longworth" escalated to "My dear
Theresa" and then "Cara Theresa Mia." At first they negotiated their
long-distance attraction in code: Longworth invented a fiancée for

him in order to account for his irregular letter writing, and Yelverton confided that *"L'amour,* as you understand the *word* (sentiment?) is not, never was, and never can be, my insanity, temporary or otherwise"—a warning she did not heed (*Correspondence* 24). When Britain entered the Crimean War in 1854, Longworth, seeking a pretext for visiting Turkey to see Yelverton in person, joined the Sisters of Charity to nurse the wounded at the St. Benoit convent in Constantinople, only to find that Yelverton had temporarily returned to England. In early July 1855, Longworth complained that it had been four months since Yelverton's last letter. But he soon returned to the Crimea, and in September 1855 he met her secretly at the convent.

At this point their accounts diverge dramatically. She says that he proposed a clandestine marriage to avoid angering an uncle on whom he was financially dependent; he says that he decided to seduce her. When the Mother Superior learned of the meeting, she ordered Longworth to explain herself. In response to her request for advice, Yelverton writes, "It would be quite an impossibility to define our relative positions"—an odd response from a man who has just proposed marriage (92). To protect her reputation, Longworth told the Mother Superior they were engaged. The lovers parted with the nature of their relationship unresolved. Explaining her ideal of the chivalrous savage, a cherished romantic fantasy that had drawn her to him, Longworth encouraged Yelverton to play the part but recognized his resistance: "You . . . warn me not to trust too much," she acknowledges. But she has her own warning to deliver: *"I must trust all or not at all with you—I can have no half-measures"* (97). Neglecting their correspondence for months, he nevertheless rejected her offer to end it, although he warns her that he is "not honest" and has "no heart" (105). They continued to correspond, although their relations were stormy. Longworth claims that Yelverton had insisted on "binding me to your fate," but that since he had hesitated to make good his promise, they should part (111). Still, Yelverton continued to write. In the summer of 1856, Longworth joined Yelverton in Edinburgh, where he was stationed. Yelverton later claimed that they had frequent sexual intercourse, whereas the friend with whom Longworth was staying testified to the complete propriety of the lovers' visits.

On 12 April 1857 Longworth and Yelverton underwent a Scotch marriage, declaring their intention to be married and reading the mar-

riage vows from the Book of Common Prayer, thus beginning the trail of irregular ceremonies that would confound the courts. Scotch marriages could be notoriously offhand, providing a handy plot device for novelists, whose lovers might run off to Gretna Green for a quick wedding, as Lydia and Wickham consider doing in *Pride and Prejudice*.[3] Scotland recognized three kinds of private marriages with no witness or official record: an exchange of consent (the version Yelverton and Longworth chose), a promise of marriage followed directly by intercourse (marriage *subsequente copula*, which Longworth advanced in several trials when the exchange of consent could not be proved), and cohabitation leading to habit and repute as a married couple. A few months later they traveled to Ireland, where a priest named Father Mooney had agreed to bless their civil union in Scotland—a ceremony with no real existence in the eyes of the Catholic Church. In court Yelverton claimed that he knew this ceremony was not binding since Irish law forbade Protestants and Catholics to marry. Longworth claimed that, although they had already been married in Scotland, her religious scruples required the church's blessing. They then traveled in Ireland as husband and wife, sharing a room and a bed at several hotels (though Longworth claimed that they did not engage in sexual intercourse until after the Irish ceremony, a key point in the later trials), and then to France, where Longworth stayed, possibly suffering a miscarriage, after Yelverton returned to Scotland. When she returned to Scotland, Yelverton urged her to emigrate to New Zealand and promised to join her. The next day his brother Frederick renewed the suggestion. The day after that, 26 June 1858, Yelverton married Emily Forbes, reputedly a widow of means.

In August, Longworth initiated the string of trials stretching over ten years—longer than the relationship itself had lasted. The first significant legal action occurred in Dublin in February 1861. Because it was a jury trial and open to spectators, it became what we now call a media event, widely attended and reported. It inspired a deluge of writing, including Longworth's novel *Martyrs to Circumstance;* a novel by J. R. O'Flanagan titled *Gentle Blood, or, The Secret Marriage*, which drew heavily on the trial testimony and correspondence; and

[3] Fahnestock identifies Margaret Oliphant's *Madonna Mary* as one such novel directly influenced by the Yelverton case (53). W. S. Gilbert's play *Engaged* satirizes the plot device of the Scotch marriage.

the ballad "The Grand Triumph of Mrs. Yelverton."[4] The jury found in Longworth's favor. A flurry of suits and countersuits followed, all of which were decided by judges, not juries, thus depriving Longworth of one of her strongest weapons: popular sentiment. Finally, in 1867 Longworth made a "reference to oath" before the House of Lords, an archaic, last-ditch legal device that required the accused party simply to declare the truth under oath with no witness, no evidence, and no other testimony. Longworth needed to convince the House of Lords that this step was legitimate; when her lawyer failed to appear, she made the argument herself over the course of three days.[5] Probably the greatest scholarly heartbreak I have ever suffered was discovering that there is no record of this speech.[6] The Lords denied her appeal, and, after one more unsuccessful attempt to reopen the case, Longworth's legal actions came to a close in 1868.

Were they married? After several years of living with the case, I find it impossible to say. The laws that governed their marriages were arcane, and the language of their letters is, as many of the judges complained, ambiguous in the extreme: Does "I, who have sacrificed all but God to you; I who have lain at your heart, and in the sight of heaven been called yours" refer to marriage or intercourse (*Correspondence* 161)? It seems incredible that the worldly Yelverton would have allowed himself to be maneuvered into an imprudent marriage but equally incredible that Longworth would risk so much by becoming Yelverton's mistress. In the end, both lost. Longworth had to forfeit her romantic fantasies and, eventually, much of the

[4] Fahnestock also cites Caroline Norton's *Lost and Saved* and Amelia B. Edwards's *Barbara's History* as novels based on the Yelverton story (53).

[5] In her introduction to a reprint of *Zanita*, Margaret Sanborn says that Longworth was the first woman to speak before the House of Lords other than the queen, but Sanborn takes many of Longworth's self-serving claims at face value (such as her alleged fear that Yelverton might try to track her down in America, when in fact he desperately wanted to be rid of her), so this statement may not be accurate (xx).

[6] I traced it to the handwritten transcript archived at the House of Lords, which reads, "The address of Maria Theresa went over several days." The urge to fill in this gap is almost irresistible: Brian Roberts's mean-spirited and unreliable account says that the judges found her speech "exorbitant and abusive" and warned her not to be "theatrical" (50); Duncan Crow's laudatory account says that the judges "were impressed with her performance" (248). The judges' verdict, which does exist, certainly responds to her argument point by point, as it must, but repudiates it pretty thoroughly. We will never know exactly what she said or what sort of impression she actually made on the judges.

popular support she had won during the Dublin trial, while Yelverton was suspended from his military duties and put on half pay. To understand how they came to such a pass, we need to return to the figure of the woman reader, hypothesized in chapter 3 and incarnated in Longworth, a "highly accomplished lady" whose "poetic fancy" was formed by her reading and in turn shaped her life (*Full Report* v, 146).

Writing Your Own Romance: The Yelverton Correspondence

Longworth was obviously a dedicated reader of popular literature, patterning her fantasies and expectations on its conventions just as conservative commentators feared women would do.[7] To read her letters is to encounter over and over again literary plots, tropes, and language. This is surely one reason why her story achieved the popularity it did and lent itself so readily to cultural reproduction as "a romance in real life," with Longworth as its "unfortunate" heroine (*Times*, 5 March 1861: 10). Many of the details of her own life—her unprotected status, her choice between a spiritual life and an earthly love (the predicament of the heroine in Charles Kingsley's popular novel *Yeast*), the sentimental costuming of the army officer and the Sister of Charity—and much of the rhetoric of her letters blend seamlessly into romantic conventions. Once the affair was over, Longworth returned her fantasies to their literary origins, making real novels out of a life that she had already cast in novelistic terms. Other writers followed suit: J. R. O'Flanagan's *Gentle Blood*, written immediately after the Dublin trial, draws freely from Longworth's letters; almost a hundred years later, Duncan Crow quotes directly from Longworth's novel *Martyrs to Circumstance* in reconstructing Long-

[7] One possible source, which her experience echoes in many ways, is the popular French novel *Les lettres de Mistriss Fanny Butlerd*. The heroine conducts an epistolary romance with an aristocrat and, when her lover proves unfaithful, publishes their correspondence in order to claim her own interpretive power over their relationship. Longworth's life bears an uncanny similarity to the novel, as described by Elizabeth Heckendorn Cook. I am particularly struck by the fictional Fanny's desire to take power by "going public," as Cook says. Fanny refuses to have her words appropriated and reframed by men, a fate that often befalls women's writing in the epistolary tradition. She eventually trades the sexual contract—broken by her lover's duplicity—for the more secure contract between author and reader. The novel remained steadily in print from 1757 to 1836; it is possible that Longworth read it as a student in a French convent. I am indebted to Lisa Zunshine for this reference.

worth's thoughts, speeches, and motives as if it were a documentary account of her experience. And, while this smooth repackaging of conventions might suggest simple repetition, Longworth's story as a whole reveals how complex this process can be. Her models carry contradictory implications and subtexts, and her letters are as various as the narratives on which she draws, offering a kaleidoscope of subjective and narrative possibilities.

Some of her models provided conventional visions of a carefully denatured love, with little trace of sexual passion. In Yelverton she thought she had found a "chivalrous savage," a paragon of romance from her childhood reading: "I have been in love with such a one from the age of ten years, when I formed my first conception of an ideal man from Scott and Cowper," Longworth announces, adding dryly, "I need not say how much I have had to unlearn of those days" (*Correspondence* 95). Longworth enumerates the qualities of her ideal partner: "a man who has a sound mind and warm heart . . . who is bold and brave, and gentle and kind, stooping on earth to none but the weak and helpless; who knows no other bonds but those of honour and affection, the protector of the feeble, and the guardian of justice and honesty; too noble for a tyrant, too generous to be selfish; a man realizing the intentions of the Creator, and worthy [of] the glorious gifts bestowed upon him." This laundry list of good qualities certainly sounds as if it were drawn from a novel, though I have not found a hero who represents the perfect balance of chivalry and savagery in Scott or Cowper.[8] The relationship she imagines with him— "a little Platonic at first," then shading into a non-platonic category

[8] My incomplete readings of Scott and Cowper have not turned up any definitive candidates, though Fergus Mac-Ivor in *Waverley* and Saladin in *The Talisman* might fit. Other possibilities occur in Alexander Welsh's list of "dark heroes" such as Rob Roy, the earl of Leicester in *Kenilworth*, George Staunton in *The Heart of Midlothian*, and Clement Cleveland in *The Pirate*, though the last three are seriously flawed. Deloraine in *The Lay of the Last Minstrel* also fits this pattern (see Anstice). This collection of possibilities makes me think that Longworth may have had in mind a type rather than a single character. It also suggests that Longworth was quite willing to simplify her sources, since many of these characters are not wholly admirable. Scott, at least, expresses notoriously mixed attitudes toward chivalry, ranging from qualified admiration to indulgence to outright satire (for an extended discussion of Scott's attitudes toward chivalry, see Hart 150–245). Thanks to Larry Swingle and Ina Ferris for their suggestions on this question. The Cowper concordance suggests no promising leads under "chivalry" or "savage," and neither my reading nor my inquiries have found any likely examples. I have begun to wonder if Longworth was referring to James Fenimore Cooper.

which she never specifies—consists of only the most elevated emo-
tions: "esteem, admiration, affectionate trust, and confidence, *ideal-
ized, ethereal love* . . . the elixir *par excellence* of life" (97). Whatever
sensuality lurks in this description is safely buried in her moral and
spiritual vocabulary.

The suppression of passion implicit in this description is literalized
elsewhere in the letters in a scenario of melodramatic suffering that
proved one of the most significant literary borrowings of both her let-
ters and the trials. In the hope of extracting a commitment from
Yelverton, Longworth relates a poignant moment when she is con-
fronted by the Mother Superior about the relationship, the convent
setting and her religious habit heightening Longworth's claim to vir-
tuous womanhood. His proposal of a secret marriage has crushed her,
she writes; she knows that she should throw him over if they cannot
have an honorable connection, but her life is not worth living with-
out him. When a group of plague victims arrive, she offers to nurse
them, seeking to resolve her dilemma in a noble death. She tells the
Mother Superior: " 'But you know I don't fear infection in the least,
and don't care a fig for my life; it's a burden to me.' I felt at the mo-
ment that the plague would be a blessing to make the *finale*. She read
my wretched thought, and said anxiously, 'You have given him up?' I
wanted to say *yes*, but the word seemed to choke me; my teeth got
very fast together, and I could not utter a syllable" (107). Longworth's
self-presentation clearly trades on melodramatic conventions, espe-
cially in its heightened rhetoric and its display of virtuous suffering.
Choking, clenching her teeth, almost fainting from heartbreak, Long-
worth exhibits her pain outwardly on her body. While ostensibly re-
porting her decision to nurse the sick, this set piece clearly signals
her attachment to Yelverton; but, just as clearly, it does not place
Longworth in the position of expressing that attachment directly. Al-
though she cannot say "yes" and affirm that she has given him up,
neither does she say "no." Her muteness literalizes what William
Cohen calls the "unspeakability" of active desire, and her incipient
swoon suggests that the proper heroine must give up consciousness
rather than declare her feelings.

At other moments, however, Longworth finds ways to express her
passion. The requirements of respectability may have forbidden hero-
ines from engaging in sexual activity, but novels were nevertheless
able to represent eroticism in encoded ways. As Cohen argues, the
very pressure of respectability provoked creative expression: "an elab-

orate discourse—richly ambiguous, subtly coded, prolix and polyva-
lent, that we now recognize and designate by the very term *literary*"
(3). What Cohen calls the "unspeakability" of sex implies a threshold
of explicitness that literature must not cross; respecting that thresh-
old requires literary language to cultivate subtlety and ambiguity in
order to express what it cannot openly declare (3). And, like the bed-
room threshold that the bride crosses on her wedding night—or,
rather, across which she is carried by her husband, to preserve her
erotic passivity—the threshold of discursive explicitness marks the
gulf between the virginal heroine and the sexually aware woman.
Longworth was certainly drawn to literary language and often re-
spected this unspoken rule. Yet she also tested the boundaries of
decorum, discovering the hidden sexual dimensions of her literary
models. Her incursions across the threshold of explicitness undo the
mystifications of literary codes and the ideological constraints on fe-
male sexuality to which that language responds.

Exploiting the rich verbal encoding Cohen describes, Longworth
frequently uses familiar tropes of physical response that are among
the most durable conventions of romantic novels, even to the present
day. In them the body is broken into distinct parts, each intensely
alive, in a way that both emphasizes sexuality and mutes the control-
ling consciousness that "owns" the desire: "The eyes yearn to see
you, the ears are distended to catch the first sound of your voice and
footfalls, the hands throb and tingle to touch you and feel you once
more within their grasp" (*Correspondence* 181). This declaration re-
sembles passages from hundreds, perhaps thousands of novels (al-
though Longworth's tin-ear metaphor of distended ears is, as far as I
can tell, all her own). Take, for example, this passage from *East
Lynne:* "All her veins were tingling, all her pulses beating; her heart
was throbbing with its sense of bliss" (Wood 24). In these tropes, the
tingling and throbbing hint at other erogenous zones that are as un-
mentionable as they are strongly implied. The threshold of explicit-
ness remains intact, both discursively, in the unspeakability of sex,
and, ideologically, in the (relative) innocence of the throbbing yet
modest heroine, whose body speaks for her so that she will not have
to speak for herself. Using similar codes, Longworth alludes to mysti-
cal forces that draw her to Yelverton, suggesting both a potent sexual-
ity and a lack of conscious will: Yelverton's animal magnetism and
"odic force" are responsible for her infatuation (*Correspondence* 138).
But then Longworth crosses the threshold, completing the throbbing-

and-tingling passage with an expression of explicit desire: "I want you! I want you!! I want you!! As to there being any arrears of petting, I am crabby. I *must* have them, or I shall hate you" (181). Decoding the indirect language of attraction, Longworth also lays claim to her own desire, making clear that what she wants is not merely "an ethereal love" but intimate physical contact. I want to stress that the threshold of explicitness marks a significant ideological shift: it is not simply a difference of degree that separates literary-sexual discourse from "I want you" or the throbbing heroine from the woman who demands petting. The threshold marks the difference between a sexual object and a sexual subject.

The nature of Longworth's challenge to both the discursive rules of romance and the ideology of female purity appears even more vividly in her manipulation of melodrama and its heroines. As with Cohen's sexual/literary discourse, Longworth pushes her encounter with the Mother Superior, described earlier, beyond the threshold of explicitness, in a revision that reveals her as an astute interpreter of literary conventions, alert to their unacknowledged subtexts. Longworth recognizes that such scenes of pathos stage an erotics of suffering, in which innocence and vulnerability act as powerful aphrodisiacs, tacitly inspiring sexual advances. In Elizabeth Gaskell's *North and South*, for instance, moments of distress repeatedly augment the erotic appeal of Margaret Hale, the novel's noble heroine: having been felled by a stone during a labor strike, Margaret's beautiful, prostrate body elicits the hero's first declaration of love, the rather chilling statement "Dead—cold as you lie there, you are the only woman I ever loved!" (181); during a traumatic interrogation by a police officer, her "lips swelled into a richer curve," her hair tumbles out of its combs, and her "beautiful brows" undergo a "pitiful contraction of suffering" (273, 277). With coding that is considerably less subtle, Bulwer-Lytton's popular *Ernest Maltravers* renders the same convention, literalizing the seductive appeal of suffering virtue in the naive speeches of its heroine, Alice.[9] Bulwer-Lytton develops a kind of double-talk that saturates her sexuality while insisting on her inno-

[9] Published in 1837, the novel was canonized as a paradigmatic love story and cited in later novels (sometimes condescendingly) as a kind of instruction manual for budding young romantics; for references in this vein, see Kingsley's *Yeast* and Jewsbury's *Half-Sisters* (11, 186). Maltravers himself is a likely candidate for the role of chivalrous savage, combining wild, Byronic exploits with a noble heart and a poetic vocation.

cence: abused and abandoned by her brutish father, Alice draws Mal-
travers's attention by soliciting his protection and giving him a grate-
ful kiss, "wholly unaware that she had committed an unmaidenly or
forward act," the narrator assures us (57). Alice is a walking double
entendre: sexual meanings seep into every word and gesture, yet she
is magically insulated from meaning those meanings.[10] Both of these
heroines are marked for sexuality but lack any knowledge of their ap-
peal, especially in the case of Margaret, who loses consciousness by
the end of both scenes.

Longworth radically transforms this model in her convent scene.
Having appealed to Yelverton's pity with the account of her swoon—
like Margaret, she avoids sexual self-awareness with a convenient
loss of consciousness—she shifts her tone and self-representation,
radically revising the erotics of suffering. Entrusted to a Jesuit priest,
she is recuperating, she reports, "in a kind of little Eden; the loveliest
spot in the world, shut in by mountains on every side, except where I
just get a beautiful peep of the Bosporus. Such a delicate nook there
never was, and only wants *somebody* to make it a *paradise.* Eve her-
self could not enjoy it alone" (*Correspondence* 107). Heartbroken and
under the protection of a priest, Longworth ought to be too distraught
to admire the scenery, much less invite her rakish suitor to enjoy it
with her, but she has reinterpreted the story. The allusion to Eve and
the garden accurately implies the transgressive impulse behind the
passage: her touching seclusion is the perfect setting for a sexual fall.
The passage is noteworthy not only for its bold expression of sexual
desire but also for its manipulation of representational codes. Demys-
tifying melodrama as a form of erotica, Longworth divines the sexual
intentions veiled by the fetishizing of female suffering and attributes
them, radically, to the suffering heroine. Unlike Alice, Longworth
knows what she means.

We might say that Longworth has merely adopted the male point of
view and understood herself as an attractive object, just as Ellen Mon-

[10] But not for long. In a gesture toward the more permissive Byronic values it en-
gages, the novel actually has Maltravers seduce Alice and impregnate her. It takes
Bulwer-Lytton two three-volume novels to bring his protagonists together in holy
matrimony, with a wild plot that involves a sexless marriage between Alice and an
older man offered as proof of her virtue—she is saving herself for Maltravers, her one
true love—and an episode of near-incest between Maltravers and a girl who appears to
be his and Alice's daughter. It goes without saying that by mid-century such baroque
sexual plotting would not do for respectable literature.

roe did in *Mysteries of London* when she imagined a theatrical audience admiring her beautiful arms.[11] Valorizing female weakness, Victorian culture may have marked off suffering as especially suited to this double consciousness, as suggested by Eliza Lynn Linton, that most worldly of Victorian advice givers: "A real woman, with her instincts properly developed—among them the instinct of admiration [i.e., how to win admiration]—knows how to render even invalidism beautiful; and indeed, with her power of improving occasions, she is never more charming than as an invalid or convalescent" (211). Linton clearly understands the seductive appeal of suffering and expects women to cultivate the same understanding, although she naturalizes the appeal as the effect of "instinct."[12] This "real woman" is caught somewhere between Alice's innocence and Longworth's brazen invitation, reflecting Victorian ambivalence about female self-display as both necessary and suspect: a lady must be aware of male admirers and arrange herself in their sightline without actively seeking out attention. Though passive in her desire, she must be "a constantly available text" (Langland, "Enclosure Acts" 10).[13] But in Longworth's letter as in *Mysteries of London,* adopting the male sightline opens the way to sexual subjectivity, this time in the service of a heterosexual seduction rather than autoeroticism. Because it is defined by conventions of heterosexuality, Longworth's subjectivity is perhaps more compromised than Ellen's. She authors her own position as sexual object, doing exactly what her narrative models do, only more crudely. But as she imaginatively enters the role of seducer, she appropriates the sexual knowledge and desire of the hero. As a reader she must have understood the erotics of suffering, since the heroine is the only character who does not realize her appeal, which is constantly acknowledged and acted on by male characters such as Ernest Maltravers and Margaret Hale's admirers. Longworth the author knows what the heroine is forbidden to know, and, as the

[11] This passage calls to mind John Berger's famous claim that "women watch themselves being looked at" (47).

[12] Joan Riviere's well-known essay "Womanliness as Masquerade" provides a useful gloss on Linton's "real woman" in its insistence that femininity is always performed (306). Defining the relationship between genuine womanliness and masquerade, Riviere says, "They are the same thing"; likewise, Linton does not find any difference between the deliberate improving of occasions and instinctive femininity (307).

[13] See Harman, Mermin, and Nord for discussions of the equation between public display and transgressive female sexuality.

passage develops, she closes the gap between author and character. Authorial and erotic agency go hand in hand in this passage.

Longworth's come-hither turn as the sexy Sister of Charity is unusual, to say the least. But while she rewrites her literary models only once in this vein, she repeatedly voices an explicit sexual self-consciousness, playing the role of the sophisticate who knows her own appeal. Teasing Yelverton with accounts of other suitors (I count at least six in the course of the correspondence), bantering about romance, dropping French and Italian phrases, Longworth appears not as a lonely, convent-bred ingenue but as a worldly, cosmopolitan woman eager for experience. In this guise she mocks the romantic rhetoric that she herself uses elsewhere—the mystical attraction, the extreme emotion, the desire to fulfill one's fantasies: "He scarcely dares to hope, yet he feels that there is no bounds to the *bonté de mon coeur d'ange*, and that I shall not refuse him. All his deepest and happiest *rêves* are realized as by magic in me. Oh, it's most beautiful in French. I could not tell whether to laugh or cry" (*Correspondence* 113).

It is tempting to see these cynical comments as a kind of "outing" that exposes her true nature, since the pieties of stock Victorian romance do not compel belief for a modern audience. But I do not see her self-presentation as a suffering heroine as false, or this version of herself as more authentic or less mediated by cultural models. Instead, it borrows from another gender type: the male adventurer. Just as Yelverton is an object of desire for her, he is also a powerful figure of identification. The perfect companionship she describes in other letters is based not on the complementary opposition of male and female but on likeness and accord, on shared feelings and equal participation in stirring events. In this fantasy, partnership with men provides a way out of domesticity. As an officer in the Royal Artillery traveling to distant places and fighting heroic battles, Yelverton provided an outstanding model; certainly he made a better man of action than devoted lover. Like Longworth's cousin "Alcide," another brave fighter in the Crimea, he opened up expansive new forms of experience. Longworth contrasts the boredom of her life—"nothing to do but dream and paint"—with the challenge of Yelverton's: winning a medal in battle, losing his trusted horse, struggling against a hurricane (52). She writes him sermons on the heroism of war—the "great and noble cause," the "momentous, solemn crisis" in which a man can "test what sterling qualities he has within him" (58). Longworth closes the gap between this life and her own by defining herself as a

daring hero and love as a military exploit. These passages suggest that Longworth may have regarded their problems—including Yelverton's reluctance to commit himself—as part of the thrill rather than as warnings to be sensible and desist: "No obstacle daunts me—and struggle only augments my courage" (111). "My whole nature demands the risk, the trial must be made," she declares, offering a series of plans for meeting secretly and for overcoming his financial difficulties (157). She is under "siege" and may be "taken prisoner" by the "enemy," meaning friends who caution against the relationship (122). She resolves one "immense battle" of this sort by brandishing a pair of pistols to prove that she can take care of herself (32).

In these passages Longworth presents herself as a different kind of heroine: assertive, confident, and free, with "a *penchant* for drifting about" and a disdain for conventionality to match Yelverton's (32). It is interesting to note that in both her novels she stresses the nonconformity of her fictional alter egos. In *Martyrs to Circumstance*, Thierna rejects the discipline of the Sisters of Charity and displays a "reckless devotion" in her dangerous wartime nursing (60), while Zanita frustrates the civilizing efforts of her foster parents, at one point attending church dressed as a boy. Longworth clearly understands the Sisters of Charity as providing opportunities for heroic exploits in exotic settings: "I [have] some thoughts of devoting myself to humanity, in the shape of a *Soeur de Charité*—I think it is a sort of vagabond life that would just suit me; but a *vivandière* [camp follower] I think, might be a little more exciting" (*Correspondence* 33). The conventional representations of war nurses tended to reiterate traditional gender roles, stressing their motherly or sisterly tenderness, but, closing the gender gap, Longworth seeks the next best thing to being a soldier herself.

This strain of Longworth's letters is surprising but not wholly unusual, particularly if we consider it in light of the musings of Florence Nightingale, another fugitive from domesticity who took up wartime nursing in the same rebellious spirit. In her semi-autobiographical fragment *Cassandra*, Nightingale reflects on the tedium of middle-class ladyhood—"the monotonous events of domestic society"—and promotes the unlikely pastime of novel reading as a constructive avenue of escape (207). Deriding the notion that "women have no passion," Nightingale sketches a secret world inspired by novels in which demure young ladies become bold heroines, braving "unheard of trials" and "romantic dangers" with a "loved and loving compan-

ion" (206–7). What better sources for such fantasies than the historical romances of Scott, the inspiration for Longworth's ideal of the chivalrous savage, which combined the romantic heroes of love stories and high adventure? It is no wonder that Longworth prized such tales for they join History, a grand narrative already steeped in glory, to her own experience, enlarging the scale of her romantic life.

Robert Polhemus argues that Scott's novels provided a widely adapted template for grand passion, one that shows the erotic destinies of an individual woman as enmeshed in public life, marking, as he says, the "interjection of women into traditional 'history'" (56). The backdrop of the Crimean War surely helped Longworth to understand her experience in this way, and she found it easy enough to recast her relationship in the form of a historical romance in her novel *Martyrs to Circumstance*, set entirely in the context of the war.[14] Such stories could normalize ambition by linking it to a love story even as they dignified love by linking it to noble exploits. But it is not necessary to assume that the woman reader enters the story by identifying with the love-struck heroine, as Polhemus does.[15] Scott was the favorite author of many girls, who did not mention his fictional lovers but instead sought "a good stirring story, with a plot and some incidents and adventures" (Rose 201).[16] It is the hero whose experi-

[14] Despite its ineptitude, the war may have provided an unprecedented opportunity for such imagining, since it was graphically available through photography exhibits (Green-Lewis 97–144). Florence Nightingale's well-publicized role also offered an accessible and acceptable image of female heroism. Poovey notes the "military narrative of individual assertion and will" which formed a significant part of Nightingale's public image (169).

[15] Indeed, Scott's heroines do not offer much encouragement, since they seldom survive history. This is true in *Lucia of Lammermoor*, singled out by Polhemus as a repeated inspiration to other writers, and in *Kenilworth*, perhaps the closest model to Longworth's experience in its depiction of Amy Robsart's secret marriage to the earl of Leicester, a vacillating if not so callous aristocratic lover. Longworth could have found a more engaging model of shared heroism outside of heterosexual love, such as in the experience of Fergus and Flora Mac-Ivor, brother and sister who are "all in all to each other" and who throw themselves with equal fervor into the political intrigue of the Jacobite rebellion (*Waverley* 327).

[16] Rose also notes girls' preference for other novelists we traditionally think of as writing for boys, including Kingsley, Jules Verne, and Defoe (199, 201); surprisingly, girls' second-favorite magazine was the *Boys' Own Paper*, a pretty clear indication that their reading crossed gender boundaries. Since this study was conducted in 1888, it may not reflect the reading habits of the 1840s and 1850s, when Longworth was forming her expectations. But she clearly felt free to appropriate a masculine plot and persona in her desire for excitement.

ence strikes out most dramatically from "the monotonous events of domestic society"; perhaps he was the primary figure of identification for these woman readers, or perhaps they did not pay much attention to gender and imagined themselves engaged in the same exploits. In her desire for the vagabond life of a *vivandière*, and even in recasting love as a heroic battle, right down to the pistols, Longworth's erotic imagination gestures beyond romance: love might provide some of the ingredients she seeks, or it might be only a pretext, a vestigial plot device, in a narrative of companionship and adventure.[17] For Longworth—and, Nightingale suggests, for many women—reading was a way of rewriting the gendering of experience, offering plots and identifications that were multiple, flexible, and unpredictable.

What, in the end, can we make of these divergent roles, voices, and stories? They constitute an alarming psychological portrait: here is a decentered self with a vengeance. Longworth makes no attempt to reconcile, mediate, or even acknowledge the heterogeneity of her personas. Although I have arranged my quotations in a kind of progression, from most romantic-conventional to most unusual, they do not follow a neat pattern. Like the multiple personalities of a television drama heroine, Longworth's different personas seem unaware of one another's existence. Taken as a consciously crafted epistolary romance, however, Longworth's letters are not quite so disturbing. Displaying the highs and lows of passion, they take on a kind of coher-

[17] The fact that modern formula romances also involve a component of adventure suggests the enduring functionality of this union. Janice Radway's readers of popular literature, mainly housewives and mothers, repeatedly mention exotic locales and dramatic events among such books' chief rewards; many of the contributors to *Dangerous Men and Adventurous Women*, a collection of essays by romance writers, also explain the appeal of their books in terms of the heroine's bravery and daring. Radway considers this vicarious experience one of the two main compensations that romance offers its readers, although she also implies that readers use this as a rationalization, since it enables them to pass off their reading as educational (113). Likewise, Laura Kinsale and Linda Barlow go further, arguing in slightly different ways that women readers enjoy romances because they identify with the hero, partaking of masculine qualities and experiences. Kinsale says the reader "often *becomes* the hero as she reads" (35), while Barlowe argues, from a Jungian point of view, that "the romantic hero, in fact, is not a man at all. He is a split-off portion of the heroine's own psyche which will be reintegrated at the end of the book" (49). The romance writers seem to me to be bending over backward to counter the charge that romances merely inculcate women's dependence on men, but their assumption that romance reading involves more than the reader's fantasy of being the passive object of a man's attention is extremely useful in understanding Longworth's experience; see Kinsale 32–36.

ence, for love is the ultimate decentering experience, that is one of its attractions. Longworth clearly reveled in this human drama, even when it pained her. But this assessment, too, is incomplete, for Longworth's desires extend beyond the love story, as my final portrait of her as an adventurer suggests. Longworth's letters remind us that reading is by no means predictable or monolithic, that many different narratives will find their way into the hands of an individual reader, and that readers are ingenious enough to select, take apart, and rewrite the narratives they encounter. Longworth manipulated her literary models to cast herself as both object and subject, exploiting several different identifications and points of view, focusing her own experience through the passive heroine, the male seducer, and the soldier as her imagination roamed freely through plots and subject positions.

And, equally important, her reading inspired her to pursue the agency and excitement of authorship. Her ability to create events and developments rather than merely react to them must have been a large part of the appeal of her letter writing. Authorship supplied some control over her position of neglect and loneliness, transforming her from the "Woman Who Waits" to the "Woman Who Writes," as Linda Kauffman says of the heroines of epistolary fiction (25). If Longworth's letters often read like an entirely self-absorbed fantasy, alarmingly insulated from the reality of Yelverton's tepid responses, they also provided a compelling outlet for her active imagination and allowed her to exercise her emotions on a grand scale. Developing strategies for narrating her ambition, her letter writing moved her desire into the real world as she attempted to force Yelverton into the plots she devised. Her aggressive defense of her fantasies after Yelverton's marriage required her to cultivate a range of talents: she spoke and wrote eloquently for a public audience, acted as publisher for her letters, and studied law in order to mount her own defense in the final House of Lords action. Complicitous in patriarchal values, she also protested, strenuously and publicly, against their constraints. If nothing else, Longworth's epistolary romance trained her in the profession she eventually adopted when her master passion ended: she became a newspaper columnist, an author of travelogues, a poet, and a novelist. That is, romantic obsession made her a writer.[18]

[18] The *Dictionary of National Biography* identifies her as an "authoress," though it devotes most of her entry to the trials. It is interesting to note that readers of con-

Femininity on Trial

However rich and compelling as a quasi-literary document, Long-worth's epistolary romance did not lead to marriage. Yelverton's abandonment compelled her to pursue him in court, with the hope of forcing him into the role of husband. Longworth launched herself into the public eye with the Dublin trial of 1861, beginning a new period in her life. Touted as a "romance of real life," the trial became the city's principal public entertainment, drawing a lively audience that hissed, cheered, and applauded throughout the proceedings (*Yelverton Marriage Case* v). Hordes of spectators jammed into the court—more with each passing day—until police were required for crowd control. After enduring three days of pushing, shoving, and trampling furniture, an enterprising court official decided to sell tickets, further closing the gap between the courtroom and the theater. Dropping advertisements to make room for coverage of the trial, local newspapers were snatched up as soon as they appeared, more than making up for lost revenues with additional sales. On the final day of the trial, fifty-thousand people thronged the Dublin streets awaiting the verdict, and, when the court ruled in Longworth's favor, a gang of men unhitched the horses from her carriage and pulled it through the streets themselves, escorting her to her hotel, where she delivered a victory speech from a balcony to the adoring audience.[19] Immediately after the verdict, concerned citizens began collecting contributions for her legal expenses. The public, it seemed, could not get enough of the Yelverton case.

On the face of it, the actual suit could hardly have been more ordinary. Longworth had decided to approach her grievance with a circumscribed, legalistic tactic: she asked a friend of hers, John Thelwall, to sue Yelverton for £256, to cover the cost of some clothing he had bought for her while she was residing with him and his wife. Because a husband was legally liable for his wife's debts, a finding in Thelwall's favor would imply a marriage, although it would not legally establish one or even establish Yelverton's responsibility for

temporary formula romances often take the same path from reader to writer, either inspired by a favorite author or moved by their dislike of a particular book to write something better. See Radway (68–69).

[19] The *Full Report* estimates the crowd at 100,000, but the more conservative 50,000, reported in *Yelverton Marriage Case*, sounds more likely to me.

future debts. But the strategy had the crucial advantage of allowing Longworth to give evidence on her own behalf, as she could not have done if she were party to a suit or claimed to be Yelverton's wife. Moreover, since this action was a jury trial, Longworth hoped—correctly—that an extended appearance before an audience would bring her popular support as a foundation for future actions. Public interest called forth a range of breathless accounts of her appearance and demeanor, complete with stock commentary and illustrations, broadening the meaning of the case well beyond the narrow legal issue to larger cultural questions about gender identity, a result that worked very much to Longworth's advantage. Although, technically, she was not even one of the principals in this most famous of the trials, she dominated the proceedings.

In fact, the case put Longworth's character on trial. As the judge complained, there was very little actual evidence to go on: the Scotch marriage did not require any witnesses or documentation, and the Irish marriage was not really a marriage at all but a blessing or a confirmation. Nor did the correspondence offer incontrovertible proof for either side. No letters referred explicitly to marriage or illicit sex, though key passages could be taken to imply either. Sometimes missing, torn, crossed out, or mutilated, individual letters redoubled rather than resolved this question. One letter, which had clearly been tampered with (though both principals denied having done so), read either "petting sposa bella mia"—"petting my dear wife"—or "possiblemente some petting," reinscribing the question of whether Longworth was a wife or a mistress (*Yelverton Marriage Case* 76–77).[20] In the absence of facts, the judge told the jury that they would have to decide whether Longworth was more likely to have entered into a marriage or an affair.

In light of the passion and unconventionality of many of Longworth's letters, it seemed possible, if not likely, that this ambiguity

[20] Longworth's very identity was in question at times. Attempting to establish whether Longworth and Yelverton had had sex before the Irish ceremony, Emma Crabbe, Longworth's long-suffering friend from the first Edinburgh trip, showed hotelkeepers a lock of blond hair, hoping that they would identify it as Longworth's and thus damage their credibility in court. Later, to the same end, she presented herself to other innkeepers in the hope that they would take her for Longworth. It is possible that these false clues found their way into *Lady Audley's Secret*, serialized at the time of the trial, in which a lock of hair and another woman's body are used to fake Helen Talboys's death.

could have tipped over into deviance in the eyes of the jury. And Longworth did not completely mute her worldliness during the trial. She corrected one lawyer's French, reminded another that she could not testify about another person's state of mind, and joked with the court about her other suitors, confiding that she did not like one of them because "he was short and broad" (*Yelverton Marriage Case* 21). The very existence of love letters implicated Longworth in a dangerous sexual self-consciousness.[21] Furthermore, Longworth had taken the unladylike step of publishing the correspondence herself. This act and her appearance in court, in and of themselves, might be expected to condemn her as unwomanly. Many fictional portraits of women in court suggest this interpretation. These appearances involve "the trauma of being made a public spectacle," with all the sexual connotations that such display conferred (Krueger 338). In *Mary Barton*, for example, Mary is forced to "tell, before that multitude assembled there, what woman usually whispers with blushes and tears, and many hesitations, to one ear alone"—that is, she is made to speak of love in public (Gaskell, *Mary Barton* 390).[22] In the real world, the explosion of journalistic coverage of divorce proceedings in the wake of

[21] The "graphically passionate correspondence" between Madeline Smith and her lover destroyed her reputation even though she was not convicted of his murder in her 1857 trial (Boyle 61; the final verdict was "not proven"). As Kauffman notes of fictional love letters, when women are enjoined to silence and the absence of desire, "transgression lies in telling" (20).

[22] Like Mary and Hetty Sorrel, Rachel of the ominously titled novel *The Clever Woman in the Family* collapses in hysteria and unconsciousness for having "stepped out of her place" by appearing in public (Yonge 253). These characters are "cured" of their desire for attention by relentless, punitive exposure in court. As classic confrontations between institutionalized male power and women's private emotions, these fictional trials present femininity as a disabling condition. The trial scenes in these four novels are suggestively similar, as each resolves itself in the woman's shame and loss of consciousness. The authors' attitudes, however, do vary: Gaskell enlists the readers' sympathy for Mary as she is badgered by a callow lawyer, while the other characters are presented as getting what they deserve; I would argue, though, that even in *Mary Barton*, public exposure functions as a kind of a punishment for Mary's self-willed display earlier in the novel, instilling in her the shame she ought to have felt when she was reveling in Harry Carson's admiration.

The signal exception to this pattern is Trollope's *Orley Farm*—which, interestingly enough, was published serially during the trial. The novel brilliantly renders the authentic performance of femininity, as analyzed by Rivière and implied by Linton, when Lady Mason wins public sympathy and a favorable verdict (which, legally, she does not deserve) by effectively playing the role of the lady she really is, much like Longworth.

the divorce bill of 1857 (part of the Matrimonial Causes Act) repeatedly linked women's appearance in court to sexual conduct.[23] The 1861 Dublin trial unfolded in the context of lurid exposés of female infidelity. But other trials developed in a different direction, suggesting that femininity could yield considerable power in public settings. Both Queen Caroline and Caroline Norton won popular support as the victims of profligate men.[24] One might argue that their aristocratic status lent them special protection; but working-class women also won sympathy and favorable verdicts in breach of promise suits. As Ginger Frost argues, "the advantages of femininity were decided" in such cases (55). These legal actions involved a different set of gender dynamics, marshaling support around the figure of the wronged woman.

In the Yelverton trial, sympathy trumped censure. Longworth became a paradoxically public private woman, made visible to ratify female virtue. This is the great theme of the trial, cast in apocalyptic terms by one of the trial reports: "Years of sincere penitence, exemplary conduct, even the pleadings of a broken heart will not avail to wash away a sin which respectable society never pardons. The SAVIOUR may bring back the lost sheep, but the world will never permit her to rejoin the flock" (*Yelverton Marriage Case* v). This pronouncement might seem unpromising for a worldly woman such as Longworth, but perhaps because the stakes were so high, most of the participants—even, for the most part, Yelverton's own counsel—preferred to affirm gender ideology rather than police the deviance of an individual. Divorce trials might force evidence of female misbehavior into the public arena, but Longworth's lawyers found ways to mobilize the ideology of female purity to her advantage. Neither the lawyers nor the spectators, not even the Chief Justice himself, were inclined to assimilate Longworth's complex rewriting of romance into their understanding. Instead, they reverted to the most simplistic strain of melo-

[23] According to Barbara Leckie, newspaper accounts of divorce trials circulated "the fear that women's sexuality could not be adequately controlled and that women's sexual transgressions would not be adequately punished" (77). She notes that, while in theory anyone might sue for divorce, 97 percent of all divorces were granted to men (Leckie 64). Leckie mentions the Yelverton trial of 1861 in her discussion of adultery trials although the issue there was not technically adultery (65–66).

[24] For fuller discussions of Queen Caroline's trial, see Clark; of Norton's trial, see Poovey (51–88), and Chase and Levenson (21–45).

drama, in which an innocent maiden is persecuted by a vicious rake, and good and evil exist in absolute, undiluted form.[25] This strategy was something of a minor legal tradition, forming an important part of the Queen Caroline and Caroline Norton trials, and was crucial in the widely publicized breach of promise trial of Maria Foote in the 1820s.[26] Longworth's lawyers capitalized on this kind of melodrama in their opening remarks when they urged the jury to vote "in assertion of the cause of virtue" against "the machinations of vice" (*Yelverton Marriage Case* 9). Commentators followed suit, describing her in terms that would do justice to the holiest heroine: "She has walked through the flames unscathed, and she has come forth as a shining example, with scarcely a parallel in history; a heroine of virtue—pure, stainless, gifted, noble" (*Full Report* 112).

Several aspects of the case made this evocation of melodrama both instrumental and persuasive. For one thing, Longworth's formulaic descriptions of her suffering in the correspondence provided an emotionally charged foundation for this approach. Although this self-presentation was compromised by other passages, the situation of the trial itself changed the story of the letters: whereas Longworth had been writing to a lover, by the time of the trial he had thrown her over and so become a villain. Her abandonment would also have taken on public significance in the context of the female redundancy crisis, particularly acute in Ireland because of extensive male emigration and widespread poverty (Nolan 3). By the 1860s, the collision of ideology and demographics suggested that the patriarchal promise had been broken: it could no longer be claimed that middle-class women needed no economic power because men would always take care of them. What could symbolize this crisis more directly than Yelverton's refusal to take Longworth as a wife? The jury had the choice of siding with the forsaken middle-class woman or the callous aristocrat who had left her vulnerable and unprotected in order, it was said, to marry money.

Longworth's publication of her correspondence with Yelverton assisted this interpretation. Furious that many of the letters had been

[25] See Brooks and Mitchell for analyses of this strain of melodrama.

[26] Susie Steinbach's account of the Maria Foote trial is especially cogent, as she links the victimization of the melodramatic heroine to the vulnerable status of women as unequal partners in the marriage contract—"passive recipients of [marriage] promises and innocent victims if such promises were broken" (11). This double victimization accounted for the legal victory of Foote, who, with two illegitimate children, was an even more dubious exemplar of virtue than Longworth.

published without her consent in newspaper accounts of the early legal actions, she issued her own edition, providing commentary, reordering some of the letters, and explaining events that had taken place between them with her own "connecting narrative." As far as I can tell, these rearrangements and explanations have no material effect on the letters' implications, but they strongly suggest that Longworth has been the victim of misrepresentation, implicitly advancing her claim to the role of the injured woman. Equally significant are the ways in which she contextualizes the letters. First, she includes testimonies from her sisters to her good character, representing herself as an honorable woman embedded in a caring family rather than the vagabond she might have appeared to be. Similarly, the trial reports represented her in the most conventional tropes of romantic fiction. The *Yelverton Marriage Case* included particularly evocative illustrations, perhaps because it was published by George Vickers, an experienced and highly successful publisher of popular novels. In an illustration of Yelverton's alleged proposal, Longworth's bashful posture signifies a maidenly modesty in the face of male desire (figure 15). In addition, Longworth provides her own introduction to counter the potential charge of indecorous self-display, insisting that "I am in no sense to be regarded as the desecrator of that sacred confidence which should exist between correspondents" (v). Instead, she argues, she been forced into the public eye to defend her honor as an unwilling victim in a struggle between good and evil: "I stand alone, with the wild, pitiless waves of all that is evil dashing around me, while only a single plank divides me from the bottomless gulf of utter desolation and shame; but that one slender plank is truth, and my helm is conscious rectitude" (vi). Pitted against the "foul insinuators" who interpretively recommit Yelverton's dishonoring of her by regarding her as a mistress, the reader is enlisted to save Longworth's reputation by reading the letters—and Longworth herself—properly, in both senses of the word: a proper—that is, accurate—reading will not perceive any impropriety. Longworth's introduction establishes two of the main strategies used in the trial: first, it identifies her as the innocent victim in a melodramatic plot; and second, it encourages participants and readers to regard the trial as a reenactment of her relationship with Yelverton, in which they must choose the part of hero or villain. The trial became a test of how to treat a lady.

Longworth's behavior on day two of the proceedings might have been enough to establish her identity as a tragic victim: seeing

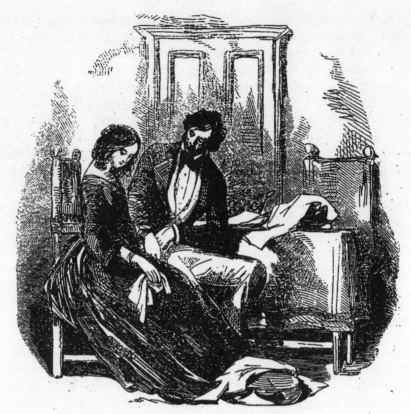

PROPOSALS OB MARRIAGE CONSIDERED.

Figure 15: Head demurely bowed, Longworth listens to Yelverton's proposal. *Yelverton Marriage Case, Thelwall v. Yelverton, Unabridged Copyright Edition* (London: George Vickers, 1861), 53.

Yelverton, she gave a "start of convulsive terror and of horror" and promptly fainted (*Full Report* 93). But if her swoon failed to confirm her pathos, other aspects of her situation would have assisted in her self-presentation. Most important was her work as a Sister of Charity in the Crimea. Longworth's lawyers made much of the fact that Yelverton claimed he had first formed the idea of making her his mistress in Constantinople, when, as they put it, he

> looked upon the beautiful form of an educated and beautiful lady, with the emblem of her Redeemer's agonising death upon her breast, ministering like an angel of mercy to the wounded and the dying—as she cooled the feverish heat in the head of one with the moistened sponge;

as she moistened the parched lips of another with the soothing draught; and consoled the dying with the hope of an eternal reward—with the desire of the reprobate and conceived the desire to ruin her forever! (*Full Report* v–vi)

One trial report opened its account with an illustration of Longworth in her habit, underscoring her purity and his perfidy from the start (figure 16); other illustrations showed her leaning over the bed of a fallen soldier (figure 17).

While the saintly image of Longworth ministering, moistening, and consoling set Yelverton's heinous fantasies in sharp relief, she benefited equally from the insistent construction of Crimean nurses—even Sisters of Charity, in their religious garb—as women of the sort one might meet with pleasure in a drawing room. Treatments of nurses repeatedly stress their qualities: they have a "charming, unaffected manner" ("House" 262), with "a light delicate hand, a gentle voice, a quick eye" (Jameson 76). The habit of a Sister of Charity is "not unlike the present fashion," while her room is the essence of British domesticity, with its "white draped beds, . . . air of cheerfulness, . . . lively but not gaudy papers on the wall . . . polished floors, . . . neat carpets" (39). The Mother Superior is described as "a very elegant nun of fascinating manners" (37–38, 39). The sole purpose of a story in *Fraser's* titled "A Hospital Nurse" is to reassure the reading public that girls could become nurses without loss of caste or gentility; by the end of the story, "pale, tall, delicate-looking Mary" has convinced her cynical brother-in-law that she has chosen a ladylike vocation (96). This unofficial campaign to join nursing and respectability was so strenuous that the editors of *Punch* felt compelled to ridicule it, presenting the conversation of two society girls who are contemplating a future in the Crimea: "MISS NIGHTINGALE had given a *ton* to the thing, and on one's return one would be quite *distingué*" ("Nurses of Quality" 193); the uniform, fortunately, is *"comme il faut"* (194). This concern to normalize wartime nursing by making it an extension of middle-class femininity, which *Punch* found so amusingly inappropriate, helped Longworth by muting its potentially dangerous associations. The patina of British ladyhood mitigated the foreignness of her work with the French Catholic Sisters of Charity. So strong was this image that no mention was ever made of Longworth's stated reasons for nursing: she wanted adventure, and she wanted a way to see Yelverton.

In fact, Longworth's lawyers had little trouble turning her convent life to good account and securing her identity as a proper English-

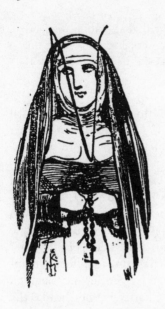

FIGURE 16: The image of Longworth in her Sisters of Charity habit opens this trial report, asserting her purity from the start. *Yelverton Marriage Case, Thelwall v. Yelverton, Unabridged Copyright Edition* (London: George Vickers, 1861), 1.

woman in spite of her French background and Catholic beliefs. They sketched a touching portrait of young Theresa repeating her catechism "with the lisping accents of childhood," then putting those holy precepts to use in her nursing (*Full Report* 94). Although there were no Catholics on the bench, Yelverton's lawyers badly miscalculated the religious allegiances of the Dublin audience: when a lawyer badgered a priest to reveal Longworth's confession, the courtroom erupted in protest (*Times*, 25 February 1861: 5). (Evidence of Catholic sympathy can be found in the ballad "The Grand Triumph of Mrs. Yelverton," written in response to the verdict, which celebrates not only Longworth's triumph but also that of "the holy Church of Rome.") And, when the defense claimed that Longworth's French upbringing and her reading of sophisticated French novels had "tainted" her, her lawyers countered with her fortunate allusions to Scott and Cowper to certify her sound English character (*Yelverton Marriage Case* 58). These particular features of her case helped to construct the comfortable, sympathetic image of Longworth as a model English lady rather than a dubious and passionate foreigner.

What ultimately guaranteed this image was Longworth's supremely persuasive gender performance. Longworth infatuated the public with her ladyhood: "the dignified and lady-like manner in which she expressed herself," the "hair of that rich and glowing hue, in which Titian and the painters of his school delighted to portray their ideal beau-

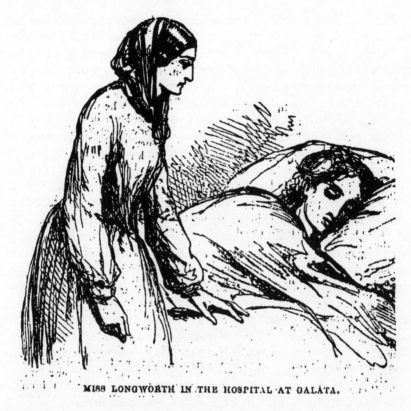

MISS LONGWORTH IN THE HOSPITAL AT GALATA.

FIGURE 17: Longworth nurses the sick in the Crimea. *Full Report of the Important Trial; Thelwall v. Yelverton (Marriage Case) Before Lord Chief Justice Monahan, in the Court of Common Pleas, Dublin* (Glasgow: William Syme & Co., 1861), 52.

ties," her "intellectual power," "great tenderness," and of course her "perfect taste," displayed by her "black silk dress, with a velvet mantilla of the same colour, a white French bonnet, and mauve-coloured gloves" (*Yelverton Marriage Case* frontispiece). Implicitly, public reading of Longworth rested on what Judith Butler calls the necessary coherence of gender identity, the insistence that all the details of dress, behavior, gesture, and so forth add up to a single image, to maintain the fiction that they emanate from a unified and stable essence. Longworth's appearance and manners overwhelmingly did so. Accounts repeatedly stressed her beauty, her comportment, and her accomplishments. And these visible attributes were read back to an interior self, a womanly essence: her "sweet and musical voice, and exquisite propriety of diction, plainly indicated a lady" (*Yelverton Marriage Case* iv).

Although Longworth's letters reflected unconventional desires, she had clearly mastered the signifying practices of middle-class femininity in her person; she performed the expected function of a middle-class woman, well versed in the prescriptions of conduct books and novels: "representing gentility" (Langland, *Nobody's Angels* 27). If her life story happened to lack an obligatory tableau of ladyhood, trial accounts helpfully supplied it, as in an illustration of Longworth playing piano—a scene that, while standard in popular novels, is never mentioned in her letters or in any legal testimony (figures 18 and 19). Such accounts assumed that Longworth's appearance bespoke a clear class and gender identity, which in turn bespoke female virtue. Longworth's body raised the issue of legibility that, as we have seen, preoccupied Basil, Walker, and Munby. Could this young, lovely, accomplished middle-class woman willingly enter into an affair? Could she accept the role of mistress and then enlist the courts of Ireland to declare her a wife? Could she, so visibly a lady, be manipulative, deceitful, and desiring? The trial responded to this possibility no less emphatically than *Basil*'s destruction of Margaret Sherwin or Walker's transformation of bodies into statues. In his instructions to the jury, the Chief Justice stated unequivocally, "It appears to me, though sworn to [by Yelverton], a matter that one can scarcely conceive to occur" (*Full Report* 108).

The idea that Longworth's genteel appearance could be elaborately staged to conceal a different kind of self was inadmissible, exposing as it did the instability of class and gender identities. If playing the piano signifies ladyhood, what is to stop an aspiring adventuress from learning? As we saw in the urban paranoia discussed in chapter 2, such questions troubled mid-Victorian culture, with its fungible status markers and its detailed recipes for genteel conduct. What the Chief Justice could scarcely conceive to occur appeared routinely in novels and was about to occur on a grand scale in the sensation fiction of the 1860s, signaling the obsession with counterfeit female identities.[27] Longworth might be another Lydia Gwilt, the protago-

[27] As we saw, *Basil*'s Margaret Sherwin was one of many such fictional impostors: Lydia Gwilt in *Armadale*, Lizzie Eustace in *The Eustace Diamonds*, Becky Sharp in *Vanity Fair*, and Lady Audley in *Lady Audley's Secret* (all accomplished pianists) impersonate ladies with their melting beauty and their genteel accomplishments, seizing social perquisites—including and especially husbands—to which they are not entitled. These novels both raise and quell the possibility of imposture, presenting duplicitous heroines and then exposing them in the end. To reassure readers that

FIGURE 18: In a conventional scene designed to showcase her accomplishments, Ellen Percy plays the piano in G. W. M. Reynolds's popular novel *Ellen Percy, or, the Memoirs of an Actress*, 2 vols. (London: John Dicks, 1857), 1:305.

nist of Collins's *Armadale*, who outraged an *Athenaeum* reviewer by living "to the ripe age of thirty-five, and through the horrors of forgery, murder, theft, bigamy, gaol, and attempted suicide, *without any trace being left on her beauty*" (x; emphasis added). The trial responded to this anxiety not by spinning sensational tales of conniving women but by reverting to the simple melodrama that, by defini-

such bodies are indeed legible, novels provide clues that redraw the body to reveal its true identity: the lurid Pre-Raphaelite portrait in *Lady Audley's Secret*; Becky Sharp's "hideous tail," signifying her snakelike duplicity (672).

FIGURE 19: As in figure 18, this illustration signifies Longworth's ladyhood by showing her playing the piano, a scene that is never described in the letters or trial testimony. *Yelverton Marriage Case, Thelwall v. Yelverton, Unabridged Copyright Edition* (London: George Vickers, 1861), 64.

tion, could not entertain the possibility of a false self. Longworth's body, potentially the site of subversive sexual experience, became the unmistakable sign of ladyhood, needing no interpretation since it wears its meaning on its well-tailored sleeve.

If Longworth was not a depraved adventuress, commentators still had to reckon with her unmistakable departures from propriety. It was admitted by all that she had been "rash, adventurous, imprudent, ambitious" and had behaved with "great indiscretion" (*Yelverton Marriage Case* v, vi). But her lawyers managed to turn her rash behavior to her favor, capitalizing on her suffering by presenting her as a woman who had loved "too dearly and too well"—almost a stock type, as the Shakespearean echo suggests (*Yelverton Marriage Case* 164). Dinah Muloch describes such a woman as essentially feminine: anyone who is "properly a *woman*" is marked by "one particular— she 'loves too much'" (263). Longworth's romantic obsession was

construed as the highest expression of a woman's nature: "She gave him affection—she gave him her love—a woman's love! Who can fathom its depths? Who can measure its intensity? Who can describe its devotion?" (*Yelverton Marriage Case* 164). In valorizing female emotion, trial accounts define the loving woman not as a passionate sexual mate but as an exemplar of spiritual values:

> Our affections were by an Almighty hand planted in the human heart. They have survived the fall, and repaired the ravages of sin and death. They dignify, exalt, and inspire our existence here below. . . . [W]hen the mysterious union between soul, and body is dissolved, the high affections of our nature, purified, spiritualized, immortalized, may add to the felicity unspeakably reserved for the spirits of the just made perfect, through the countless ages of eternity. (*Yelverton Marriage Case* 164)

Trailing her clouds of glory, the loving woman regenerates those around her with the depths of her love. Incredibly, the sophisticated, peripatetic Longworth, who tells Yelverton that "she must have some petting" and that she has a "*penchant* for drifting around," is remade as the Angel in the House.[28]

Yelverton's testimony could hardly have helped Longworth more if she had scripted it herself. His baldly proclaimed wickedness fit neatly into the format of simple melodrama. Whether he had married Longworth and thrown her over or engaged in an illicit affair with her, he had violated the standards of male propriety. As an officer, he was expected to set a good example; Longworth's lawyers made almost as much of his uniform as of her religious habit, declaring that it, too, was a shockingly inappropriate costume for a seduction. In court, Yelverton played the role of the mustache-twirling villain to the hilt; more than Longworth herself, he was a stock melodramatic figure, resembling "an aristocratic villain from the pages of the *London Journal*" with his loose Regency-era morals and his aristocratic disdain for other classes (Fahnestock 51). His testimony was so offensive that it sounds willfully self-destructive. Told "You appear very cool, sir," by the prosecution, Yelverton replied, "Not in bed" (*Yelverton Marriage Case* 83). Given his identity as a member of the "de-

[28] Only the *Saturday Review* noticed "the lava flame of passion" in Longworth's letters, or recognized her astute management of effects when she presented herself to Yelverton in her Sister of Charity habit "under the most picturesque circumstances" ("Yelverton Case" [1861]: 241).

spised Irish landlord class" with a relatively recent pedigree, Yelverton's class snobbery further eroded his image (Erickson and McCarthy 278).[29] Expounding his theory of seduction, Yelverton asserted that only women of "gentle blood" should be exempt from immoral pursuit; since other women had less to lose socially, their seduction was presumably less ruinous. By "gentle blood" he meant lineage alone; neither education, manners, nor accomplishment guaranteed immunity. This definition provoked intense and lasting public outcry, receiving extended attention in all accounts of the trial and inspiring an entire novel, J. R. O'Flanagan's *Gentle Blood*, in which the flirtatious Captain Silverton learns the error of his class prejudice and marries the middle-class Sybella Longsword.[30] Thus, the trial also staged the competition of two different versions of ladyhood, the mid-nineteenth-century bourgeois ideal of character, manners, and morals, and the earlier privileging of family alone. Yelverton capped his performance with a contempt for religion, dismissing Longworth's desire for a priest's blessing and identifying himself jocularly as a "Protestant-Catholic," a formulation that amused and confounded the spectators.[31] Yelverton's counsel could hardly have drawn a more difficult client. To win their case, they had to present him as a heartless seducer. But defending such a man might tarnish their own reputations. They distanced themselves from him as best they could, one of his lawyers declaring, "There is a vast deal in the conduct of my client, the defendant in this case, which I will not hesitate to deprecate and condemn" (*Yelverton Marriage Case* 135).

[29] According to Bodkin, his grandfather was a wool comber who had risen to a position of political power because of his eloquence and was rewarded with a peerage. See also W. L. Burns, *The Age of Equipoise*, for a brief discussion of the class issue raised by Yelverton's testimony (255–57).

[30] One of the trial accounts sets off this testimony under the heading "The 'Honourable' Major Yelverton's Notion of a Lady," the only heading that does not refer to a particular day of the trial (*Full Report* 60).

[31] Cyrus Redding's popular novel *A Wife and Not a Wife* borrows from the religious dimension of the Yelverton story, though it does not follow it very closely in other respects. Captain O'Brien marries a young Catholic woman and, when he discovers that she is not as rich as he thought, tries to invalidate the marriage by declaring that he was a Protestant at the time of the marriage. The novel rails against the arcane marriage laws that make such a ploy possible, a frequent feature of commentaries on the Yelverton case (though more often directed against the insubstantiality of Scotch marriages than the religious restrictions in Ireland). As this novel, the bigamy novels of the 1860s, and *Gentle Blood* suggest, the Yelverton case presented a variety of possible plot complications.

With these principal roles clearly established, the trial restaged the melodramatic contest between virtue and vice. The defense lawyers became the villains who repeated Yelverton's dishonoring treatment, and the prosecution served as the lady's champion. After being booed for their disrespect, Yelverton's lawyers switched their tactics and diluted their accusations to the vanishing point: "I do not mean to say a single word in her general disparagement," says one (*Full Report* 52). Far from privileging male power, the court was predisposed in Longworth's favor. As one of Yelverton's lawyers told the jury: "I cannot but feel that the presuppositions of yourselves as well as those of the audience would in all cases be in favour of the woman and against the man. I would be extremely sorry that it were otherwise" (*Yelverton Marriage Case* 55). Longworth's lawyers capitalized on the early attacks on her character, representing their legal defense as a form of chivalry: Yelverton's lawyer, said one, "impeaches her virtue, questions her chastity, assails her honour, and I stand up to defend them all" (*Full Report* 146). In their closing speech, her lawyers called on the jury and audience to join them in their chivalrous enterprise: "She finds an advocate in you—in the respected judge on the bench— in every heart that beats within this court—in every honest man throughout the kingdom" (*Full Report* 103).

The Yelverton trial functioned as a "social drama," a public event that forces society to declare its values (Turner, *Dramas* 340). The trial functioned not to control female deviance—Longworth's admitted imprudence and ambition—but to reassure the public of its own humanity. Perhaps this is its greatest debt to the simplistic melodramas of the theater: like them, it constituted "a remarkable, public, spectacular homage to virtue," allowing not just Longworth but the entire community to bask in its own moral glow (Brooks 25). Longworth became a powerful symbol whose welfare reflected the good values of her society. Whereas Yelverton's predatory sexuality and atavistic belief in "gentle blood" assumed that class and gender hierarchies were sites of exploitation, the trial's outcome defined them as relationships of protection and responsibility. *Communitas*—a sense of social harmony—was at stake, foregrounded by the issues of class, nationality, and religion raised by Longworth's particular circumstances (Turner, *Dramas* 231). In fact, her minor divergences from Englishness—the Catholicism and French upbringing that might have alienated the public—may actually have enhanced the sense of *communitas*, intensifying her pathos and lending an especially grati-

fying high-mindedness to popular sympathy. Creating a community
from the shared endorsement of her virtue, the trial was portrayed as
leveling political and religious divisions: "Her being an English-
woman had no effect in damping the ardour of the most bigoted Mile-
sian or Ultramonist,—her having been a Sister of Charity and a con-
vert to the Church of Rome did not check the sympathy of the most
intolerant Orangeman" (*Times*, 6 March 1861: 5). The verdict pro-
duced an orgy of *communitas*, as spectators "shook hands with
people they did not know, save that they looked as glad as them-
selves" (*Freeman's Journal*, 5 March 1861: 2). Finding against her, one
commentator wrote, would "inflict an indelible stain on the great
body of the community" (*Full Report* 103).

Thus the trial quieted anxieties about patriarchal failure and fe-
male adventuring in a single stroke. But it must be noted that while
the suffering woman symbolized social unity based on a shared hu-
manity in this particular instance, the sex as a whole did not benefit.
One reason why audiences and attorneys found—or made—Long-
worth such a sympathetic figure is that her case did not claim any
new political or social power for women (as Caroline Norton's trial
did, for example). Indeed, Longworth claimed only the most tradi-
tionally esteemed female role, that of the long-suffering wife. No real
public power was at stake, although Longworth's personal status de-
pended heavily on the outcome of the trial. The trial displaced real
social conflict, offering up the chivalrous protection of one individual
without having to acknowledge the unequal economic positions of
men and women that placed Longworth—and, according to census
figures, tens of thousands of women like her—in such a tenuous posi-
tion in the first place.

Only one group resisted the framework of melodrama. In yet an-
other incident worthy of fiction, the Chief Justice asked the women
in the audience to leave the room because he expected to hear sexu-
ally explicit testimony. Many simply refused to go. In the words of
one account, the Chief Justice had to "personally remonstrate with
some of them individually," and they left only with "a good deal of
reluctance" (*Yelverton Marriage Case* 55). Better schooled than the
men, perhaps, in the erotics of suffering, they gave melodrama the
same deviant gloss that Longworth did, looking forward to sexual ex-
citement rather than moral edification. The Chief Justice finally suc-
ceeded in hustling them out of the court, ostensibly for their own
good. I like to imagine these prurient women leaving through the

ladies' door, set aside during the trial to maintain the fiction of deli-
cate female sensibilities.

This amusing piece of stage business reenacts, in miniature, the
business of the trial: to erase the sexually conscious woman and re-
place her with a saint. Fittingly, these women are reconstructed in
one of the trial reports as barometers of purity, the group that can be
counted on to gauge Longworth's character because their "moral
sense . . . is sound and true with regard to woman's virtue": "No in-
tellectual powers—no charms of manner—no plausibility of state-
ment—no romantic incidents—no strange vicissitudes, could attract
the regard or secure the interests of the ladies of Ireland toward one of
their own sex who had sacrificed the jewel of her honour, even for a
coronet. . . . With quick perception, with an intuition that seldom
errs, they detect the real character through every disguise" (*Yelverton
Marriage Case* 5). In fact, these women are exactly the appropriate
judges since they seem to understand so much better than any of the
other participants the "real character" of Longworth and her story.

The trial ends on a delightful note of irony as Longworth, in the
role of Virtuous Woman, displayed throughout Dublin waving from
her carriage, delivers a victory speech from the balcony of her hotel
(figure 20). She begins, " 'My noble-hearted friends, you have made
me this day an Irishwoman . . . ' [Vehement cheering.]" (*Full Report*
55, 8). The identification between Longworth and Irishwomen is fit-
ting: both challenged cultural definitions of femininity with their un-
seemly interest in sex, and both were protected from the conse-
quences of this fall by those very definitions. We know that ideology
does not always describe actual behavior, but the Yelverton trial is an
especially glaring stance of ideology as wish fulfillment. Despite the
apocalyptic claim that the world "never pardons" a sexual transgres-
sion, the trial demonstrated a certain "give" at the level of behavior
and a schizophrenic willingness to separate behavior and ideology.
Neither the public's pardon nor Longworth's absolute purity led to
her resounding victory. Instead, paradoxically, gender ideology pro-
tected its transgressor and preserved itself by refusing to notice that it
had been transgressed.

The Dublin trial was the high-water mark of Longworth's saint-
hood. Focusing more tightly on legal issues, subsequent trials re-
vealed the unique leverage Longworth had gained by performing be-
fore a popular audience and a jury. These social actors constituted a

FIGURE 20: Longworth is drawn through the streets of Dublin by her admirers, continuing her career as a public-private woman on display. *Yelverton Marriage Case, Thelwall v. Yelverton, Unabridged Copyright Edition* (London: George Vickers, 1861), 191.

particular interpretive community to which Longworth also belonged. Well versed in the conventions of romantic and melodramatic literature, they reveled in the suggestiveness of literary language and the drama of events, which gave credence to the gestalt of femininity on which Longworth's success depended. But the trials that followed involved a different interpretive community consisting entirely of judges and lawyers. The cues that immediately triggered the literary associations of a popular audience did not have the same effect on legal professionals searching for unambiguous evidence, nor did these professionals see Longworth's melodramatic rhetoric as evidence of her innocence. Instead, they found themselves frustrated by the

"richly ambiguous, subtly coded, prolix and polyvalent" character of literary discourse, complaining, "Instead of plain matters being stated in ordinary language, we are asked to extract marriage and promise of marriage from metaphors, riddles, dreams, imaginary dialogues, and vague allusions" (*Longworth or Yelverton* 205).[32] Moreover, in the absence of a popular audience, lawyers could attack Longworth more freely. In the 1862 Court of Sessions case that united actions by Longworth and Yelverton into one suit, Yelverton's lawyers called her "a rather fast girl," "wanting in female delicacy," "bold and unfeminine," and—perhaps most alarmingly—"a woman who knew the meaning of language" (134, 136).[33] They noted that Longworth had traveled to the Crimea with the purpose of seeing their client and that she had clearly been the pursuer through much of their correspondence. Without self-appointed protectors to denounce such accusations, the lawyers could mount a more effective attack. One judge who ruled in her favor added that both Yelverton and Longworth had "so contravened the established proprieties of social life as to deprive them of sympathy" (164).

This is not to say that the values and rhetoric of the Dublin trial disappeared altogether. In the 1862 Court of Sessions case, one lawyer repeated the Chief Justice's categorical refusal to believe that a lady could also offer to be a man's mistress: "It is scarcely credible that a lady in the position, and with the talents and accomplishments of the pursuer, should deliberately make such a proposition" (*Longworth or Yelverton* 154). Another argued that her letters simply could not express "what rarely occurs in a well-educated Englishwoman—that sensual passion has usurped the place of virtuous love" (173). Newspaper accounts continued to rehearse Longworth's beauty and accomplishments and to dub her story "romantic." And audiences—though smaller and more specialized—continued to gather at the proceedings. An unusual number of peers attended Yelverton's successful ap-

[32] This complaint recurs throughout the transcript (*Longworth or Yelverton* 146, 150, 173, 196).

[33] Indeed, the judges studiously disavowed such compromising knowledge of language: referring to Yelverton's promise of "bon-bons . . . [not] real ones," the Lord Ordinary announced that these were "words to which the defender attaches a meaning of a kind which it is not necessary to mention, and which the Lord Ordinary, who does not adopt the defender's meaning, does not at present understand" (*Longworth or Yelverton* 107). How the Lord Ordinary is able to judge that it is unnecessary to mention the meaning of words that he does not understand remains a matter of mystery.

peal before the House of Lords in 1864, appearing "on any pretense that could be obtained" (*Times*, 29 July 1864: 9).

Still, as one judge declared at Yelverton's appeal, "The question which we have to decide is one of law only; not of honour or morals" (*Times*, 29 July 1864: 11). In the 1864 appeals case, the gap between the legal and literary interpretations of Longworth's story appears vividly, revealing the extent to which the rules of interpretation had changed. Both Longworth and Yelverton were operating under literary assumptions, each attempting to invoke the ideology of female purity, though to opposite ends. Yelverton averred that he and Longworth had cohabited in Scotland before the Irish ceremony in an obvious attempt to discredit her as a fallen woman. Longworth, for her part, insisted that she had waited for Father Mooney's blessing, once more assuming the role of devout Catholic that had proved so effective in the Dublin trial. In this she succeeded—but with disastrous results. In claiming that she and Yelverton were married *subsequente copula*, Longworth had to establish that both the promise and the *copula* had occurred in Scotland; no act in Ireland could finalize a marriage under Scottish jurisdiction. Declaring that she had held fast to her religious scruples, Longworth simultaneously invalidated her marriage. The judges measured the sincerity of her conviction by its terrible legal cost: "Her respect for the religious aspect of marriage led her to a course of action fatal to her own interests" (*Times*, 29 July 1864: 9). Demonstrating her sexual purity, Longworth forfeited a victory in court because, while her actions accorded with social beliefs about female virtue, they did not satisfy the legal test for marriage.

Moreover, her active pursuit of legal satisfaction fatally eroded her image as a vulnerable ingenue. In addition to her repeated actions against Yelverton, she mounted ill-advised and unsuccessful suits against the *Saturday Review*, which had printed two unflattering articles about her, and against Emily Forbes, the woman Yelverton had married. Longworth struggled to maintain her image, writing pathetically to the *Times* that she still hoped that "God's providence" would grant her "some little crumb of good" as a reward for "striving well and faithfully to do my work" (6 August 1867: 6). She asked the "British Press and public" to champion her as it had throughout the Dublin trial, but the sympathy she retained did not translate into any concrete power (6). The social capital Longworth gained from the Dublin trial was fragile and intangible, not secured by any legal, economic, or institutional status. It depended on her keeping the anom-

alous aspects of her behavior below the tipping point, where it was still possible to understand her as a paragon of virtue. Her role was essentially static, heavily underwritten by the simple fact of her ladylike appearance. She was a body frozen on a stage. Her attempt to sustain this identity called attention to the paradox on which it rested: that her repeated self-display through lawsuits, novel writing, and letters to editors was not really consonant with the passivity of the melodramatic heroine but instead required a certain immodesty and aggressiveness. In the article that provoked her lawsuit, the *Saturday Review* portrayed her as an adventurer who "schemed as no modest woman would scheme" ("Yelverton Case" [1864]: 135), while Hepworth Dixon attacked her autobiographical novel *Martyrs to Circumstance* as a "coarse" piece of self-promotion, with its adoring descriptions of the heroine's dainty feet and saintly virtues (Crow 235). Inserting her iconic status into a temporal flow with her continuing demands for justice, she revealed the agency and intentionality that kept her in the public eye. The Victorian ambivalence about display which Longworth played on so creatively in her correspondence assisted in her undoing.

Life after Yelverton

Having failed in her first attempted career—marriage—Longworth pursued a second life as a writer. Although the love affair she had sought never fulfilled her, she plucked several important threads from her romantic fantasies, most obviously the power of authorship. Longworth hardly achieved literary distinction; *Martyrs to Circumstance* is sometimes laughably bad, though it was published by Richard Bentley, one of England's foremost houses. But, publishing her books under some variation of "Therese Yelverton, Vicountess Avonmore," she did appropriate the authority to define and represent herself through her characters and as an author, and she did achieve financial self-sufficiency. In place of a single partner, Longworth substituted a readership; in place of the woman's passive, unequal role in the marriage contract and the properly retiring role of wife, she negotiated a more equal, gender-neutral contract with her audience and a delicately balanced position between public and private that kept her name—but not her body or her sex life—in respectable circulation. As a writer, Longworth found a more dispersed, less

volatile, and ultimately more reliable arena for the admiration she craved.[34] Ironically, Longworth found her libidinal needs better met outside of romance.

Exercising an erotic imagination that had been tempered by experience, Longworth re-created her affair in more satisfying—if wildly divergent—terms as a novelist. Written immediately after the Dublin trial and set entirely in the Crimea, *Martyrs to Circumstance* reinscribes the formulaic plots and characters of historical romance and melodrama. Barely disguising names and circumstances, the novel bends events and personalities to concoct a sentimental, wish-fulfilling tale of true love. The heroine, Thierna, is an unconventional but virtuous nurse in the Crimea whose lover, Captain Etherington, is persuaded by his heartless mother to give her up for a rich widow; when he is fatally wounded in battle, Thierna dies nursing him. *Martyrs to Circumstance* was clearly written to cement public sympathy by retelling Longworth's story in more conventional melodramatic terms. It must also have satisfied her in several ways: she created a passionate suitor whose love never wavered, punished him for his transgressions, and perfected herself as the blameless and beloved Thierna. Published about ten years later and set in Yosemite, *Zanita* strikes a much darker tone; the aim of this wish-fulfilling fantasy is revenge. The heroine, Zanita, an Indian changeling, is pure id with a passion for the aristocratic but shady Egremont which is all animal magnetism and jealousy. But the novel never judges her, presenting her as a force of nature, a true child of the Yosemite who cannot be tamed. Competing for Egremont with her saintly cousin Rosie, Zanita disappears with him one night; the next morning both are dead, Egremont lying grotesquely disfigured at the bottom of a crevice, Zanita preserved in perfect beauty floating in an icy lake. Deeply bereaved by both deaths, Rosie eventually recovers and marries Kenmuir, a close friend of the family (obviously modeled on John Muir, founder of the Sierra Club, whom Longworth met during her travels in the United States). One can imagine Longworth sending Yelverton/Egremont to his grisly death with relish, and can equally see the appeal of the wild Zanita, who cares for nothing but her own

[34] Again, her life looped back into fictional models: Longworth followed the path of Fanny Butlerd, who turns to the public for support by publishing her love letters once her aristocratic partner abandons her. My understanding of Longworth's transition from lover to author is indebted to Cook's analysis of audience and the author-reader contract in Butlerd's story.

impulses and is not one to take romantic betrayal lying down. I think of her as a release from Longworth's strenuous efforts to maintain her ladyhood, from the need to overlay her passion, anger, and aggression with appropriately pathetic rhetoric. And perhaps Longworth also projected herself into Rosie, the perfect lady who never feels any unconventional impulses and who is saved from the worthless Egremont to marry a chivalrous savage. Different as they are, the stories have two elements in common: both decry the redundancy of British women, and both are narrated in the first person by a happily married, respectable woman who is not one of the protagonists. In the role of narrator, Longworth escapes romantic obsession.

After reworking her love story in novels, Longworth gave up erotic plotting altogether (except for a brief, improbable epistolary fling with John Muir), concentrating instead on her love of adventure.[35] Surprisingly, Longworth's romantic obsession led to a life as an independent, free-spirited woman, which allowed her to integrate her competing personas in the role of a lady traveler.[36] The adventure she imagined in romantic fantasies and historical romances came to her directly, without the mediation of a male companion. Journeying to the United States, she became friends with Muir and Bret Harte (she contributed a poem to Harte's new journal *Overland Monthly* in 1869) and described her wilderness travels in *Teresina in America*. In the early 1870s she traveled to Asia and America to continue her life

[35] Longworth could hardly have found a better candidate for the role of the chivalrous savage than Muir, a gentleman who was also rugged and perfectly at home in the wild. Their relationship is treated by his biographers, who generally consider her a neurotic and unwelcome hanger-on (see Clarke 88; Turner, *Muir* 206). The exception is Bade, who describes her as "one of the most noted women of her time, and a warm friend of John Muir" (1:279). For his part, Muir expresses a genuine affection for her, thinking when he hears of her stranded at night alone in the Yosemite, "It seems strange to me that I should not have known and felt her anguish in that terrible night, even at a distance" (Bade 1:238).

[36] She did not completely give up her animosity toward Yelverton in this new genre. Under the guise of cross-cultural reporting, she briefly indulges her old grievance, calling Ceylon "A Woman's Paradise" for its female polygamy and noting with approval the American custom of shooting men who renege on a promise of marriage (*Teresina Peregrina* 2:162; *Teresina in America* 2:285, 1:312). Occasionally she uses her travelogues to defend herself directly, as when she describes an encounter with a trapper whom she meets on the train, who tells her, "Many a time, when our three-month post used to be brought in, I have burned my midnight oil to read those tender words of yours. . . . [Y]ou had better have married a *bear* than a nobleman" (*Teresina in America* 2:15).

of adventure. She insists on her ladyhood, decrying demands for women's rights as unfeminine and complaining about the lack of proper ladies' maids on American trains (*Teresina in America* 2:5). Yet she also insists on her courage and daring: during a terrible typhoon in Hong Kong harbor, she proudly reports that she is the only woman aboard the flimsy ship and more than holds her own with the sailors. Trapped in a canyon in Yosemite alone in a blizzard, Longworth sleeps in a hollow tree wrapped in her saddle pad with her horse's head drawn next to her for warmth—a far cry from the romantic evening on deck with Yelverton cuddling under the plaid shawl. The canyon was reportedly named after her, the first white woman to discover it, in a characteristically complicated gesture toward her romantic past and her newfound authority. Although the name she used was surely Yelverton, implying her refusal to give up her master passion, she appropriated Yelverton's patrimony against his will as her own property and appropriated the prerogative of naming in order to memorialize herself.[37]

In the end, travel writing better accommodated Longworth's unusual personality than love. In Gloria Steinem's famous phrase, she became the man she wanted to marry. In *Teresina Peregrina* she writes poignantly, "I never had anything my heart desired in my life until I had ceased to wish for it"—a clear reference to the pleasure she found in life once she gave up Yelverton (1:214). The woman with a "penchant for drifting about" finally made a profession of it; the Waiting Woman with the overheated imagination finally became the Woman Who Writes for a Living. The lonely young woman with "nothing to do but write and paint" spent her last year in South Africa in the midst of the war in Transvaal. She gained a measure of local celebrity as Kate the Critic, a satirical columnist who skewered the respectable male citizens of the town—perhaps a delayed and displaced reaction to the British court system and to Yelverton himself. And, although she had failed to make him her husband, she won one last, posthumous victory in the *Natal Witness*, the paper that published her columns. Calling her "the heroine of the famous Yelverton case," it legitimated her self-constructed identity, affirmed her self-proclaimed innocence, and overturned the final verdict of the Yelverton marriage cases when it titled her obituary "The Late Lady Avonmore."

[37] Crow claims that the canyon bears her name (265), but I could find no indication of this on maps.

5 *My Secret Life*

The Consolation of Pornography

In *My Secret Life,* the anonymous sexual memoir that has become the official exemplar of Victorian pornography, we see the most frank, explicit, extended document of erotic self-fashioning in nineteenth-century Britain. For Walter, the pseudonymous protagonist, sex *is* identity: in eleven volumes, Walter never carries on a conversation, eats a meal, travels, or reflects on any subject unless sex is involved. In this respect the memoir diverges widely from the other texts I have examined here, especially those expressing the displaced, highly fraught male sexuality of the spermatorrhea panic and the experience of men on the street. Bypassing indirection, *My Secret Life* is monomaniacally devoted to sex, sex, and more sex, an unfathomably narrow range of experience that, along with Walter's "recherché" experiments, has helped to define it as perverse (1533). But within this narrow range, *My Secret Life* engages some of the most critical issues of the sex-gender system, especially the apparently indissoluble link between gender identity and sexual orientation which Foucault calls "sex-desire" (157). Not only does Walter understand himself as a bold rebel fighting an anti-pleasure regime (that is, as an Other Victorian), but also his sexual experiments themselves challenge the fortified body boundaries of masculinity, the defensive distancing of other bodies, and the polarized, hierarchized positions of masculinity and femininity, heterosexuality and homosexuality. I take these challenges seriously, although I also note their limitations: indeed, both the experimental and the conservative elements of Walter's encounters flow inseparably from his position as a bourgeois man. Still, I have been drawn to his text not only because it is indispensable for anyone interested in the Victorian erotic imagination but also because it illustrates the transformative potential of the "shock" of sex (Lane 29). Walter's sexual escapades

protest the straitjacket of bourgeois, heterosexual masculinity, perpetually unraveling it and reforming it into strange new designs.

In more recent years *My Secret Life* has functioned almost exclusively as a shorthand for "sexist Victorian pornography," though it has seldom been read in any detail, with the obvious exception of Steven Marcus in *The Other Victorians*; for this reason I quote it fairly extensively. It has been characterized as exemplifying the domination of women: Marcus insists that Walter's "women are transformed into something less than human beings" (134); Susan Gubar identifies the book with the "dehumanization" and "objectification of women" (48); and Ian Gibson accuses Walter of sadism (186).[1] Over the course of its 2,300 pages, it is certainly possible to find incidents that confirm these judgments and that ally the text with the classic pornography condemned by critics such as Andrea Dworkin, which graphically represents men's unquestioned power over women through sexual possession (30–31).[2] Moreover, in Walter's stupendous sex drive and women's eager receptiveness we can see the fantasy of utopian pleasure, in which men never have to cope with fear or failure.[3] At times, *My Secret Life* provides the "images of unimpaired masculinity" that obscure the gap between ideological ideals and actual men, participating in the "mésconnaissance" that allows the penis to masquerade as the phallus (Silverman 42). If the spermatorrhea panic negotiated this gap by punishing the body and installing "hard" moral character as its tyrannical overseer, *My Secret Life* covers it with anecdotes of unqualified sexual success.

But in spite of its chronicling of Walter's potency, *My Secret Life* does not entirely collapse the penis into the phallus. Instead, along with these wish-fulfilling moments, it displays fear, anxiety, and failure as Walter ricochets from glory to humiliation, betraying idealized

[1] See also Fraser Harrison's comparison of Walter and Alec D'Urberville, discussed by Meckier. Meckier takes a less judgmental view of *My Secret Life*, seeing it as a parodic rendering of the relationship between love and money. Neither Gubar nor Harrison spends much time on the text itself; similarly, while Foucault and Mason mention the text as an exemplary document in the history of sexuality, neither attends to it in any detail.

[2] For other versions of this "pornography is the theory, rape is the practice" argument, see definitions of pornography as a "legal text" or "Here's how" of male supremacy (West 112, Stoltenberg 69).

[3] This description fits a revisionist approach to pornography, which sees it as a wish-fulfilling fantasy that compensates for men's felt lack of power. An illuminating version can be found in Bordo (290–98).

images by exposing his conflicted psychology and dwelling on the inadequacies of his penis. A product of the culture that invented spermatorrhea, he is repeatedly scolded about the terrible consequences of masturbation by his censorious godfather, and retains, even in his wildly experimental adulthood, a sense of degradation about this practice. In his younger days, he is equally disturbed by his homosexual impulses, though he struggles mightily to overcome his scruples. Although Michael Mason rightly observes that Munby and Walter are on opposite ends of the sexual spectrum—the one a timid idealist (Mason considers him a virgin) and the other sexually insatiable—they share their internalization of ideological norms and their quest for shame-free sex (46). Whereas Munby wraps himself in a pastoral myth, Walter thumbs his nose at his culture and evolves a conscious philosophy that repudiates these teachings, declaring that sex is a "natural, virtuous, wholesome connexion"—though the repeated failure of his philosophy to free him from shame, a constant source of frustration, testifies to the power of ideology (83).[4]

Nowhere is the failure of mésconnaissance—the recognition of *mis*-recognition—more obvious than when Walter dwells on the inadequacies of his penis. When he is young, his prepuce is too tight to move, and his mocking friends make him feel deformed. As he grows older, beset by fears that his member is too small, he is sometimes driven to the device of asking prostitutes for reassurance: "My prick's not a very big one, is it?" Walter observes plaintively, to which the women always obligingly make a "complimentary" reply (379). (It seems not to occur to him that they could hardly say anything else and keep his business.) And, to his mortification, experiences of impotence abound.[5] Issues of what Marcus dubs "intactness" preoccupy Walter: Is his penis as big as other men's? Will he be able to maintain an erection? Will he please his partner? Will he escape venereal disease (171)? As much a record of male anxiety as of male potency, *My Secret Life* overturns the taboo against representing the penis *as* penis—that is, as an unpredictable, vulnerable organ. In this, Walter does directly what spermatorrhea surgeons could do only indirectly, creating in his memoir a place of bodily self-exploration.

[4] See, for instance, 119, 128, 130, 148, 201, 292–94, 313, 829, 1505, 1568, 1667, 2020, 2054, 2099.

[5] As Gibson remarks, "It is hard to think of any Victorian book in which the misery of impotence is transmitted so convincingly" (185).

Moreover, the coexistence of these contradictory images and incidents—some lionizing Walter's superhuman appetites, others revealing him as pathetically insecure—suggests the need to read *My Secret Life* as a complex text with multiple meanings rather than to assume uncritically that it has a simple, single meaning, as universalizing condemnations of pornography often do.[6] Above all, *My Secret Life* is concerned with the mysteries of masculinity. Critics continue to debate whether the text is real or fictive, a relevant question as far as historical accuracy is concerned; but no matter what its historical status, the text is an invaluable record of the fantasies produced by heterosexual masculinity.[7] Whether Walter really sleeps with over twelve thousand women (and a number of men) or merely fabricates the most fulfilling sex life he can conceive, *My Secret Life* shows what form his desires take when he sets out to rewrite or escape ideological mandates. Perversely—as of course is appropriate for this document of perverse appetites—I offer a sympathetic interpretation of *My Secret Life* as a manual for deconstructing masculinity.

Sociable Sex

One of the most conspicuous ways in which Walter challenges ideology is in his relationships with women. Although our assumptions about pornography might lead us to expect a reenactment of the gender hierarchy played out through sexual relations, Walter's endless copulations, most of them based on mutual desire, revise Victorian gender codes. As Marcus notes, Walter's ideas about female sexuality diverge wildly from "the official version" (120), including Acton's famous pronouncement that "as a general rule, a modest woman seldom desires any sexual gratification for herself" (394). Even if we

[6] See Wicke on assumptions about the "transparency or univocity of the pornographic artifact" (71). One of the few critical works actually to read pornographic texts rather than simply impose a single generic meaning on them is Linda Williams's *Hard Core*, which remains an incisive account of the destabilizing possibilities of graphic sexual representations based on her close and theoretically informed interpretations of a wide range of pornographic films.

[7] Mason assumes that the text is a true account of actual experience (44), while Marcus insists on its authenticity, a word that recurs frequently in his two-chapter discussion (94, 114, 118, 120, 123, 124). Gibson, Gay, and Meckier consider it a fabrication based on very little actual sexual experience (173, 468, 168). For an extensive discussion of its authorship, see Gibson.

choose a more liberal Victorian expert who accepts the possibility of female pleasure, Walter's endless parade of perpetually randy, sexually experienced women is a startling one. No doubt the responsiveness of these women was a flattering ideal, enacting the fantasy of the total gratification of male needs. But at the same time that it serves male interest, it also grants women an active sexual desire. Instead of the polarized roles of active men and pure, passive women, Walter imagines sexual partnerships: body parts may distinguish men and women (though Walter narrows this gap with his atavistic belief in female ejaculation), but their desires and pleasures are identical.[8] Creating matched sets of erotic adventurers with uniformly desiring bodies, the text fulfills Angela Carter's controversial version of pornography's promise: it "declares [itself] unequivocally for the right of women to fuck" (27). Walter imagines a closeness between men and women beyond what is possible in everyday genteel life, in which men and women can enjoy each other's society only under tightly controlled, closely supervised circumstances, and conversation and behavior are carefully scripted to enforce indirection and distance. In brothels and bedrooms, on sofas and in carriages—and, of course, on an omnibus, *Basil*'s ultimate site of nasty urban eroticism—*My Secret Life* creates a kind of anti-world to the decorum of the drawing room and the anxiety of the street, a place where men and women enjoy what Walter sees as the ultimate human connection—sex—without paranoia or shame. It is impossible not to object to some of Walter's encounters; but in its own bizarre way *My Secret Life* offers a relatively sunny, egalitarian depiction of male-female relations, a counter-fantasy to the defensive voyeurism and dangerous liaisons that fill my earlier chapters.

[8] See Laqueur's classic discussion of the transition from the single-sex model to the belief that men and women had radically different sexual physiologies, and also for the persistence of the single-sex model throughout the nineteenth century (233–34); on this persistence, see also Mason (204). While Walter's belief lags behind cutting-edge Victorian science, the question of female ejaculation has been reopened by both scientists and sex-gender theorists. Surveying recent research on the subject, Zaviacic and Whipple conclude, "the phenomenon of female ejaculation exists" (150). Ideologically, female ejaculation and its denial have been understood as significant, since ejaculation has been associated with potency and pleasure (and since what women have reported as ejaculation has generally been redefined by doctors as urinary incontinence). For two well-known essays on these issues, see Linda Williams's essay "A Provoking Agent" and Chris Straayer, "The Seduction of Boundaries."

With this model of gender similarity and shared desires, many of Walter's encounters are companionable—even, in his early years, charming. With one of his first partners, Walter shares his volume of *Aristotle's Masterpiece*, a popular medical handbook that he regarded as a fount of forbidden knowledge, and ends one of his "romps" with a pillow fight (45).[9] In dissolving barriers of modesty and ignorance, sex leads to intimacy between men and women: "Nothing opens a man's and woman's heart to each other like fucking" (96). Walter understands sex as leveling even class distinctions, although, as I will argue later, this utopian belief must be seriously qualified or even wholly rejected. But Walter maintains it in theory, arguing not only that all women are united across the class divide by their love of sex—"women are all the same, from the princess to the peasant," as he bluntly puts it (375)—but also that men and women are united in the same way: "A washerwoman would banter with a prince if the subject was cunt, without the prince being offended. To talk of fucking with a woman is to remove all social distinctions" (624). My point is not to argue that this is really the case but rather to insist that Walter's fantasies do not usually take the form of domination scenarios; what he seeks instead is familiarity, even intimacy, with sex as the universal solvent, eroding barriers between men and women. Especially in his youth, Walter sometimes becomes deeply involved with his sexual partners, using terms such as "honeymoon" and "marriage" to convey his sense of intimacy (185, 238). He and his first partner, Charlotte, he tells us, "loved each other with all our souls" (75). Walter represents their relationship as an equal partnership, to which she brings affection, passion, and a firsthand knowledge of women's bodies of which he is deeply appreciative. Walter is not wholly romantic; in retrospect he attributes his intense feelings to mutual lust rather than to any profound admiration for each other's character. Still, their model is the companionate marriage: they are "in all respects as much like man and wife as circumstances would let us be," pooling their money, giggling over their escapades, weeping over separations (83).

Nor is he immune to falling in love. Perhaps the most touching episode involves his relationship with Sarah Mavis, a beauty who, ac-

[9] In a later episode he enjoys "cuddling" on the bed with his partner (277). For a discussion of the multiple versions of *Aristotle's Masterpiece*, see Porter and Hall 33–64.

cording to Walter, posed for the painter William Etty and turned to prostitution only out of economic necessity (549). Here Walter is more a lovesick swain than a cool seducer, surveying himself in a mirror to find the best angle for displaying his erection as a less sexually obsessed man might check out his hairstyle or outfit. He declares his adoration for her, sobbing when she threatens to leave him, offering to marry her and adopt her children. When she cuts short his visits, he is furious; when she treats him like a husband, ecstatic. Possessed by the beauty of her body, he also imagines a fuller relationship, again like a companionate marriage: "[I] liked the domesticity of sitting and reading to her . . . I liked her conversation" (566). It is true that while Walter reads to her he is also feeling her up; every emotion, thought, and behavior passes through sex. With Sarah he seeks a complete integration of love and desire, uniting emotional and tactile sensations so that they reinforce and express each other.

If his later attachments lack the tenderness and depth of his early ones, they remain egalitarian and friendly, taking on the form of erotic partnerships. In Camille, another woman named Sarah, Jessie, and H., Walter finds willing sexual collaborators who feed his appetite for novelty with their own superior experience.[10] Typically, as he confesses a fantasy—sometimes with shame or trepidation—his friend reassures him, provides appropriate partners, participates, and later reminisces with him. These postmortems are the scenes of much companionable sex talk, knitting together relationships that sustain themselves over time—in the case of the later Sarah, more than four years. Because of his libertarian philosophy, Walter understands himself as participating in an exhilarating subculture; once they find each other, he and his partners create an oasis of permissiveness in the midst of what they understand as inhibiting social norms. Brilliantly, Marcus has termed *My Secret Life* a "pornutopia" to stress Walter's pursuit of every conceivable sexual pleasure (268). It is also utopic in imagining private spaces of sexual and linguistic freedom. Walter and his partners are in league together, supporting each other in their shared interests. Of H., a sexual collaborator who has moved to the country, he says, "Living far off now, without a male or female friend with whom to talk about sexualities, more than ever now she looked to our days of meeting, and hours of unrestrained voluptuousness"—as if she were a fellow philatelist who had moved

[10] Marcus identifies H. as Helen Marwood (186).

to a land without stamps (2193). Walter offers his partners the chance to confide their secret desires, repeatedly taking the role of the confidant, "a willing listener who had no canting objections" (2017).[11]

This pairing of language and sexuality is one of the hallmarks of *My Secret Life*. Making women talk dirty is one of the ways in which Walter breaks down reserve and establishes intimacy. Like sex itself, Walter's graphic talk rejects a taboo of polite society, violating in particular the prescribed modesty of femininity. It may be reductive to call the Victorian era "the golden age of euphemism," as Joss Marsh does, but Walter clearly understands his bawdy talk as a protest against convention (215). This is one of his bonds with his partners; as he says of H., "Both of us liked to call a spade a spade" (2193).[12] Like a secret handshake or a mysterious password, Walter's sexually explicit vocabulary marks a special community that defines itself against mainstream culture. Thus his meetings with one of his partners begins with a parody of polite behavior: "Our conversations used to begin by my asking 'How's your duff?' 'Oh! nicely, thank you; how is your jock?'" (172). Moreover, though I argue that in most ways *My Secret Life* does not fit mainstream definitions of pornography, it does conform in one important respect: it maintains an unwavering belief in the libidinal power of sex talk. In her famous critique, Catharine MacKinnon classes pornography with other texts in which words are, in legal terms, tantamount to actions, defining the genre as "part of a sex act" that "gives men erections," a form of foreplay whose effects are as physical as if they had involved actual bodily contact (101). Walter would concur wholeheartedly with this claim, but with the significant caveat that words arouse women as well as men. Dirty talk often accompanies orgasm, marking a simultaneous corporeal and verbal climax: " 'In my cunt a—ha,'—burst from her," Walter reports of one such moment, which leaves both partners "in a transport of all-pervading voluptuousness as we lay speechless in

[11] See also: "She was delighted to get a confidant in me, to whom she could unbosom herself unreservedly" (490); "it was as if for the first time in her life she had had a confidant" (601).

[12] His language may also represent a protest against the class dimensions of respectability, if, as Marsh claims, blasphemy and its related transgression of obscenity represent "a class crime of language," euphemism being the sociolect of the bourgeoisie (8). For Walter, bawdy language is a kind of common denominator of all people which, like bodies and sexual desire, levels social distinctions; thus, as he says, "a washerwoman may banter a prince" about sex (624).

each other's arms," completely spent in language and desire (894). His seductions often involve a vocabulary of escalating explicitness; when he arrives at the word "fuck," he senses his partner's readiness (182). As Marcus argues, this certainly is one of the pleasures of writing a sexual autobiography: as Walter rereads and revises, he reexperiences his pleasure as well—and so, presumably, will future readers (187). In this implied theory of language, words are not intended to connote delicate shades; they are incantations that automatically effect arousal, and they need only to be uttered to call forth the same magical effect again and again.

"I've fucked you,—I'm a man you see"

This bald-faced, nearly parodic declaration—"I've fucked you,—I'm a man you see"—seems to rescind all the progressive implications of the relationships I have described (406). Locating masculinity in his erect penis, Walter claims the subjective coherence of a unified gender and sexual identity. This formulation of heterosexual manhood nods toward a crude biological bottom line, a heterosexist Nature that has configured male and female anatomy so that they are a perfect, unquestionable fit. This assumption, and the cultural laws that follow from it, grant Walter the privilege of fucking because he is a man, and they certify him as a man because he has successfully fucked. If, however, this moment decisively knots together masculinity and heterosexuality, it also exposes their separate threads. Walter's declaration hints at the need to certify something uncertain, which in fact is the case. His euphoric self-definition follows a double emasculation in which he is browbeaten by his wife and then fails to make love to a servant who has taken pity on him. Walter's apparently definitive statement reflects the relief that he has finally, after strenuous and humiliating effort, achieved some official version of manhood, not that he automatically enjoys that status because of his always-already erect penis. Moreover, by linking his gender identity to his sexual performance and the gender of his partner, Walter reveals his masculinity as relational and contingent. He cannot simply *be* a man; he requires an erect penis, a willing woman, and a consummation. "I'm a man you see" does not simply affirm an identity that is already there but actually constitutes that identity: Walter's successful fuck is a performative sex act. What was he when he could not

maintain an erection—a woman? a homosexual? a eunuch? Walter's obsession with the proper phallic functioning of his penis speaks not only to his sexual performance but also to his gender identity and sexual orientation. Marcus's term "intactness" usefully captures the interdependence of bodily performance and subjectivity.

Yet for Walter, intactness is a burden as well as an ideal. Alongside and intertwined with the familiar male fantasy of sexual domination lies a contradictory desire to participate in other selves and subject positions. Among the qualities that have led critics to see pornography as a blueprint for patriarchy is the iconography of sex itself: the man on top penetrating the woman with his active, thrusting organ; the woman on the bottom passively receiving the royal penis. Angela Carter disdainfully calls this the "mythically correct, sacerdotal position," designed to ratify the gender hierarchy (7). In contrast, *My Secret Life* yearns for sexual and subjective plenitude by multiplying the possible meanings of intertwined bodies: its sexual permutations offer graphic, literal explorations of the locatedness and relationality of subjectivity. Walter's pornutopic fantasies court the vertiginous excitement of sexual and subjective anarchy.

To appreciate the significance of Walter's experiments, we need to see how Victorian men are made. Maintaining a strong belief in innate gender roles, Victorian culture nevertheless understood mature manhood as the result of a multistage developmental process. Though traced in terms of institutions and practices rather than detailed psychodynamics, this version of masculinity has much in common with psychoanalytic theory, with its emphasis on maturation as a dynamic and potentially unstable process dependent on a series of shifting identifications.[13] Ideally, at every stage the subject takes on a particular gender identity and libidinal object, realigning subjectivity and sexuality to produce the heterosexual man. But because the process of identification is potentially destabilizing, opening the self to competing identities, and because the relationship between gender role and sexual orientation does not conform neatly to the requirements of Foucault's "sex-desire" system—that men love only women

[13] Psychoanalytic theory analyzes different modes of taking in other identities, distinguishing among identification, incorporation, and introjection. I have not specified Walter's experiments in detail but have followed Fuss's lead in using "identification" as a subsuming term (*Identification*).

and women love only men—it entails a delicate balance of fluidity and stability that is not easy to achieve. In earlier chapters I stressed the importance of masculine body boundaries as literal and metaphorical markers of subjective coherence; in the context of male development, the tension between shifting subjectivities and the desired fixity of adult selfhood may also account for this defensiveness, as men struggle to resist the claims of abjected selves. As Walter's memoir makes clear, this developmental process, though dedicated to producing a stable union of masculinity and heterosexuality, can also open the way to less fixed and categorical erotic experiences.[14]

Boys are expected to arrive at adulthood by proceeding through three institutions: home, school, and marriage. Samuel Smiles's influential conduct book *Character* lays out this developmental scheme. In the first stage, the mother achieves a paramount importance to her young sons through what Smiles calls "imitation" (49). The cult of the home insists that the mother be an object of adoration and respect. In addition, she serves as a model of selfhood to her sons, whose identification with her is "constant" and "unconscious" (49, 78): they "mould themselves after her manner, her speech, her conduct, and her method of life. . . . [H]er character is visibly repeated in them" (50). The word "unconscious" suggests that this imitation is profound and ineradicable, that the mother lives on in and through her sons.[15] But this feminine identification implicitly threatens masculinity. In adult life, Smiles posits the familiar polarities of Victorian ideology: women are the "heart," men are the "brain," and so forth (51). How, then, does the mother-identified son, formed on a female model, become a masculine man?

In his chapter titled "Companionship and Example," Smiles attempts to bridge the developmental gap with the homosocial world of the boys' school, taking Tom Brown's Rugby as a prime example. In

[14] John Tosh provides a related description of male development but differs in emphasizing the Victorians' strong "sense of innate sexual difference" (103). It seems to me that beneath this confidence lay a fear that identity was undermined by the very conditions of its construction, as my discussion indicates. Nevertheless, Tosh's argument provides valuable insights into the ideas and experiences of growing up male in nineteenth-century Britain.

[15] Tosh discusses the extent to which this ideal could be realized in actual lives, finding Evangelical families the most likely to actively promote the mother's moral authority (114).

fact, the cult of the boys' school, developed around Dr. Arnold and the Tom Brown series, may reflect the importance and difficulty of this transition from the feminized home to the masculine public world.[16] Once again, imitation plays a central role, as older boys serve as models for younger ones as a matter of institutional policy—or, as *Tom Brown's Schooldays* unsentimentally puts it, the older students must set a good example because "the boys follow one another like herds of sheep" (Hughes 144). Under the praepostor system, younger boys apprentice themselves to older ones in order to learn masculinity, aspiring to become, in Thomas Hughes's nicely suggestive phrase, "cock of the school" (98). Smiles never explains how the first generation of students come to be boys and so fails to resolve the problem of identification within male development. As if in tacit recognition of this difficulty, he attributes an almost supernatural effect to male influence, which acts by "inspiration, quickening and vivefying" (91)— a series of metaphors that posit a rebirth from a male parent figure to supplant actual maternity. At this point femininity, though embodied in the sacred mother, becomes the identity against which the son defines himself. As John Tosh observes, "Becoming a man means leaving women behind—or at least the women who have provided nurture in childhood" (112).[17] Boys can succeed at Rugby only by distancing themselves from their original identification: "Don't ever talk about home or your mother," Tom advises a new arrival (188).

At the same time, Smiles's eroticized description of male influence introduces a new problem. That influence consists of "an electric power, which sends a thrill through every fibre, flows into the nature of those about him, and makes them give out sparks of fire" (91). These metaphors clearly invoke the romantic friendships, akin to love affairs, that flourished in boys' schools at mid-century. It is by now a truism that the homosociality of school became a defining feature of men's emotional lives, and in some instances of their erotic lives.[18] Affection and emulation go hand in hand; describing the "pas-

[16] Tosh sees the boys' school as "an indispensable introduction to the company of males" (105); see his discussion of how individuals made the transition from home to school (104–7).

[17] See Tosh's discussion of a father's concern about "the contagion of femininity" when his son stayed at home too long (120).

[18] For instance, see Tosh (110). For a fictional treatment, see *Coningsby:* "At school, friendship is a passion. It entrances the being; it tears the soul. All loves of after-life can never bring its rapture, or its wretchedness" (*Disraeli* 72). Other fic-

sion," "rapture," and "wild satisfaction" of his friendship with Con-
ingsby, Oswald Millbank reflects that there is, "not a gesture, not a
phrase from Coningsby, that he did not watch and ponder over and
treasure up. Coningsby was his model" (Disraeli 72). It is easy to see
how the idealization of schoolboy friendships not only celebrated
masculinity but also masked forbidden homosexual activities that
follow logically from homoerotic attachments. As we saw in the con-
text of the spermatorrhea panic, single-sex schools were understood
as hotbeds of alarming depravity as well as noble friendships. John
Addington Symonds recalls his own experience at Harrow as a bar-
rage of distinctly unromantic sexuality: "Here and there one could
not avoid seeing acts of onanism, mutual masturbation, the sports of
naked boys in bed together. There was no refinement, no sentiment,
no passion; nothing but animal lust in these occurrences" (1:94). This
second stage of development, which promises to set boys on their
proper masculine course, in fact produces the same problem as the
first stage: it links imitation and attachment. At this stage it is easy
to see how boys become men but not how they become heterosexual
men.[19]

In the final stage of development, men must commit themselves to
heterosexuality, though this transition is even more inexplicable
than the male identification of the boys' school.[20] Once again, young
men trade one attachment for another, substituting young women for
schoolmates, while their initial affection for the mother is allowed to
reemerge in the form of heterosexual love. To smooth Tom's transi-
tion, *Tom Brown's Schooldays* explicitly capitalizes on both his male

tional treatments include *Lady Audley's Secret, Hard Cash,* and *Tom Brown's
Schooldays,* which normalizes Tom's relationships by condemning the "sickly ro-
mantic friendships" in which "miserable little pretty white-handed curly-headed
boys [are] petted" by older boys (233). Debates on victoria@listserv.indiana.edu sug-
gest the complexity of separating emotional and erotic elements from these friend-
ships; exchanges focused primarily on Tennyson and Arthur Hallam but also refer to
Edmund Gosse and Rudyard Kipling (see Bristow, 6 May 1997; Kolb, 7 May 1997;
Kolb, 16 May 1997; Norton, 24 May 1998, for representative comments).

[19] For discussions of Symonds's school experience and his understanding of homo-
erotic desire, see Buckton (60–106) and Lane (34–35). For more a extensive discussion
of conceptualizations of homosexuality that developed through public school life, es-
pecially the study of the classics, see Dowling (67–154). See also Lane's discussion of
the "asymmetry" of masculine desire, under which rubric he includes the unstable
relationship of desire and identification.

[20] See Gay on sweethearts as mother substitutes (*Tender Passion* 21–34).

and female attachments when he develops an instantaneous crush on his friend Arthur's mother. Tom's gaping admiration is so obvious that Arthur chides him for forgetting his manners, while Tom finds himself wondering "if Arthur's sisters were like her" (321). The wife is the mother refigured, instituting a "regimen of domestic affection" that "will insensibly elevate" her husband's character by her example (Smiles 336, 342). But the persistent literary triangle of hero, best friend, and sister/mother/wife suggests that these developmental switchbacks are not easily navigated: *Coningsby*, *Lady Audley's Secret*, and *Hard Cash* all marry the hero off to the friend's sister, whose convenient resemblance to her sibling facilitates the trade.[21] Even the ideology of separate spheres, a spatial ideal that embodies the polarity of masculine and feminine, reflects the persistence of dual identifications, as the husband goes to the homosocial world of work in the morning only to return to the wife's realm of domestic influence at night, as if to regulate the divergent tendencies of manhood.

Even in adult life, then, alternative identifications and love objects lurk beneath the proper ones, so that identity must stabilize itself by denying these shadow selves. As psychoanalytic theory tells us, subjectivity is a composite, a layering of conflicting identifications and attachments. In this light, Smiles's "imitation" is a kind of "mental infection" in which other subjectivities cross ego boundaries to infiltrate the self (Fuss, *Identification* 41).[22] Fuss eloquently describes the chaos of this subjectivity by accretion: "Identification thus makes identity possible, but also places it at constant risk: multiple identifications within the same subject can compete with each other, producing further conflicts to be managed. . . . The history of the subject is therefore one of perpetual psychical conflict and of continual change under pressure. It is a profoundly turbulent history of contradictory impulses and structural incoherencies" (49). While this chaos is implicit in Smiles's theory, it is masked by the description of smooth developmental progress in which each stage graciously gives way to the next. But in contemporary theoretical accounts, develop-

[21] It has also been suggested that such a dynamic was at work in the relationships of Tennyson, Gosse, and Kipling, though it is riskier to attribute an unspoken motivation to the lives of actual people (see the victoria@listserv citations in fn. 18).

[22] This language sets up an interesting resonance with the fear of infections from other bodies discussed in chapter 2, linking urban fears about sexual invasion with male development.

ment is either a perpetual struggle or a recurring experience of loss, in which inappropriate selves are amputated in the name of stability.

Moreover, normative masculinity is further complicated by the dangerous relationship between identification and desire. Classic Freudian theory insists that, after the pre-oedipal stage, the two exist in inverse relation: a male identification comes with a ready-made desire for women.[23] But other theorists, more in line with Smiles's scheme than Freud's, argue that identification and desire are linked, so that to identify with a woman is to find her desirable as both a model and a love object.[24] It is difficult to separate the wish to be like someone and the wish to have someone, because they are in some sense the same: "The desire to be like can itself be motivated and sustained by the desire to possess: being can be the most radical form of having. Identification may well operate in the end not as a foreclosure of desire but as its most perfect, most ruthless fulfillment" (Fuss, "Fashion" 737).[25] This is precisely the unexamined consequence of Smiles's and Hughes's developmental models: at each new identificatory stage until his final adult position, the boy takes on a new sexual orientation along with his new gender identity.[26]

[23] See Fuss: "A simultaneous desire for and identification with the same object would be a logical impossibility for Freud" (*Identification* 67).

[24] This is the crux of Sedgwick's famous argument that homoerotic identification is an important but disavowed part of oedipal progress, creating strong same-sex attachments that heterosexuality mediates but does not necessarily replace by positioning a woman "between men." *Character* and *Coningsby* modify this claim in a historically specific way: homoeroticism is not disavowed in the world of school, but soon afterward the erotic component of male friendship must be transferred, by some mysterious process, to women. In a sense, Victorian ideology makes a finer and trickier distinction than Sedgwick, accepting homoeroticism at one stage in life while pathologizing homosexuality entirely.

[25] This is the crux of the Oedipus complex—the movement toward exclusive identification with the same-sex parent and, concomitantly, toward desire for the opposite sex. According to Parveen Adams, Freud, like Smiles, fails to resolve the critical issue of how such a movement is stabilized so that it erases all vestiges of its complicating origins: "We will not have any satisfactory explanation of how femininity and masculinity are knotted into positions of relative fixity" (22). For Adams, "an insistent play of bisexuality" is the logical outcome of Freud's theory of development (24). Unlike Freud's formulation Smiles's idea of imitation suggests the plausibility of a direct relationship that links object choice and identification.

[26] Feminist versions of object relations theory stress the difficulty of female development because the daughter is forced to maintain an identification with the mother while giving the mother up as a love object and switching her erotic attachment to

Thus the norms of adulthood ensure that loss, pain, and confusion are part of "successful" development.[27] In her account of identification, development, and normative roles, Judith Butler has famously argued that subjective norms entail melancholia, as the subject mourns for the selves and erotic objects it has had to discard to achieve coherence (*Gender Trouble* 57–72). This insight has inspired my chapter title "The Consolation of Pornography" (with apologies to Boëthius, who is spinning in his grave), for through sex play Walter consoles himself for these losses, finding ways to recapture, in controlled settings, his abjected selves and desires.[28]

In its broad terms, Walter's forced march toward adulthood resembles the model I have described. In his early years he is surrounded by women, with "scarcely a boy acquaintance," while his mother inculcates the values of purity and innocence, keeping him away from the grooms and male servants to protect him from their crude example,

men—unlike sons, who have the presumably easier task of maintaining the sex of their object choice while switching only their identification from mother/woman to father. But male development is equally complicated because it requires the boy to maintain his object choice while taking masculinity as his model. Like the daughter, he must separate the intertwined forces of identification and desire, maintaining his love for women but repressing his investment in femininity.

[27] Marcus labels Walter's experiments "polymorphous perversity," referring to the infant's as yet undisciplined erotic impulses. To me this characterization is inaccurate in two ways: first, it ignores the ongoing conflicts in sexuality and identity and the extent to which they are built in to "normal" development. Second, and underlying this first problem, is the assumption that social norms of sexuality and identity are intrinsically healthy, so that a retreat from normative adulthood is automatically immature or neurotic. It is hard to make a case for Walter as a supremely healthy specimen, but his experiments carry much greater ideological significance than Marcus's label allows.

[28] Boëthius warns the sensualist:

> Who tasts those joyes which fading pleasure yields,
> His age will rue the follies of his youth:
> But if you travell in the spatious fields
> of learned Arts, there seeking pretious truth,
> The sacred Treasure, which you thence have gained,
> In wants and troubles shall your succor prove. (23)

Countering with his description of the index to *My Secret Life*, Walter implies that pleasure never fades and no succor could be more serviceable than reliving erotic experiences: "It . . . presents almost at a glance the large number and variety of amusements which the sexual organs afford to both men and women, from early childhood to extreme old age and even to their last hours, the most agreeable reminiscences" (2315).

including their sexual knowledge (when Walter steals off to watch a stallion mount a mare, he is quickly hustled away) (18). But Walter learns to manipulate this enforced female identification to camouflage his erotic intentions. Taking advantage of his status as an honorary female—his mother calls him a "great girl"—he dallies with his mother's friends and steals kisses while sitting on their laps, a practice that his mother cannot quite fathom but nevertheless forbids (35). Living in a woman-centered world gives him access to female bodies that he increasingly finds desirable. Significantly, at this stage in his life he is attracted only to older women; for instance, he resents being expected to dance with girls his age, preferring to keep company with maternal figures. For Walter, the proximity of bodies has a powerful effect, and they imprint their desirability on his imagination.

Walter's school experience introduces a new combination of self-hood and desire. Like the students of Rugby, he learns his male identification from other boys; but rather than modeling manly behavior on the playing field as Tom Brown does, they endlessly compare the size of their penises. Made of sterner stuff than Symonds, Walter participates in male sex games with gusto. Among his educational routines are "frigging parties" with other schoolboys, which combine the compare/contrast mode of learning about male bodies with adventures in sexual pleasure (29). It is intriguing to attempt to reconstruct the dynamics of these rituals; certainly they do not include "I've fucked you,—I'm a man you see." For one thing, there is no fucking, only touching and looking. Potency is not signified by penetration, especially not in relation to a passive, receptive vagina. Counterintuitively, it is the erect penis that is passive in this setting, dependent on the motion of another person's hand to stimulate and guide it. Moreover, sexual positions are interchangeable: everyone is touching and being touched, and everyone is male.

In addition, this interchangeability provides bodily self-knowledge. Walter avidly reports the size and shape of other penises as a way of gauging the strange changes of his own developing body. While the specter of impaired masculinity hangs over the proceedings, motivating boys to check their equipment for acceptability, they make their comparisons among actual organs, each different, each displaying the variable features of real bodies rather than the absolute properties of a cultural image. And, in a further complication, these homosexual pleasures also extend Walter's heterosexual education as the boys pool their limited knowledge about women and recount their imagi-

nary seductions while they touch one another. Walter says: "The pleasure of frigging, now I had tasted it (and not before), opened my eyes more fully to the mystery of the sexes, I seemed at once to understand why women and men got together" (52). In Symonds's letters, this revelation might be explained by the feminine identity ascribed to attractive boys, who were given girls' names and called the "bitches" of their partners, but Walter describes no such custom. Instead, his desire for women grows from his arousal by other boys and by the sight of other erect penises.[29] For boys with a purely theoretical knowledge of heterosexual intercourse, homosexual play clarifies the physical pleasure of inserting a penis into an enfolding body part, with a boy's hand standing in for a vagina. Walter does not elaborate on his new understanding, but he may also be discovering the collaborative aspect of sex, the excitement of arousing or being aroused by another person which solitary masturbation cannot provide.

Thus, schoolboy sexuality refuses two essential propositions of normative masculinity: first, the developmental move of separating identification from desire in order to knit masculinity and heterosexuality into an exclusive union; and second, the bifurcation of sexual orientation into homosexuality and heterosexuality. Seen in this light, Walter's homosexual activity is less interesting as a specific, recognized perversion than in its simultaneous engagement of heterosexuality, homosexuality, and masculinity. I do not mean to idealize this stage of sexual development. The frigging parties fill Walter with dread about his inadequacies and encourage him to gloat over boys who are less well endowed. Schoolboy sex is not simply an instance of supportive male bonding. But it does construct adolescent male sexuality as a hybrid affair that challenges the either/or structure of sexual orientation.

Walter's first encounter with a prostitute, under the tutelage of his precocious cousin Fred, reflects these sexual experiments. Although such a sexual initiation sounds conventional enough, the introduction of a woman adds a layer of heterosexual pleasure to Walter's development without canceling out homosexuality. Walter joins Fred in

[29] Walter does not explain how homosexual play leads to an understanding of heterosexuality, although we can assume that he applies his growing knowledge of women to the limited range of sexual pleasures that are actually available to him. When he leaves school, he develops a distaste for frigging, concentrating instead on bedding female servants whenever he can, but he does not explain how and why he makes this change.

propositioning two young women, though, in comparison to his brazen cousin, he is anxious and timid. Fears about venereal disease beset him so that he cannot perform. But Fred comes to the rescue, pushing his own woman against the bed and yanking his erect penis out of his pants. Walter says, "An electric thrill seemed to go through me at this sight, I pulled the other into the same position at the side of Fred's" (117)—a nice parallel to the "electric . . . thrill" that Smiles considers part of the influence of older schoolboys. The two boys begin to have intercourse with the women, looking all the while at each other's penises. Then, at the peak of their excitement they touch each other so that they ejaculate at the same time. What is the "sight" that thrills Walter so corporeally? It is three sights, calling into play different kinds of vision. First is the sight of Fred's prostitute locked in Walter's voyeuristic gaze. Second is the sight of Fred's penis as an erotic object, aroused by the prostitute but also available to Walter for sexual pleasure. This is a particularly graphic example of the positioning of women between men, in Eve Kosofsky Sedgwick's phrase, in which the presence of the prostitutes allows Fred and Walter to share a homosexual experience under the guise of heterosexual sex. I am not sure what kind of vision operates here, because I see this sexual excitement as inextricably entwined with the third: the sight of Fred's erect penis as a model of heterosexual masculinity, capable of inspiring similar erection in Walter's stubbornly flaccid one through a visual dynamic of identification. Walter self-identifies as a man, putting himself in Fred's place as he situates himself and his prostitute in the same position as the other couple and his penis obligingly takes the erect posture of Fred's organ. This mirroring allows him to participate in a particular gender-coded bodily practice, extending the schoolboy initiations in which boys are both models and erotic objects.

In *Male Matters*, Calvin Thomas describes his reaction to an incident from his own childhood in which he watched a boy defecate on school grounds: "[I was] thrilled . . . positively *beside myself* with glee on witnessing this event" (2). In addition to the obviously thrilling transgressions of defecation (and at school, no less) and voyeurism, Thomas notes a third: being "beside myself," stepping out of one's own skin to inhabit vicariously another's body, thereby violating "the boundaries of ego coherence" (2). This understanding of vision as something that takes you out of yourself is very different from its role in museums and on city streets, for example, where it

objectifies what it looks at and de-corporealizes the viewing subject. For Walter, vision is almost a form of touching, an intimate way of seeking knowledge as well as arousal, and gives way to shared physical contact. As Walter simultaneously touches the prostitute with his penis and Fred with his hand, his orgasm is both heterosexual and homosexual. Although for once Walter offers almost no description of the women, their genitals, their actions, or their words, I do not think this is because Fred and Walter are "really" homosexuals; it is because, in this early, anxiety-fraught sexual encounter, it is Walter's use of Fred as both a mirror and a source of excitement that makes his heterosexual pleasure possible. In addition to refusing the abjections of development, Walter refuses the historical process by which, as Foucault argues, homosexual practices become understood not as discrete acts but as the symptomatic behaviors of a perverse being called "the homosexual." Imagining an erotic realm beyond the brutality of "sex-desire," Foucault envisions "bodies and pleasures" liberated from such official, categorical identities (157). Walter's experiments suggest that these bodies and pleasures are available even within the system of sex-desire. For Walter, homoeroticism is one of an ever-changing kaleidoscope of delights rather than an exclusive orientation.

Decades later, Walter's multidimensional pleasure culminates in what he calls "the crowning act of my eroticism" (1533). Still excited by the sight of other men's penises, which he spies in various bawdy houses, Walter asks Sarah, his friendly procuress, to find him a clean man with whom he can learn more about male sexuality. For the adult Walter, the penis still seems as fascinating and mysterious as the dark continent of female sexuality, and though he has concerned himself at other points with detailed descriptions of female genitalia, here he seeks to satisfy what he calls "the desire and curiosity of twenty years," that is, "knowledge of . . . the penis" (1548). It may seem odd that twenty years of nearly unbroken sexual activity would have left his curiosity unslaked. Nevertheless, perhaps because representations of female bodies abound while men's actual bodies remain largely veiled to protect the phallic ideal, Walter understands himself as embarking on an unprecedented quest for bodily self-knowledge.[30]

[30] Although Linda Williams argues in *Hard Core* that pornography seeks knowledge of female sexuality, hidden from male view in the interior of the female body in contrast to the visible penis, *My Secret Life* suggests that, at least in the nineteenth century, men lacked first and foremost the knowledge of their own bodies. As I noted in chapter 1, the idea of the veiling of the penis is a staple of masculinity studies; see

Once again, he seeks a combination of ways of knowing: visual and external, that is, how the body looks; and tactile and internal, that is, how the body feels. Thus he needs the presence of a second man, again, as a mirror and double as well as a homosexual partner.

Sarah finds an out-of-work craftsman named Jack who is, to Walter's relief, clean, quiet, and clearly not a male prostitute. (Walter's uneasiness at their meeting is almost touching; less like a hardened debauchee than an adolescent on his first date, he thinks, "What an ass he will think me. . . . What's *he* thinking about. . . . How shall I begin—I wish I had not come. . . . Then an idea came. 'Would you like something to drink?' " [1535–36]). When Walter fails to arouse him after much fondling, the two begin to discuss women, which excites them both.[31] Sarah disrobes, giving Jack an erection; Walter says admiringly, "He was a model of manly, randy beauty" (1540). Walter begins to touch him while Jack touches Sarah. Watching Sarah, Walter also becomes erect, and, when Jack comes, Walter enters her while continuing to touch Jack. Excited by the prospect of mingling sperm with Jack, Walter encourages him to have intercourse with Sarah, while Walter touches them both: "My hands roved all over them" (1541). After Jack ejaculates inside Sarah, Walter enters and does the same, realizing his fantasy of mingling semen with Jack and Sarah as well, owing to his archaic belief in the single-sex model of sexuality, which assumes that women ejaculate as men do: "My spunk—his spunk—her spunk—all in her cunt together. . . . The idea of my prick being drowned in these mixed exudations overwhelmed me libidinously" (1541). Later, Walter persuades Jack to engage in anal intercourse. At one point Walter literally puts himself in a woman's place when he sucks Jack's penis; remembering a delightful experience with a French prostitute, he says, "I did exactly what had been done to me as nearly as I recollected" (1546).[32] In fact, Walter's initial desire to hire a male partner stems from his voyeuristic self-placement in a woman's position: "The handsome pricks which I had

Bordo for an especially cogent discussion, and Kestner for a historically specific one, centering on Victorian paintings (esp. 237).

[31] It is worth noting that, whereas Fred was the erotic inspiration in the prostitute scenario, a woman fulfills that function here, suggesting the shifting nature of sexual orientations.

[32] Interestingly enough, the woman-sucking-man's-penis position was, for Walter, itself originally a reversal of cunnilingus. While he is licking a female partner early in his sexual career, he gets an inspiration: "Do to me what I am doing to you . . . put it in your mouth" (91).

seen women play with, the ease with which their doodles were han-
dled, the ready way a girl brought a rebellious prick to stand and
spend by coaxing it in her mouth, etc. [one wonders what Walter has
omitted here], raised again the desire to feel and play with a prick my-
self" (1534). The intactness of Walter's identity as a heterosexual
male is challenged by his penis's changing relationships—to a man,
to a woman, to a vagina, to a hand, and eventually to a rectum—as
well as by the shifting erogenous zones of genitals, hand, and mouth.
Eventually he buys a large mirror and sets it up by the bed for self-
voyeurism, replaying the visual dynamic of identification he ex-
ploited so successfully with Fred and the prostitutes.

Once again, these erotic scenarios combine homosexuality and het-
erosexuality, identification and desire. For Walter, Sarah is both a
prop to stimulate the less adventurous Jack and a source of excite-
ment in her own right. Jack is simultaneously an erotic object and a
model of manhood, a source of knowledge about masculinity. And
normative masculinity itself is rewritten, if not actually erased for a
moment, in the welcome breaching of body boundaries. Looking back
to the spermatorrhea panic, we can recall the punitive treatment of
semen as everything that violates masculine "continence." Liquid
rather than solid, lacking firm boundaries, leaking out through the
body's borders, this emission had to be disowned to preserve the
myth of the self-controlling, autonomous body. We remember, too,
the fear of the erotic miasma of urban women, a parallel threat to
male self-control figured in bodily boundaries. Walter's "spasm of li-
bidinous sympathy," mingling bodily fluids, embraces incontinence:
not only does he thrill at the breaching of his own bodily boundaries,
which leaves him almost unconscious with pleasure, but also he de-
liberately immerses his body and its effusions in the bodies and effu-
sions of others. Walter clearly understands himself as throwing over
yet another taboo: "Sperm is now to me clean, wholesome" (2033).
The image of three streams of bodily fluids merging suggests the mo-
mentary collapse of the gender hierarchy, and even of difference.
Once again, Walter certainly could not conclude this performance by
crowing, "I've fucked you—I'm a man you see."

Over a period of several weeks, the three meet many times and ex-
periment with many different positions and possibilities. As they
proceed, Walter decides that Jack is becoming more and more femi-
nine; his skin is now soft and pale since he is no longer working (in a
traditional sense) and spends most of his time indoors. Eventually,

Jack dons a pair of women's stockings and shoes. Does this mean that he is taking the feminine position so that Walter can disguise his homosexual desires as heterosexual ones? Has Jack always been latently feminine—whatever that means—and therefore consented to take the role of a man's lover in the first place? Has his feminized role as the partner whom Walter orders around and who is frequently "on the bottom" turned "a model of manly, randy beauty" into an honorary woman? Or does he become a person with another distinct identity—a transvestite, who, as Judith Butler claims, has a gender as real as anyone else's, though not one that conforms to social norms. My aim is not to answer these questions but to recognize the making and remaking of sexualities and subject positions in these diverse erotic encounters. Defying a single coherent subjectivity gives the encounters their distinctive charge—what Thomas describes in his childhood memory as being "thrilled . . . beside myself" and what Walter calls, variously, "excited beyond measure" (1549), "distracted" (1543), and "overwhelmed" (1541). After be sodomizes Jack, Walter says, "I came to myself—how long afterwards I cannot say" (1563). I want to take these metaphors almost literally: Walter finds these encounters so vertiginous—ecstatic, horrifying, unhinging—precisely because his sense of selfhood is at stake.

In spite of the traditional characterization of pornography as enforcing polarized gender roles and compulsory heterosexuality, these subjective challenges are the most compelling aspect of sex for Walter. Even in his early years, part of the pleasure of his heterosexual encounters is "to be part of [a woman's] body" (943), and part of his fascination with women is a wish "to experience the feeling a woman has" during and after sex (243). He continues to associate fellatio with femininity: reflecting on another encounter, he remarks, "What a pleasant sensation is a nice smooth prick moving about one's mouth. No wonder French Paphians say that until a woman has sucked one whilst she's spending under another man's fucking, frigging, or gamahuche, that she has never tasted the supremest voluptuous pleasure" (2098). An equal opportunity erotomaniac, his interest in penises and vaginas, preferably both at once, continues unabated to the end of the memoir, as he arranges a series of threesomes and foursomes, almost always with mirrors. Once he is lucky enough to find a partner who is double-coded for gender, a "beaugarçon" who resembles both a ballet girl and the Apollo Belvedere, and who incites Walter's desire "to Socratize him"—a witty neolo-

gism for the high-minded, platonically authorized homosexuality of elite boys' schools (2052). Walter sucks his penis while a female prostitute sucks Walter's and Walter masturbates the female prostitute, so that he takes on a male and female position simultaneously, making love to a man (who is also gay and feminine) and a woman. His endless inventiveness plumbs every possibility of inter-body geometry, achieving variations on his favorite theme of mutual intermingling: "We all began fucking together" (1557).

While Walter's explicitness and insight are unusual, his cross-gender and cross-sexual experiments are not: part of the appeal of Victorian pornography was the fantasy of subjective experimentation it granted to its writers and (presumably male) readers. Pornographic stories are replete with cross-dressed, hermaphroditic characters in multiple combinations that recall Walter's recherché sex play. In *Nunnery Tales*, the male protagonist, dressed throughout as a woman, explores novitiates' bodies, thanks to his disguise, and fondles the penis of a priest. In "The Secret Revealed," Queen Esther wins a king's undying passion by ravishing seven other virgins with a gigantic dildo strapped to her body before she is ravished by him. Even explicitly homosexual pornography summons these shape-shifting pleasures. In *The Sins of the Cities of the Plains*, the prostitute Jack Saul's memoir of the Boulton and Park cross-dressing scandal, double-coded bodies point to homosexual desires, but they also depict more mobile pleasures.[33] Mary Ann, really Ernest Boulton, has small hands and feet, a feminine face, an "Adonis-like figure," and an enormous penis, and Jack Saul describes a youthful affair with a mustachioed woman whom he takes for a man (6). He recalls the frigging parties of his schooldays, then reminisces about spying on a dairymaid, who invites him to perform cunnilingus on her while she reciprocates with fellatio. He is seduced by an aristocratic woman, then her brother, then both at once in a freewheeling triangle reminiscent of Walter's experiments. The sequel, *Letters from Laura and Eveline*, features a "hermaphrodite-bride" who, though she turns out to be a man, finds it "awfully delicious to be taken for a woman, and addressed as a woman" (25, 46). Satirizing sex/gender norms, this text maps a jokey heterosexuality onto homosexuality with a rhapsodic

[33] For a discussion of the scandal and another reading of this text, see Cohen (*Sex* 72–129, esp. 123–29).

description of a bridal gown of "superb white satin, trimmed with Valenciennes lace, and Honiton lace veils" and a euphoric wedding night consummation in which the husband exclaims, "There, I shoot a baby into your womb," as he buggers his "wife" (10–11, 44). But Eveline's equally rhapsodic descriptions of the delights of sex, "heightened by the piquancy of changing one's sex, and being changed into a woman," cannot be entirely reduced to a cover story for the "real" homosexual subtext; instead, they also point to the unreality of all identities in this parodic world of simpering girls in white wedding dresses and "strong, hairy, lustful" men making babies (52).

The figure of Laura (who of course is "really" a man) having sex with two girls at once, one by cunnilingus and the other by genital intercourse, encapsulates the pleasures of these texts, which steadfastly refuse to settle down into any single kind of sexuality, or to mark their characters as exclusively embodying one sex or the other. As homosexuality became increasingly fixed and stigmatized as an inalienable identity—just as heterosexuality was fixed and sanctified—it is not surprising that its pornography should also open itself up to shifting, multiple pleasures. Moreover, as male development suggests, adult masculinity is a compound of heterosexual and homosexual desires and female identification; to "be" homosexual, no less than heterosexual, does not necessarily rout other subjective and sexual possibilities. This is not to deny the profundity or lived reality of self-identifications or to reduce sexual orientation to a mere preference that can be changed at will. Rather it is to suggest that identifications claimed as core selves are surrounded by and grounded in other identifications, like the harmonics of a musical note, which consists of both a central pitch and related overtones. Although they may confuse or jeopardize the core self, these harmonic identifications are also available for pleasure.

In my efforts to rehabilitate *My Secret Life* as an insightful and radical assault on normative masculinity, I have risked idealizing it, for Walter's experimental temperament has very firm limits. He revels in the delirium of orgasmic communion, but he recovers his stability as a matter of course at the end of each encounter. What anchors Walter is class and money. As Marcus says, "For him, the absolute reality of class, its 'naturalness,' is as self-evident, inevitable, and unquestion-

able as his own sexual drives" (136).[34] He insists on the priority of his desires: Jack's turns with Sarah come only after his, and with Walter's permission. "I had not brought him to fuck my woman—my letch was for frigging him," Walter declares, reminding Jack that because he pays the bills, his desires come first (1545). When Jack reaches for Walter's penis, Walter bridles: "My pulling *his* about seemed quite a proper thing for *me*, for I had paid him for it; but directly *he* touched *my* prick, I felt disgusted.—The mind is an odd thing—if a gentleman had felt me, should I have been equally shocked?" (1551). Walter overcomes this aversion, enjoying Jack's touch and the fondling of other men ("Look at you two feeling each other's pricks," Sarah the procuress fondly remarks, as if they were two young lovers holding hands [1555]), but whatever experiments he performs, he will leave the bed a gentleman. In spite of their sexual intimacy and his eventual acceptance of Jack's touch, Walter still resents his "familiarity," a lack of deference that Walter experiences as a much greater violation than their physical escapades (1560). While Sarah's hermetic room provides a fantasy space for sexual experiments, it does not undo the status inequality among the participants. Walter wants to try on as many positions as he can manage without relinquishing his ultimate control over the proceedings; his safety net is the fact that he has paid for everything, including Jack's silk stockings, and so can set whatever boundaries keep this dimension of his identity intact. As far as Walter is concerned, Jack may revise his gender identity in the direction of femininity—a move down the hierarchical ladder—but he cannot adopt the privileges of a gentleman.

In other chapters I have traced the normalizing strategies that cloaked unauthorized pleasures in some kind of respectability: the pathologizing and denial that encoded homoeroticism in the spermatorrhea panic, the idealizations of art and pastoral values of urban eroticism, the boundary setting of genital passion in *Mysteries of London*, the rhetoric of melodramatic suffering in the Yelverton marriage trials. For Walter, class privilege sets a different kind of boundary that makes his experiments possible—not culturally respectable, for it is hard to imagine any strategy that could smuggle this farrago of perversions past Victorian ideology, but *psychologically* tenable for

[34] Marcus's analysis of the interconnection of class, money, and sex is one of the strongest aspects of his interpretation; see especially his discussion of the pathos of one of Walter's working-class partners (145).

Walter himself. His freedom depends on others' subjection, willing or not, to his designs. No matter what their sexual positions, Walter is "on top" in class relations. In fact, within the controlled space of the brothel, Walter experiences his most secure, unambiguous sense of class identity. In his young adulthood he is often plagued with financial problems, mainly because of his own extravagance, and is forced to depend on his mother ("who did nothing but upbraid me" [362]) and then on his detested first wife for financial support. Kept on a tight leash, Walter feels "quite needy" and "utterly wretched," unable to afford even to ride an omnibus during his marriage (364). He often experiences middle-class masculinity as a frustrating social position, raising expectations of entitlements that he cannot always achieve. But while the economic situation and family relations of his youth consign him to a position of impotence, in flush times, within the brothel, he is in a position of control, authoring the relationships in which he will participate.

Walter's proprietary comments about who can touch whom remind us that these wish-fulfilling encounters take place within a set of material circumstances, including the grinding poverty that drives Jack into this line of work in the first place, and that the transgressive play that they offer is precisely play. Walter hires the actors, directs the sexual scenarios, and determines what will and will not happen to his body—a luxury that his prostitutes and working-class male partners do not have. Walter's sex play is ideologically significant in that it rejects Victorian sexual norms, but it is not politically subversive in the sense of challenging, in any real or public way, the power inequities that are grounded in hierarchical norms of subjectivity. With particular clarity, his experience opens a gap between transgressive sexuality and social change: his challenge is not only local in its effects but also retrograde in its class politics. Walter does not want to level the hierarchy. His experiments are exactly that, partial and provisional. I would speculate that the combination of sexual transgression and class privilege is what gives *My Secret Life* its appeal: this heady whirl of changing sexual positions, this euphoric recovery of lost subject positions, takes place without any final loss of social position.[35] This, Diana Fuss argues, is the basic quality of identification: it is not

[35] Class privilege would also figure in the experience of reading the other pornography I describe, since its preservation suggests that it was expensive, printed in limited editions, and priced for a select audience.

a mutual exchange or an attentive encounter with difference but an appropriation of whatever the other has that the subject wants. Fuss likens it to "colonization" and "cannibalism," adding that to "respect the Other as Other" would mean to "stop identifying" (*Identification* 9, 35, 39). Women and homosexuals are in a position—literally—to have sexual experiences that Walter desires, and his identification with them broadens his erotic horizons. But he also retains his place in the class hierarchy: he is in a position to script, to sample, to slum, but not to bear or even understand the consequences of living inalienably in those subordinate social positions. Although Walter creates a protected private space for his erotic theatrics, we never forget that his privacy is bought by economic power; it is not really private at all but rests on the very role he attempts to escape, that of the bourgeois gentleman.

The Monotony of Sex

Is sex monotonous? Judging from characterizations of pornography, one would be inclined to say yes. Pornography is accused of representing the same thing over and over again, mindlessly repeating sexual episodes that, except for some peripheral window dressing (or undressing), are basically alike. Gibson condemns *My Secret Life* as hopelessly unimaginative because "the scenarios repeat themselves endlessly" (230). Marcus claims, "The need for variety is itself monotonous, and the mechanical monotonous variety of compulsive sexuality and pornography is one of their chief common characteristics" (181). Other critics condemn "that quality of sameness" and "the inescapable monotony of pornographic writing" (Dworkin 228–29; George Steiner qtd. in Gubar 55). When I have taught sections of *My Secret Life* to graduate students, they could hardly wait to tell me how bored they were. Even Henry Spencer Ashbee, foremost Victorian collector of pornography, compiler of the definitive pornographic bibliography, and possible author of *My Secret Life*, bemoans (perhaps disingenuously, considering his interests) pornography's "dull and monotonous" repetitions, with "copulations on every page" (qtd. in Pearsall, *Worm* 370). Perhaps I would be wise to take these assertions at face value rather than implicitly classify myself with a monomaniacal pervert like Walter, with his insatiable appetite for writing about sex, if not for actually experiencing the thousands

of sex acts he describes—for, like Walter, I find these constantly shift-
ing permutations of human bodies fascinating (though I must confess
that even my attention occasionally flagged over the book's 2,300
pages and I was reduced to skimming a few hundred sexual encoun-
ters). To me, these declarations of boredom feel as compulsive and
monotonous as Walter's copulations are alleged to be. Perhaps Walter
has become a figure of disidentification for these readers because he
displays an unabashed appetite for sex that troubles "cool" modern
sensibilities as well as Victorian proprieties.

For his part, Walter is not a bit bored, nor does he find his endless
copulations redundant. On the contrary, variations in partners, body
parts, and sexual positions captivate him. Marcus accuses Walter of
reducing women to their "anonymous" body parts (119), but in fact
the opposite seems true: if anything, Walter displays an obsessive in-
terest in the minor differences that distinguish one vagina from an-
other. His anatomizing of genitalia reflects an impulse toward classi-
fication that we might regard as objectifying (certainly it fits neatly
into Foucault's *scientia sexualis*, with its goal of total knowledge),
but it also takes on a more human aspect when he credits his partners
with renewing his interest in familiar pleasures. Of his bawdy verbal
foreplay with Sarah the procuress he says, "I have gone through this
talk with other women, but with Sarah it seemed quite novel"
(1465).[36] Walter is a connoisseur of sex, savoring subtle variations in
the way that an oenologist might elaborate on the differences be-
tween fine burgundies. Although his appreciation is limited to bodies
and sexual style, unlike the usual novelistic interests to which we are
accustomed—character, education, artistic ability, and so forth—
within this narrow range he is alive to the individuality that distin-
guishes one partner and one sex act from another:

> It mattered not to me whether similar pleasure had been mine before
> or not, whether the erotic whims and fancies, amorous frolics, volup-
> tuous eccentricities, were identical or not.—I described them as they
> had occurred to me at the time, and the pleasure of doing so was nearly
> the same, even had I done them twenty times, and described them
> twenty times.
>
> But the woman, the partner in my felicity was frequently fresh and
> new to me, and I to her; and this newness prevents satiety in sexual

[36] See also 1517, 1881, 1984.

frolics. There is always a shade of difference in the manners and behaviour of women in sexual preliminaries, and even in final performance. One woman never kisses or sighs, embraces or fucks, in exactly the same manner as another. The broad features from beginning to ending are the same. A coupling of the genitals finishes it all. But there are delicate shades of difference even in fucking which make the variety so charming, and describing them was ever new and amusing to me, when the charmer was new to me. (1504)

This passage has its own charms—not the least of which is the implicit juxtaposition of Walter's "delicate shades of difference" with his furious, indelicate fucking in many episodes. But Walter's sensitivity to these delicate differences is what lends *My Secret Life* its significance. All partners, all positions, all sex acts are *not* alike; they carry different meanings and yield different pleasures. The repetition of its "broad features" does not necessarily mean that sex is always the same, and that this repetition is therefore boring. There is no doubt that Walter is compulsive, narcissistic, and sometimes insufferable. But his compulsiveness is a productive one, opening insights into identify formation that a better-adjusted (that is, better-defended) psyche could not provide. In spite of our proliferating sexual discourses, we lack a very extensive, nuanced framework for interpreting sexual intercourse itself or for narrating the body's experiences, perhaps because we have linked erotic experience so deterministically to the sex of the erotic object. *My Secret Life* sketches one possible framework, using sexual positions as components in a complex grammar of subjectivity and sexual orientation. It challenges our understanding of the relationship between pornography and patriarchy, gender and genre, along with its challenges to sexual and subjective norms. It is Walter's savoring of shades of difference—delicate or otherwise—as much as his commitment to pleasure that feeds the radical insights of *My Secret Life.*

Afterword

Pleasures Then and Now

Throughout this book I have stressed the distinctive, context-specific nature of these narratives, while at the same time asserting their cultural salience: because their unauthorized pleasures emerged within an anti-sensual ideology, they were, as I have said, available within it, unlike utopian dreams of a natural sexuality or an unmarked body existing miraculously beyond culture. Even though their impact on dominant beliefs was rarely significant (with the exception of the spermatorrhea panic's effect on the practice of medicine), their continuing cogency can be felt in their relevance to contemporary issues in gender and sexuality studies: the phallus and the penis, the gaze, reader-response theory, psychoanalytic understandings of identification and development. What I want to do now is to consider in a concrete, if brief and partial way, the relationship between some of these narratives and our modern paradigms, not to attempt a coherent history of transgression or to chart some idealized progress toward sexual and gender liberation, but to use these Victorian texts as vantage points from which to view our own critical and cultural landscape.

We might start with Theresa Longworth's bold rewriting of romance narratives and its implications for theories of pleasure and reading. As I suggested in my discussion of the Yelverton marriage case, Longworth's letters demonstrate the difficulty of constructing "the woman reader" and "the woman writer" as repositories of a distinctively feminine sensibility. In neither role did Longworth feel entirely bound by gender identity but rather felt free to try on the perspectives and prerogatives of masculinity. In this respect her experience departs dramatically from feminist reader-response theory. The possibility of a cross-gender identification that enlarges

rather than deforms women readers barely registers in modern think-
ing, which has preoccupied itself with the damaging effects of andro-
centric texts. Judith Fetterley's influential concept of "immascula-
tion"—the adoption of a misogynist reading position enforced by a
male-authored text—has dominated considerations of women's read-
ing experience (xx). In its development of Fetterley's argument, Pa-
trocinio Schweickart's well-know essay "Reading Ourselves" asserts
categorically that "the process of immasculation does not impart vir-
ile power to the woman reader" and celebrates instead women's liter-
ature and feminist readers as representing "the woman's point of
view" (42, 51). Published in 1986, the essay has been repeatedly an-
thologized and continues to be regarded as influential and representa-
tive.[1]

Similarly, despite its very different psychoanalytic and narratologi-
cal orientation, Susan Winnett's "Coming Unstrung: Women, Men,
Narrative, and Principles of Pleasure" assumes a woman reader
whose distinctive body-based desire cannot be accommodated by
male texts or critical paradigms; like Schweickart, she assumes that
norms of reading will typically align male protagonists and male
readers but exclude women. What is most striking about these two
essays is that both actually note the potential power of cross-gender
identification but fail to integrate this observation into their ac-
counts of women's reading. Schweickart reports her satisfactory iden-
tification with Birkin in *Women in Love* despite his "patriarchal trap-
pings" (42), while, almost as an aside, Winnett considers a possible
"accident" in the act of reading in which a "woman's desire would
coincide exactly with the desire of the male protagonist and his offi-
cial surrogate, the male reader" (515). I do not want to rehash old
complaints about essentialism; certainly there are interpretations of
individual texts and implied readers in which gender does work in the
way Schweickart and Winnett propose (including my reading of *The
Mysteries of London* in chapter 3). In fact, it is precisely because of

[1] The essay, included in Robyn Warhol and Diane Price Herndl's *Feminisms*
(1997), was also added to the second edition of Michael Hoffman and Patrick Mur-
phy's *Essentials of the Theory of Fiction* (1996), along with a handful of other pieces
that "had already proven to be strong texts to which others have referred in the past
five years in various books and articles," again suggesting its prominence (1). It has
also been reprinted in *Falling into Theory: Conflicting Views on Reading Literature*,
edited by David H. Richter and Gerald Graff (1994), and Elaine Showalter's *Speaking
of Gender* (1989).

her social location as a woman that Longworth was drawn to male narratives. But the possibility of productive cross-gender identifications has not been considered theoretically interesting, even by a critic who enjoyed one. Longworth's reading suggests the outlines of a more flexible theory in which imaginative experience compensates for the constraints of real life and even models alternative life stories, revealing a blind spot in this critical paradigm.

A second comparison concerns Reynolds's *Mysteries of London* and its representation of female autoeroticism. What was an occasional flash of possibility in the nineteenth century—in this novel and in Walker's comments about the "ineffable pleasure" women's bodies offer women themselves—has become a major cultural and theoretical presence today. From Irigaray's vision of a self-pleasuring female body replete with erogenous zones to more recent feminist accounts of fetishism and fashion, modern critics have theorized a self-contained sexuality independent of men. As one fashion scholar and practitioner declares, "Most of the pleasure [of buying shoes] involves a private fantasy that starts with me and ends at my feet. Men don't get a look in" (qtd. in Gamman 101). Similarly, Virginia Blum has analyzed the new libidinal practices of *Sex and the City*, whose women lust after designer clothes even more than they do after men. In one episode, Carrie Bradshaw looks back and forth between a pair of sleek black patent leather Mary Jane's—Manolo Blahnik, of course—and the rather lumpy middle-aged male editor who, having found them for her, is ready for his reward. She makes the obvious choice: truly fabulous shoes are a much more gratifying and dependable source of pleasure than this man, or perhaps any man. As a final example of this trend, take a magazine ad for Aerosoles shoes: "He loves me, he loves me not, who cares?" If you have great shoes, who needs heterosexuality?[2]

It is tempting to trace a straightforward evolution from modest Victorian moments of female pleasure to its full-blown emergence in the late twentieth and early twenty-first centuries. This path is discontinuous, however, not only because we cannot find (or, rather, I have not found) a steady evolution of representations connecting these historical points, but also because so many modern examples locate au-

[2] Readers who have noticed that shoes figure most prominently in these contemporary discussions of fashion are encouraged to consult the collection in which Gamman essay appears: Shari Benstock and Suzanne Ferriss's *Footnotes: On Shoes*.

toeroticism not in the body itself but in clothing. As the Aerosoles ad makes clear, this once unauthorized pleasure can now be authorized in part because it serves the interests of consumer capitalism. While feminism has made women's pleasure a political issue, this increased visibility has also made it a convenient marketing tool. The very fact that women's pleasure has cultural currency indicates that it is at least partially acceptable but at the same time has become more subject to appropriation. Being reduced to an Aerosoles ad is certainly a dispiriting fate for the erotic energies of *Mysteries of London*, but it is not a definitive one; it is only one moment in the ongoing interplay of constraint, emergence, and co-optation that constitutes the history of sexuality. And perhaps we might also celebrate *Sex and the City* and the Aerosoles ad for refusing the fashion double bind, which insists that women adorn themselves and then requires them to be ashamed of their investment in clothing. In this way they continue Reynolds's implicit rewriting of "vanity" as an alias for autoeroticism, for he too uses clothing as a signifier of femininity—as when the cross-dressing Eliza Sydney admires herself in the mirror when she is dressed as a woman—and therefore as a legitimate source of pleasure.[3]

Finally, I want to make the obvious move and consider Walter's adventures in relation to our modern identity politics, especially the emerging tension between homosexuality and bisexuality. We might regard Walter as an early queer theorist, acting out his rejection of the sex-gender system with the cutting-edge, binary-rejecting sexuality modern critics often associate with bisexuality. As one says, bisexuality necessarily entails "dismantling the entire apparatus which maintains the heterosexual/homosexual dyad" (Jo Eadie qtd. in Dollimore, "Bisexuality" 527). Walter's experiments function as a kind of implicit critique of the enduring power of categorical subjectivities even in gay and lesbian studies, in which bisexuality often occupies a role that is at once oppositional and peripheral.[4]

[3] Blum makes a complex and persuasive argument about the implications of this "mutual extension of the material and sexual domains" (too complex for me to reproduce here, certainly) and concludes with the hopeful suggestion that clothing is a source of connection among women, knitting them together in emotional and erotic ways "instead of [acting as] mere narcissistic extensions" or as perfect—because undemanding, flattering, and possessable—substitutes for men (10, 19).

[4] The massive anthology *Queer World* (Duberman 1997), weighing in at 678 pages and encompassing fifty-two essays, mentions bisexuality three brief times. Similarly, Mark Blasius's long, carefully argued review essay "Contemporary Lesbian, Gay, Bisexual, Transgender, Queer Theories and Their Politics" concentrates almost exclu-

Still, there are obvious problems with equating Walter, bisexuality, and freedom, and they have everything to do with identity politics— that is, with the recovery of categorical subjectivity which Walter strives so hard to cast off. Lesbians and gays have sometimes taxed bi- sexuals with copping out, playing with homosexuality for a taste of transgression but refusing the dangerous business of actually identi- fying as homosexual: "L.U.G.," as the acronym goes—"lesbian until graduation," that is, until economic and social power are at risk.[5] For gays and lesbians who make this argument, embracing identity poli- tics is an ethical responsibility and a step toward social change. From this point of view, Walter is the Victorian prototype of the Lesbian until Graduation. Resisting heteronormativity, he pursues his li- aisons without risking his social or economic power. Although he is happy—thrilled—to relinquish identities that reside in specific sex- ual positions and practices, he never abandons his class and gender status. He fails to see that the subject positions he occupies playfully, temporarily, and by choice are the inalienable fate of his companions, and that with these positions come inequality and oppression from which Walter benefits directly, as they provide a steady stream of sex- ual partners for hire. The perspective of identity politics, in short, re- veals the very idea of erotic play as grounded in privilege. Thus, the relationship between *My Secret Life* and queer theory is a reciprocal one. They illuminate each other precisely because of the differences in their historical settings. From the categorical subjectivity Walter rejects comes the reverse discourse of identity politics, which offers a critical perspective from which to critique his rebellion.

The Yelverton marriage case revises reader-response theory; *Mys- teries of London* imagines forms of female sexuality that would emerge full-blown over a hundred years later, with new dimensions and a complicated politics; *My Secret Life* and queer theory critique each other. Not surprisingly, these historical relationships are no less heterogeneous than the pleasures that have preoccupied us in this book. The Victorian texts might seem trivial or eccentric at first glance, but they engage us today because they do their own kind of

sively on gays and lesbians. Significantly, both of these works signal broader interests in their titles but quickly refocus on gay and lesbian studies.

[5] See Marjorie Garber's insightful discussion of the L.U.G. phenomenon (*Vice Versa* 45–46). Her book as a whole is a rich exploration of the complexities of bisexu- ality.

Unauthorized Pleasures

theorizing, implicitly analyzing and critiquing ideological constraints that continue to trouble us. When I refer to their "logics," this is what I mean: they think through new structures for gender and sexuality. Reading these narratives opens up productive, mutually informing relationships—between past and present, lived experience and ideology, popular culture and theoretical paradigms—that both enrich our understanding of Victorian sexuality and illuminate our own search for pleasures.

Works Cited

Acton, William. *The Functions and Disorders of the Reproductive Organs in Childhood, Youth, Adult Age, and Advanced Life*. 4th American ed., from last London ed. Philadelphia: Lindsay and Blakiston, 1875.

Adams, James Eli. *Dandies and Desert Saints: Styles of Victorian Masculinity*. Ithaca: Cornell University Press, 1995.

Adams, Parveen. "Per Os(cillation)." In *Male Trouble*. Ed. Constance Penley and Sharon Willis. Minneapolis: University of Minnesota Press, 1993. 3–25.

Alcott, Louisa May. *Behind a Mask: The Unknown Thrillers of Louisa May Alcott*. Intro. Madeleine Stern. New York: William Morrow and Co., 1975.

Alice, or the Adventures of an English Girl in Persia. London: James Greenwood, n.d.

Allen, Rick. "Munby Reappraised: The Diary of an English Flâneur." *Journal of Victorian Culture* 5 (2000): 260–86.

Almira's Curse, a Historical Romance, or the Black Tower of Bransdorf. N.p. [England], n.d.

Altick, Richard. *The Shows of London*. Cambridge: Harvard University Press, 1978.

Amatory Experience of a Surgeon, The. Printed for the Nihilists. Moscow, 1881.

Anderson, Amanda. *Tainted Souls and Painted Faces: The Rhetoric of Fallenness in Victorian Culture*. Ithaca: Cornell University Press, 1993.

Anstice, Sir Robert H. *The Political Heroes of Sir Walter Scott*. Port Washington, N.Y.: Kennikat Press, 1917.

Apter, Emily. *Feminizing the Fetish: Psychoanalysis and Narrative Obsession in Turn-of-the-Century France*. Ithaca: Cornell University Press, 1991.

Bade, William Frederic. *The Life and Letters of John Muir*. 2 vols. Boston: Houghton Mifflin, 1923.

Barlow, Linda. "The Androgynous Writer: Another Point of View." In *Dangerous Men and Adventurous Women: Romance Writers on the Appeal of the Romance*. Ed. Jayne Ann Krentz. Philadelphia: University of Pennsylvania Press, 1992. 45–52.

Barret-Ducrocq, Françoise. *Love in the Time of Victoria: Sexuality, Class, and Gender in Nineteenth-Century London*. Trans. John Howe. London: Verso, 1991.

Beaumont, Cyril W. *Fanny Elssler (1810–1884)*. London: C.W. Beaumont, 1931.

Bennett, Tony. "The Exhibitionary Complex." In *Thinking about Exhibitions*. Ed. Reesa Greenberg, Bruce D. Ferguson, and Sandy Nairne. London: Routledge, 1996. 81–112.

Benstock, Shari, and Suzanne Ferriss. *Footnotes: On Shoes*. New Brunswick: Rutgers University Press, 2001.

Berger, John. *Ways of Seeing*. London: British Broadcasting Corporation and Penguin Books, 1972.

Berridge, Victoria. "Popular Journalism and Working-Class Attitudes, 1854–86: A Study of Reynolds's Newspaper, Lloyd's Weekly Newspaper, and the Weekly Times." Ph.D. diss. University of London, 1976.

Blasius, Mark. "Review Essay: Contemporary Lesbian, Gay, Bisexual, Transgender, Queer Theories and Their Politics." *Journal of the History of Sexuality* 9 (1998): 642–74.

Bleiler, E. F. Introduction to *Wagner, the Wehr-Wolf* by George William MacArthur Reynolds. New York: Dover Publications, 1975.

Blum, Virginia. "The Cheating Curve: Dressing Up *Sex and the City*." Paper delivered at the Narrative Conference, April 2002, East Lansing, Mich.

Bodkin, M. McDonnell, K.C. *Famous Irish Trials*. Dublin, Maunsel & Co., 1918.

Boëthius. *The Consolation of Philosophy*. Trans. I. T. Ed. William Anderson. Carbondale: Southern Illinois University Press, 1963.

Bordo, Susan. *The Male Body: A New Look at Men in Public and in Private*. New York: Farrar, Straus and Giroux, 1999.

Boyle, Thomas. *Black Swine in the Sewers of Hampstead: Beneath the Surface of Victorian Sensationalism*. New York: Viking, 1989.

Brantlinger, Patrick. *The Reading Lesson: The Threat of Mass Literacy in Nineteenth-Century British Fiction*. Bloomington: Indiana University Press, 1998.

Brontë, Charlotte. *Villette*. Harmondsworth: Penguin, 1982.

Brooks, Peter. *Reading for the Plot: Design and Intention in Narrative*. New York: Vintage, 1984.

Buckton, Oliver. *Secret Selves: Confessions of Same-Sex Desire in Victorian Autobiography*. Chapel Hill: University of North Carolina Press, 1998.

Bulwer-Lytton, Edward. *Ernest Maltravers*. 3 vols. London: Saunders & Otley, 1837.

Burns, W. L. *The Age of Equipoise: A Study of the Mid-Victorian Gentleman*. New York: W.W. Norton & Co., 1965.

Burt, Daniel. "A Victorian Gothic: G. W. M. Reynolds's *Mysteries of London*. *New York Literary Forum* 7 (1980): 141–58.

Butler, Josephine. *Personal Reminiscences of a Great Crusade*. London: Horace Marshall, 1896.

———. *The Voice of One Crying in the Wilderness*. London: J.W. Arrowsmith, Ltd., 1913.

Butler, Judith. *Bodies That Matter: On the Discursive Limits of "Sex."* London: Routledge, 1993.

——. *Gender Trouble: Feminism and the Subversion of Identity.* New York: Routledge, 1990.

——. "Revisiting Bodies and Pleasures." *Theory, Culture, and Society* 16 (1999): 11–20.

Carpenter, William B. *Principles of Human Physiology, with Their Chief Applications to Pathology, Hygiene, and Forensic Medicine.* Philadelphia: Lea and Blanchard, 1843.

Carter, Angela. *The Sadeian Woman.* London: Virago Press, 1979.

Chase, Karen, and Michael Levenson. *The Spectacle of Intimacy: A Public Life for the Victorian Family.* Princeton: Princeton University Press, 2000.

"City Highways." *Tait's Edinburgh Magazine* 25 (1858): 135–36.

Clark, Anna. "Queen Caroline and the Sexual Politics of Popular Culture in London, 1820." *Representations* 31 (1990): 47–67.

Clarke, James Mitchell. *The Life and Adventures of John Muir.* San Francisco: Sierra Club, 1980.

Cohen, Ed. *Talk on the Wilde Side: Toward a Genealogy of a Discourse on Male Sexualities.* London: Routledge, 1993.

Cohen, William. *Sex Scandal: The Private Parts of Victorian Fiction.* Durham: Duke University Press, 1996.

Collins, Wilkie. *Armadale.* Oxford: Oxford University Press, 1989.

——. *Basil.* Oxford: Oxford University Press, 1990.

——. *Man and Wife.* Oxford: Oxford University Press, 1995.

Cook, Elizabeth Heckendorn. *Epistolary Bodies: Gender and Genre in the Eighteenth-Century Republic of Letters.* Stanford: Stanford University Press, 1996.

Cooter, Roger. *The Cultural Meaning of Popular Science: Phrenology and the Organization of Consent in Nineteenth-Century Britain.* Cambridge: Cambridge University Press, 1984.

Corbett, Mary Jean. *Representing Femininity: Middle-Class Subjectivity in Victorian and Edwardian Women's Autobiographies.* New York: Oxford University Press, 1992.

Courtenay, Francis Burdett. *A Practical Essay on the Debilities of the Generative System, Their Varieties, Causes, Treatment, and Cure.* London: T. Hill, 1838.

——. *Revelations of Quacks and Quackery; a Series of Letters by "Detector," Reprinted from "The Medical Circular," by their author, F. B. Courtenay.* London: H. Bailliere, 1865.

——. *On Spermatorrhea and the Professional Fallacies and Popular Delusions Which Prevail in Relation to its Nature, Consequences, and Treatment.* London: H. Bailliere, 1858.

Coward, Rosalind. *Female Desire.* London: Paladin, 1984.

Crary, Jonathan. *Techniques of the Observer: On Vision and Modernity in the Nineteenth Century.* Cambridge: MIT Press, 1992.

Crow, Duncan. *Theresa: The Story of the Yelverton Case.* London: Rupert Hart-David, 1966.

Crozier, Ivan. "William Acton and the History of Sexuality: The Medical and Professional Context." *Journal of Victorian Culture* 5 (2000): 1–27.

Culverwell, Robert James. *Lecture to Young Men on Chastity, and Its Infringements. A New and Original Medico-Philosophical Work on the Physiology of the Passions, Illustrative of the Rise, Progress, Attainment and Decline of the Human Reproductive Powers, Portraying the Results of Youthful Improvidences, the Indiscretions of Mature Age, and the Follies of Advanced Life.* London: Sherwood and Co., 1847.

——. *The Solitarian; or, The Physiology of the Passions, Their Use and Abuse, with "A Philosophy of Loving and Being Loved" (A Medical Sketch).* London: for the author (Reynell and Weight), 1849.

Curtis, J. L. *Manhood; The Causes of Its Premature Decline; with Directions for its Perfect Restoration.* London 1859.

Dallas, E. S. *The Gay Science.* 2 vols. 1866. Reprint, New York: Garland, 1986.

Dalziel, Margaret. *Popular Fiction One Hundred Years Ago: An Unexplored Tract of Literary History.* London: Cohen and West, 1957.

"Dangers of the Streets." *All the Year Round* 15 (1866): 154–57.

Davidoff, Leonore. "Class and Gender in Victorian England." In *Sex and Class in Women's History.* Ed. Judith L. Newton, Mary P. Ryan, and Judith Walkowitz. London: Routledge, 1983. 16–71.

Davis, Tracy. *Actresses as Working Women: Their Social Identity in Victorian Culture.* London: Routledge, 1991.

Dawson, R. *An Essay on Marriage: Being a Microscopic Investigation into its Physiological and Physical Relations; with Observations on the Nature, Causes, and Treatment of Spermatorrhea, and the Various Disorders of the Procreative System in Men; Illustrated by Cases.* London: H. Hughes, 1845.

——. *An Essay on Spermatorrhea and Urinary Deposits with Observations on the Nature, Causes, and Treatment of the Various Disorders of the Generative System, Illustrated by Cases.* 3d ed. London: H. Hughes, 1847.

De Roos, Walter. *The Medical Adviser; A Treatise on the Anatomy and Physiology of the Organs of Generation, with Practical Observations on the Premature Loss of Sexual Power, and Plain Directions for Its Perfect Restoration.* London: by author, n.d. (1851?).

Dellamora, Richard. *Masculine Desire: The Sexual Politics of Victorian Aestheticism.* Chapel Hill: University of North Carolina Press, 1990.

——, ed. *Victorian Sexual Dissidence.* Chicago: University of Chicago Press, 1999.

Dews, Peter. "Power and Subjectivity in Foucault." *New Left Review* 144 (1984): 72–95.

Dickens, Charles. "Preliminary Words." *Household Words* 1 (1850): 1–2.

Digby, Ann. *Making a Medical Living: Doctors and Patients in the English*

Market for Medicine, 1720–1911. Cambridge: Cambridge University Press, 1994.

Disraeli, Benjamin. *Coningsby.* Harmondsworth: Penguin, 1983.

Dixon, Hepworth. "The Literature of the Lower Orders." *Daily News,* 26 October; 2, 9, 25, 29 November; 16 December 1847.

Doane, Mary Ann. *The Desire to Desire: The Woman's Film of the 1940s.* Bloomington: Indiana University Press, 1987.

——. *Femmes Fatales: Feminism, Film Theory, Psychoanalysis.* New York: Routledge, 1991.

Dollimore, Jonathan. "Bisexuality, Heterosexuality, and Wishful Theory." *Textual Practice* 10 (1996): 523–39.

——. *Sexual Dissidence: Augustine to Wilde, Freud to Foucault.* Oxford: Oxford University Press, 1991.

Dowling, Linda. *Hellenism and Homosexuality in Victorian Oxford.* Ithaca: Cornell University Press, 1994.

Duberman, Martin. *A Queer World: The Center for Lesbian and Gay Studies Reader.* New York: New York University Press, 1997.

Dworkin, Andrea. "Against the Male Flood: Censorship, Pornography, and Equality." In *Feminism and Pornography.* Ed. Drucilla Cornell. Oxford: Oxford University Press, 2000. 19–38.

Eagleton, Terry. *The Ideology of the Aesthetic.* Oxford: Blackwell, 1990.

Eclectic Review 18 n.s. (July–December 1845): 74–84.

Eliot, George. *The Mill on the Floss.* Harmondsworth: Penguin, 1979.

Erickson, Arvel B., and Fr. John R. McCarthy. "The Yelverton Case: Civil Legislation and Marriage." *Victorian Studies* 14 (1971): 275–91.

Export, Valie. "The Real and Its Double: The Body." *Discourse* 11 (1988–89): 3–27.

Fahnestock, Jeanne. "Bigamy: The Rise and Fall of a Convention." *Nineteenth-Century Fiction* 36 (1981): 47–71.

Fetterley, Judith. *The Resisting Reader: A Feminist Approach to American Fiction.* Bloomington: Indiana University Press, 1978.

Fitzgerald, Percy. *The World Behind the Scenes.* London: Chatto and Windus, 1881.

Flint, Kate. *The Woman Reader, 1837–1914.* Oxford: Clarendon Press, 1993.

Foucault, Michel. *The History of Sexuality: An Introduction.* Vol. 1. Trans. Robert Hurley. New York: Vintage Books, 1990.

Freud, Sigmund. "Fetishism." In *Standard Edition of the Collected Psychoanalytic Works.* Vol. 21. Ed. James Strachey. 1927. Reprint, London: Hogarth Press, 1964. 198–274.

——. "Instincts and Their Vicissitudes." In *Standard Edition of the Collected Psychoanalytic Works.* Vol. 14. Ed. James Strachey. 1914–16. Reprint, London: Hogarth Press, 1957. 117–140.

Frost, Ginger. *Promises Broken: Courtship, Class, and Gender in Victorian England.* Charlottesville: University Press of Virginia, 1995.

Full Report of the Important Trial Thelwall v. Yelverton, (Marriage Case,) Be-

fore Lord Chief Justice Monahan, in the Court of Common Pleas, Dublin. Glasgow: William Syme & Co., 1861.

Fuss, Diana. "Fashion and the Homospectatorial Look." *Critical Inquiry* 18 (1992): 713–37.

——. *Identification Papers.* New York: Routledge, 1995.

Gamman, Lorraine. "Self-Fashioning, Gender Display, and Sexy Girl Shoes: What's at Stake—Female Fetishism or Narcissism?" In *Footnotes: On Shoes.* Ed. Shari Benstock and Suzanne Ferriss. New Brunswick: Rutgers University Press, 2001. 93–115.

Garber, Marjorie. "Fetish Envy." *October* 54 (1990): 45–56.

——. *Vested Interests: Cross-Dressing and Cultural Anxiety.* New York: Routledge, 1992.

——. *Vice Versa: Bisexuality and the Eroticism of Everyday Life.* New York: Simon and Schuster, 1995.

Gascoyen, George G. "On Spermatorrhea and Its Treatment." *British Medical Journal,* 20 January 1872: 67–69; 27 January 1872: 95–96.

Gaskell, Elizabeth. *Mary Barton.* Harmondsworth: Penguin, 1970.

——. *North and South.* Oxford: Oxford University Press, 1982.

Gay, Peter. *The Bourgeois Experience: Victoria to Freud: Education of the Senses.* Vol. 1. Oxford: Oxford University Press, 1984.

——. *The Tender Passion.* Vol. 2. Oxford: Oxford University Press, 1986.

Gibson, Ian. *The Erotomaniac: The Secret Life of Henry Spencer Ashbee.* London: Faber and Faber, 2001.

Gledhill, Christine. "Pleasurable Negotiations." In *Female Spectators: Looking at Film and Television.* Ed. Deirdre E. Pribram. London: Verso, 1988. 64–89.

Gouley, John W. S. *Diseases of the Urinary Organs.* New York: Wood and Co., 1873.

"Grand Triumph of Mrs. Yelverton." Dublin, 1863.

Green-Lewis, Jennifer. *Framing the Victorians: Photography and the Culture of Realism.* Ithaca: Cornell University Press, 1996.

Grosz, Elizabeth. *Volatile Bodies: Toward a Corporeal Feminism.* Bloomington: Indiana University Press, 1994.

Gubar, Susan. "Representing Pornography: Feminism, Criticism, and Depictions of Female Violation." In *For Adult Users Only: The Dilemma of Violent Pornography.* Ed. Susan Gubar and Joan Hoff. Bloomington: Indiana University Press, 1989. 47–67.

Hall, Lesley. "'The English Have Hot-Water Bottles': The Morganatic Marriage between Medicine and Sexology in Britain since William Acton." In *Sexual Knowledge, Sexual Science: The History of Attitudes to Sexuality.* Ed. Roy Porter and Mikulas Teich. Cambridge: Cambridge University Press, 1994. 350–66.

——. "Forbidden by God, Despised by Men: Masturbation, Medical Warnings, Moral Panic, and Manhood in Great Britain, 1850–1950." *Journal of the History of Sexuality* 2 (1992): 365–87.

Harman, Barbara Leah. "In Promiscuous Company: Female Public Appearance in Elizabeth Gaskell's *North and South." Victorian Studies* 31 (1988): 351–74.

Hart, Francis R. *Scott's Novels: The Plotting of Historical Survival.* Charlottesville: University Press of Virginia, 1966.

Heath, Stephen. *The Sexual Fix.* New York: Shocken Books, 1982.

Hoffman, Michael, and Patrick Murphy, eds. *Essentials of the Theory of Fiction.* Durham: Duke University Press, 1996.

"Hospital Nurse; An Episode of the War. Founded on Fact." *Fraser's Magazine* 51:301 (January 1855): 96–105.

"House in Westminster." *Cornhill Magazine* 6 (1862): 258–68.

Hudson, Derek. *Munby, Man of Two Worlds: The Life and Diaries of Arthur J. Munby, 1828–1910.* New York: Gambit Press, 1972.

Hughes, Linda, and Michael Lund. *The Victorian Serial.* Charlottesville: University Press of Virginia, 1991.

Hughes, Thomas. *Tom Brown's Schooldays.* Oxford: Oxford University Press, 1989.

Humphries, Anne. "The Geometry of the Modern City: G. W. M. Reynolds and *The Mysteries of London.*" Reprinted, *Browning Institute Studies* 11 (1983): 69–80.

Illustrated London Life. 16 April 1843.

Irigaray, Luce. *This Sex Which Is Not One.* Trans. Catherine Porter. Ithaca: Cornell University Press, 1985.

James, Louis. *Fiction for the Working Man, 1830–1850.* London: Oxford University Press, 1963.

———. "The Trouble with Betsy: Periodicals and the Common Reader in Mid-Nineteenth-Century England." In *The Victorian Periodical Press: Samplings and Soundings.* Ed Joanne Shattock and Michael Wolff. Toronto: University of Toronto Press, 1982. 348–66.

Jameson, Anna. *Sisters of Charity, Catholic and Protestant, Abroad and At Home.* London: Longman, Brown, Green, and Longman, 1855.

Jewsbury, Geraldine. *The Half-Sisters.* Oxford: Oxford University Press, 1994.

Jex-Blake, Sophia. *Medical Women, A Thesis and History.* Edinburgh: Oliphant, Anderson & Ferrier, 1886.

Kahn, Dr. *Catalogue of Dr. Kahn's Anatomical and Pathological Museum* (includes *The Shoals and Quicksands of Youth*). N.p., n.d.

Kaplan, E. Ann. *Women and Film: Both Sides of the Camera.* New York: Methuen, 1983.

Kauffman, Linda S. *Discourses of Desire: Gender, Genre, and Epistolary Fictions.* Ithaca: Cornell University Press, 1980.

Kearns, Gerry, and Chris Philo. "Culture, History, Capital: A Critical Introduction to the Selling of Places." In *Selling Places: The City as Cultural Capital, Past and Present.* Ed. Gerry Kearns and Chris Philo. Oxford: Pergamon Press, 1993. 1–32.

Kestner, Joseph. *Masculinities in Victorian Painting.* Aldershot: Scolar Press, 1995.

Kingsley, Charles. *Yeast*. London and Glasgow: Collins Clear-Type Press, n.d.

Kinsale, Laura. "The Androgynous Reader: Point of View in the Romance." In *Dangerous Men and Adventurous Women: Romance Writers on the Appeal of the Romance*. Ed. Jayne Ann Krentz. Philadelphia: University of Pennsylvania Press, 1992. 31–44.

Kristeva, Julia. *Powers of Horror: An Essay on Abjection*. Trans. Leon S. Roudiez. New York: Columbia University Press, 1982.

Krueger, Christine. "Witnessing Women: Trial Testimony in Novels by Tonna, Gaskell, and Eliot." In *Representing Women: Law, Literature, and Feminism*. Ed. Susan Sage Heinzelman and Zipporah Batshaw Wiseman. Durham: Duke University Press, 1994. 337–55.

La Belle, Jennijoy. *Herself Beheld: The Literature of the Looking Glass*. Ithaca: Cornell University Press, 1988.

Lallemand, Claude François. *A Practical Treatise on the Causes, Symptoms, and Treatment of Spermatorrhea*. Trans. and ed. Henry J. McDougall. Philadelphia: Blanchard and Lea, 1865.

La' Mert, Samuel. *Self-Preservation: A Popular Inquiry into the Concealed Causes of those Obscure and Neglected Disorders of the Generative System Originating in Certain Solitary Habits, and Youthful Excesses, and Terminating in Nervous Disability, Impotence, Sterility, Indigestion, Insanity, and Consumption*. Manchester: by author, 1841.

Landers, Ann. *Wake Up and Smell the Coffee! Advice, Wisdom, and Uncommon Good Sense*. New York: Villard, 1996.

Lane, Christopher. *The Burdens of Intimacy: Psychoanalysis and Victorian Masculinity*. Chicago: University of Chicago Press, 1999.

Langbauer, Laurie. *Women and Romance: The Consolations of Gender in the English Novel*. Ithaca: Cornell University Press, 1990.

Langland, Elizabeth. "Enclosure Acts: Framing Women's Bodies in Braddon's *Lady Audley's Secret*." In *Beyond Sensation: Mary Elizabeth Braddon in Context*. Ed. Marlene Tromp, Pamela K. Gilbert, and Aeron Haynie. Albany: State University of New York Press, 2000. 3–16.

——. *Nobody's Angels: Middle-Class Women and Domestic Ideology in Victorian Culture*. Ithaca: Cornell University Press, 1995.

Laqueur, Thomas. *Making Sex: Body and Gender from the Greeks to Freud*. Cambridge: Harvard University Press, 1990.

"The Late Lady Avonmore." *Natal Witness*, 17 September 1881 (Saturday Supplement): 1.

Lawrence, Christopher. "Medical Minds, Surgical Bodies: Corporeality and the Doctors." In *Science Incarnate: Historical Embodiments of Natural Knowledge*. Ed. Christopher Lawrence and Steven Shapin. Chicago: University of Chicago Press, 1998. 156–201.

Leckie, Barbara. *Culture and Adultery: The Novel, the Newspaper, and the Law, 1857–1914*. Philadelphia: University of Pennsylvania Press, 1999.

Leinwand, Theodore. "Negotiation and New Historicism." *PMLA* 105 (1990): 477–90.

Letters from Laura and Eveline, Giving an Account of Their Mock-Marriage and Wedding Trip. London: privately printed, 1903.

Levy, Anita. *Other Women: The Writing of Class, Race, and Gender, 1832–1898.* Princeton: Princeton University Press, 1991.

Linton, Eliza Lynn. *The Girl of the Period and Other Social Essays.* London: Richard Bentley and Son, 1883.

Longworth (or Yelverton) v. Yelverton. In *Appeals Cases and Writs of Error, 1867.* Vol. 233. 20–43.

Longworth or Yelverton v. Yelverton and *Yelverton v. Longworth.* In *Cases Decided in the Court of Sessions.* 19 December 1862. Edinburgh: T. and T. Clark and U. and R. Stevens Sons, and London: Haynes 1863.

[Longworth, Maria Theresa] The Honourable Mrs. Yelverton. *Martyrs to Circumstance.* London: Richard Bentley, 1861.

——. *Teresina in America.* 2 vols. London: Richard Bentley and Son, 1875.

——. *Teresina Peregrina; or, Fifty Thousand Miles of Travel Round the World.* 2 vols. London: Richard Bentley and Son, 1874.

——. *The Yelverton Correspondence, with Introduction and Connecting Narrative.* Edinburgh: Thomas Laurie, 1863.

——. *Zanita: A Tale of the Yosemite.* New York: Hurd and Houghton; Cambridge: Riverside Press, 1872.

MacDonald, Robert H. "The Frightful Consequences of Onanism: Notes on the History of a Delusion." *Journal of the History of Ideas* 28 (1967): 423–31.

MacKinnon, Catharine. "Only Words." In *Feminism and Pornography.* Ed. Drucilla Cornell. Oxford: Oxford University Press, 2000. 121–29.

Marcus, Steven. *The Other Victorians: A Study of Sexuality and Pornography in Mid-Nineteenth-Century England.* New York: New American Library, 1966.

Marsh, Joss. *Word Crimes: Blasphemy, Culture, and Literature in Nineteenth-Century England.* Chicago: University of Chicago Press, 1998.

Marshall, Gail. *Actresses on the Victorian Stage: Feminine Performance and the Galatea Myth.* Cambridge: Cambridge University Press, 1998.

Marshall, Tim. *Murdering to Dissect: Grave-Robbing, Frankenstein, and the Anatomy Literature.* Manchester: Manchester University Press, 1995.

Mason, Michael. *The Making of Victorian Sexuality.* Oxford: Oxford University Press, 1994.

Matthews, Mrs. "Ennobled Actresses." *Bentley's Miscellany* 17 (1845): 594–98.

Mavor, Carol. *Pleasures Taken: Performances of Sexuality and Loss in Victorian Photographs.* Durham: Duke University Press, 1995.

Maxwell, Richard. *The Mysteries of Paris and London.* Charlottesville: University Press of Virginia, 1992.

Mayhew, Henry. *London Labour and the London Poor.* 4 vols. New York: Dover, 1968.

Mays, Kelly. "The Disease of Reading and Victorian Periodicals." In *Litera-*

ture in the Marketplace: Nineteenth-Century British Publishing and Read-ing Practices. Ed. John O. Jordan and Robert Patten. Cambridge: Cambridge University Press, 1995. 165–94.

McClintock, Anne. *Imperial Leather: Race, Gender, and Sexuality in the Colonial Contest.* London: Routledge, 1995.

McTeer, Victoria. "Moral Travel." Paper delivered at the Narrative Confer-ence, April 2000, Atlanta, Ga.

McWhorter, Laddie. *Bodies and Pleasures: Foucault and the Politics of Sex-ual Normalization.* Bloomington: Indiana University Press, 1999.

Meckier, Jerome. "Never in Lapland: A Clue to the Nature of *My Secret Life.*" *English Language Notes* 16 (1978): 168–77.

"Mending the City's Ways." *All the Year Round* 15 (1866): 613–17

Mermin, Dorothy. *Godiva's Ride: Women of Letters in England, 1830–1880.* Bloomington: Indiana University Press, 1993.

Michie, Helena. *The Flesh Made Word: Female Figures and Women's Bodies.* Oxford: Oxford University Press, 1987.

Milton, John Laws. *On Spermatorrhea: Its Pathology, Results, and Compli-cations.* London: Robert Hardcastle, 1875.

Mitchell, Sally. *The Fallen Angel: Chastity, Class, and Women's Reading, 1835–1880.* Bowling Green: Bowling Green University Popular Press, 1981.

——. "Sentiment and Suffering: Women's Recreational Reading in the 1860s." *Victorian Studies* 21 (1977): 29–45.

Modleski, Tania. *Loving with a Vengeance: Mass-Produced Fantasies for Women.* New York: Methuen, 1982.

Moscucci, Ornella. "Clitoridectomy, Circumcision, and the Politics of Sex-ual Pleasure in Mid-Victorian Britain." In *Sexualities in Victorian Britain.* Ed. Andrew H. Miller and James Eli Adams. Bloomington: Indiana Univer-sity Press, 1996. 60–78.

Muloch, Dinah. *A Woman's Thought about Women.* London: Hurst and Blackett, 1858.

Mulvey, Laura. "Afterthoughts on 'Visual Pleasure and Narrative Cinema' In-spired by *Duel in the Sun.*" *Frameworks* 15–17 (1981): 12–15.

——. "Visual Pleasure and Narrative Cinema." *Screen* 16 (1975): 6–18.

Murray, Janet Horowitz. *Strong-Minded Women and Other Lost Voices from Nineteenth-Century England.* New York: Pantheon Books, 1982.

My Secret Life. 2 vols. New York: Grove Press, 1966.

Nead, Lynda. *The Female Nude: Art, Obscenity, and Sexuality.* London: Routledge, 1992.

——. *Myths of Sexuality: Representations of Women in Victorian Britain.* Oxford: Blackwell, 1988.

——. *Victorian Babylon: People, Streets, and Images in Nineteenth-Century London.* New Haven: Yale University Press, 2000.

Neuberg, Victor E. *Popular Literature: A History and Guide.* Har-mondsworth: Penguin, 1977.

Nightingale, Florence. *Cassandra, and Other Selections from Suggestions for Thought.* Ed. Mary Poovey. New York: New York University Press, 1992.

Nolan, Janet. *Ourselves Alone: Women's Immigration from Ireland, 1885–1920.* Lexington: University of Kentucky Press, 1989.

Nord, Deborah. *Walking the Victorian Streets: Women, Representation, and the City.* Ithaca: Cornell University Press, 1995.

"Nurses of Quality for the Crimea." *Punch* 27 (4–25 November 1854): 695–98.

O'Flanagan, J. R. *Gentle Blood, or, The Secret Marriage.* Dublin: M'Glashan and Gill, 1861.

O'Neill, Ellen. "(Re)presentations of Eros: Exploring Female Sexual Agency." In *Gender/Body/Knowledge: Feminist Reconstructions of Being and Knowing.* Ed. Alison M. Jagger and Susan R. Bordo. New Brunswick: Rutgers University Press, 1989. 68–91.

Oppenheim, Janet. *Shattered Nerves: Doctors, Patients, and Depression in Victorian England.* Oxford: Oxford University Press, 1991.

Owen, Robert Dale. *Moral Physiology; or, A Brief and Plain Treatise on the Population Question.* Boston: J. P. Mendum, 1875.

Pearsall, Ronald. *Tell Me, Pretty Maiden: The Victorian and Edwardian Nude.* Exeter: Webb and Bower, 1981.

——. *The Worm in the Bud: The World of Victorian Sexuality.* New York: Macmillan, 1969.

"Penny Magazine." *Saint Pauls Magazine* 12 (1873): 542–49.

Perry & Co., R. and L. *The Silent Friend.* London, 1847.

Peterson, M. Jeanne. "Dr. Acton's Enemy: Medicine, Sex, and Society in Victorian England." *Victorian Studies* 29 (1986): 569–90.

——. *Family, Love, and Work in the Lives of Victorian Gentlewomen.* Bloomington: Indiana University Press, 1989.

——. *The Medical Profession in Mid-Victorian London.* Berkeley: University of California Press, 1978.

Pile, Steve. *The Body and the City: Psychoanalysis, Space, and Subjectivity.* London: Routledge, 1996.

Pointon, Marcia. *Naked Authority: The Body in Western Painting, 1830–1908.* Cambridge: Cambridge University Press, 1990.

Polhemus, Robert. *Erotic Faith: Being in Love from Jane Austen to D. H. Lawrence.* Chicago: University of Chicago Press, 1990.

Pollack, Griselda. "The Dangers of Proximity: The Spaces of Sexuality and Surveillance in Word and Image." *Discourse* 16:2 (winter 1992–93): 3–50.

Poovey, Mary. *Uneven Developments: The Ideological Work of Gender in Mid-Victorian England.* Chicago: University of Chicago Press, 1988.

Porter, Roy. *Disease, Medicine, and Society in England, 1550–1860.* London: Macmillan, 1987.

Porter, Roy, and Lesley Hall. *The Facts of Life: The Creation of Sexual Knowledge in Britain, 1650–1950.* New Haven: Yale University Press, 1995.

Prasch, Thomas. "Photography and the Image of the London Poor." In *Victorian*

Urban Settings: Essays on the Nineteenth-Century City and Its Contexts.
Ed. Debra N. Mancoff and D. J. Trela. New York: Garland, 1994. 179–94.

Radway, Janice. *Reading the Romance: Women, Patriarchy, and Popular Literature.* Chapel Hill: University of North Carolina Press, 1984.

"Rape of the Glances." *Saturday Review* 13 (1862): 124–25.

Rappaport, Erika Diane. *Shopping for Pleasure: Women and the Making of London's West End.* Princeton: Princeton University Press, 2000.

Reader, W. J. *Professional Men: The Rise of the Professional Classes in Nineteenth-Century England.* London: Weidenfeld and Nicolson, 1966.

Redding, Cyrus. *A Wife and Not a Wife.* 2 vols. London: Saunders, Otley & Co., 1867.

Reynolds, George William MacArthur. *Ellen Percy; or, the Memoirs of an Actress.* London: John Dicks, 1857(?).

——. "Letter to the Industrious Classes: To the Needlewomen of the United Kingdom." *Reynolds's Miscellany of Romance, General Literature, Science and Art* 16 (1847): 251.

——. *The Modern Literature of France.* London: George Henderson, 1839.

——. *Mysteries of the Court of London.* 3rd ser. 2 vols. London: John Dicks, 1853.

——. *The Mysteries of London.* 1st ser. 2 vols. London: George Vickers, 1846.

Ritchie, Robert. *A Frequent Cause of Insanity in Young Men.* Reprinted in *Embodied Selves: An Anthology of Psychological Texts, 1830–1890.* Ed. Jenny Bourne Taylor and Sally Shuttleworth. Oxford: Clarendon Press, 1998. 215–17.

Riviere, Joan. "Womanliness as Masquerade." *International Journal of Psycho-Analysis* 10 (1929): 303–13.

Roberts, Brian. *Ladies of the Veld.* London: John Murray, 1965.

Rose, Jonathan. "How Historians Do Reader Response: or, What Did Jo Think of *Bleak House*?" In *Literature in the Marketplace: Nineteenth-Century British Publishing and Reading Practices.* Ed. John O. Jordan and Robert L. Patten. Cambridge: Cambridge University Press, 1995. 195–212.

Rosen, David. "The Volcano and the Cathedral: Muscular Christianity and the Origins of Primal Manliness." In *Muscular Christianity: Embodying the Victorian Age.* Ed. Donald E. Hall. Cambridge: Cambridge University Press, 1994. 17–44.

Rosenberg, Charles. "The Bitter Fruit: Heredity, Disease, and Social Thought in Nineteenth-Century America." *Perspectives in American History* 8 (1974): 189–235.

Rosenman, Ellen. "'Just Man Enough to Play the Boy': Theatrical Cross-Dressing in Mid-Victorian England." In *Gender Blending.* Ed. Bonnie Bullough and Vern Bullough. New York: Prometheus Books, 1997. 303–10.

Sanborn, Margaret. Introduction to *Zanita: A Tale of the Yo-Semite.* Berkeley: Ten Speed Press, 1991.

Sartre, Jean-Paul. *The Philosophy of Jean-Paul Sartre.* Ed. Robert Denoon Cumming. New York: Vintage, 1965.

Saville, Julia. "The Romance of Boys Bathing: Poetic Precedents and Respondents to the Paintings of Henry Scott Tuke." In *Victorian Sexual Dissidence*. Ed. Richard Dellamora. Chicago: University of Chicago Press, 1999. 253–77.

Schweickart, Patrocinio P. "Reading Ourselves: Toward a Feminist Theory of Reading." In *Gender and Reading: Essays on Readers, Texts, and Contexts*. Ed. Elizabeth A. Flynn and Patrocinio P. Schweickart. Baltimore: Johns Hopkins University Press, 1986. 31–62.

Scott, Walter. *Kenilworth: A Romance*. Ed. J.H. Alexander. Edinburgh: Edinburgh University Press, 1993.

——. *Waverley; or, 'Tis Sixty Years Since*. Oxford: Oxford University Press, 1986.

Sedgwick, Eve Kosofsky. *Tendencies*. Durham: Duke University Press, 1993.

Shields, Rob. "Fancy Footwork: Walter Benjamin's Notes on *Flâneurie*." In *The Flâneur*. Ed. Keith Tester. London: Routledge, 1994. 61–80.

Showalter, Elaine. *Speaking of Gender*. London: Routledge, 1989.

Silverman, Kaja. *Male Subjectivity at the Margins*. London: Routledge, 1992.

The Sins of the Cities of the Plains, or the Recollections of a Mary-Ann with Short Essays on Sodomy and Tribadism. Erotica Biblion Society: London and New York, 1881.

Sisters of Charity, and Some Visits with Them: Being Letters to A Friend in England. London: Joseph Masters, 1855.

Smiles, Samuel. *Character*. Chicago: Donohoe, Henneberry & Co., 1899.

Smith, Albert. *The Natural History of the Ballet Girl*. London: D. Bogue, 1847.

Smith, Alison. *The Victorian Nude: Sexuality, Morality, and Art*. Manchester: Manchester University Press, 1996.

Smith, F. Barry. "Sexuality in Britain, 1800–1900: Some Suggested Revisions." In *A Widening Sphere: Changing Roles of Victorian Women*. Ed. Martha Vicinus. Bloomington: Indiana University Press, 1980. 182–98.

Spencer, Herbert. "Personal Beauty." In *Essays: Moral, Political and Aesthetic*. New York: Appleton, 1865. 149–62.

Sprigge, S. Squire. *The Life and Times of Thomas Wakley*. Huntington, N.Y.: Robert E. Krieger Publishing Company, 1974.

Stafford, Barbara Maria. *Body Criticism: Imaging the Unseen in Enlightenment Art and Medicine*. Cambridge: MIT Press, 1994.

Stallybrass, Peter, and Allon White. *The Politics and Poetics of Transgression*. Ithaca: Cornell University Press, 1986.

Stanley, Liz. *The Diaries of Hannah Cullwick, Victorian Maidservant*. New Brunswick: Rutgers University Press, 1984.

Steele, Valerie. *Fashion and Eroticism: Ideals of Feminine Beauty from the Victorian Era to the Jazz Age*. New York: Oxford University Press, 1985.

Steinbach, Susie L. "The Melodramatic Contract: Breach of Promise and the Performance of Virtue." *Nineteenth-Century Studies* 14 (2000): 1–34.

Stoltenberg, John. "Pornography and Freedom." In *Making Violence Sexy:*

Feminist Views on Pornography. Ed. Diane E. H. Russell. New York: Teachers College, Columbia University, 1993. 65–77.

Straayer, Chris. "The Seduction of Boundaries: Feminist Fluidity in Annie Sprinkle's Art/Education/Sex." In *Dirty Looks: Women, Pornography, Power.* Ed. Pamela Church Gibson and Roma Gibson. London: BFI Publishing, 1993. 156–75.

Stratton, Jon. *The Desirable Body: Cultural Fetishism and the Erotics of Consumption.* Manchester: Manchester University Press, 1996.

Sussman, Herbert. *Victorian Masculinities: Manhood and Masculine Poetics in Early Victorian Literature and Art.* Cambridge: Cambridge University Press, 1995.

Symonds, John Addington. *The Letters of John Addington Symonds.* 3 vols. Ed. Herbert M. Schueller and Robert L. Peters. Detroit: Wayne State University Press, 1967–69.

Teevan, W. F. "On Spermatorrhea." *Lancet* 20 August 1870: 276.

Tester, Keith. Introduction to *The Flâneur.* Ed. Keith Tester. London: Routledge, 1994. 1–21.

Thackeray, William Makepeace. *Vanity Fair.* New York: Holt, Rinehart and Winston, 1967.

Theweleit, Klaus. *Male Fantasies: Women, Floods, Bodies, History.* Vol. 1. Trans. Stephen Conway. Minneapolis: University of Minnesota Press, 1987.

Thomas, Calvin. *Male Matters: Masculinity, Anxiety, and the Male Body on the Line.* Urbana: University of Illinois Press, 1996.

Thurston, Carol. *The Romance Revolution: Erotic Novels for Women and the Quest for a New Sexual Identity.* Urbana: University of Illinois Press, 1987.

Tomkins, Silvan. *Shame and Its Sisters: A Silvan Tomkins Reader.* Ed. Eve Kosofsky Sedgwick and Adam Frank. Durham: Duke University Press, 1995.

Tosh, John. *A Man's Place: Masculinity and the Middle-Class Home in Victorian England.* New Haven:Yale University Press, 1999.

Trollope, Anthony. *Orley Farm.* Oxford: Oxford University Press, 1985.

Turner, Frederick. *Rediscovering America: John Muir in His Time and Ours.* New York: Viking, 1985.

Turner, Victor. *Dramas, Fields, and Metaphors: Symbolic Action in Human Society.* Ithaca: Cornell University Press, 1974.

Tyler, Sarah. *What She Came Through.* 3 vols. London: Daldy, Ibister and Co., 1877.

Vicinus, Martha. " 'Helpless and Unfriended': Nineteenth-Century Domestic Melodrama." *New Literary History* 13 (1981): 127–43.

——. *Independent Women: Work and Community for Single Women, 1850–1920.* Chicago: University of Chicago Press, 1985.

Waddington, Ivan. *The Medical Profession in the Industrial Revolution.* Dublin: Guill and MacMillan, 1984.

Walker, Alexander. *Beauty in Woman Analysed and Classified with a Criti-*

cal View of the Hypotheses of the Most Eminent Writers, Painters, and Sculptors. London: Simkin, Marshall, and Co., 1892.

——. *Woman Physiologically Considered as to Mind, Morals, Marriage, Matrimonial Slavery, Infidelity, and Divorce.* London: A. H. Baily, 1840.

Walkowitz, Judith. *City of Dreadful Delight: Narratives of Victorian Danger in Late-Victorian London.* Chicago: University of Chicago Press, 1992.

——. *Prostitution and Victorian Society: Women, Class, and the State.* Cambridge: Cambridge University Press, 1980.

Welsh, Alexander. *The Hero of the Waverley Novels: New Essays on Scott.* Princeton: Princeton University Press, 1992.

West, Robin. "Pornography as a Legal Text: Comments from a Legal Perspective." In *For Adult Users Only: The Dilemma of Violent Pornography.* Ed. Susan Gubar and Joan Hoff. Bloomington: Indiana University Press, 1989. 108–30.

Wicke, Jennifer. "Through a Gaze Darkly: Pornography's Academic Market." In *Dirty Looks: Women, Pornography, Power.* Ed. Pamela Church Gibson and Roma Gibson. London: BFI Publishing, 1993. 62–80.

Willcock, J. W. *The Laws of the Medical Profession; with an Account of the Rise and Progress of its Various Orders.* London: J. and W. T. Clarke, 1830.

Williams, Linda. *Hard Core: Power, Pleasure, and the "Frenzy of the Visible."* Berkeley: University of California Press, 1989.

——— "A Provoking Agent: The Pornography and Performance Art of Annie Sprinkle." In *Dirty Looks: Women, Pornography, Power.* Ed. Pamela Church Gibson and Roma Gibson. London: BFI Publishing, 1993. 176–91.

Wilson, Marris. "Contributions to the Physiology, Pathology, and Treatment of Spermatorrhea." *Lancet,* 23 August 1856: 215–17; 13 September 1856: 300–302; 1 November 1856: 482–84; 13 December 1856: 643–44; 11 April 1857: 376–77.

Wilson, Mrs. C. Baron. *Our Actresses; or, Glances at Stage Favorites, Past and Present.* 2 vols. London: Smith, Elder, and Co. 1844.

Winnett, Susan. "Coming Unstrung: Women, Men, Narrative, and Principles of Pleasure." *PMLA* 105 (1990): 505–18.

Wohl, Anthony. *Endangered Lives: Public Health in Victorian Britain.* Cambridge: Harvard University Press, 1983.

Wood, Mrs. Henry (Ellen). *East Lynne.* Ed. Sally Mitchell. New Brunswick: Rutgers University Press, 1984.

Working Women in Victorian Britain. Microform. Marlborough, Wiltshire: Adams Matthew Publications, 1993.

Yeazell, Ruth. *Fictions of Modesty: Women and Courtship in the English Novel.* Chicago: University of Chicago, 1991.

"Yelverton Case." *Saturday Review* 11 (1861): 240–41.

"Yelverton Case." *Saturday Review* 18 (1864): 134–35.

"The Yelverton Case Judgment." *Times,* 29 July 1864: 9–11.

Yelverton Marriage Case, Thelwall v. Yelverton, Unabridged Copyright Edition. London: George Vickers, 1861.

Yelverton v. Yelverton. In *English Reports: Ecclesiastical, Admiralty, and Probate and Divorce.* Vol. 4. Edinburgh: W. Green & Sons, Ltd.; London: Stevens and Sons, 1921. 866–74.

Yelverton v. Yelverton. In *Law Reports; Scotch and Divorce Appeal Cases before the House of Lords.* Vol. 1. London: William Clowes and Sons, 1869. 228–31.

Yelverton v. Yelverton. In *Report of Scotch Appeals in the House of Lords.* Vol 2. Edinburgh: William Green, 1895: 1256–92.

Yonge, Charlotte M. *The Clever Woman of the Family.* Harmondsworth: Penguin (Virago Press), 1985.

Young, Iris Marion. *Throwing Like a Girl and Other Essays in Feminist Philosophy and Social Theory.* Bloomington: Indiana University Press, 1990.

Zaviacic, Milan, and Beverly Whipple. "Update on the Female Prostate and the Phenomenon of Female Ejaculation." *Journal of Sex Research* 30 (1993): 148–51.

Index

Page numbers given in *italics* refer to illustrations or their captions.

About the Author

Ellen Bayuk Rosenman is an Associate Professor of English at the University of Kentucky. She is the author of *The Invisible Presence: Virginia Woolf and the Mother-Daughter Relationship* and *A Room of One's Own: Women Writers and the Politics of Creativity.*